ADVERTISING and RACE

This book is part of the Peter Lang Media and Communication list.
Every volume is peer reviewed and meets
the highest quality standards for content and production.

PETER LANG
New York • Bern • Frankfurt • Berlin
Brussels • Vienna • Oxford • Warsaw

LINDA C. L. FU

ADVERTISING and RACE

GLOBAL PHENOMENON, HISTORICAL CHALLENGES, AND VISUAL STRATEGIES

PETER LANG
New York • Bern • Frankfurt • Berlin
Brussels • Vienna • Oxford • Warsaw

Library of Congress Cataloging-in-Publication Data
Fu, Linda C. L.
Advertising and race: global phenomenon, historical challenges,
and visual strategies / Linda C. L. Fu.
pages cm
Includes bibliographical references and index.
1. Advertising–Social aspects–History. 2. Minorities in advertising–History.
3. Stereotypes (Social psychology) in advertising–History.
4. Advertising–Cross-cultural studies. 5. Racism–History. I. Title.
HF5811.F85 659.1'042–dc23 2014005959
ISBN 978-1-4331-2218-7 (hardcover)
ISBN 978-1-4331-2217-0 (paperback)
ISBN 978-1-4539-1334-5 (e-book)

Bibliographic information published by **Die Deutsche Nationalbibliothek**.
Die Deutsche Nationalbibliothek lists this publication in the "Deutsche
Nationalbibliografie"; detailed bibliographic data are available
on the Internet at http://dnb.d-nb.de/.

Cover and book design by Linda C. L. Fu, PhD

© 2014 Peter Lang Publishing, Inc., New York
29 Broadway, 18th floor, New York, NY 10006
www.peterlang.com

CONTENTS

List of Figures ..vii

Preface..xi

INTRODUCTION..1

PART ONE **17**

A GENEALOGY OF THE TROPES OF THE RACIAL OTHER
AND THEIR USE IN EARLY ADVERTISING

CHAPTER 1
Race, Slavery, and Advertising..23

CHAPTER 2
A Colonial Racial Script and Early Advertising37

CHAPTER 3
Post-World War II Racial Politics and Advertising77

PART TWO 111

DEPLOYMENTS OF THE RACIAL OTHER WITHIN THE CONTEXT OF CONTEMPORARY GLOBAL ADVERTISING

CHAPTER 4

Advertising, Race, and Global Disjunctures117

CHAPTER 5

Race in Public Interest Campaigns ..143

CHAPTER 6

Race in Commercial Campaigns...189

CONCLUSION ...259

References ..265

Index ..281

LIST OF FIGURES

CHAPTER 1
1.1 Slave auction leaflet, David & John Deas, 176929
1.2 Slave for sale ad, *American Weekly Mercury*, 173829
1.3 Runaway slave ad, *Virginia Gazette*, Williamsburg, 176933
1.4 Runaway slave flyer, 1860 ...33
1.5 Runaway slave illustration, Library of Congress, 180035

CHAPTER 2
2.1 Pears' soap ad, "The White Man's Burden", 189945
2.2 The White Man's Burden illustration, *The Detroit Journal*, 189948
2.3 Face Angles diagram, Camper, 1791 ...49
2.4 Hierarchy of Living Beings diagram, White, 179950
2.5 Pears' soap ad, "The Temple of Beauty", 188753
2.6 Pears' soap ad, "Three Graces", 1887 ..53
2.7 Hottentot Venus show British poster, 1810 ...55
2.8 Hottentot Venus show French editorial print, 181255
2.9 "Savage Barbarity" illustration, 1818 ...56
2.10 Rough on Rats ad, "THEY MUST GO!" 188557
2.11 Criminal Man photo collection, Lombroso, 187658
2.12 Vinolia soap ad, "You Dirty Boy", 1893 ..62
2.13 Pears' soap ad, "Recommended for Complexion", 188462
2.14 Pears' soap ad, "Happy Jappy", 1910 ..63
2.15 Pears' soap ad, "Christian Missionaries in China", 191065
2.16 Aunt Jemima Pancake Flour ad, "At the World's Fair", 189367
2.17 Aunt Jemima Pancake Flour ad, "Old Plantation's Famous Secret", 193567
2.18 Cream of Wheat ad, "Ain't we cute", 191767
2.19 Paterson's "Camp" Coffee packaging, 194567
2.20 Minstrel show poster, circa 1920s ...68
2.21 Puvodni Karlovarska Becherovka poster, circa 1930s69
2.22 Piccaninny Watermelon poster, "OH—I IS NOT!", circa 1930s69
2.23 Gold Dust poster, "Makes Dishwater that Digs", 191069
2.24 W.S. Kimball & Co.'s cigarette tradecard, Zulu King, 188871

2.25 W.S. Kimball & Co.'s cigarette tradecard, Afghan ruler, 188871
2.26 Duke's Cigarettes tradecard, Chinese Mandarin, 188871
2.27 Frank Rippingille's ad, "Englands gift—A blessing to all nations", 189772

CHAPTER 3
3.1 Union Carbide ad, "Science helps build a new India", 196284
3.2 Van Heusen ad, "4 out of 5 men want Oxfords...", 195290
3.3 New York Central Railway ad, "NEW New York Central", 1947..........91
3.4 Austin Nichols ad, "An Invitation to Taste", 196091
3.5 Tourism ad, "What's cooking?", 1957 ...92
3.6 Tourism ad, "So close...So enticing...", 195492
3.7 Van Heusen ad, "A feast for the eyes!", 195192
3.8 Aunt Jemima trademark, 1968 ..93
3.9 Fun to Wash packaging, 1950s ...93
3.10 Sambo's Pancakes trademark, 1960s ..93
3.11 *The Story of Little Black Sambo* book cover, 1920s...........................93
3.12 *Little Black Sambo* book cover, 1920s ...93
3.13 Schlitz ad, "Make your move to Schlitz", 195997
3.14 Johnnie Walker ad, "You'll be glad you said 'Johnnie Walker Red'", 1964......97
3.15 Old Hickory ad, "It seems all the nicest people drink Old Hickory", 196497
3.16 Bleach and Glow cream ad, "You'd never know...", 1960101
3.17 Black and White Bleaching Cream ad, "Melt him like a snowman", 1959....102
3.18 Palidia ad, "Lighten Dark Skin", 1964...103
3.19 Nadinola ad, "the bright...light...beautiful answer", 1966...................103
3.20 ARTRA ad, "New beauty for women all over the world", 1964103
3.21 AMBI ad, "Successful people use AMBI", 1964105

CHAPTER 4
4.1 Nike ad, "Nike now in Vietnam", 2007120
4.2 Coca-Cola website icon, The Chronicle of Coca-Cola, 2010134
4.3 UN World Decade for Cultural Development logo, 1988......................135
4.4 UNESCO "People to People—Paper Unites" calendar cover, 1991135
4.5 Benetton brochure, 1984..139
4.6 Benetton ad, 1991 ..139
4.7 Levi's ad, "All asses were not created equal", 2010...........................141

CHAPTER 5
5.1 CRE ad, "What was Worse?", 1998..145
5.2 CRE ad, "Scared?", 1998 ..149
5.3 CRE ad, "Improve Your English", 1998149
5.4 CRE ad, "No-One Respects Me", 1998 ...149
5.5 MoD recruitment poster, "Your Country Needs You", 1997155

5.6 British Army recruiting poster, "Britons, Join Your Country's Army", 1914155
5.7 US Army recruiting poster, "I Want You for US Army", 1917157
5.8 British Army recruiting poster, "Who's Absent", 1916157
5.9 US Navy recruiting poster, "19 Weeks, That's All It Takes", 1971..............157
5.10 US Navy recruiting poster, "You can be Black, and Navy too", 1972157
5.11 The British Council poster, "Britain" (people), 1998165
5.12 The British Council poster, "Britain" (food), 1998165
5.13 The Royal Mail commemorative stamps (set of four), 1984166
5.14 UNICEF poster, "Chances Are He Will Starve to Death", 2002171
5.15 UNICEF poster, "Bad Water Kills More Children Than War", 2007..........173
5.16 ISHR poster, "Stop the oppression of women in Islamic world", 2008173
5.17 Cordaid ads, "People in Need" (set of four), 2007177
5.18 Humana ad, "Let your 2nd hand clothes help the 3rd world" (water), 2009179
5.19 Humana ad, "Let your 2nd hand clothes help the 3rd world" (school), 2009179
5.20 ARPA ad, "Their Extinction Is Ours as Well" (set of three), 2009........183
5.21 Stainilgo ad, "For the Removal of Discolorations", 1902184
5.22 Tourism Thailand ad, "Karen", 2008 ...185

CHAPTER 6
6.1 Darkie toothpaste packaging, 1920s ...190
6.2 Darkie logomark, 1920s–1991..193
6.3 *The Best of Al Jolson* album cover, 2006 issue193
6.4 *Stage Highlights 1911–1925* album cover, 1991 issue..............193
6.5 Darlie logomark, 1991 ..199
6.6 Savage Arms logomark (original), 1913................................200
6.7 Savage Arms logomark (1st makeover), 1953200
6.8 Savage Arms logomark (2nd makeover), 1984200
6.9 Savage Arms 1905 catalogue, 1905................................201
6.10 Chief Lame Bear, 1898 ..201
6.11 Savage Arms 1915 catalogue, 1915................................201
6.12 Cleveland Indians baseball team logos, 1928–present205
6.13 Conguitos trademark (original), 1961207
6.14 Conguitos trademark (1st makeover), 1997207
6.15 Conguitos trademark (2nd makeover), 2009207
6.16 Pirelli ad, "Power Is Nothing Without Control" (Lewis), 1994213
6.17 Pirelli ad, "Power Is Nothing Without Control" (Pérec), 1996..................219
6.18 Pirelli ad, "Power Is Nothing Without Control" (Ronaldo), 1998219
6.19 Pirelli's PZero ad (Campbell), 2005219
6.20 Pirelli's PZero ad (Campbell and Beckford), 2005................................219
6.21 Pirelli's PZero ad (Beckford), 2005................................219
6.22 Bit COPA ad, "a Bit more exciting" (middle-aged couple), 2007223
6.23 Bit COPA ad, "a Bit more exciting" (young couple), 2007223

6.24 Bit COPA ad, "a Bit more exciting" (girl and boy), 2007......................223
6.25 DIESEL ad (scorpion), 2005 ...225
6.26 Magnum Light ad (waist), 2004..227
6.27 Magnum Light ad (buttocks), 2004 ...227
6.28 Snowboard School ad, "Good Technique Is Everything", 2003227
6.29 Levi's ad, "In Every Experience", 1992 ...228
6.30 Wasa Light Rye ad, 2007 ..231
6.31 Timberland ad, "We Stole their Land, their Buffalo...", 1989.................235
6.32 M&M's ad, "Happy Birthday, Madiba", 2007240
6.33 Renault ad, MEGANE (Che Guevara), 2007 ..242
6.34 LV ad, "always the unexpected..." (African gig operator), 1984.............245
6.35 LV ad, "always the unexpected..." (Chinese porters), 1984245
6.36 Southwark White Beer ad, "Although sceptical at first...", 2007247
6.37 Southwark White Beer ad, "After much debate...", 2007247
6.38 Habitat, "Tribal Collection" ad, 1998 ...251
6.39 She Bear lingerie ad, "Wear it for Yourself", 2000255
6.40 Mangaloo juice ad, "Freshly squeezed", 2009257

PREFACE

This book is about advertising and race in society. It captures a phenomenon in which the advertising industry deploys the concept and imagery of "race" through strategic and creative constructions. In the process, the faces, bodies, and cultural identities of the "racial Other" are turned into commodity signs in advertisements for mass consumption and used as an elixir to perform the magic of advertising in a race to gain attention, to persuade, to influence, and to dominate. This practice is as old (if not older) as the advertising profession and is rooted in a colonial culture. Tracing key concepts, metaphors, stereotypes, and imageries of the racial Other in advertising from the eighteenth century on, and using a combined semiotic interpretation and Foucauldian-inspired genealogical approach, this book examines imageries of the racial Other in historical and contemporary advertising campaigns to delineate both the continuities and changes in what is termed the "colonial racial script" within global advertising representations. In offering my research, I hope to provide a fresh critical angle, an extended scope, and a streamlined reference point to help puzzle out the interrelationships between image and strategy, between colonial and postcolonial ideology, between old and new rhetoric, and between overt and covert stereotype of the racial Other through mainstream advertising discourses.

It was a long road that took me from the beginning of my research to the publication of this book. What inspired me and kept me going in this huge undertaking was a keen interest in developing a deeper understanding of the interrelationship between advertising and race. This interest goes far beyond the fact that both my professional and academic careers are closely associated with advertising and branding culture, strategy, and design, and that my cultural identity as Chinese-Australian makes me one of the "racial Other" by definition. Indeed, the farther I travel along the path, the more I realize that apart from being socially and culturally engaging, the study of advertising representations

of the racial Other is intellectually stimulating because of their conceptual fluidity and visual ambivalence. Moreover, this subject mater is also professionally absorbing because of the historical affinity and strategic adaptability of the concept of race and the rhetorical plays of such a concept in the hands of the advertising institution. I hope my readers will take away this sentiment to some degree from this book. And I will be forever grateful if this book can inspire you, the reader, to learn more, to think more deeply, and to make positive contributions to the subject matter along your academic and professional paths.

I would like to express my special gratitude to Dr. Brian Morris for generously sharing his intellect, knowledge, and experience with me, and for his insightful feedback, from which I have greatly benefited, on various aspects of my draft. His keen interest and unreserved support throughout my original research have made it a pleasant journey that I will never forget. I would also like to extend special thanks to Dr. Elisabeth Patz, Prof. Jeff Lewis, and Prof. Katherine Frith for the guidance, mentoring, and warm support they gave me in one way or another at different stages of my research career. And I sincerely thank Jane Harriss for sharing her friendship, enthusiasm, wisdom, and time in helping to proofread my earlier draft.

I am grateful to Mary Savigar, Senior Acquisitions Editor at Peter Lang Publishing, for her belief in the value of my work to the study of advertising in the first place, and the support she and her team gave me along the way. You are true professionals.

My heartfelt gratitude goes to my family: my late mother 馬群堅 taught me that determination is essential to success in life; my father 符立夫 not only inspired my enthusiasm to learn, explore, and create, but was also my role model; and my sister Jenny Fu who, despite her own achievements, cheered every small step I made with joy and encouragement. Last but not least, I am indebted to my husband Alan Lim for his ongoing belief and unconditional support, for giving me a helping hand whenever I needed it, and for his understanding and patience throughout my journey. Without the love you have collectively shared with me, I could not possibly have achieved what I have.

——————— ❧◎❧ ———————

I also acknowledge

All the people who have supported me throughout my life,
and those who helped to build my professional knowledge
as well as my visual collections of the subject matter
before and during this project.

Race-centered issues have been considered central to a wide variety of social struggles and cataclysmic events over the past century and even before. In 1903, the prominent African American intellectual and political activist W.E.B. Du Bois had the foresight to recognize that, as he famously put it, "[t]he problem of the Twentieth Century" would be "the problem of the color-line" (Du Bois, 2007: 24). Now, at the beginning of the twenty-first century, we can find numerous affirmations of this claim and considerations of its continuing consequences. Given that the accelerated process of globalization from the 1980s onward appears to have altered many political, cultural, and social dynamics, we may ask: Are race politics still in play in the twenty-first century, or has the concept of race lost its currency and ceased to be relevant? Are we in an age of color-blindness, as some claim, or is it the case—as leading sociologist Howard Winant asserts—that "the quandary of race, the theme that claimed so much attention so long ago, stubbornly refuses to disappear"? (Winant, 2007: 571).

The advertising industry, while only one player in the wider modern discourse on race, has arguably been crucial in giving commercial and public expression to ideas about race and relaying them to a variety of audiences. The vital role of advertising and its imageries in modern society and culture have been widely acknowledged in scholarly discussions since Raymond Williams's groundbreaking 1961 book, *The Long Revolution*. Alongside notable authors such as Judith Williamson, John Sherry, Sut Jhally, Robert Goldman, Mary Cross, Katherine Frith, Timothy Malefyt and Brian Moeran, and Sean Nixon, James Twitchell goes so far as to suggest that the modern American institution of advertising is comparable in scope and magnitude to the Roman Catholic Church of the early Renaissance (Twitchell, 1996: 229). Matthew Hilton goes one step further in claiming an iconic status for the advertisement in our time, writing:

> The advertisement became the icon of the twentieth century, the most persistent element in the visual culture of the vast majority of the population. It utilized imagery and copy that tried to bring all, or as many consumers as possible, under the umbrella of the commodity. In this sense, the advertisement served as the visible emblem of modernity just as much as did the aesthetic creation or the political ensign. (Hilton, 2001: 46)

In addition to these claims, advertising has been considered by scholars as "a cultural system," "a cultural industry," a "sphere of ideology," and "the official art of capitalism." These affirmations of the central positioning of advertising in modern capitalist economies and societies support the notion that advertising provides a rich source of insight into the dominant Western concepts and worldviews at different historical moments.

Core among these concepts are those of racial identity. Advertising and branding materials offer a wealth of cultural documents through which we can develop a deeper understanding of the ways in which the concept of the "racial Other" is presented and apprehended in this system of a late world capitalist culture, also known as global commodity culture. Since the age of colonialism, racial identity and its representation have been in motion. "The job facing the cultural intellectuals," Edward Said has rightly reminded us, is "not to accept the politics of identity as given, but to show how all representations are constructed, for what purpose, by whom, and with what components" (Said, 1993: 314).

The final two decades of the twentieth century witnessed an unprecedented popularity in the use of images of the racial Other in the work of Western advertising agencies. Tropes of the racial Other were widely used in a range of campaigns with diverse political, cultural, and commercial objectives. Media observers have noted this emergence of an increasing presence of non-White imageries in advertisements. As one of them writes: "Marketers who have long painted portraits of consumers in shades of white are adding colors to their palettes" (Elliott, 1996). This increased consumption of the racial Other in advertising continues into the present century. For example, a study jointly conducted by Britain's Institute of Practitioners in Advertising and Extreme Media reported that ethnic minorities featuring in television and print advertisements in the United Kingdom had tripled in 2003 (BrandRepublic UK, 2004). In the United States, a similar phenomenon had been observed earlier and dubbed "rainbow advertising" or "mosaic advertising" in mainstream media. While such hype can easily be taken as a "natural" progression in a

globalizing and relatively more racially tolerant milieu, it needs to be pointed out that the phenomenon is far from natural or given. Instead, we might start with the assumption that colors have not simply been "added" for no reason but have been strategically "deployed" for different purposes and with different rhetorical strategies in mind.

These strategies and their contexts require investigation and analysis if we are to understand this emerging global phenomenon beyond its face value, and to read through the racialized advertising images and be able to recognize their behind-the-scenes interrelationships with commercial and political agendas, historical challenges, and the strategic deployments of such imageries. In other words, the increased awareness of the phenomenon needs to be extended to the awareness of its tradition and transformation, its commodity, cultural and social value, and the politics of race and representation. All these dynamics are what make racial discourses in advertising the ways they were, the ways they are now, and—more than likely—the ways they will be.

This book examines cultural artifacts such as print advertisements and branding materials to analyze the use and usefulness of imageries of the racial Other in historical and contemporary advertising and branding campaigns. Essentially, it seeks to delineate both the changes and continuities in what is termed the "colonial racial script" within advertising media representations while tracing the origins of that script back to the eighteenth century and identifying key genealogical moments in its production in the current age of globalization. It is argued that this colonial racial script has been a crucial underlying narrative defining and confining the racial Other within the visual culture of advertising ever since its inception as a key modern industry and cultural form. But what are the dynamics of that script, which took shape under quite different historical conditions, in contemporary advertising and branding discourses operating within the "new" historical context of globalization? More specifically, has the concept of the "racial Other" deployed in print advertising and branding campaigns changed its colonial script within the context of contemporary globalization?

KEY APPROACHES

The journey we are about to embark on is a quest for insights into the questions posed above. It will be a long journey, as it surveys an over-300-year span of advertising concepts and imageries. It will also carry us far and wide, as it discusses over 100 advertising and branding materials that are designed by leading multinational advertising agencies located in 13 countries across the globe. Key aspects of the approach are signposted here to help us prepare for and navigate throughout the journey.

To explore the key similarities and differences between the contemporary uses of imageries of the racial Other in advertising and their colonial moments of inception, this book combines semiotic interpretation and a Foucauldian-inspired genealogical approach that has been specifically designed for this journey (and potentially for other media studies that wish to look not only for meanings of text but also for their historical recurrences and relationships) as an alternative to the commonly used semiotic approach in advertising literature to date.

For decades, semiotics—a "science that studies the life of signs within society" (Saussure, 1969: 16) —has dominated media analysis and has been deployed systematically to study non-traditional "texts" from cinema to TV to music. Since the appearance of the groundbreaking works in the field— especially Roland Barthes's 1957 *Mythologies* (published in English in 1972) and Judith Williamson's 1988 *Decoding Advertisements: Ideology and Meaning in Advertising*—semiotics has become *the* methodology for a huge number of advertising studies.[1]

Yet like any theoretical approach, semiotic analysis is not without limitations, as a number of critics have shown. Within the field of advertising studies, Liz McFall, for example, questions the tendency to place too great an emphasis on meaning: "[W]hile debates about the nature of meaning provide a fertile and fascinating philosophical challenge, in the end they reveal little about advertising" (McFall, 2004: 9-10). Instead she calls for a more genealogically oriented study of advertising, one that investigates "the piecemeal fabrication of forms" as "an alternative approach to study advertising from the endless semiotic pursuit of meaning" (McFall, 2004: 33). Indeed, as this author began to survey a large sample of advertising materials and ask questions beyond meanings of specific texts, it became apparent that while the much-trusted semiotic approach is a powerful tool for interpreting

the social and cultural meanings of each advertisement in question, its inherent focus on the meaning of texts can—if used alone—steer one's vision away from the recurrences of past practices in contemporary advertising that this book aims to pursue. Essentially, our quest beckons us to inspect old examples as well as new varieties of advertising materials, and to analyze their specific contexts and discourses as well as historical challenges to them and recurrences. At the end of this journey, we will emerge from a jungle of ads that are full of the familiar, the surprising, and the contradictory, with an appreciation not only of the signs and meanings that fascinate us but also their variations that give us a glimpse of the larger picture. Therefore, utilizing a combined semiotic and Foucauldian genealogical approach offers a useful framework within which our quest is structured, data are analyzed, and questions are addressed.

KEY FEATURES

Although the questions posed in this book entail a historical perspective, and while over three centuries' worth of data have been used in this study, it needs to be made very clear that this book is *not* a study of advertising history in terms of the deployment of imageries of the racial Other. Rather, it is a study of the strategic deployment of imageries of the racial Other in advertising through the lens of what Foucault calls "the moment of arising" (Foucault, 1977: 148). In other words, we are not approaching the subject as a linear historical evolution progressing from one stage to the next to find out, for example, if it simply has improved from brutal to sensitive in manner, or from trivial to sophisticated in rhetoric. Rather, while these aspects were indeed taken into consideration, we are employing a Foucauldian genealogical approach to the advertising data in a manner that is "sensitive to their recurrence, not in order to trace the gradual curve of their evolution, but to isolate the different scenes where they engaged in different roles" (Foucault, 1977: 140).

With this principle in mind, the analyses undertaken in this work were performed according to thematic discourses in which imageries of the racial Other were used to fill those different roles in individual campaigns within different arenas. It is through the lens of a genealogical approach that this book framed its analyses and captured some unique scenes in which racial politics

were in play. It allowed us to engage the conditions, practices, and articulations, and to register the typical needs, motivations, dilemmas, and strategies for deploying imageries of the racial Other in advertising.

The dynamic between use and usefulness guides the interrogation of visual data in this book, as it examines how unevenly (some appear so familiar; some seem quite strange) the concept of the racial Other has been taken advantage of and shaped into racialized advertising imagery to serve various campaign objectives. Of these dynamics, the discursive formation of racial ideology, its interplay with the visual representation of the racial Other, and the historical continuity and discontinuity of the phenomenon in question are the key concerns. As such, analyses have been framed along cultural rather than technical, political rather than aesthetic, and value-driven rather than style-driven lines.[2] By critically reading visual texts alongside the discursive contextual factors influencing the ads, the recurrence and variation of colonial racial scripts will be made visible and meaningful to help address the questions posed by this study.

In researching this book, a broad selection of print advertisements and branding materials featuring racialized imageries has been collected. They range from magazine ads, press ads, and outdoor posters to branding materials such as logos, mascots, packaging, magazine covers, corporate literature (e.g., brochures and leaflets) and postage stamps. For the genealogy of the deployment of imageries of the racial Other in early advertising (Chapters 1, 2, and 3) when the colonial script was being formed, the data cover the period from the eighteenth century to the 1970s. For the globalization case studies in Chapters 5 and 6, the data cover the period between 1980 and 2010.

All the primary materials selected for the second part of the book are characteristically mainstream and "global." They are either produced by government agencies, international non-government organizations (NGOs), or international non-profit organizations (NPOs) under the category of public interest campaigns, or by multinational brands or inspiring newcomers to the global market under the category of commercial campaigns. In addition, the advertising agencies producing these campaigns are mainly multinational agency networks themselves; many have their headquarters and ultimate centers of decision making located in New York, London, or Paris. Given the profile of the advertisers and agencies involved, the selected advertisements and branding materials are not only indisputably mainstream, but they also enjoy a high degree of global exposure—either by circulation (such as the

placement of ads and products) or by reputation (such as through international awards or being selected for professional publications).

While efforts have been made to ensure some national diversity in terms of the origins of the primary sources, the visual texts herein tend to be largely Americentric (though this is true to a lesser extent in Part Two). This is due to the general dominance of advertising and branding materials originating in the United States. This inseparable connection between U.S. cultural politics and the ideology of race has been widely recognized. Leading American historian Barbara Fields, for example, insists that such a relationship "would be absurd and frivolously provocative to deny" (Fields, 1982: 145). As she argues: "Elsewhere, classes may have struggled over power and privilege, over oppression and exploitation, over competing senses of justice and right; but in the United States, these were secondary to the great, overarching theme of race" (Fields, 1982: 144). The U.S. experience has also had great significance for the wider world—a key historical period examined in this book is indeed the "American Century," in which, as David Harvey points out, "the power conferred was global and universal rather than territorially specific" (Harvey, 2003: 50). This book further argues that as a result of the political, economic, military, and cultural dominance of the United States, its treatment and representation of the racial Other are not only a territorial legacy confined to national boundaries, but also a symbolic legacy that stands for "the West" and which has a disproportionately significant global influence.

Advertising has been seen as one of the most characteristic and most vigorous of American institutions, a point initially made by Daniel Boorstin and endorsed by recent critics.[3] The very fact that advertising has attracted increasing scholarly interests from a wide range of disciplines in recent decades further supports this view. The pervasive role that advertising has played as an everyday cultural resource for the formation of racial ideology cannot be overstated. Consider the following claims:

> [Advertisements] play a vital role in the economic and political machinery of American values. Advertisements are as essential to American society as life is to death. (Joseph & Lewis, 1986: 151)

> From the turn of the century to the mid-1960s negative advertising images of blacks were pervasive throughout America. Some became American icons and permanent staples in most homes. It was difficult to prepare a meal without using food products featuring a stereotypical pickaninny, black mammy, or black Sambo. (Kern-Foxworth, 1994: 40)

By penetrating the everyday life and space of U.S. households, the stereotypical representation of the racial Other in advertising contributes greatly to the formation and relaying of racial ideology. For example, as one Black advertising executive observed during the Civil Rights Movement of the 1960s: "The advertising industry did not create discrimination, but is one of the most powerful influences for continuing it" (quoted in Chambers, 2009: 122). Part One of this book not only evidences these assertions but also analyzes the historical tenor, agenda, and strategies in play behind some of the most iconic racialized advertising imageries.

In the spirit of a Foucauldian genealogy, this book has tried to capture historical moments from the best vantage point. The United States, as a major battleground of racial ideology and representation in advertising, often provides such a vantage point. The extraordinary challenge to racist doctrines and practices brought about by the Civil Rights Movement—and the advertising industry's attempts to resist, defuse, or endure that challenge—were both intense and tactical. Hence, the U.S. data that dominate Chapter 3 provide a telling foretaste and context for coming changes as the world entered the phase of contemporary globalization.

Part Two offers a more geographically diverse presentation of data related to the origin of advertising. Chapters 5 and 6 scrutinize advertising and branding materials by deploying imageries of the racial Other developed in the United States, the United Kingdom, France, Germany, Italy, Switzerland, The Netherlands, Spain, and Australia. The few ads designed by agencies outside of Western countries qualify for inclusion because either the advertising/branding material was designed by the regional branch of a multinational advertising network with headquarters in the West (e.g., JWT Thailand; BBDO South Africa) or was designed for an international corporation or organization with headquarters in the West (e.g., Colgate-Palmolive's Darkie rebranding; ARPA of the United Nations' "Their extinction is ours as well" campaign), or both. Not only do they qualify by association, but, most important, the nature of the association dictates that it is the "lead office" that originates the communication messages, sets the communication strategy, and gate-keeps the creative outcomes.

DEFINITION OF KEY TERMS

One dimension of the genealogical approach to this quest is a consideration of the contested and historically contingent nature of some of the key terms around which it is oriented. While the key terms noted here will be discussed widely in this book, some initial elaboration is useful to outline a number of the intellectual assumptions that the study begins with.

RACE: As a concept, "race" is, arguably, biologically illegitimate yet socially real. Although endorsed as truth by leading Western statesmen, philosophers, and scientists since the eighteenth century, its scientific credibility collapsed in the 1960s. Nowadays, contemporary thinking and scholarly positions commonly hold that, as stated in the American Anthropological Association's Statement on "Race," "present-day inequalities between so-called 'racial' groups are not consequences of their biological inheritance but products of historical and contemporary social, economic, educational, and political circumstances" (AAA, 1998). Further, this book recognizes that "race" is a shifting signifier. As a social invention involving the interplay of social dynamics within particular contexts, its meanings and currencies are more fluid than fixed. "Race" does not have a fixed referent, but for centuries this social category has typically been made visible by skin color. Within different cultural systems, race has been associated with various social divides (not necessarily in a linear order and often not affixed to a single category) such as species, religion, class, nation, citizenship, and culture. If race is a marker of the times, then the concept of "race" itself is also shaped and marked by the specific social and cultural dynamics of its time.

The dilemma this book faces is that, on the one hand, inquiries into the research question hinge on the concept of "race," and, as problematic as it is, the term—along with related "color" terms that have been, and still are, the markers of race—needs to be uttered, even if the author does not agree with them. On the other hand, as Henry Louis Gates, Jr., has argued, the term "race" and its related markers—such as "black" and "white" (and "red," "yellow," and "brown," for that matter)—are arbitrarily constructed "rhetorical figures of race, to make them natural, absolute, essential" by Western writers (Gates, 1985: 6). Using these terms, therefore, runs the risk of being interpreted as generalizing essential differences. For these reasons, and to indicate

disagreement, the author asks the reader to mentally place scare quotes around her use of the terms "race" and "people of color" throughout this book. For the same reasons, this book also capitalizes the initial letters of the terms Black, White, Red, Yellow, and Brown.

RACIAL OTHER: With its currency across various academic fields including philosophy, psychoanalysis, and communication, "the Other" is understandably a multifaceted concept. In the domain of cultural studies and media studies, ethnicity—together with class and gender, as "the Other" of the White-male dominated culture—attracts much of the emphasis (e.g., During, 1993; Fitzgerald, 1992; Wright, 1985). In the fields of Development Communication and International Communication, in line with postcolonialism, the "Third World," or the previously colonized nations, is often referred to as "the Other" by Western scholars (e.g., Burns, 1975; Weatherby, Long, Cruikshanks, Gooden, Huff, Kranzdorf & Evans, 1994). As Michael O'Shaughnessy suggests: "The term 'other' highlights the fact that that which falls into the category of 'other' has historically been seen as deviant, unusual and strange because it exists outside the boundaries of what the West deems normal" (O'Shaughnessy, 1999: 225).

In visual terms, Stephen Spencer suggested that the Otherness of the racial Other can be recognized by visibly different skin color, clothing, location, and cultural practices from an "Identikit." At the same time he recognized that the differences "are not only physical and geographical but also social, economic and cultural" (Spencer, 2006: 8). In keeping with the views of O'Shaughnessy and Spencer, the term "the racial Other" in this book denotes the "non-White people," the "colored people," the "Oriental," the "Third-World people," the "underdeveloped people," and the "visibly different minorities." For the same reason as that noted for "race," the author asks the reader to place scare quotes around her own use of the term "racial Other" as well as the above-mentioned terms throughout this book.

TROPES OF THE RACIAL OTHER: In the language of advertising, both linguistic and visual tropes are deployed. Beyond the existing terms that tend to be specific to the visibility of the racial Other, such as "image" and "identikit," this book finds the term "trope" most effective in covering the wide range of rhetorical devices used in advertisements. With its linguistic origin, a trope is, in short, the use of figurative language that also denotes a common and often recurring theme. Without probing deeply into the territory of

language studies in this book, we will witness the use of various tropes such as metaphor, stereotype, pun, cliché, historical irony, and sarcasm among ads new and old—either in words, as visuals, as conceptual bases, or in any combination of these.

THE WEST: In the context of this book, "the West" (and, by extension, "Western World" or "Occident") refers to the countries of western and central Europe and its past settler colonies in the Americas and Oceania—namely, the United States, Canada, Australia, and New Zealand. This is the common use of the term in contemporary discourse. However, it needs to be pointed out that, like "race," the term "the West" is problematic. Although it apparently entails geographic distinctions, it includes Australia, which lies outside the Western Hemisphere, while a large number of nations inside its boundaries (such as Western Africa and some Pacific nations) are excluded. While claiming shared culture and beliefs, it excludes Latin America, which is not only geographically located in the west, but also has shared linguistic and religious roots with nations of "the West." Therefore, this book considers this usage to be grounded in a geopolitical divide, one closely associated with the history of colonialism.

"The West" is often used as a marker in contrast to its "Other"—in geographic and cultural senses, as opposite to "the East" or "the Orient," and in a geopolitical sense, as opposite to "the Rest" or "the South." In addition, in dominant discourse within Western nations, "the West" is also commonly a synonym for "the First World" and connotes an "advanced," "rich," "democratic," "scientific," "technological," and "free" world—in contrast to "the Third World," which is perceived as a "backward," "poor," "less-democratic"/"autocratic," "natural," "traditional," and "oppressed" world.

Furthermore, because the population of the geographic West and the majority of settlers in colonies outside Europe were of European descent under the colonial regime, people of "the West" are also denoted as the so-called "White race," in contrast to the "non-White races" or "people of color." Paradoxically, Whiteness has been normalized and rendered irrelevant to "color" in racial terms—no color, no abnormal features, "just people"— a rhetoric that is "historically, socially, politically and culturally produced and…linked to…relations of domination," as Ruth Frankenberg puts it (Frankenberg, 1993: 6).

GLOBALIZATION: The use of the term "globalization" in this book is in line with Roland Robertson's perspective of the concept as referring "both to the compression of the world and the intensification of consciousness of the world as a whole" (Robertson, 1992: 8). In other words, it is a phenomenon as well as a process. It also needs to be noted that, apart from being used to denote a phenomenon and a process, the term "globalization" is also perceived and expressed in this book as a paradigm and a domain of cultural knowledge about race and racial ideology.

Contrary to common misconceptions, and despite the term only coming into popular use in the 1980s, globalization as we call it now is not new. Depending on their chosen perspective, some scholars, such as Immanuel Wallerstein (1974) and Roland Robertson (1992), identify its starting point as early as the fifteenth century, while others, such as John Meyer (1980), attribute it to the seventeenth century. Likewise, there is disagreement on the number of stages of globalization. However, the late nineteenth century, as marked by the turn of High Imperialism, is generally recognized by these theorists as a critical transitional moment. A more streamlined understanding of the process and phenomenon of globalization offered by the World Bank identifies three stages of globalization: (1) from 1870 to 1914; (2) from 1950 to about 1980; and (3) from 1980 to the present (World Bank, 2002). This largely reflects the chronology established by Meyer, albeit with his seventeenth-century "Medieval Christendom" moment omitted. An appreciation of these earlier historical junctures, which I gained while conceptualizing this research, is reflected in the construction of this book. It examines advertising data within four historical moments: eighteenth-century Transatlantic Slave Trade; the eighteenth-to-nineteenth-century colonialism and High Imperialism; the post-World War II, postcolonial, and Civil Rights Movements in Part One; and the current phase of globalization from the 1980s to the present in Part Two.

Thus, in this book, the designated use of the term "globalization" to denote the current historical moment should not be taken as disregarding or excluding earlier developments in the course of globalization. Rather, it should be seen as a matter of expression. Instead of either naming the earlier phases numerically or sequentially, or from a pool of diverse but not-yet-agreed-upon markers, the author feels that the different historical moments are more clearly and meaningfully identified by the historical significance that marked their characters. Therefore, except to denote the concept itself, the term is qualified

where appropriate with "contemporary" or "current phase," although sometimes the term is used "as is" to avoid repetition.

THE STRUCTURE OF THIS BOOK

Advertising is not produced in a vacuum, and there is no "degree zero" (to borrow Barthes's term) in the language of advertising. The same can also be said about the concept of race. As Kamari Clarke and Deborah Thomas put it, "context is everything, and historical specificity is crucial" to understanding the contemporary process of racial transformation (Clarke & Thomas, 2006: 32). To gain a deeper understanding of the subject matter and to address it in the limited space of this work, each of the two parts of the book is designed to link and examine the contextual factors of specific historical moments that shaped the concepts of race within textual discourses of race in advertising.

In the three chapters that comprise Part One, this book establishes a genealogy of the trope of racial Other and its manifestations in early advertising. Following Nietzsche and Foucault, prominent American philosopher Cornel West has effectively mapped a genealogy of modern racism. The author shares West's interest in "the emergence (Entstehung) or the 'moment of arising' of the idea of white supremacy within the modern discourse in the West" (West, 2003: 299), albeit with a more specific interest in the other side of the coin—the trope of the racial Other within the modern discourse in the West. How has the concept of the racial Other been established and developed in key historical moments within the social and cultural contexts of Transatlantic Slave Trade, the colonization campaigns, and the post-World War II and postcolonial racial struggles? And how have such aggregated concepts managed to operate as a colonialist racial script within advertising discourses? Part One traces the ethos and developments of knowledge, ideology, and discourses of race during three key historical moments, as evidenced through proto- and early advertisements.

Part Two contains the bulk of contemporary case studies. It is divided into three independent yet closely related chapters. The first one outlines the relevant context in which the imageries of the racial Other are deployed, while the following two critically analyze a range of public interest and commercial

campaigns. By design, Chapter 4 serves as an introduction to both Chapters 5 and 6, and findings from all of these chapters are summarized in the "Conclusion" chapter. Thus, the chapters that make up Part Two do not come with their own opening and concluding sections. The motivation for examining public interest advertising campaigns as a category among case studies in Part Two is a recognition of the important part that these campaigns play in contemporary advertising discourse. It also reflects a need to expand our understanding of the strategic negotiation of the meaning of goods, in a commonly addressed and more articulated commercial sense, to include the strategic negotiation of the meaning of institutions, policies, and beliefs in a far less attended social sense.

The six chapters contained in Parts One and Two cover the following material:

PART ONE

CHAPTER 1 traces the roots of the deployment of imageries of the racial Other in advertising within the historical moment of Transatlantic Slave Trade. It identifies a moment when the attitude toward Africans changed as a result of colonial conquests and the slave trade, and when the concept of race was reinvented to define a master/slave relationship. Taking into account the political economy and cultural practices of the slave system, and examining advertising data from eighteenth-century slave trade ads and runaway slave ads in terms of their common tropes, this chapter unveils advertising's earliest realization of the potential commodity sign value of racialized visual symbols (in this case, Black bodies) and of the need to adopt rhetoric to match the motivation behind the ad. By doing so, the chapter chronicles advertising's earliest contribution to the mass communication of the colonial racial ideology, as these ads help to invent a conceptual, mythical, and visual equation between Blacks and slavery.

CHAPTER 2 examines a key moment in which the most intense political, intellectual, and visual developments of the concept of "race" are mounted. From the Age of Enlightenment to the era of High Imperialism, leading Western statesmen, intellectuals, and institutions contributed to the epistemology of race. This was the time when the colonial racial script established its authority, as essentialist racism, scientific racism, and commodity racism were widely

articulated throughout the colonialist West. This chapter pinpoints the most dominant notions, metaphors, and categories about the racial Other in Western discourses. It discusses the ethos of the colonial racial script when racial differences were conceptually and visually coded into advertising languages through the eyes of colonial minds, and represented in the prints of early advertisements, posters, and media materials. These materials represent, in effect, the birth of the modern advertising industry.

CHAPTER 3 concerns the moment of ascendancy of racial politics brought about by worldwide post-World War II and postcolonial anti-racism sentiment and the Civil Rights Movement in the United States. This is not only a moment when the "rules of the game" and the rigid colonial racial script were seriously challenged for the first time, with unprecedented pressure for equal opportunity to present and be represented in a non-discriminatory light in advertising, but also a moment when an increase in Black-owned media and Black consumer power led to the development of new themes targeting this market segment. This chapter captures the strategic response of the advertising industry (particularly in the United States) to this unprecedented attack—a response involving a "double movement" in which, on the one hand, imageries of the racial Other were typically rendered invisible in ads in mainstream media while, on the other hand, they were used in ads placed in Black-owned media to lure Black audiences to consumerism.

PART TWO

CHAPTER 4 locates advertising within the disjuncture produced within the political economy of a global commodity culture while also drawing on critiques of American-centered cultural imperialism. This chapter analyzes the discursive factors that contribute to the rise of a global advertising industry, the dominant wisdom and practices within a global market, and its contribution to global culture. It identifies the shifting market, identity, rhetoric, and paradigm as the crucial axes affecting and complicating the use and usefulness of imageries of the racial Other in advertising. By applying the complexity of the conditions and challenges of the global commodity culture to the advertising industry—itself a major contributor to that culture—this chapter provides a broad contextual background for the analyses to come in Chapters 5 and 6.

CHAPTER 5 analyzes the use and usefulness of imageries of the racial Other in public interest campaigns for government and non-government organizations within the context of contemporary globalization. The chapter scrutinizes the stereotypical and not-so-stereotypical imageries of the racial Other strategically deployed in campaigns promoting claims such as multiculturalism and racial equality, as well as initiatives such as foreign aid and environmental protectionism. The emergence in the 1980s of public interest advertising campaigns deploying imageries of the racial Other produced some new themes and strategies in using such imageries as persuasive signs to promote political and social propositions and to influence current affairs.

CHAPTER 6 examines commercial campaigns for some of the leading global brands and newcomers within the context of contemporary globalization. Recognizing the commodity-sign value that the racial Other has possessed since its inception, the advertising industry has exploited and transformed "racial Otherness" into some well-known themes and profitable commercial icons. However, as the context has become more complex, racial identities have become more fluid, and the deployment and construction of imageries of the racial Other have arguably become more multifaceted. As in Chapter 5, each case studied in this chapter provides an example through which to consider the continuities and/or discontinuities of the broader colonial racial script.

NOTE

[1] Including attempt of my own (Fu, 2000), together with other studies of the visual representation of the racial Other in advertising such as O'Barr, 1994, and Ramamurthy, 2003.

[2] Although I have touched on some aspects of the Other as the need has arisen, drawing on my professional background as a practitioner when necessary.

[3] The point was made by Boorstin in his 1973 book The Americans: The Democratic Experience and has been endorsed by, most notably, Marchand, 1985; Twitchell, 1996; and Berger, 2004.

PART ONE

A GENEALOGY OF THE TROPES OF
THE RACIAL OTHER AND THEIR USE
IN EARLY ADVERTISING

To understand contemporary processes of racial formation, it is critical to clarify the relationships between older imperial relationships and current configurations of power, to identify the ramifications of these two projects' motivations for classifying populations, and to clarify their visions of the future. In other words, context is everything, and historical specificity is crucial.

— Clarke & Thomas, 2006: 32

The idea of race began to take shape with the rise of a world political economy. The onset of global economic integration, the dawn of seaborne empire, the conquest of the Americas, and the rise of the Atlantic slave trade were all key elements in the genealogy of race.

— Winant, 2004: 155

A more focused analysis of the cultural implications of ads is possible if we rethink advertising and commodity-signs in the context of the historical development of capitalist political economy and class relations.

— Goldman, 1992: 22

Part One of this book constructs a genealogy of the tropes of the racial Other and their deployment in proto- and early advertising from the sixteenth century up through the end of the 1970s. Against the backdrop of modernity, the first two chapters selectively chart key justifications and articulations of racial concepts by Western intellectuals and luminaries. These concepts formed the basis of a hegemonic and durable worldview of "race." Despite the ideological biases of these concepts, they individually and collectively created powerful ripple effects that sweep beyond their original domains of knowledge. For example, Darwin's theory of the preservation of favored races in life struggles was used in the development of Social Darwinism and Nazism; Hoffman's statistics on the insurability of Blacks not only helped

stop the progress of anti-discrimination legislation against the insurance sector's racially discriminatory practices, but also helped maintain the racial status quo in the wider society; Camper's theory of face angle not only affirmed racialized aesthetics, but was also used to strengthen the concept of the Great Chain of Being. The West's political history is littered with the exploitations of concepts of race. Thomas Jefferson used specific concepts of race to justify the Jim Crow laws to maintain the slavery system in eighteenth-century America; Benjamin Disraeli made race an obsession of nineteenth-century Victorian Britain; and the notions of race behind Adolf Hitler's fanatical anti-Semitism led to the Holocaust during World War II.

Historical succession is, as Foucault suggests, a matter of contests and struggles between forces. In this regard, intellectual involvements in the battle over the meaning of race have unfolded over the course of the history of the West. The battle against racism and the struggle over racial identity and equality gained serious momentum post-World War II, a period examined in the third and final chapter of Part One. The inclusion of the postcolonial moment provides an appreciation of a certain degree of reorganization of power occurring at this time and its impact on the status quo of racial ideology in cultural discourse.

Like politicians deploying the concept of the racial Other to serve their agendas in historical struggles centered around slavery, conquest, subjugation, and ethnic cleansing, advertisers also have a history of using the dominant racial concept for a wide range of purposes in the modern era. What makes the racial discourse in early advertisements interesting are the ways in which it takes up the dominant racial beliefs established through scientific and political discourses and transforms them into cultural artifacts and commercial devices. These racialized devices contribute to the political and economic advancements of the West over the Rest, armed with the power of visual persuasion. Even when used only as material evidence of a bigger picture of the development of racial concepts (as they are generally presented in Part One), advertising discourses reveal how a range of intellectual and social conceptions of the racial Other became integrated into earlier forms of commodity capitalism within the context of modernity.

If we approach advertising as a sphere of cultural production and communication through which dominant ideas are relayed, then we can construct a genealogy of how dominant ideas about "race" were articulated and circulated at different historical moments through its discourses. The

construction of a genealogy of the tropes of the racial Other and their use in early advertising in the three chapters of Part One is designed to travel across three key moments that map dominant notions of race and their embodiment in early advertisements. For the benefit of further contrast and analysis, the intellectual tenets surrounding and deriving from the Enlightenment regarding the idea of the racial Other and their interplay with changing socioeconomic conditions as expressed in early advertisements are at the core of the discussion in this first part of the book.

Because of the diversity of disciplines involved in the body of knowledge on race, and since the dominant concept of race has never stopped being developed and transformed, its mobility and multiplicity cannot be grasped simply through a linear lens. Most notably, complex dynamics are in play, the development of racial concepts is often influenced by the old and challenged by the new, and evidence of substantial overlap is extensive. A genealogical approach allows—indeed encourages—historical conditions and key events to be narrated like a "patchwork," as Foucault puts it. To tackle the challenge, this book will approach the genealogy in such a patchwork fashion and with a nonlinear way of seeing and narrating. This approach adopts Foucault's stand in rejecting traditional historical accounts, which are characterized by treating events as uninterrupted continuities and stabilities. Through the construction of a genealogy that links significant historical events and discourses with the tropes of the racial Other and their use in early advertising, the intention is to reveal the potency and complexity in the articulation of race during the course of history on one hand, and the inscription of historical events on advertising's use of the tropes of racial Other on the other. In so doing, we are gaining a vantage point to track down the plurality, chaos, and modification of the colonial concepts of race and the dominant attitudes over time toward the racial Other in the West, with the help of advertising from its earliest inception.

RACE, SLAVERY, AND ADVERTISING

> Most European societies were involved in African slavery in one way or another. And, in general, the image that most Europeans had of Africans was that of slaves, of subordinate and powerless people.
>
> – Spencer, 2006: 61

> Many people have probably never thought about the importance of advertising in the preservation of slavery. In fact, slavery—a practice by which human beings are owned by other human beings—would not have been such an effective institution without the vehicle of advertising.
>
> – Kern-Foxworth, 1994: 3

In the long history of slavery, the Transatlantic Slave Trade—which saw the mass transportation of mainly West Africans to the Americas—is considered the most widespread and systematic. Over a period of about 450 years beginning in the middle of the fifteenth century, millions of Africans were forcibly transported overseas as slaves (Eltis, 2000). Spanish traders took the first African slave shipment to America in 1502, and the Portuguese—and eventually the Dutch, French, and English—quickly followed suit (Rout, 1977). By the end of the eighteenth century, Britain had come to dominate the trade, with around 150 slave ships leaving Liverpool, Bristol, and London each year. According to the British Empire & Commonwealth Museum in Bristol, between 1698 and 1807 more than two-thirds of the city's trade was directly related to slavery (British Empire & Commonwealth Museum, 2007). Arguably, the wealth of the city of Bristol at the time was built on the slave trade.

Slave trading developed as a lucrative commercial system. As the ships carrying slaves docked in the Americas, traders used all available means of

communication at the time, mostly a town crier or a local newspaper, to advertise the arrival and trading of slaves (Hughes, 1983: 14). Consequently, images of Black slaves began to emerge under a slavery theme in eighteenth-century print media ads. Slave-trading advertisements are among the most permanent historical documents available in terms of describing the people and conditions involved during this period (Smith & Wojtowicz, 1989).

As historical documents, slave-trading advertisements provide evidence of the way in which slave traders and speculators took advantage of the power of advertising to promote and support their trading regime. As the influential historian Ulrich B. Phillips noted, apart from the more conventional "auction" and "to be sold" ads, advertising also promoted some rather left-field methods of slave selling, such as by raffle or lottery (Phillips, 1966: 192). While slave trading was not totally dependent on advertising, research shows that there is little doubt that advertisements served as a useful mechanism for that economy (Kern-Foxworth, 1994: 3).

The eighteenth century was marked by the broader rise of mass print media. Williams, for example, claims that from the 1700s until our own century, the history of communication is largely "the history of the Press." In particular, he notes the rise of the earliest form of press advertising and observes: "Finally comes the material which was in fact to sustain the eighteenth-century newspaper: the body of small commercial advertisements" (Williams, 1961: 204). Consequently, early newspaper advertising became technologically and culturally available to slave traders and owners. The growing pervasiveness of advertisements in newspapers in this period led Dr. Johnson to remark on their abundance and to formulate the dictum that "Promise, large promise, is the soul of an advertisement" (*Idler*, 1759). While Johnson's comments referred to ads promoting consumer products such as razors and beauty lotions in eighteenth-century British newspapers, historians noted that the same explosion of advertising in U.S. newspapers included a flowering of ads promoting the capture and trading of slaves (see, e.g., Hughes, 1983; Windley, 1983; Kulikoff, 1986; Smith & Wojtowicz, 1989).

This historical moment can also be considered one of the "pictorial turns" (Mitchell, 2002: 92–94) in Western history, during which mass-produced images were becoming much more commonplace. While the pervasiveness of newspaper advertisements containing images may not seem significant by today's standards, it had a major impact on the mediascapes of the time, given the absence of the competing visual media platforms we have available today.

It is within this historical context that this book examines two major categories of slavery advertisements—the slave-trading advertisements and the runaway advertisements. The focus here is on the continuities and contradictions in the visual discourse on race and the construction of commodity sign values within the political economy of a slavery system.

The link between race and slavery is neither God-given nor primordial, but is rather a constructed worldview that became a dominant idea in the West at this time. Slavery existed centuries before the concept of race was invented, according to scholars such as Stephen Spencer (2006: 57). While slavery has always operated on a power relationship, in its earliest form it was not race-based. In ancient Greece, according to research, "[s]laves were generally conquered peoples, but were not identified with any particular somatically defined or cultural group, even though they were often of a different ethnicity than the Greeks," and most slaves at the time were of light complexion (Blum, 2002: 110). This kind of non-race-based slavery system can also be found in ancient Rome, where slaves could be prisoners of any skin color and nationality caught on the frontiers of the empire (Thompson, 1989). Indeed, in his book *Before Color Prejudice: The Ancient View of Blacks*, Frank Snowden claims there is no evidence that dark skin color served as the basis of invidious distinctions anywhere in the ancient world (Snowden, 1983: 101–107).

The concept of race in its earliest modern form also does not necessarily invoke discriminatory connotations. Basil Davidson draws on a rich range of historical evidence to show that the Europeans' initial encounter with the Africans did not originally invoke a belief in the link between Black backwardness and inferiority. According to Davidson:

> In short, and again with the exception that so vast a subject must allow, the Europeans of the sixteenth century believed that they had found forms of civilization which were often comparable with their own, however differently and variously dressed and mannered. A later age would prefer to forget this, and would roundly state that Africa knew nothing but a savage and indeed hopeless barbarism. (Davidson, 1994: 43)

The above passage summarizes the change in European attitudes toward Blacks from the initial encounter. The "later age" Davidson refers to marks a shift in opinion toward race as a result of European colonialism. In defining this key moment, Lawrence Blum suggests:

Ideas of superiority and inferiority of entire peoples were largely a product of the encounter of Europeans with Africans and the indigenous peoples in the Americas, through conquest, colonization, and, later, the Atlantic slave trade. Contact with these groups *prior* to a full commitment to colonization and expansion by no means resulted in primarily negative images of them. (Blum, 2002: 111; emphasis in original)

Despite popular assumptions and misperceptions, histories of first contacts reveal that the encounter with the racial Other did not necessarily evoke racism, but the wider apparatus of colonization and key parts of it, such as the slave trade, did.

Hence, slave-trading ads reveal more than simply a commercial operation in action. They also offer insights into the visual articulation of racial stereotypes and commerce in its original and protean form. For example, Marilyn Kern-Foxworth notes that the skillfulness of individual slaves was often emphasized in these advertisements (Kern-Foxworth, 1994). On the other side of the scale, however, those most vulnerable in a slavery system—women and children—were treated remarkably differently. As evidence of the conditions Black women and children suffered under the oppressive patriarchal culture and the dehumanizing slavery system, researchers found that many ads described the Black female slaves on offer as being sold "for no fault but breeding" (Smith & Wojtowicz, 1989: 8). Not only did the cycles of childbearing for Black women and the hard labor demanded by the masters make women undesirable slaves, but Black babies were regarded as burdens and, at times, even advertised as giveaways. Indeed, women were more likely to be sold, and sold separately, than men, as they were less valuable in the eyes of slave masters (Robertson, C., 1996: 13).

Although historians have relied on an analysis of archival advertisements to piece together an account of the social status and life of Blacks during this historical period, their collective focus has been on written language. As rightly identified by Kern-Foxworth in her 1994 book *Aunt Jemima, Uncle Ben and Rastus*, in the field of advertising studies the importance of slavery-related ads has generally not been understood. While this work remains the most in-depth analysis of slavery-related advertisements to date, consistent with Kern-Foxworth's treatment of advertising data in other periods, visual representation is not part of the discussion. Published discussions of the strategies behind the visual depiction of the slaves in these ads also cannot be found. While representations of the racial Other at the time were still strongly dependent on the power of written language, many slavery-related ads used the power of

visual language. The following sections present a detailed case for recognizing the rising importance of visual culture in this eighteenth-century historical moment, where a deep belief in "knowing by seeing" and an enriched depictional vocabulary were key elements of the visual culture of the time.

"PRIME HEALTHY NEGROES"

This section demonstrates how visual interventions were used to serve the commercial interests of the slave traders and speculators and, ultimately, the interests of the colonial power. Reflecting the limitations of the image reproduction technology of the time, the most frequently used visual devices were woodcut images and special typographic treatments. Although these ads may look unpolished by today's standards, they nonetheless provide a means to appreciate advertising imagery's early contribution to the formation of racial ideology.

Consider the following two examples from the University of Virginia database. Figure 1.1 is a 1769 leaflet circulated in Charleston, South Carolina, to promote an event where, according to the copy, "a cargo of ninety-four prime, healthy Negroes consisting of thirty-nine men, fifteen boys, twenty-four women and sixteen girls" were to be sold. Figure 1.2 is a 1738 newspaper advertisement that appeared in the *American Weekly Mercury*, offering "A parcel of fine young healthy, Negroe slaves, boys and girls" for sale.

Enslaved Black people in both ads were depicted with the aid of illustration. In the case of the leaflet, an effort to represent the gender and age groups of the slaves for sale is evident. This illustration not only served to provide a physical description; it used details such as costume and posture to assign value to these Blacks to attract prospective slave buyers. It helped them to see what these enslaved Negro men and women could do for them once at their disposal—most typically men for plantation labor, and women and children for domestic needs.

Unlike the leaflet that promotes a big slave-trading event offering nearly 100 slaves, the newspaper ad does not mention the number of slaves to be sold, but, judging by its description and scale, that number is presumably considerably less. In comparison with the former, its depiction of the Negro

slaves is also less sophisticated. Nonetheless, like the leaflet, the visual intervention in the ad helps to enhance the written sales pitch: the imagery of three Blacks with different builds and in slightly different costumes in this illustration helps to convey the advertiser's message that there were a variety of slaves on offer; the feathers on their heads add a sense of non-threatening exoticism; and their expression of cheerfulness promotes their commodity value as desirable properties to potential buyers.

Remarkably, to maximize the traders' profit margin, the ads made an effort to dress up the Negro slaves (not literally, as all characters were nearly naked in these ads). Not only were these Black characters depicted as in good spirits and of non-threatening appearance; the images were also reinforced with words such as "prime, healthy," and "fine young healthy" in the respective copy for both ads—this despite the fact that these people were forcibly removed from their homeland, and despite the inhuman conditions they endured during the journey through the Middle Passage in which many died and others arrived in poor health. In fact, a large number of slaves died during the first year after their arrival, during the so-called "seasoning" phase (Ploski & Williams, 1989).

Two significant characteristics can be identified from these slave-trading ads. The first is the "default" use of Black imagery, which denotes the concept of slaves using illustrative icons of Blacks so exclusively that no other racial identity can be found. The second is the consistent discourse that describes slaves as property. The former trend is also apparent in runaway ads in the following section, so we will concentrate on the latter trend here.

With the help of words and typographic enhancements, slave-trading ads consistently represented Blacks as inanimate objects or properties that were "imported" to the Americas as "a cargo" or "a parcel," as these two examples and many others demonstrate. If the eighteenth-century slave-trading ads helped to spread the rhetoric of the slave as "property" in America, this dehumanization of Blacks gained an institutional seal of approval in the famous Dred Scott decision of the U.S. Supreme Court in 1857, wherein Chief Justice Roger B. Taney proclaimed that "Negroes were seen only as property; they were never thought of or spoken of except as property." According to Audrey Smedley, given that property was considered more sacred than people in American law, this ruling meant that the property rights of masters overshadowed the human rights of slaves (Smedley, 1997). With the backing of institutional power, the American slavery system effectively dehumanized the "negroes" and transformed them into "things" that belonged to the master

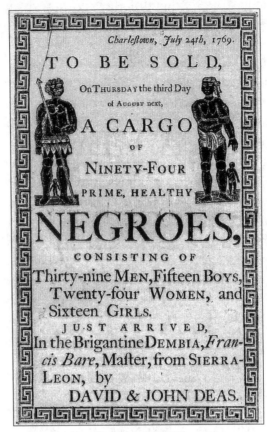

Figure 1.1, *1769*

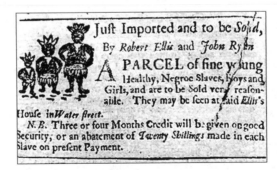

Figure 1.2, *1738*

class and, in so doing, stripped them of their human rights, despite then U.S. President Thomas Jefferson's much-publicized statement that "All men are created equal."

In short, in helping to promote this aspect of the colonial economy, which profited from what Robert Young calls "an exchange of bodies as of goods, or rather of bodies as goods" (Young, 1995: 181), Black imageries were used in slave-trading ads to sell Blacks themselves as prime properties by and for the slave traders. In the tradition of the racial discourses outlined here, and in the interest of justifying slavery, Blacks were conceptually dehumanized by categorizing them as property. In the interest of attracting buyers and increasing profits, a false sense of these Black properties' "good condition" was created, and the pain and suffering they endured denied. In the process of appropriating Black skins, Black bodies, and other Black symbols, the construction of racially based commodity signs showcases the earliest evidence of the play of race politics in advertising discourses in which Blackness was at once dehumanized and idealized. It is through this manipulation of racial Otherness that this book located a key moment in which the recognition of racial Otherness was attached to commodity value in the slave-trading market.

CUNNING ROGUISH OUTLAWS

The Transatlantic Slave Trade operated within an oppressive social and economic relationship whereby slaves were often subjected to extremely brutal and inhuman treatment. As Joe Feagin suggests, White-on-Black oppression was fundamental and systemic in U.S. history, and super exploitation and extreme violence were central to the slavery system (Feagin, 2006: 53–84). The extreme discriminatory measures that the enslaved racial Others—the Negro, mulatto, and Indian slaves—endured can hardly be imagined but can be proved by the chilling official documents of the time that legitimized the oppressions:

> All servants imported and brought into the Country…who were not Christians in their native Country…shall be accounted and be slaves. All Negro, mulatto and Indian slaves within this dominion…shall be held to be real estate. If any slave resists his master…correcting such slave, and shall happen to be killed in such correction…the master shall be free of

all punishment…as if such accident never happened. (1705 Virginia General Assembly declaration)

The high level of oppression and brutality endured by the slaves was not readily accepted by them. Despite the harsh punishments imposed by the institution of slavery, there were a significant number of slave rebellions in the Americas. In their struggle with the master class, many enslaved people rebelled by running away from captivity. Within this context, another theme of eighteenth-century advertising featuring the racial Other emerged in America— "Runaway Slave" ads. The number of these ads was substantial, estimated to be among the thousands by the mid-eighteenth century (Windley, 1983). By the second half of the century, these ads had become routine cultural artifacts (Kulikoff, 1986; Prude, 1991).

The majority of the runaway ads appeared in newspapers in the form of classified ads, with some in the form of posters. A perusal of the collection of advertisements from eighteenth-century Virginia newspapers and other historical documents shows that the use of imagery remained a luxury in eighteenth-century runaway slave advertisements, and the representations of the racial Other were still heavily dependent on written language. Designed to communicate messages announcing runaway slaves and offering rewards for their capture and return, any noticeable characteristics that would assist in identifying and capturing the runaway slaves were listed in great detail in these ads. As a result, descriptions such as names and aliases, gender, age, physical features, and distinguishing marks, clothing, and apparel formed the most basic components of runaway ads.

Although there is a lack of published analyses of these ads from within the advertising discipline, historians have used the archival runaway slave ads as evidence of the life experiences and struggles of slaves within the slavery system (e.g., Mullin, 1972; Windley, 1983). Gerald Mullin, for example, interprets the copy of some of the runaway slave ads to help establish an understanding of the reasons behind the slave rebellions (Mullin, 1972). The economy of inclusion was also noted to be in play in the placement of runaway ads. The masters would not bother to advertise the runaways if they were not considered as productive laborers and, therefore, valuable slaves. Thus, it comes as no surprise that advertisements for slaves who were old, disabled, or otherwise unable to work were often never placed (Kern-Foxworth, 1994: 12).

A 1991 study by Jonathan Prude using 1750–1800 data from American newspaper runaway ads also yields some findings and understanding of

aspects of the visual presence of eighteenth-century slaves. In it, Prude uses the term "unfree laborers" to study a particular group of "runaways," as opposed to fugitive soldiers, criminals, and missing family members. Among the runaway ads, he focuses on Black slaves but also includes convict laborers from Britain and other non-chattel slaves such as the so-called bound and indentured servants. With an interest in understanding how people at the bottom of society were described and seen by those with power over them, and working primarily on written descriptions, Prude finds that the most obvious distinctive characteristic of the runaway ads is their focus on plebeian figures. He suggests that skin color as well as unfashionable costume and "servant-like" bearing were frequently used in advertising copy to provide visual references for a higher-class readership. Such descriptions used words to depict the slaves as an identifiable "lower sort" in the society while helping the slaveholders to capture their runaway subjects. In a culture deeply sensitive to all things visual, Prude argues, the appearance of runaways through detailed descriptions in the ads should be understood through a range of social relationships, which include race.

As mentioned earlier in this chapter, studies of slavery-related advertisements often focus on the written language, with a lack of attention paid to the visual aspects. Yet visual language is powerful and dynamic. If we are prepared to look deeper, it allows us to learn not only about the visible characteristics and style of the ads, but also the hidden cultural and social relationships. From different papers published in different states, the following three ads describing different runaway slaves provide some valuable insights into our understanding—despite their relatively small and blurred appearance.

Of interest here are the similarities as well as the marked differences between these runaway ads and the slave-trading ads. Judging by the collection of decades of runaway slave ads from the University of Virginia database, the similarity involves the tendency to apply shared illustrative icons in ads across times, regions, and media ownership. An ad placed by Thomas Jefferson and published on September 14, 1769 in the *Virginia Gazette* in Williamsburg (Figure 1.3) exemplifies a typical eighteenth-century style of runaway ad. Not only are the tone of discourse and the kind of information included in ads during this period identical to this one, but the visual device—a running blackfaced character—was widely deployed in ads of the same genre within the Virginia database and beyond, making it one of those iconic "runaway slave" images in print for decades.

Typical visual devices used in runaway ads serve to portray a Black-skinned character as a "slave." Such a character often carries some sort of possession, and his or her posture conveys the concept of a fugitive "on the run." One of these generic Black imageries, similar to (or in the same style of) the Jefferson ad, would have been used indiscriminately in many other runaway ads—irrespective of whether the skin color of the subject in the ad was Black or mulatto or White, or whether the runaways fled alone or in a group. In other words, such images are found to be not necessarily racially, nor quantitatively, true to their respective written description. Of the ads shown here, for example, Jefferson's runaway slave was described as a Mulatto with specific emphasis of "his complexion light," yet the visual device shows a blackfaced man. Notably, the very same image has been deployed in ads aimed at slaves described with an array of skin tones, such as "Negro," "Mulatto," "brown," "light brown," "yellow," and "light." Nearly a century later, in 1860, a flyer issued by G.D. Williams (Figure 1.4) offered a $200 reward for the capture and return of two of his runaway slaves. With yet another frequently used image in runaway slave ads of the time, the visual device featured one Black man—despite the fact that, first, there were two slaves (both Jim and Jack) on the run from their master and this flyer was aimed at the pair, and, second, they were both being described as "of a light black or brown color" rather than Black. Such a one-color-fits-all visual strategy applied in many other slavery ads—in this case, the generic Black image created was not used only in ads aimed at runaway slaves of Negro origin, but also those of Native American, Scottish, and Irish origins.

Given this multipurpose approach, perhaps here is the proper place to point out a key similarity between slave-trading ads and runaway ads—the default-

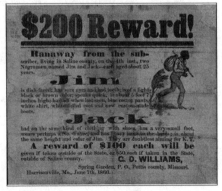

Figure 1.3, *1769*

Figure 1.4, *1860*

style deployment of Black imagery across slavery ads flagged in the previous section. Slave-trading ads share the same problem as runaway ads in that illustrative icons of Blacks denote the concept of slaves so exclusively that no other racial identity can be found in these ads. Such a default setting is hardly natural, given the fact that Blacks were not all slaves (Horton & Horton, 1998) before the establishment of a race-based slave system in America. Conversely, slaves were not necessarily Black. Native Americans were also enslaved (Perdue, 1979; Sturm, 2002) as well as, arguably, some Whites from Britain (Jordan & Walsh, 2008).

Why is this blanket use of Black imagery in both the slave-trading ads and runaway ads significant? First, it provides evidence of an original practice of racial stereotyping in the works of proto-advertising. Second, and most important, it can be seen as early evidence of the use of a racial signifier (Blackness, in this case) to convey a complicated conceptual link between "Blacks" and "slaves." As such, it is better to consider the visual devices used in slavery ads as *symbols* rather than mere descriptions. In other words, the symbolic Blackness generalized in these ads not only stood for Black people, but also for the concept of slaves. Eventually, such symbolism fixed Blacks as slaves, as inanimate items, and as inhabiting the bottom reaches of the society. In runaway ads, for example, Blackness was assigned the meaning of a kind of lost property that "belonged" (borrowing the language repeatedly used in the copy) to the master class. The construction of meaning through visual devices and their frequent repetition in mass media contributed to the formation of a myth that Blacks were "natural slaves." In so doing, slavery-related ads at once connoted the equation between Blacks as slaves, while reinforcing the conceptual linkage between Blacks and slaves.

Let us now turn to the marked differences between slave-trading ads and runaway ads. Although one can write about the differences in terms of sophistication and particulars of depiction and style between the former and the latter, our critical attention here is placed on the differences in the rhetoric on the same concept—the Black slaves.

The differences in rhetoric between the slave-trading ads and runaway slave ads are significant when surveying archival data, and are determined according to the interests of the advertisers and driven by the political economy of the slavery system. Slave-trading ads glossed over the poor physical condition of the slaves, while the runaway ads smeared their character and stripped them of their dignity.

While the slave-trading ads collectively constructed an attractive figure of Black slaves and boasted of their condition and skills, the runaway slave ads painted an ugly figure. The ad in Figure 1.3 publicized Jefferson's list of the flaws of his "artful" runaway slave Sandy, such as being an alcoholic and a thief with an "insolent" and "knavish" nature. Character attacks were not limited to written language. Visual devices brought to life the mental concept of derogatory terms such as "cunning," "roguish," and "deceitful" by constructing undignified images of the runaway slaves. For example, the two visual devices taken from the Library of Congress's Rare Book and Special Collections (1800) in Figure 1.5 consistently portray slaves negatively, in stark contrast to the portrayal of the desirable and non-threatening features seen in slave-trading ads. From facial expression to posture, Black slaves were depicted as bad natured, untrustworthy, reprehensible, and dangerous crooks, if not criminals.

The significance of this in relation to our quest is that it implicates slavery ads, in the form of proto-advertising, as a source in establishing the negative stereotypes that would be associated with Blacks in the future. The reading of slavery-related ads, and the identification of the marked differences in rhetoric between the ads aimed at selling slaves and the ads aimed at controlling slaves, is also significant. It is by looking back to the earliest form of advertising as we know it in the West that we observe the raw source of racial stereotyping and the original form of racial commodification.

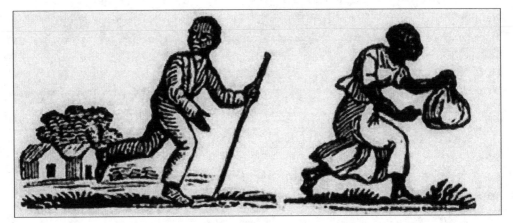

Figure 1.5, *1800*

❧◉❧

Spencer has rightly claimed that "the image that most Europeans had of Africans was that of slaves" (Spencer, 2006: 61). Further to this observation, and as this chapter has demonstrated and argued, it can also be said that the imagery of Black slaves used in slavery-related ads from the eighteenth century onward helped to complete and circulate such an image in the most easily understood, vivid, and memorable visual way.

Together with other visual regimes, such as colonial exhibitions and the expos popular among colonial nations in the eighteenth and nineteenth centuries, slavery-related advertisements in the Americas during this period acted as "go-betweens" (borrowing Mitchell's term [2002: 97]) in social transactions, which contributed to the construction of human relationships. At the pinnacle of the slavery system brought to the New World through European colonization, the human relationships under construction were those of power relations between the colonialist West and its colonized Other, between the superior Whites and the inferior Blacks, and the commodity relationships between slaveholders and the enslaved Africans. With reference to this time and context, the slavery moment outlined in Chapter 1 has demonstrated some unique aspects of visual colonization centered on the system of slavery and the use of the tropes of the racial Other in print advertising during its infancy.

Furthermore, the polarized discourses of the racial Other embodied in slavery-related advertisements demonstrate that the depictions of the racial Other, while all degrading in tone, differ in their representational strategies and rhetoric: slave-trading ads commodify the racial Other for profit, while runaway ads demonize them for control. In short, by focusing on the construction and discourse of race within the political economy of the slavery system, it is observable that the tropes were created essentially for the operation and maintenance of the slavery system.

Chapter 1 has demonstrated how the identities of the racial Other were polarized, how the rhetoric was altered, and how the commodity value of racial Otherness was realized and attached to the skin and body of Blacks in slavery-related advertisements. In Chapter 2 our focus will turn to the "scientifically supported" discourses of race from the Enlightenment to the time of High Imperialism and their embedding within the nascent institution of advertising.

A COLONIAL RACIAL SCRIPT AND
EARLY ADVERTISING

...it is a fact that at least since the seventeenth century what is called humanism has always been obliged to lean on certain conceptions of man borrowed from religion, science, or politics. Humanism serves to color and to justify the conceptions of man to which it is after all obliged to take recourse.

— Foucault, 1984: 44

The modern epoch was founded on European imperialism and African Slavery. Both these systems were organized racially.

— Winant, 2004: 205

Victorian advertising took explicit shape around the reinvention of racial differences. Commodity kitsch made possible, as never before, the mass marketing of empire as an organized system of images and attitudes.

— McClintock, 1995: 130

This chapter traces and examines the interrelationship between the colonial racial script and the coding of race in early advertising amid a rapidly developing nineteenth-century consumer culture. Amid the political economy of that key historical moment, dominant colonial racial ideas, such as those of a racial hierarchy and racial aesthetics, framed the ways in which the racial Other was perceived, described, and pictured in cultural discourses. In advertising, the colonial racial script informed, inspired, and framed the coding of the racial Other conceptually and visually. Conversely, as advertising draws, translates, renders, and embeds colonial racial ideology—

and transforms its stock of stereotypical racial metaphors into visual signs used to sell everyday items—it also popularizes the emerging dominant, elitist philosophical and scientific racial notions. Put another way, it makes them come alive and transforms them into everyday truths through what has been termed by Anne McClintock as "commodity racism" (McClintock, 1995).

One of the key characteristics of the nineteenth century was its intense development of colonial racial concepts that complemented the peak period of European imperial expansion. Key among these concepts was that of "scientific racism" along with the centuries-long accumulation of racial discourses from humanities and religion. The resulting racial script not only provided the intellectual underpinning for various colonial projects, but also was simultaneously adopted by the cultural industries of the time, including advertising which was in its infancy as a cultural institution.

The institutional formation of professional advertising in the nineteenth century coincided with the age of High Imperialism in which there was a shift from colonialist territorial expansion and slave trading to imperialistic economic exploitation when European imperial nations used their power to seize new markets and control cheap sources of raw materials. The escalation was not only a result of the Industrial Revolution but also a continuation of the spirit of its predecessor—the commercial revolution and the earliest development of capitalism. It is against this backdrop that advertising found its space and importance within the developing consumer culture in the West. As Leigh Schmidt summarizes:

> A vast consumer culture was already flourishing in late-eighteenth-century London, and the spreading of that culture in North America was a matter of both immediate and prolonged enterprise. This "empire of goods" was built on an array of new industries that made commodities of everything from pottery to pets, from clocks to cutlery, from leisure and entertainment to shaving and soap. With the need to match the rising levels of industrial production with comparable boosts in demand, the burgeoning consumer culture was founded as well on ever-expanding forms of advertising, marketing, and promotion—newspaper puffs, bow-window displays, handbills, fashion magazines, and fashion dolls. (1997: 32)

As a result of this expansion in production and consumption, the nineteenth century witnessed the emergence of the advertising agency and the systematic development of the business of professional advertising, which employed

techniques from the fields of psychology and statistics, as well as professional copywriters and artists (see Packard, 1957; Leiss, Kline, Jhally & Botterill, 2005). This increased professional specialization not only reflects a change in the way the industry functioned operationally, but also signals the beginning of a more sophisticated approach in communicating advertising messages in which rhetoric and strategy became major focuses of attention.

Among the many roles that advertising played in the growth of consumer culture, it was chiefly responsible for the emergence of commodity racism. While utilizing the discourses of scientific racism that saturated elite nineteenth-century literature, commodity racism was remarkable in that it was not classbound in the same way as science, philosophy, and other forms of "exclusive" knowledge. Embodied in advertising, evolutionary racist notions in their visual forms were easier to package, communicate, and bring to life for a mass market. As this chapter will reveal, through leisure activities—such as going to a freak show or an expo as promoted by posters and brochures—ordinary citizens became cognizant of the primitive sexuality and conduct of the "Hottentot Venus" from Africa or the "Man Eaters" from Australia. Flipping through the pages of newspapers, magazines, and storybooks, they might visually learn about the "Half-devil and Half-child" Filipino and the "Blood Thirsty Savage" Indian. In stores they were exposed to ads and packaging showing Black adults and children as servants and Sambos. In other words, the colonial racial ideology that had been established through institutional and intellectual discourses was translated into stereotypical visual imagery and racial iconography and effectively spread to the wider population through early advertising and promotional materials.

THE RISE OF SCIENTIFIC/PHILOSOPHICAL RACISM

Beginning in the 1840s, according to Feagin, "the deep structure of racialized oppression set in place by European colonists and their descendants to exploit the oppressed African Americans was gradually extended to other people of color" (Feagin, 2006: 16). The colonial project during this period was not only "the most important in magnitude" but was also considered "the most fraught with consequences, resulting from the European expansion. It overturned in a brutal manner the history of the peoples it subjugated" (Balandier, 1974: 34).

As colonial expansion reached its pinnacle, Western colonial nations faced the challenge of intellectually justifying their territorial conquests and

subjugation of the racial Other. The shift in the West toward science as a dominant epistemological paradigm had occurred since the Enlightenment, which, according to Margaret Jacob, was an important framework within which that justification could be framed. She noted:

> In the midst of an international political crisis that Protestants defined as a struggle against arbitrary authority, science presented new standards for arriving at the truth.... Science stood for philosophical elegance—the elimination of any abstract notion for which no physical reality seemed to exist. (Jacob, 2001: 15)

Prior notions of race, informed by religious doctrine and the experience of early colonial exploration, were by and large built on observational opinions and intuitive generalizations. For example, reporting his initial encounter with Native Americans, Columbus painted those who greeted him with an apparently friendly attitude as "simple children of nature," while those with a hostile attitude in subsequent encounters were described as "cannibals." The former were considered to be receptive to tutelage in civilization and Christianity, while the latter must be subdued by force or eliminated. Sixteen of 22 known editions of Columbus's letter were published in Europe in the late fifteenth century, not only in Spanish but also in other languages such as Latin, Italian, and German, and in English in the early sixteenth century (Dickason, 1997: 5–6). During the Valladolid debate (1550–1551), held in front of a Spanish royal audience and often described as the first and last public debate about race on such a scale, Columbus's description of Indian cannibalism, Aristotle's notion of the "natural slave," and the Bible were used by the renowned Spanish philosopher Juan Ginés de Sepúlveda in his arguments supporting the forceful enslavement of Native Americans. Sepúlveda unambiguously generalized that Indians were "barbarous and inhuman peoples abhorring all civil life, customs and virtue" (quoted in Pagden, 1982: 116). Furthermore, he argued that the Indians could only be made useful to the Spaniards and amenable to Christianity by way of force through slavery. By the seventeenth century, William Petty's influential work on race, *The Scale of Creatures*, was issued. Transforming racial differences into a color-coded racial hierarchy, this 1677 writing proclaimed that people of color belonged to a distinct and inferior species located between White men and animals.

These early racial debates and notions proved to be of great value in serving the system of colonization. Key actors, empires, statesmen, and intellectuals

supported and reinforced each other, and, in so doing, these ideas eventually became popular beliefs in the West. However, in a culture where people had begun to believe that science was the foundation of truth about mankind and the natural world, it became less convincing to continually proclaim the inferiority of other races without scientific proof. As a result, to maintain the credibility of existing racial beliefs, scientific backing was required more than ever (Jacob, 1988: 191). President Thomas Jefferson's call for scientific proof of Black inferiority is expressed in his only published book, *Notes on the State of Virginia* (1787), and stands as one example of this phenomenon in racial politics. Despite his official declaration that "All men are created equal," he "believed fervently that all persons of African descent should not be permitted to reside in the new republic unless they were enslaved" (Magnis, 1999: 491). Blacks, in Jefferson's mind, had a lesser share of beauty, possessed lesser ability in reasoning, imagination, and poetry, required less sleep, and were only capable of superficial emotions compared to Whites. He also asserted that "their [Black] inferiority is not the effect merely of their condition of life" (Jefferson, 1955: 138–143). To add currency to his observations and "suspicions" and to support his policy, Jefferson needed scientific backing.

While publicly against slavery, Jefferson owned 175 slaves and as many as 225 at the peak of his slaveholding (Finkelman, 2003). More ironically, as David Waldstreicher has pointed out, despite his rhetoric, Jefferson "put black inferiority on a scientific basis and, in doing so, helped lay the groundwork for the modern, scientific racism, which would prove so useful to proslavery advocates in the antebellum period" (Waldstreicher, 2002: 37). The contradictions between two of Jefferson's legacies—liberty and slavery—points to a key moral paradox of the Enlightenment.

The intellectual project of racial classification found as much support in philosophy as it did in science. Prominent Enlightenment intellectual figures such as Blumenbach, Hume, Kant, and Hegel all contributed to the idea of race, mainly expressing White supremacist disdain for Africans and African culture (Eze, 1997). Hegel, for example, typified such thinking when he proclaimed: "The Negro is an example of animal man in all his savagery and lawlessness, and if we wish to understand him at all, we must put aside all our European attitudes…nothing consonant with humanity is to be found in his character" (Hegel, 1975: 177). Between the seventeenth and eighteenth centuries, Blumenbach and Kant, along with Bernier, Buffon, Linnaeus, Meiners, Voltaire, and others, developed their own systems for classifying and

rating the known races of the world. Despite these leading Enlightenment thinkers' different approaches and different positions on slavery and the humanity of "race," the forms and shapes of racial classifications and hierarchies they developed and promoted, without exception, positioned Whites at the top of the scale and Blacks at the bottom, with the remaining colored races in between.

THE AESTHETIC DIMENSIONS OF RACIAL CLASSIFICATION

While the most frequently articulated (and now criticized) aspects of inferior qualities assigned to the non-White races were centered on intellectual and moral grounds that characterized their inward traits, a less attended yet significant aesthetic dimension recurs within these discourses in racial classification. For example, rather than categorizing races into color-coded groups such as white, yellow, red, and black, as did Linnaeus, or white, yellow, red, black, and brown, as did Blumenbach, another eighteenth-century scientist, Christoph Meiners, divided race into just two categories—light and dark—according to skin tone. These skin-tone-specific racial groups were then attributed with opposite aesthetic values. The outcome of this aesthetic judgment is presented as a "light, beautiful" race and a "dark, ugly" race. As we will see later, Meiners was far from alone among Western thinkers in making such discriminatory judgments based on the outward traits of the racial Other.

The aesthetic dimension of colonial racial classification is significant to works in visual culture and, in particular, the visual representation of the racial Other in advertising that is the core of this book. It is argued here that racially organized aesthetic notions contributed to colonial aesthetics and the deployment of the racial Other in advertising—from the very moment when non-White characters were considered useful and deployable, to the continued play of visual codes, racial identities, and various discursive modes. Colonial aesthetics not only set standards that deemed non-White races ugly; they also preemptively deemed them abnormal and, more important, assigned social meanings to these aesthetic and normative standards. As a result, the stated "ugly" and "abnormal" outward traits of the racial Other were coded with inferior inward traits in areas such as humanity, morality, and intellect, and thus determined their place in a civilized world, as the following sections will show.

SCRIPTING AND VISUALIZING DIFFERENCE

Animalism has been a fundamental theme in colonial discourses concerning both the outward and inward traits of the racial Other. Hegel's indicative and influential work, *The Philosophy of History*, published in 1837, describes inferior characteristics of Africans through tropes such as "animal man," "barbarism and savagery," "barbarous ferocity," "terrible hordes," "barbarity," "savagery and lawlessness," "primitive," and "animality." These are employed by Hegel to build his case for eliminating Africa from consideration as a legitimate part of his World's History (Hegel, 1975: 176–178).

While Hegel gave no place to the Africans in world history, other leading thinkers fixed a place for Blacks in the "Great Chain of Being." In his essay "The Inequality of the Human Races" (1853–1855), Gobineau wrote: "The negroid variety is the lowest, and stands at the foot of the ladder. The animal character, that appears in the shape of the pelvis, is stamped on the negro from birth, and foreshadows his destiny" (Gobineau, 2003: 195). To understand how negative values were assigned to the facial features of Blacks, consider the explicit and brutal language of Voltaire. To prove his claim that "The negro race is a species of men different from ours as the breed of spaniels is from that of greyhounds," each part of a Black face became a symbol of inferiority:

> Their round eyes, their flat nose, their lips which are always thick, their differently shaped ears, the wool on their head, the measure even of their intelligence establishes between them and other species of men prodigious differences. (quoted in Cohen, 2003: 85)

In the mind's eye of these much-respected intellectuals, Africans and their Blackness were perceived and proclaimed as everything opposite to the Europeans: the subhuman/non-human Other; the primitive Other; the barbarous Other; the wild Other; the undeveloped Other; the unhistorical Other; the unintelligent Other; and the lowliest Other.

Physical anthropometry added its weight and dimension to this colonial racial script. It was a popular branch of the eighteenth- and nineteenth-century study of race in which scientists made a range of judgments based on the physical measurements of the body forms of different races. Metric dimensions of the human figure, particularly the skull/face and skeleton/body, were studied, and the results assigned meaning. These physical measurements were

promoted as indicators of human evolution, abilities, skills, and behavioral attributes, as well as beauty, the ideal, and normality.

The following sections identify three general racial scripts generated by Western thinkers, scientists, statesmen, and cultural elites. Their manifestations in early advertising are examined to demonstrate the visual pollination of popular culture by the elite ideas of racial Otherness circulating at the time.

THE UNCIVILIZED OTHER

"Uncivilized" was one label frequently attached to the racial Other in colonial racial discourse.

This categorization strengthened the myth of the naturalness of Europe's dominant global position and the mythology that it was her superior traits (not actions or opportunities) that had put it at the top of the world. With this myth in mind, colonization became justifiable in the spirit of God-given noble duty and progress. Enlightening the darkest corner of the world became a European mission, and this was communicated through the call to "Take up the White Man's Burden," as British poet Rudyard Kipling so famously put it—an ideological imperative that was quickly embodied within a Pears' soap advertisement in the United States (Figure 2.1).

Kipling's poem "White Man's Burden" was written at the end of 1898 during the signing of the Treaty of Paris that concluded the Spanish-American war over Puerto Rico, Guam, the Philippines, and Cuba. It appeared in the 12 February 1899 issue of the popular magazine *McClure's* days after the Philippine-American war was declared, at a time when the United States was at a crossroads in deciding whether the country should join the European scramble for empire. Urging the United States to become an imperial power, Kipling utilized his "power of observation, originality of imagination, virility of ideas and remarkable talent for narration" (Nobel Prize Official Website)— a talent that won him the 1907 Nobel Literature Prize—and began his influential poem with this verse:

> Take up the White Man's Burden—
> Send forth the best ye breed—
> Go bind your sons to exile
> To serve your captives' need;
> To wait in heavy harness,
> On fluttered folk and wild—Your new-caught, sullen peoples,
> Half-devil and half-child.

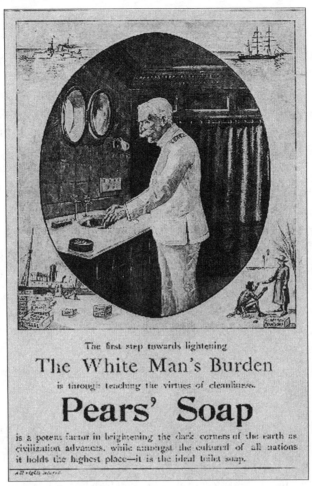

The first step towards lightening

The White Man's Burden

is through teaching the virtues of cleanliness.

Pears' Soap

is a potent factor in brightening the dark corners of the earth as civilization advances, while amongst the cultured of all nations it holds the highest place—it is the ideal toilet soap.

Figure 2.1, *Pears' Soap, 1899*

"White Man's Burden" is influential in many regards. First, it was widely circulated. Apart from appearing in *McClure's*—the popular monthly magazine that helped shape the moral compass of the time—it is estimated that the poem appeared in at least 600,000 copies of newspapers across the nation, reaching more than one million U.S. readers (Murphy, 2010: 23). Second, it was a timely contribution to the propaganda urging the United States to become the newest colonial power, replacing Spain in the Pacific. Conscious of the debate within the United States about imperialism, Kipling sent a copy of the poem before its release to Theodore Roosevelt, who was then the governor of New York (and soon to become the 25th vice-president and 26th president of the United

States). Roosevelt had been arguing for the annexation of the Philippines so that the United States would hold a proud place in the world. The poem obviously caught Roosevelt's attention and appealed to his political agenda, as he forwarded it to another leading expansionist in the U.S. politic—Henry Cabot Lodge—recommending it as "rather poor poetry, but good sense from the expansionist viewpoint" (Murphy, 2010: 31). Third, it inspired political discourse as well as advertising discourse at the time. In political language, carrying on the line of the White Man's Burden, then U.S. President McKinley portrayed the Philippines as having been "dropped into our lap" and the United States as duty-bound to bring Christianity and the benefits of Western civilization to the "unenlightened" areas of the world, to the people who were "unfit for self-government." In McKinley's words, "there was nothing left for us to do but to take them all, and to educate the Filipinos, and uplift and civilize and Christianize them, and, by God's grace, do the very best we could by them, as our fellowmen for whom Christ also died" (quoted in Tucker, 2009: 929). In visual language, eight months after the poem was published in *McClure's*, Pears' soap launched an advertisement in October 1899 with the very same title— "The White Man's Burden."

The ad conveyed the colonial relationship through both words and images. Among the written and visual languages, there is no shortage of familiar concepts and expressions from those racist notions highlighted earlier in this section, though they are twisted to create a link between the superiority of the product and the superiority of the White man. The copy reads:

> The first step towards lightening The White Man's Burden is through teaching the virtues of cleanliness. Pears' Soap is a potent factor in brightening the dark corners of the earth, as civilization advances, while amongst the cultured of all nations it holds the highest place—it is the ideal toilet soap.

The colonized racial Other was not positioned as the main character in this advertisement. That honor was reserved for well-known colonist Admiral George Dewey. Then commodore of the U.S. Navy's Asiatic Squadron, he became a national hero after he led the U.S. Navy's demolition of the Spanish fleet in the first battle of the Spanish-American war in Manila Bay in 1898. He also negotiated the help of the locals, who were led by Filipino independent leader General Emilio Aguinaldo, who played a crucial role in ending the Spanish occupation (Tucker, 2009: 114; 177). To support the advertiser's claims,

Dewey was depicted in the center of the ad washing his hands with Pears' soap. The well-equipped washroom helped to construct the Western ideal of civilized living, and Dewey's white U.S. Navy uniform, with his rank on his shoulders, added to his fame as a national hero and made him an ideal symbol of the White man who would bear the "burden" of civilizing a subjugated race.

The ironic events that followed the joint effort to drive the existing colonizer, Spain, out of the Philippines not only turned Filipinos from de facto allies to wartime enemies of the United States, but also determined the manner in which they were depicted. A series of events led the newborn Philippine government to conclude that the United States actually "came to the Philippines not as a friend, but as an enemy masking as a friend"—as Filipino historian Teodoro Agoncillo puts it (Agoncillo, 1990: 213-214). Prompted by the realization that the United States had no interest in liberating the islands (Library of Congress) and that the true nature of the "independent" illusion was no more than replacing an old colonial master from Spain with another from the United States, on 5 January 1899 President Aguinaldo declared his country's position to the world:

> My government cannot remain indifferent in view of such a violent and aggressive seizure of a portion of its territory by a nation which arrogated to itself the title of champion of oppressed nations. Thus it is that my government is disposed to open hostilities if the American troops attempt to take forcible possession of the Visayan islands. I denounce these acts before the world, in order that the conscience of mankind may pronounce its infallible verdict as to who are true oppressors of nations and the tormentors of mankind. (quoted in Agoncillo, 1990: 215)

On 4 February 1899, the Philippine-American war began when shots were fired by U.S. soldiers. Derogatory images of the Philippines emerged in print media, beside the tagline "The White Man's Burden." The character from the 18 February 1899 issue of *The Detroit Journal* (Figure 2.2) is a typical artistic expression of the animalistic and uncivilized Filipino, leaving out any trace of the human side of the local freedom fighters whom the United States once used to help gain control of the Southeast Asian country from the Spanish.

In the Pears' ad, the imagery of the Filipino was, by design, far less dominant. Although the reader was shown neither face nor gender, the popularity of Kipling's poem and other cultural discourses on race ensured that the imagined qualities of an uncivilized "Half-devil and half-child" came to mind. The colonized Other was given a place at the bottom of the

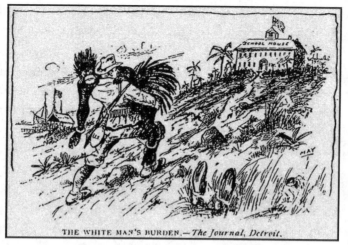

Figure 2.2, The *Detroit Journal, 1899*

illustration. An image supposedly representing an indigenous person was fixed in a lower position within the ad (in both body language and composition), in line with the colonial racial hierarchy. Seated on the ground of a remote land, the filthy semi-naked figure was depicted in a subservient posture, both hands raised while looking up at a colonialist "savior" figure who was not only standing tall but was also in the act of "giving" the gift of civilization. While Kipling's poem portrayed the Filipinos (and indeed all colonized natives) as "Half-devil and half-child" and "fluttered folk and wild" who were also sullen, unappreciative, and uncooperative, Pears' White Man's Burden ad depicted the non-White Other as small, shadowy, lowly, dirty, and needy. The Pears' soap ad, with its mighty colonial hero and the ill-defined Other figure, was coded with the dominant racial notions outlined earlier—through which the public imagination and attitude toward the colonial relationship and the colonized racial Other were vividly framed.

THE UGLY OTHER

"One of the most important characteristics of tribes and peoples is beauty or ugliness," claimed Meiners, who championed the notion of a world divided into a "light, beautiful" race, and a "dark, ugly" race (quoted in Jahoda, 2007: 25). As various measures were developed to make aesthetic judgments about races, another aspect of racial classification—based on a hierarchy of beauty

and normality—emerged. Once again, Blacks were placed at the bottom of the hierarchy and Whites at the top, with the racial Other rendered ugly according to colonial aesthetics. To Meiners, and thinkers before and after him, the finding of beauty or ugliness among different races always followed an implication of racial identity. To advertisers, such knowledge affected the representation of the racial Other, from their exclusion or inclusion, to their depiction.

Camper's 1791 theory of facial angle was one of the most influential works of the time in regard to the physical traits of race. A horizontal line from the earhole to the base of the nose and a vertical line from the incisor teeth to the most prominent part of the forehead in profile formed the facial angle. This angle, Camper proposed, has significance in terms of racial identity and the ideal of beauty, among other aspects. Comparing the skulls of a European, a Mongol, a Negro, and an ape, Camper found that the resulting angle differed (Figure 2.3). He wrote: "If I make the facial line lean forward, I have an antique head; if backward, the head of a Negro. If I still more incline it, I have the head of an ape; and if more still, that of a dog, and then that of an idiot" (quoted in Cohen, 2003: 93–94).

Based on his observation of the statues of Greek gods and heroes, Camper found a common facial angle of around 100°. According to Walker, he therefore surmised that the Greeks believed that the 100° facial angle

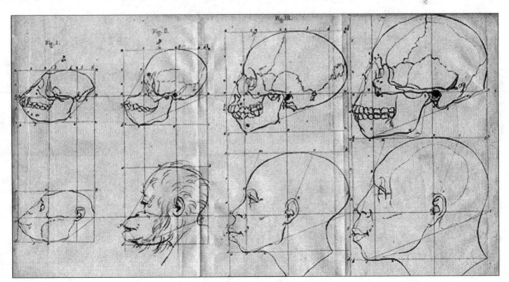

Figure 2.3, *Camper, 1791*

constituted the most beautiful countenance (Walker, 1834: 56). Remarkably, the facial angles of Roman statues were found to be in the range of 85° to 90°, with most Europeans 80°, most Negroes 70°, the orangutan 58°, and the African tailed monkey 42°. Camper concluded that "Everything above eighty degrees belonged to the realm of art, everything below seventy degrees to the animal kingdom" (quoted in Spencer, 1997: 263).

Despite the fact that Camper himself was essentially a monogenist who did not regard non-Europeans as a separate biological species (Meijer, 1999; Poliakov, 2003), his findings and drawings were frequently referenced in the theory of the Great Chain of Being. In attempting to construct a representation of such a "chain" between man and animal, Charles White's work is most noteworthy because of his conscious attempt to use the power of imagery in his detailed narration of the Great Chain of Being, and the connection he made between racial aesthetics and racial inequality.

While "Man" had always been at the top of the chain, in 1799 White went one step further by specifically placing European Whiteness at the top of his diagram (Figure 2.4). Obviously based on Camper's model, White constructed a hierarchy of living beings involving man and beast, from high to low, by using illustration and layout in an unambiguous and odious manner. White seemed aware of the significance of his comprehensively constructed visual hierarchy and its implications for the relationships in any society and system. He wrote: "From Man down to the smallest reptile, Nature exhibited to our view an immense chain of being, embrued with various degrees of intelligence and active powers, suited to their stations in the general system" (quoted in Spencer, 1997: 263).

Face angle was not the only measure used in the colonial racial aesthetic hierarchy. For the superior race, every outward feature typical of European

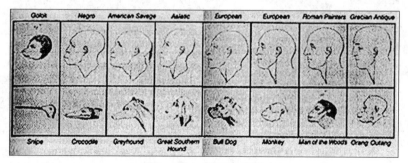

Figure 2.4, *White, 1799*

Whites, from skin tone to hair texture to expression, was highly praised. For White,

> that variety of features, and fullness of expression; those long, flowing, graceful ringlets; that majestic beard, those rosy cheeks and coral lips…In what other quarter of the globe shall we find the blush that overspreads the soft features of the beautiful women of Europe, that emblem of modesty, of delicate feelings, and of sense? (quoted in Horsman, 1981: 50–51)

In White's argument, the physical features of the Europeans were not only beautiful and artistically and sensually pleasing; they also embodied the superior qualities of gracefulness, greatness, dignity, and humility. All these outward features of Whiteness became facial symbols that stood for White supremacy. In contrast, a range of Black facial symbols were likened to animals as noted in, for example, Voltaire's observation quoted earlier. As being non-White meant being excluded from the realm of art and beauty, it comes as no surprise that dark-skinned characters were absent in advertisements that required beautiful and graceful imageries, such as these two Pears' ads (Figures 2.5 and 2.6).

While members of the racial Other were considered not only not beautiful but also animalistically ugly, they were also considered ugly within colonial aesthetics because of the said "abnormality" of their physiques and facial features—symbols of deformity and monstrosity. Meiners, for example, using his Eurocentric standard, published works such as *On the Growth of Hair and Beards among the Ugly and Dark-Skinned Peoples*, *On the Colors and Shades of Different Peoples*, and *On the Differences in Size Among Different Peoples*. He found that the Native Americans had a weak and plump body, a big "shapeless" head, and that even their hands were not in proportion—being "either too small or too large" (cf. Zantop, 1997: 26); that Chinese women had small "piggish" eyes; and that the Negro males had extraordinarily large "animal-like" penises (cf. Jahoda, 2007: 25–26). This line of unflattering references was not new to the books of the colonial racial script. Similar attitudes can be found in François Bernier's typology of races, in which he saw Blacks this way:

> 1. Their thick lips and squab noses, there being very few among them who have aquiline noses or lips of moderate thickness. 2. The blackness which is peculiar to them, and which is not caused by the sun, as many think….The cause must be sought for in the peculiar textures of their

bodies, or in the seed, or in the blood—which last are, however, of the same color as everywhere else. 3. Their skin, which is oily smooth, and polished, excepting the places which are burnt with the sun. 4. The three or four hairs of beard. 5. Their hair, which is not properly hair, but rather a species of wool…and, finally, their teeth whiter than the finest ivory, their tongue and all the interior of their mouth and their lips as red as coral. (quoted in Baum, 2006: 54)

Although the racial stereotypes offered by Meiners and Bernier are only drops in the ocean of the colonial racial script, they typify how the outward traits of the racial Other were framed and articulated. No other forms of advertising placed more emphasis on the "ugliness," "wildness," and "abnormality" of the racial Other than the materials promoting the exhibiting and parading of colonized native people in the home nation of the colonial powers. They perhaps best demonstrate how these racial concepts were used and transformed within the language of advertising.

The practice of organizing native human exhibitions began as early as 1500, when native Americans were brought to Spain and Portugal by explorers and put on display as exhibits from the New World (Pieterse, 1992). This practice had escalated by the late nineteenth century to become a phenomenon within the popular cultures of the major imperialist nations of Europe and the United States. Some were organized by the imperial states as part of world expos or world fairs. Others were run by circuses or zoos as part of shows or collections, and they attracted huge numbers of spectators who paid to see the captive native people displayed alongside the wild animals and exotic plants of colonized lands afar. The 1851 Crystal Palace Great Exhibition in London and the 1889 Exposition Universelle in Paris, for example, offered live displays of native people, attracting six million and thirty-two million spectators respectively (Maxwell, 2000: 1). The colonized people on display were at once commodified and objectified by the colonial organizers, who operated within a relationship of absolute power. More than just a source of entertainment and amusement, the public display of the racial Other also served as a means to reinforce the colonial racial ideology and the scientific notions of racial classification and theories of progress. As Ann Maxwell noted: "These displays [of colonized people] not only drew massive crowds but also claimed an educative function and gained the imprimatur of contemporary scientific theories of race" (Maxwell, 2000: 1). The same can be claimed of the proto-advertisements for the "Hottentot Venus," which, while promoting this colonial obsession, reinforced the ugliness of the Black female body.

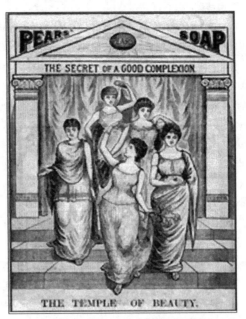

Figure 2.5, *Pears' Soap, 1887*

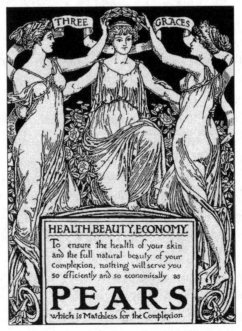

Figure 2.6, *Pears' Soap, 1887*

Taking place in the years 1810–1815 in the U.K. and France, the public parade of Saartje Baartman, a young Khosian woman dubbed the "Hottentot Venus" by her original British handler, was one of the earliest human freak shows of colonized people. It made a lasting contribution to racial discourse and debate. As Crais and Scully put it: "Throughout the nineteenth century and well into the twentieth century, the Hottentot Venus participated in the great debates on evolution, race, and female sexuality" (Crais & Scully, 2009: 144). Although the poster being discussed here received very little scholarly attention in the field of advertising, it should be recognized that the imagery of the Hottentot Venus is iconic for a centuries-long racist cultural practice that lasted in the West until the 1970s. It put the concept of racial inequality squarely in front of people's eyes—and directed the spectators' gaze to the "abnormality" of the Black female body and sexuality.

The 1810 British poster (Figure 2.7) from the collection of the City of Westminster Archives Centre and the 1812 French editorial print (Figure 2.8) shown here were both designed to promote the "Hottentot Venus" show in their respective countries. Lured to England in 1810 by a British surgeon, Baartman was treated as an object of public spectacle, performing alongside animals for the paying public. She was also the subject of research for the exclusive scientific community. Her selling point for the curious public was that she was a "mixed stock" African woman with overdeveloped buttocks; for the scientific elites, it was her extended labia minora (a.k.a. "Hottentot apron"). In both cases her features were used as signs of danger for racial mixing, as well as symbols of primitive womanhood and hypersexuality. As her value as a commodity in European imperial nations was based on these highly racialized attributes, it is not surprising that a similar approach was taken to promote the Hottentot Venus parades. Despite geographic and genre differences, both designs used words and pictures to set the spotlight firmly on the outward features of the woman's body to convey a sense of deformity.

In helping to create the commercial hype over the Hottentot Venus shows, the British poster depicted Cupid sitting comfortably on the oversized buttocks of the illustrated Baartman while sending out the warning: "Take care your hearts." Despite the name, and apart from gender, there is no connection between the Black Hottentot Venus and the White Greek goddess Venus—if judged only by the reactions depicted in the French editorial print promoting the show. There were no signs of admiration of beauty or of love, just disgust and revulsion. The illustration depicted shocked and amazed European

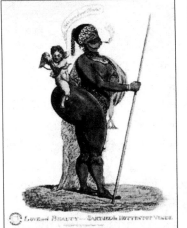

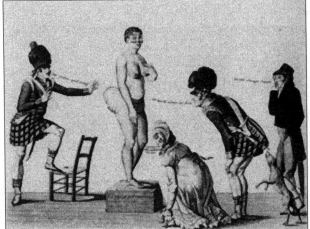

Figure 2.7, *1810*

Figure 2.8, circa *1812*

spectators examining her naked body, while exclaiming "Oh! God," "Damn, what a roast beef!" and "Ah! How comical is nature" (cf. Pieterse, 1992: 181). The public opinion, as framed and promoted by the media, cancelled out even the tiniest trace of "compliment" (albeit in an offensive way) in her show name "Hottentot Venus." Perhaps, as Victor Hugo put it in *Les Misérables*, Paris "accepts everything royalty; it is not too particular about its Venus; its Callipyge is Hottentot; provided that it is made to laugh, it condones; ugliness cheers it, deformity provokes it to laughter, vice diverts it."

Viewed alongside colonial racial aesthetics, it is clear that the "Hottentot Venus" was not meant to be perceived or appreciated for her beauty—quite the opposite, according to the way in which her image was depicted and the commentary about her framed. Under the influence of colonial racial aesthetics, dubbing Saartje Baartman "Hottentot Venus" was sarcastic and racist, and turned her into a profitable symbol of Black female hypersexuality. Her value as a human exhibit was in her physical and sexual "abnormality"— both when alive and in whole and when dead and in body parts. Spectators were never meant to admire her beauty. In the eyes and minds of European spectators, she was no more than an ugly "primitive" "sexual freak" who belonged in a circus or human zoo for their amusement and fascination. Essentially, she was used as convincing "proof" of the existing colonial racial ideology.

THE DANGEROUS OTHER

While deeming the colored people to be uncivilized and ugly, the colonial racial script also made Blackness a symbol of danger. Darwin's conclusion in *The Descent of Man* was that the native "delights to torture his enemies, offers up bloody sacrifices, practices infanticide without remorse, treats his wives like slaves, knows no decency, and is haunted by the grossest superstitions" (Darwin, 1874: 619). Blacks were viewed in colonial minds on the one hand as warmongers, barbarians, child-killers, and women-abusers, and on the other as indecent, peculiar beings.

Visualizations of the concept of the "barbarous" racial Other can be seen in nineteenth-century popular cultural narratives across genres. For example, from the collections of the British Library, a brochure promoting the 1884 "Australian Boomerang Throwers Show" in England brings graphic language alive through the use of typographic devices. Without the slightest visual sign of the objectified colonial subjects, the brochure, through its typography, promised the would-be spectators that what they would see with their own eyes were "man eaters" collected "from the Continent on the other side." The brochure used a familiar line of derogatory descriptions to stereotype the native people. In the bluntest manner, the Aborigines were not only described as man eaters, but also "ferocious, treacherous, uncivilized savages" and "blood-thirsty beasts in distorted human form." The last sentence of the promotional blurb completed the picture, delivering the essence of the commercial and racial assault: "Worth journeying a hundred miles to see these specimens of the lowest order of man." From the collection of the Beinecke Rare Book and Manuscript Library, Yale University, Figure 2.9 shows an illustration depicting an Indian man raising an axe to a White woman with the heading "Savage barbarity" and the caption "Mrs. Barber intreating a blood thirsty savage to spare the life of her little daughter." It put the concept of brutality firmly in the picture and linked it to the native people.

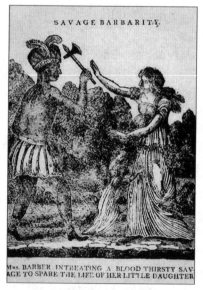

Figure 2.9, *1818*

Not quite a "man eater" like the Aboriginals or a "blood thirsty savage" like the Indian man in the above examples, a pigtailed Chinese man wearing Manchu dress was depicted in this late nineteenth-century poster as both a "rat killer" and "rat eater" who—according to folklore and judging by the big fat rat the man is about to consume—took pleasure in eating rats alive (Figure 2.10). Furthermore, the selling slogan "THEY MUST GO!" which was circulated 3 years after the federal government's 1882 Chinese Exclusion Act became law in the United States, is a play on the infamous political slogan of the powerful Workingmen's Party of California: "THE CHINESE MUST GO!" As such, this ad not only showed a twisted version of the poisonous "barbarous" racial Other by visualizing a narrative of a racial myth about Chineseness to sell the rat poison product for financial gain, but also tapped into the pulse of a xenophobic sentiment and waves of anti-Chinese movements and uproars in the society at this historical moment by utilizing a prevalent racist political statement to push two propositions at once—first, a

Figure 2.10, *Rough on Rats, 1885*

product proposition: "they [rats, mice, bed bugs, roaches, flies and the like] must go [be killed]"; and, second, as a political statement: "they [the Chinese migrant merchants and workers] must go [be deported]." In case the public didn't get the pun and missed the latter, a visual device of a hand was inserted into the layout, pointing directly at the Chinese man—not to the two rats and not to the list of rodents. It is from ads like this, this book suggests, that we identify an early evidence of a branding strategy that links the consumption of a product with a certain idea or social activism that has commonly been attributed to ads of the twenty-first century.

The colonial racial script extended the notion of the racial Other as behaviorally "dangerous" by assuming a criminal tendency. For example, according to Cesare Lombroso's theory of the "born criminal," certain physical remnants of our "ape" past were considered indicators of a "savage" type of behavior, and people possessing these visible "abnormalities" (such as a receding forehead, large ears, and broad cheekbones) were of a criminal type.

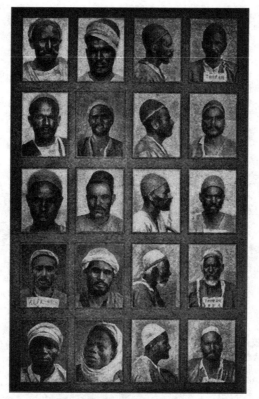

Figure 2.11, *Lombroso, 1876*

In his 1876 book *Criminal Man*, Lombroso provided a photo collection of types of African criminals (Figure 2.11) and concluded that, based on his study of 219 criminals, "Normal and beautiful physiognomy is found in only a few very intelligent criminals, especially swindlers" (Lombroso, 1876/2006: 205), compared with its opposite. According to this logic, Blacks were not only considered to be born subhuman and ugly, but also to be born savage and criminal—a stereotypical racist label that is still deployed in contemporary advertising and in the society by way of racial profiling.

Up until this point, it seems the racial Other was not of much use according to dominant racial ideology—being ruled out of the civilized world, of the realm of beauty, and of humanity and decency. But this is not the full picture. There were certain areas in which the racial Other was recognized as a capable, or even worthy, resource. Sadly, however, these "desirable" aspects were all rooted in and derived from existing concepts of inferiority in the inward and outward traits of the racial Other, which in turn reinforced and enriched the development of colonial racial ideologies.

One such area was the battlefield, where Blacks were considered natural fighters. The Civil War became an important catalyst in war anthropometry, measuring soldiers against a racial divide. Taking advantage of the first-time induction of 180,000 soldiers of African decent into the federal army, a Sanitary Commission was formed to conduct the most comprehensive study of racial differences among Whites, Indians, Blacks, Mulattos, and others, as John Haller, Jr., recounted in his 1971 book *Outcasts from Evolution*. The Sanitary Commission study was based on Adolphe Quetelet's statistical methodology used in the search for an average man, which followed Camper's study of human physiognomy, but with an added edge. The U.S. government used Quetelet's method of reading the facial appearance of different races and linking the measurements to moral and political science through probability in order to assess the suitability of newly freed Black slaves, together with Native Americans and Mulattos, for military duty. It also assessed their suitability for different job levels within the military (Molnar, 1992: 18).

Predictably, these studies collectively confirmed the ideology of White superiority in military service, barring the colored recruits from high-ranking positions. In *Outcasts from Evolution*, one examiner was quoted as saying that Blacks "never can be as well qualified as he who by nature possesses greater physical perfection and greater mental endowments" (see Haller, 1971: 28–31). Additionally, the "smaller facial angle" found among Black soldiers was

interpreted as a physical representation of "brute force rather than intellectual pre-eminence," raising concerns about their capacity to learn tactics and their personal hygiene, and fixing them as lower-ranking soldiers only. This said, the physical endowment of "full Blacks" (as opposed to "Negroes of mixed blood" who were considered incapable of enduring hardship, and thus most unfit) was rated highly in the strength department. Remarkably, Black feet attracted significant attention as racial markers. While the report characterized Whites by "the length of the head and the neck" and Indians by "the long fore-arms and the large lateral dimensions, excepting the shoulders," for Blacks it was "the wide shoulders, long feet, and protruding heels." Although some considered the foot as the only physical deformity of Black soldiers, according to Hunt, one of the expert examiners, the "large, flat, inelastic foot…almost splay-footed" was an advantage in marching over rough terrain.

The impact of the series of Sanitary Commission studies of racial differences was not limited to identifying soldiers suitable for military duty in the United States. As John Haller has pointed out, "nearly all subsequent late-nineteenth-century institutionalized attitudes of racial inferiority focused upon war anthropometry as the basis for their beliefs" (Haller, 1971: 20–21). Indeed, the markers of physical and mental readiness and usefulness found in Black recruits by the Sanitary Commission examiners were not much different from those used to mark their inferiority in society and among the cultural media, such as advertising, as this book will demonstrate. For example, their cheerfulness and "natural fondness for rhythmical movement," their "habit of obedience inculcated by the daily life of the slave," as well as their build and physical strength, were explicitly identified as qualities for Blacks being used as soldiers and potential drill-masters in the military by the same Sanitary Commission expert examiner. Tapping into the non-threatening and useful attributes, the many iconic singing and dancing Black Sambos and happy maids, cooks, and servants were also being created in nineteenth-century advertisements.

The next section examines the process by which the advertising industry turned to the stock of colonial racial discourses for inspiration, and strategically placed existing racial metaphors and stereotypes into the visuals and tag lines of advertisements. The section will show how both the handful of desirable attributes and the long list of negative attributes outlined above were capitalized on by advertisers to define and confine the racial Other in advertising discourses during the historical moments of colonialism and High Imperialism.

CODING AND COMMODIFYING RACE IN EARLY ADS

In the nineteenth century, advertisers in imperial nations began to discover even more value in the trope of the racial Other beyond its previous applications. Meanwhile, more imageries of non-White people other than Blacks were deployed in a wider range of consumer product ads. Manifestly based on imperialistic colonial racial concepts, these advertisements coded races visually and transferred these concepts from words on paper to pictures on packaging, trade-cards, posters, magazines/newspapers, and brochures. These images creatively contributed to the commodification of race in the lead-up to High Imperialism.

Victorian advertising, according to McClintock, took explicit shape around racial differences, and in turn made possible "the mass marketing of empire as an organized system of images and attitudes" (McClintock, 1995: 130). We begin our journey with the familiar script of the "uncivilized" Other and one of its archetypes in Victorian advertising—the "dirty boy." By linking darker skin tones with the concept of dirtiness, the racial Other was positioned as uncivilized. This is particularly the case in the use of Black people in some of the landmark soap advertising. Not only widely viewed as pioneering the professionalization of the industry, soap advertising is also infamous for exploiting Black imagery. Given this reputation, soap ads have became the focal point for studies of imperial advertising (see, e.g., Richards ,1990; McClintock, 1995; Ramamurthy, 2003).

These studies show the ways in which visual representations of Black people were portrayed in soap advertisements funded by leading brands in the U.K. at the peak of British imperialism. One such example is Vinolia's 1893 ad, which depicted a Black boy being challenged by a White girl who offers him a piece of soap: "You Dirty Boy, Why don't you wash yourself with Vinolia soap?" (Figure 2.12). The other significant ad with the same theme is Pears' 1884 ad (Figure 2.13), in which a Black boy seemingly unfamiliar with the bath is directed by a White boy who hands him a cake of Pears' soap with which to scrub himself. When he emerges from the bath, he is offered a mirror—again by the White boy—and finds most of his body (except his head) transformed from "black" to "white." The message in these ads was loud and clear: the soap, the Whites, and the Empire were the civilizers, and the Blacks were the uncivilized people with dirty bodies and unclean souls. With the help of the

civilizers, the latter could be washed clean and brightened up through consumerism. The ads suggested that the racial Other needs to be White (read: clean and civilized) and wants to be White. This reflected the same sentiment as the Pears' White Man's Burden ad discussed earlier. Given that the audience for these ads was predominantly White, it served as yet another visual endorsement of the European psyche based on White supremacy and renewed the call for the audience to "Take up the White Man's Burden"—only this time, the "burden" was not the external colonized subjects (such as Filipinos), but the internal colonized subjects (such as Blacks) in colonizing nations.

It is notable that only examples depicting Black imageries were used in key literature on the topic of Imperial advertising. The same data selection can also be observed in other studies that have touched on the topic. While this tendency reflects the mainstream approaches adopted by soap advertisers of the time, it would be a mistake to assume that commodity racism began and ended with images of the Black Other only. Although Black skin was more commonly exploited as a visual metaphor for racial inferiority through Victorian scripts on purity and hygiene, other non-White races were not free of such exploitation. To highlight how the "dirty" label extended beyond Black boys, let us again examine examples of Pears' ads—not only because we do not need to look elsewhere for evidence, but also because comparisons between the use of different racial tropes in promoting the same product can better capture and pinpoint the variation in rhetoric that emerged at the historical moment of High Imperialism.

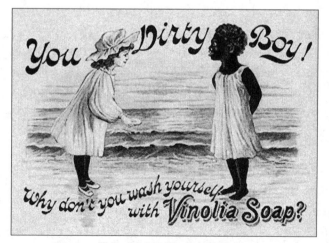

Figure 2.12, *Vinolia, 1893*

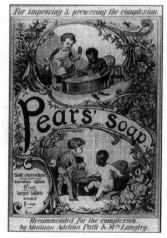

Figure 2.13, *Pears' Soap, 1884*

The first example is the use of the imagery of a naked bathing Japanese woman dubbed "Happy Jappy" as the focal point of a 1910 Pears' ad (Figure 2.14). Except for the woman's younger age, the ad is remarkably reminiscent of a scene in Mrs. Hugh Fraser's story "In Tokyo" about a young Briton's "shocking" encounter with the Otherness of Japanese bath culture:

> Some things shocked his untried prudery beyond words. It would be difficult to describe his feelings when, as he was walking, tired and dusty, through a hill village, an old woman, paddling in her bath in sight of all beholders, called out to stop him as he passed.

> "What does she want?" he asked of his guide, glancing with a visible shudder at the aged bit of humanity (brown as a last year's oak leaf, and innocent of clothes as a fish in a tank) which stretched an arm to him from a steaming tub.

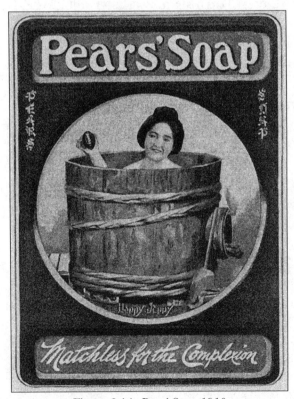

Figure 2.14, *Pears' Soap, 1910*

"She very kind woman," the guide explained, "she say, young gentleman tired, dirty, bath plenty big for two people; please get in!" (Fraser, 1899: 31–32)

In this ad, the "Happy Jappy" was also seated in a wooden bathtub, unclothed "as a fish in a tank." Just like the old woman in the story, one of her arms was also stretched out, only this time her inviting gesture was directed not only at a young Briton but also at anyone in the West who encountered the ad. Her body language may have conveyed the same invitation as the old woman in the story—"please get in"—yet the piece of Pears' soap in her hand and the special typographic treatment of an otherwise standard Pears' tag line at the time—"Matchless for the Complexion"—delivered the sales pitch for the soap through both image and word.

Through stories such as "In Tokyo" and other travellers' tales, Japan's bath culture had long been made known to the West as an infamous sign of Japaneseness. The common practice of "promiscuous bathing" in Japan raised many Western eyebrows in disgust and was interpreted as indecent, unhygienic, and uncivilized. An article entitled "Pictures of the Japanese," published in *Harper's New Monthly*, offers one example of such discourses:

The bath is also a great public institution in Japan. Men and women bathe together in a manner which shocks all our ideas of decency. As far as their persons are concerned the Japanese are certainly a very cleanly people. But this does not hold good of their garments. These are worn day and night, and rarely changed. This, together with the habit of promiscuous bathing, renders cutaneous diseases extremely prevalent. (*Harper's New Monthly*, November 1863)

While the inferiority associated with Japaneseness in this ad was different from that of Blackness, it, too, failed to meet the Western ideal of "civilized." The tone of the discourses in Western popular media, as exemplified above, indicates that Japanese bath culture (nude female bathers in particular) was perceived negatively and interpreted as a sign of immodesty, indecency, and inferiority. Yet this ad ironically deployed the female body and Oriental sexuality of the same cultural practice that so disgusted the West to lure the consumer within that culture.

The second example is another Pears' ad that exploited "Chineseness" (Figure 2.15). While the main characters depicted in this ad were said to be White missionaries, the Manchurian dress code and hairdos of China's Qing Dynasty were featured and used to strengthen Pears' selling point. Under the

heading "Christian Missionaries in China," the ad's concept is self-explanatory as related in the last two paragraphs of its copy (said to be an extract from a letter written by Miller, a war correspondent for *The Graphic* of London and *Harper's Weekly* of New York):

> —You will note the exceedingly neat and cleanly appearance of these white people in native dress. Is it due to the use of Pears' Soap, which I notice is the only soap to be found in a white man's house, anywhere in the Far East?

> —If anything can civilize and Christianize China, Pears' Soap and the missionaries will.

Although the words "dirty" or "uncivilized" did not appear in its copy, the ad was able to position the Chinese as the opposite of clean and civilized. The very fact that the "exceedingly" neat and clean native dresses worn by the White missionaries were worth writing home about relays the opposite underlying assumption—that native dresses were untidy and unclean. However,

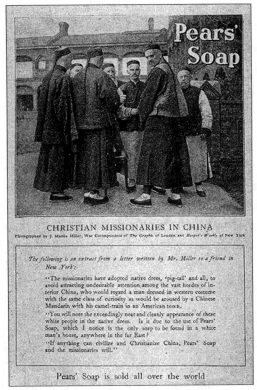

Figure 2.15, *Pears' Soap, 1910*

the reference to physical cleanliness is far-fetched and largely a sideline here. The punch line that really put China in an inferior position was directed toward the country's non-Christian religion. The non-believer status was picked up by the advertiser and used as a sign of Chinese inferiority, based on the good old likening of "Christianization" to "civilization." Following this logic, Pears' soap strategically aligned its product with the Christian missionaries. Pears' soap and White missionaries were projected as partners in a mission to civilize China—that is, while the missionaries bore the White Man's burden to Christianize China and cleanse the Chinese soul, Pears armed them with its soaps to keep clean the native dresses they wore and to civilize the Chinese.

The rhetorical use of the trope of the racial Other in consumer product ads during the period of High Imperialism was not limited to painting them as "dirty" and, therefore, "uncivilized." As the emerging advertising profession began to realize the sign value of the trope of the racial Other and to use it as a visual device to promote consumption following Pears' success, the range of deployed racial stereotypes also widened. Indeed, most of the lasting stereotypical racial icons were created during the period of High Imperialism.

Carrying on the slavery racial script, Black women were portrayed in post-slavery ads as Southern mammy-style domestic servants to promote consumer products, particularly for the manufactured food industry. The most famous identity of all is that of Aunt Jemima—the face of the first commercially marketed pancake syrup, which was on the market for more than a century. Figure 2.16 shows Nancy Green, a slave by birth assigned the original role of "Aunt Jemima" on the stage of the 1893 World Columbia Exposition. Green cooked pancakes, sang songs, and told jokes from the South to help the company promote its product. While this ad captured Aunt Jemima's stardom (character-wise and product-wise) at the Expo, it did not neglect to remind the audience of Aunt Jemima's real "place": the center point of the ad depicted Green cooking in a kitchen (belonging to a well-to-do household that also enjoyed the service of a Black male butler in full uniform). Although this subordinate status was a long-held stereotype assigned to Black women, it can also be seen in the portrayal of the Black man in ads. Figures 2.17 and 2.18 used identical rhetoric to construct of the imageries of Aunt Jemima and Rastus, two of the most recognizable faces in manufactured food advertisements. Like Aunt Jemima, Rastus (the face of Cream of Wheat) was seen wearing a broad smile while serving food to his White masters. Unlike his female counterpart, who was depicted serving a stack of pancakes to a table full of White men and

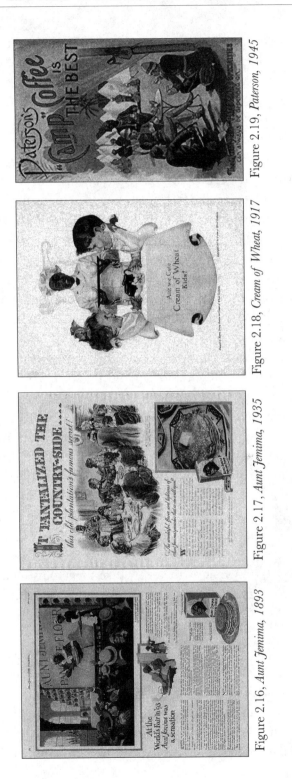

Figure 2.19, *Paterson, 1945*

Figure 2.18, *Cream of Wheat, 1917*

Figure 2.17, *Aunt Jemima, 1935*

Figure 2.16, *Aunt Jemima, 1893*

women, Rastus was portrayed serving bowls of steamy hot Cream of Wheat to two White children.

The portrayal of the subordinate role and servitude of the racial Other can also be seen beyond the kitchens and dining tables, as the packaging of Paterson's "Camp" Coffee shows (Figure 2.19). It is noteworthy that a new conqueror-conquered relationship has been added to the servant-master relationship as constructed in the imageries of Aunt Jemima, Rastus, and the like in the same period. The presence of a Black man serving coffee to a couple of seated White officers in the field, together with a number of standing Indian soldiers, exotic palm trees, and military camps in the background, added a significant colonial flavor to the product. The audience does not know if the Black man is a member of the imperial force or a local Black man who has already been "civilized" (according to his dress) by the imperial force. Perhaps it does not matter to the advertiser. Either way, we see a smiling Black man cheerfully serving his White superiors as if he knows he will make them happy—because "Paterson's 'Camp' Coffee is the Best" and the product "can always be depended on," as the ad's heading and caption claim.

The iconographical Black child imageries were no less stereotypical and useful in helping to promote various products. Figures 2.21, 2.22, and 2.23 exemplify the manner in which they were constructed as non-threatening, mirthful icons used to help sell goods ranging from alcohol to watermelons to washing powders. In addition to the exploitation of Black children, the iconic "black face show" was created in which White men darkened their faces, wore Afro wigs and hats, played the fool, and mocked Blacks on stage. Figure 2.20 (left) is an example of the promotion of such a popular yet degrading cultural event of the time. Like their minstrel and comic versions, stereotypical representations of "Sambo" from the United States and his European versions—such as "Golliwog" of the U.K., "Sarotti-Mohr" of Germany, and "Black Peter" of the Netherlands (for discussion see Pieterse, 1992)—shared extremely exaggerated facial features such as polished black skin, woolly hair, bulging eyes, white teeth, and thick red lips in proto- and early advertisements. Adhering to the colonial racial script, these outward features were visualized and commodified by advertisers, as were the character's peculiar behavior and poor use of language (think of "OH—I

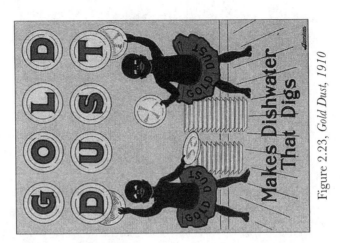

Figure 2.23, *Gold Dust, 1910*

Figure 2.22, *circa 1930s*

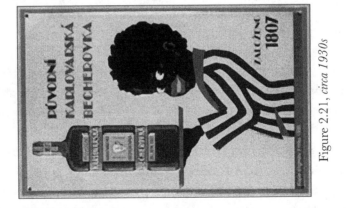

Figure 2.21, *circa 1930s*

IS NOT!" and "IT MUST BE SUMTHIN' I ET!!" attributed to the "Piccaninny" girl in the watermelon ad). While being ridiculed to help the ads gain attention and be memorable, the archetypes of Black children were coded as inferior beings in terms of their conduct and intellect.

In the peak years of High Imperialism, advertisers also began to exploit the exotic appearance of other non-White races as a result of territorial and market expansion. The different attributes of foreignness were picked up and transformed into selling points to boost the advertised product's world market dominance and universal appeal. Evidence of this phenomenon can be found in various product promotion and advertising materials. Figures 2.24 and 2.25 (from the digital collections of Duke University) show 2 of the 25 trade cards in an 1888 collection entitled *Savage and Semi-Barbarous Chiefs and Rulers* that formed part of W.S. Kimball & Co.'s cigarette promotion campaign. One features a Zulu King and the other features an Afghan ruler. Remarkably, the image of a young and dignified-looking Chief Joseph is found among the trade cards within this collection—labeled as "Joseph N. America Chief," while a portrait of an older and somber-looking Chief Joseph was featured a century later in a Timberland ad (see Chapter 6). The company's competitor, Duke's Cigarettes, made a much greater effort with a similar strategy. A total of 50 trade cards were created, for which—as claimed on the reverse side of each card—the company had "spared no pains or expense in producing." Judging by these collections, the effort invested in creating each of the featured foreign national figures and the unique backgrounds of the culture of their home nations were indeed significant for the time. The design of the trade card that featured China, for example (Figure 2.26), not only featured a Chinese Mandarin, but also made an effort to show the scenery and inhabitants of the land he represented. In addition, consumers were also presented with what looked like a coat of arms and a flag. As much as being symbols of the nation, it is worth noting that both the coat of arms and the flag served purely to show how the exotic land, exotic people, and the exotic myth (as exemplified by the substitution of a European-style dragon for the Chinese mythical version) were imagined by the Western mind. These foreign figures can be actual or imagined, and, as twisted as these visions were, they were useful devices for the campaign and for the manipulation of consumer perception. In return, each image of the foreign legends was positioned directly atop a tag line, "Duke's Cameo Cigarettes Are the Best," as though these exotic people and their respective nations actually endorsed the brand. Significantly, these are some

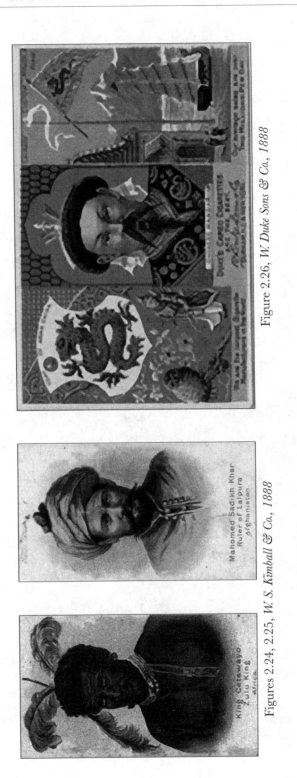

Figure 2.26, *W. Duke Sons & Co., 1888*

Figures 2.24, 2.25, *W. S. Kimball & Co., 1888*

of the earliest advertising materials that used imageries of the racial Other in the role of what is now known as "celebrity endorsers."

On rare occasions, the depiction of the racial Other came out of left field, as the example found in Figure 2.27 demonstrates. Imageries of people of different skin color were constructed to form a crowd and create a scene of frenzied demand for Frank Rippingille's stoves. They could be identified on a superficial level as merchants and/or consumers, if one judges only by the

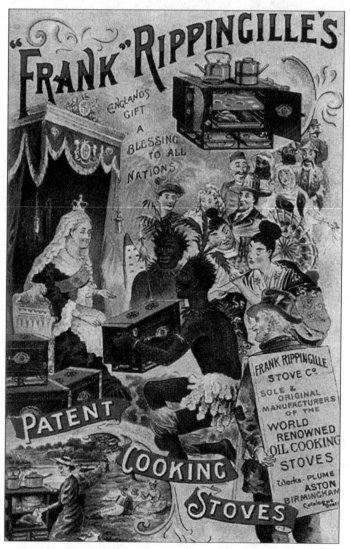

Figure 2.27, *Frank Rippingille, 1897*

apparent trading scene. However, the tag line "Englands gift—A blessing to all nations" reminds us to look beyond the obvious. The exploitation of colored people was indeed not as much about "them"—the racial Other—as it was about "us"—the British Empire, Britons, and the brand. The trope of the racial Other was chosen for this ad because of its collective sign value to help convey a sense of international appeal and global demand for the product and for popularizing the existing racial relationships: a relationship between the ruler and the ruled (the Queen vs. the commoners of different races); a relationship between the benefactor and the beneficiary (England represented by the Queen and the said superior product vs. the racial Other represented mainly by the Blacks with their excessively thick lips, the Asians with their exaggerated slit-eyes, and the Arabs with their headgear rushing for the "gift"); and a relationship between the cultured and the uncultured (represented by the well-presented White woman already enjoying cooking with her stove vs. the racial Other represented by two semi-naked Black men holding a stove with eyes and mouths wide open). This said, despite the real purpose for deploying the racial Other in this non-mainstream ad, it does provide a sign of the beginning of an unease and complicated development in the use of non-White people to promote the consumption of consumer products in later historical moments.

This chapter has identified the key features and tendencies of the colonial racial script as it emerged from the philosophical and cultural knowledge and discourses generated from the eighteenth century to the peak of High Imperialism in the nineteenth century, and examined how it was applied to define and confine the racial Other in advertising discourses right from the beginning of its professional inception during this historical moment. It captures a key moment that saw the maturing of a body of colonial racial script as well as the birth of advertising as a profession at a time when scientific racism mingled with commodity racism to generate some of the most influential racist iconographies in history. As scientific racism provided the concepts and categories of race through claims of truth and knowledge, commodity racism gave these notions commodity value by exploiting racial stereotypes and

strategically rendering them as real, believable, popular, and easier to ingest through the power of advertising.

The key characteristics of this historical moment have been clearly identified as being both expansionist and capitalist. From the colonialist territorial expansion and slave trading to the imperialist economic exploitation of markets and resources in conquered lands, the second historical moment of this genealogy as discussed in Chapter 2 is both notion-packed and action-packed. Like the African slavery discussed in Chapter 1, European imperialism was also organized racially (Winant, 2004: 205). As outlined in this chapter, this era was crucial to the formation of a dominant worldview of the concept of race: it established the authority of knowledge and key concepts about different races through natural history and various branches of science; it set the cultural attitude and value of the racial Other through cultural discourse; and, eventually, a binary racial hierarchy marked by the supremacy of the Whites and the inferiority of the non-Whites was firmly held as "truth" beyond question or doubt.

Cornel West suggests that our understanding of modern racism would be inadequate without the knowledge of the related notions, metaphors, categories, and norms embodied in modern discourse (West, 2003: 92–93). The advertisements of the nineteenth century that deployed imageries of the racial Other are one form of modern discourse from which race notions, categories, metaphors, and norms can be read and appreciated. What, then, does this interweaving of key notions and categories in intellectual and scientific race discourse with metaphors and norms encoding race in advertising race discourse tell us about advertising's deployment of the racial Other in this historical moment?

In general, we have learned to appreciate the contribution that the advertising industry and visual texts made to the establishment of the colonial racial ideology. As a project in progress, colonial racial ideology developed in uneven stages based on a wide range of works from the social, intellectual, and cultural elite. As this chapter has argued and demonstrated, the advertising industry evolved into a profession at the peak of the colonial era. It not only transformed the rich stock of colonial racial metaphors and stereotypes into images and slogans in the language of advertising; it also helped to popularize colonial racial understanding of and attitudes toward the racial Other while being paid by advertisers to promote everyday items. Arguably, advertising was one of the—if not the—most effective promoters of the colonial racial ideology

among the masses, as they did not have the knowledge of, access to, or interest in reading the body of philosophical and scientific books of the high culture, or the money to spend to see the colonized Other in freak shows, minstrel shows, or movies, among other forms of popular culture. While *Gone with the Wind*, for example, placed the southern mammy imagery on the silver screen, leaving a vivid but momentary picture of the servitude of Black women in moviegoers' minds, the imagery of Aunt Jemima and the like were in people's homes, on a box of pancake mix or a bottle of pancake syrup, ready to be consumed (pun intended).

The unambiguousness and overt racism found in colonial literature and advertising discourses was consistent. It was also consistent across advertisements themselves. The aspects of inferiority assigned to the racial Other and the often brutal language used to describe non-White people (Black people in particular) that originated in the literature of the humanities and science were picked up, transformed into undisguised racist tag lines, copy, and pictures, and used in ads with typographical and illustrative treatments. Blatantly hostile attitudes and visual executions were the norm, no matter if the ad was designed to promote freak shows parading non-White bodies or to sell a consumer product. Following the colonial racial scripts that framed the racial Other, and the cultural tenor that scorned them as the opposite of civilized, pure, beautiful, graceful, intelligent, and decent, imageries of the racial Other were commonly coded with primitiveness, dirtiness, ugliness, dangerousness, servility, and clownishness in the ads of this era.

The use of the trope of the racial Other in advertising within the context of High Imperialism was phenomenal in terms of the range of products, the number of non-White races exploited, and the variety of racially stereotypical imageries created within the ads. The capitalistic nature of the era and the successful use of imageries of the racial Other in a series of Pears' ads prompted an explosion of consumer product ads. Advertisers recognized the commodity value of imageries of non-White people and used them to sell consumer products beyond soap—from manufactured food and drinks to cigarettes, fruit, toys, entertainment, and stoves. This chapter has demonstrated that, at the same time, a dramatic territorial expansion saw the advertisers' attention turn to the non-White races of other continents (such as—to use Carl Linnaeus's terms—the Red and Yellow races) as well as the Black people of the African continent. Furthermore, in the spirit of both expansionism and capitalism of the period, efforts to create visual icons in a competitive market

resulted in the construction of some of the most memorable and lasting (albeit discriminatory) racially stereotypical icons in history. The southern mammy imagery of Aunt Jemima and the child-like imagery of the Black Sambos mentioned in this chapter were typical examples. It is notable that, while the great majority of racial stereotypes were used intensively in nineteenth-century consumer product ads, some (such as those coded as dangerous or sexual) remained by and large in the toolbox waiting for their turn to be deployed in ads. With extremely rare exceptions in which the racial Other was projected as an endorser or a consumer, the constructed imagery of the servile servant, clownish Sambo, and the exotic alien were the most common stereotypical themes created under the conditions of High Imperialism and commodity capitalism.

Having outlined the ethos of the colonial mind that set the hierarchical place for the racial Other, identified the racial concepts, metaphors, and categories from the Enlightenment to the peak of High Imperialism, and scrutinized the visual application of the colonial racial script, let us now turn to the third moment in this genealogy of the deployment of the trope of racial Other—the post-World War II era to the end of the 1960s. This era was marked by postcolonial racial politics worldwide and power struggles over racial identity and equality within the Civil Rights Movement in the United States.

POST-WORLD WAR II RACIAL POLITICS
AND ADVERTISING

Few mixtures are more volatile than race and politics. The normal frictions and resentments among individuals and groups seldom approach the magnitude of frenzy and violence produced by the politicization of race. The twentieth century, which has seen the spread of mass politics and mass ideologies to vast new regions of the globe, has also been the century of resurgent new racial persecutions, reaching new heights—or depths.

– Sowell, 1995: 117

American advertising is responsible for much of the Negro's current demand that he, too, be allowed to participate in the fulfillment of the American dream.

– Evers & Peters, 1967: 32

The historical context for this chapter is the aftermath of World War II until the end of the 1960s and its rapidly changing political and cultural climate marked by a postwar awareness of racism, struggles over racial equality within settler colonies, and decolonization movements in conquered lands. This period marks a significant phase of racial insurgency and reform in understanding the emergent new racial politics. Chapter 3 focuses on the politics of race in general and the interplay between racial politics and racial representations that affected the deployment of the trope of the racial Other in advertising.

For several reasons, the turbulent post-World War II era marked a turning point in the understanding of the concept of race and the deployment of

imageries of the racial Other in advertising. Public attitudes toward racist doctrine and practices certainly shifted markedly following the Nazi Holocaust (it was in this period that the term "racism" itself became a common criticism of all forms of racial discrimination). From the late 1940s on, the term "racism" came into frequent use—more than a decade after it was used by Magnus Hirschfeld as the title of his 1933 book. The United Nations outlawed genocide in 1948. Most significantly, the colonial race belief that had dominated the worldview of the West for centuries began to lose favor after World War II, following the extreme application of strongly related doctrines by Nazi Germany.

By 1966, the ground rules were set regarding racial discrimination. Part 1, Article 1 of the United Nations' *International Convention on the Elimination of All Forms of Racial Discrimination* resolution defined racial discrimination as

> any distinction, exclusion, restriction or preference based on race, colour, descent, or national or ethnic origin which has the purpose or effect of nullifying or impairing the recognition, enjoyment or exercise, on an equal footing, of human rights and fundamental freedoms in the political, economic, social, cultural or any other field of public life. (United Nations, 1966)

To combat racism, the same convention also resolved to

> adopt all necessary measures for speedily eliminating racial discrimination in all its forms and manifestations, and to prevent and combat racist doctrines and practices in order to promote understanding between races and to build an international community free from all forms of racial segregation and racial discrimination." (United Nations, 1966)

Three years later, in 1969, the resolution finally took effect. By the second half of the twentieth century, the harm of the racial crime had been witnessed, the evil ideology and acts against the racial Other had become known as "racism," and racial discrimination had been officially and universally condemned.

The post-World War II era also marked the beginning of growing struggles for racial equality and identity. Both the struggles for independence from Western colonial rule in non-settler colonies across the world and the struggles against racial discrimination within settler colonies (most significantly the Civil Rights Movement in the United States), provided battlegrounds between the

ex-colonialists and the ex-colonials, and between the ex-masters and ex-slaves. These two highly significant movements combined to reveal an early sign of the shifting landscape of racial politics, which included a range of postcolonial power plays in relation to racial identity.

Although there had been signs of a revolt against colonialism before World War I that led to England losing Egypt in 1922 and Iraq in 1932, decolonization became unstoppable after World War II. To gain the vital support of the colonized people, the Allies had fought both world wars under the banner of the right to self-determination, and the Atlantic Charter text of 1941 appeared to promise an end to colonialism. In the charter's text, Churchill and Roosevelt stated that, as the leaders of their respective nations, "they respect the right of all peoples to choose the form of government under which they will live; and they wish to see sovereign rights and self-government restored to those who have been forcibly deprived of them" (Atlantic Charter text of the Churchill and Roosevelt Charter of 1941).

Real progress toward decolonization was slow. When the United Nations was established in 1945, almost one-third of the world's population remained under colonial rule. According to U.N. data, 750 million people lived in non-self-governing territories dependent on colonial powers. In 1960, the U.N. General Assembly adopted the *Declaration on the Granting of Independence to Colonial Countries and Peoples* (a.k.a. *the Declaration on Decolonization*). The declaration stated that all people had a right to self-determination and proclaimed that colonialism should be brought to a speedy and unconditional end.

The remaining colonies eventually won their independence between 1947 and 1980, often through conflict and bloodshed. With the unstoppable decolonization movement in colonized lands sweeping through continents from the Middle East to Asia and Africa, the West could no longer ignore the will of self-government and the voices of resistance to colonial oppression.

The very fact that the colonized racial Other—labeled "Brown," "Yellow," and "Black," rated on the bottom of the Great Chain of Being, and deemed to be "uncivilized" and "incapable of governing"—managed to regain a sovereignty long lost to the colonial master is, in itself, a political statement that challenged not only the status quo of the colonial power structure but also the long-held colonial racial concepts that justified conquest and oppression. Despite this, the racial Other was still considered conceptually inferior by the West and in cultural discourses: as the "underdeveloped," the "Third-World,"

and the "needy," for example. While this aspect will be discussed in more detail in the coming section, here is a protesting voice from the ex-colony:

> We, politely referred to as "underdeveloped," in truth are colonial, semi-colonial or dependent countries. We are countries whose economies have been distorted by imperialism, which has abnormally developed those branches of industry or agriculture needed to complement its complex economy…. We, the "underdeveloped," are also those with the single crop, the single product, the single market. A single product whose uncertain sale depends on a single market imposing and fixing conditions. That is the great formula for imperialist economic domination. (Guevara, 1967: 31)

In the realm of intellectual developments, the bursting of the Victorian racial myth shook the scientific legitimacy of long-held colonial racial beliefs. Richard Lewontin's study of race and biology, in which he applied gel electrophoresis to blood sample data collected from all over the world in the 1960s, proved that existing blood-based imperialist colonial racial beliefs were scientifically flawed. In investigating genetic variations within and between groups that had long been regarded as races, Lewontin found that any two individuals within any so-called race might be as different from each other as they are from any individual in another so-called race. Based on this research, he concluded that race had "virtually no genetic…significance" (Lewontin, 1972). The importance of this finding to humanity and to knowledge about race was best summed up by Stephen Gould, a leading natural historian, in the 2003 PBS documentary *RACE: The Power of an Illusion*: "Under the skin, we really are effectively the same." In 1964, a team of internationally prominent scientists met in Moscow and declared that "Racist theories can in no way pretend to have any scientific foundation" (UNESCO, 1969: 48). At a 1967 conference in Paris, a committee of experts on race and racial prejudice proclaimed: "[R]acist doctrines lack any scientific basis whatsoever" (UNESCO, 1969: 50).

In the eyes of modern science, the biological myth of race was effectively debunked. However, this did not mean that the widespread and deep-rooted myths about race were no longer in play in society. Although by the late twentieth century race could no longer claim scientific credibility as a "biological entity," it still firmly existed symbolically and socially. The ideology of race, as Audrey Smedley suggested, "proclaims that the social, spiritual,

moral and intellectual inequality of different groups was, like their physical traits, natural, innate, inherited, and unalterable" (Smedley, 1997). With the demise of scientific race theory, race was only real because it remained a social category, and remained real in many people's belief systems. As such, despite its scientific and intellectual illegitimacy, the colonial ideology of race still lingered on.

Bearing these cursive contextual factors in mind, the four sections that follow are designed to examine the discursive conditions under which the "politicization of race" was in play and their effect on the strategic deployment of the trope of the racial Other in post-World War II advertising. Given the undercurrent of racial struggle that had surfaced with unprecedented strength and momentum in this historical moment, and given that the past racial injustice in the practices and representations of advertising was under attack in the United States like never before, this chapter seeks to establish whether the trope of the racial Other and its visual representation were destabilized under pressure from the vantage point of the United States—in particular, whether the Civil Rights Movement achieved its goal of altering the advertising industry's existing discriminatory practices, such as racial exclusion and negative stereotyping.

In the following sections, we begin to identify how political rhetoric made in political and advertising discourses responded to changing postcolonial race relations on the one hand, and the advertising industry's calculated response to the Civil Rights Movement's fight for the right to be present and to be represented on the other. We then discuss ads placed in mainstream magazines that deployed imageries of Blacks for White audiences before scrutinizing two typical advertising themes placed in the Black-owned magazine *Ebony*, which used Black models and targeted Black audiences. Together, they capture the interplay between racial politics and post-World War II advertising and highlight the adjusted rhetoric, developing themes, and strategic power plays that arose in this era.

ACTIONS AND COUNTERACTIONS
NEW TRICKS, SAME GAME

Where Do We Go from Here? Under this title, on 16 August 1967, Martin Luther King, Jr. delivered the last speech of his life, offering an assessment of the Civil Rights Movement at the time. The notably less-than-optimistic tone expressed in it was shared by many Black leaders of the 1970s regarding the "downward swing" of the civil rights struggle, according to Peter Levy in his documentary history of the modern Civil Rights Movement, *Let Freedom Ring* (Levy, 1992: 228). A sense of dissatisfaction was evident in this passage:

> When the Constitution was written, a strange formula to determine taxes and representation declared that the Negro was sixty percent of a person. Today another curious formula seems to declare that he is fifty percent of a person. Of the good things in life, the Negro has approximately one half those of whites. Of the bad things in life, he has twice those of whites. (King, 1972: 228)

Two key points were made by King in this landmark speech: one concerning the "voicelessness and powerlessness" that confined the life of Blacks, and the other his foresight that "A nation that will keep people in slavery for 244 years will 'thingify' them—make them things" (see King, 1972: 229–230). These are of particular significance to the politics of racial representation. Political and economic power aside, in the cultural field of advertising, a de facto racial segregation between Black and White models remained in the United States for most of the postwar period. The visual exploitation of the racial Other in ads, in the manner of the "economy of inclusion" (using Robert Young's term) where oppressed people were "thingified" (or objectified) in ads from this period, reflected this drastic lack of voice and power to present and represent. More significantly, the syndrome of oppression and commodification highlighted by King and captured in this section are not unique to the United States. Carrying on a colonial relationship described by critics such as Frantz Fanon, Edward Said, and Hélène Cixous, the voiceless and powerless the racial Other or the Orient has suffered under the dominant Western culture. This conclusion marked the starting point for postcolonial studies that began in the late 1970s and took the field of cultural studies by storm in the late 1980s, a period in which these syndromes remained

the key points of criticism shared by postcolonial scholars (see, e.g., Fanon, 1968; Said, 1978; Cixous & Clément, 1996).

FROM "UNCIVILIZED" TO "THIRD WORLD": THE ADJUSTED RHETORIC

For the formerly colonized people, the identities of their nationhood and personhood remained inferior from the West's perspective, despite the change in rhetoric. While the old "uncivilized" tag was out of fashion, its popular synonym, "underdeveloped," was eventually replaced by (or made interchangeable with) another more civil-sounding expression—"Third World"—in public discourses. Despite the change in terminology, once again the identity of the ex-colonized countries and their people were placed in a lowly position in another version of the West's evolutionary ladder, only this time it used the logic of neocolonialism and was backed by Walt Rostow's influential modernization theory. This theory painted an evolutionist picture of the world as populated by nations in various stages of "development," with all of them having to travel through the same five-step sequence toward industrialization, and with some further developed than others. The difference in the stages reached was explained by Rostow "as one would expect in *the essentially biological field* of economic growth" (Rostow, 1960: 36; emphasis added). As the West (or "the North," as Rostow preferred to call it) had reached the highest stage, and the Rest (or "the South") lagged behind, Rostow's theory provided the rich ex-colonialist nations with a rationale for maintaining their economic grip and cultural influence on the ex-colonies in the name of "aid" and "help."

Modified for the postcolonial condition, this "new" line of racial discourse, developed from the perspective of the former colonist and in the interest of the former colonist, was (like the "old" ones) visualized and promoted through advertising. A 1962 ad (Figure 3.1) for the U.S. chemical giant Union Carbide, circulated in mainstream magazines such as *National Geographic* and *The Saturday Evening Post*, is one example in which a number of postcolonial concepts were subsumed within a single-page ad that boasted of the company's success and credentials. If the heading "Science helps build a new India" fails to give enough of a clue to the postcolonial relationship between the developed, superior, and advanced Occident and the underdeveloped, inferior, and backward Orient, then the opening of the body text does:

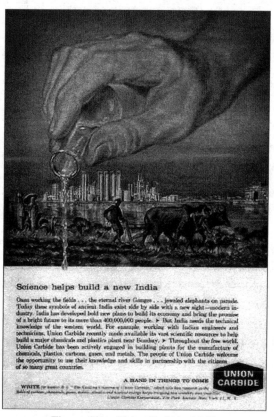

Figure 3.1, *Union Carbide, 1962*

Oxen working the fields…the eternal river Ganges…jeweled elephants on parade. Today these symbols of ancient India exist side by side with a new sight—modern industry. India has developed bold new plans to build its economy and bring the promise of a bright future to its more than 400,000,000 people.

But India needs the technical knowledge of the western world….

At the bottom right of the picture, the ad showed two oxen working the field, driven by an Indian man wearing traditional headgear and trying to balance himself. Two Indian women, also in traditional dress and with their hair covered, are seen walking into the picture from the same direction. On the other side of the sacred river Ganges, a group of tall metal structures rise up from the horizon, symbolizing the fruit of Western involvement and highlighting how "Union Carbide recently made available its vast scientific

resources to help build" the "major chemicals and plastics plant" in India, as the rest of the copy claims. To complete the story, a giant hand at the top of the ad releases red liquid from a test tube onto the land.

This ad, from its visuals to its copy, was obviously underpinned by Rostow's modernization theory, reaffirming his logic that India could not deliver its promise of a bright (postcolonial) future without the help of the (scientifically advanced) Western world (of which Union Carbide was a leading giant). The apparently tactful rhetoric expressed in this ad, therefore, was very much a "friendlier" repackaging of the existing colonial race ideology under the tag of "development."

Reading more deeply into the lines and images, we should begin to notice that not only the "uncivilized" tag has been repackaged in this Union Carbide ad, but also a range of the colonial racial scripts. For example, the giant hand from above and the test tube it holds convey the concepts of powerful, high, and scientific; while the smaller, traditionally dressed Indians, grouped with oxen at the bottom of the picture, convey the opposite concepts—weak, low, and physical. The relationship between the faceless White (ex)master and the natives constructed through this visual language reminds us (both conceptually and visually) of Fanon's power relationship between the two colonial "species" and Pears' Soap's White Man's Burden ad. In the same Union Carbide ad, we can also find traces of the concepts of progress, humanity, and quality that the White man represented, in contrast to the primitive Other as framed by the "white mythology" outlined by Young. Furthermore, the imageries of the Oriental in this ad, even with the "jeweled elephant" promised in the copy absent from the visual, demonstrate a typical set of Oriental imageries matching Said's account of such representation: the man is feminine and weak; the women are strikingly exotic; and the river Ganges is sacred. With a touch of nostalgia, the ad tells a story that while the Oriental carried on their traditional (and therefore backward) routine, their "lacking" and "passivity" were observed by the Occident, which took action to lend them a god-like hand.

The decolonization movement, together with other post-World War II events, posed a major challenge to racial discourse and racial relationships, and the dominant powers reacted tactically. When it became morally unacceptable to label formerly colonized subjects as "uncivilized," the rhetoric adopted more diplomatic labels such as "underdeveloped" and "Third World." When "colonizing" a sovereign country became a sinful act, the rhetoric of control switched to the moral high ground of "helping." Symbolized by the giant hand

from above, and the tag line "A Hand in Things to Come," the ad's tactic of muting the natives on the one hand, while speaking for them on the other, vividly painted them as "needy."

TO PRESENT AND TO BE REPRESENTED: DEMANDS AND RESPONSES

> For generations in this country, the arts have been prostituted to help foster discrimination, the dangerous illusion of "white supremacy" to make the Negro people an object of scorn and contempt.... It is to root out these falsehoods that we are dedicated.

The above is an excerpt from the Statement of Principle of the National Negro Congress (NNC; quoted in Chambers, 2009: 123). The realization of the importance of the cultural representation of Blacks in the fight for racial equality led to the establishment of NNC's Cultural Division. The division initiated a strategy of using the arts to improve the image of Blacks in society and commissioned the first study on Black employment in the advertising industry, "The Negroes Status in Advertising" in 1947 (NNC, 1947).

The U.S. government disbanded the NNC in the 1950s following allegations of communism, and "the fight for black employment and representation in advertising lay dormant for much of the 1950s" (Chambers, 2009: 127). However, its mission—to increase Black employment and change the manner in which Black imageries were portrayed—established the framework for other civil rights organizations such as the National Urban League, the Congress of Racial Equality (CORE), and the National Association for the Advancement of Colored People (NAACP) in the 1960s and 1970s. These struggles were fought both on ideological grounds in street marches demanding rights and on economic grounds through organized product boycotts and "selective patronage" campaigns by Black consumers. In an effort to change advertising's long-held discriminatory attitudes and practices against Black people, civil rights organizations demanded that Blacks be employed in advertising agencies and that the negative depiction of Blacks in advertisements cease.

Both these demands represented power-related struggles: the former a fight for the power to be present as practitioners in advertising; the latter a fight for the right not only to be represented in advertisements, but also to be represented as equals. This was a moment in history when the advertising

industry faced a direct challenge from the Civil Rights Movement on a scale and with a momentum unmatched anywhere in the world. The snapshot that captures the power play between civil rights organizations and the advertising industry provided here yields a significant contextual factor in this genealogy of the tropes of racial Other and their use in advertising during this historical moment.

On the jobs front, a 1947 study by Milton Biow that was commissioned by the NNC found that the advertising industry remained a "white world." According to this report, "The Negroes Status in Advertising," among the 20,000 employees working in New York's advertising industry, only 22 were Black. Half of these Black employees were in minor positions such as messengers, receptionists, or janitors, while the rest worked as assistants in various administrative roles. Only 15 were working on anything connected to advertising. Commissioned by a local chapter of the National Urban League, another three-year study of the employment of Blacks in New York City's ten largest advertising agencies was released in 1963. The study revealed that only 25 Blacks were employed in creative or executive roles among the city's 20,000-plus advertising workforce (NNC, 1947). The situation in the 1970s was not much better. In 1975, Vernon Jordan, the executive director of the National Urban League, again criticized the advertising industry's discriminatory employment practices. He sharply pointed out that "The advertising industry is one that deals in image selling, ideas and new concepts, but it badly needs to sell itself the idea of affirmative action" (Jordan, 1975). The criticism was well grounded—after more than a decade of struggle for Black inclusion, the gain remained fractional. Furthermore, among the small number of Black recruits entering the field of advertising, some were hired to work only on Black-related projects—a practice criticized by the Urban League as "a form of segregated integration" (quoted in Chambers, 2009: 128).

> In hundreds of advertisements in popular magazines from 1865 to 1920 which I examined, no Black person was ever depicted as the consumer. When Blacks appeared it was either as a servant or as a personality such as the Cream Of Wheat cook or Aunt Jemima. Moreover, I failed to find any national-brand advertisements directed to Black consumers. (Norris, 1990: 190)

James Norris's account summarized the consistently discriminatory treatment of the racial Other by the advertising industry, a practice that civil

rights organizations attempted to change. But the struggle for Black inclusion in advertisements also faced resistance. In fact, it could be said that a de facto racial segregation existed in advertisements for most of this period. Growth in the number of Black models used in advertisements was slow. According to Kern-Foxworth, "It was not until the 1950s that real-life blacks were used on a small scale to advertise products" (1994: 49), and most appeared in Black publications. A study conducted by Lester and Smith found that the number of Blacks featured in ads was "low in 1957, moderate in 1962–1972, gained in 1978, and [has] declined for all three magazines since 1978" (Lester & Smith, 1989: 13).

Figures aside, most disturbing was the common practice of segregating Black and White imageries in advertising. Following the lingering discriminatory tradition, Black models still had to face an "entrenched ideology that said that blacks and whites should not appear together in advertisements" and that "ads should separate the two races with ads featuring black models reserved for ethnically targeted media" (Chambers, 2009: 114). As a result of this industry-wide tradition of racial segregation, Black imagery was rarely seen in ads placed in mainstream media, except for a few renowned Black sports stars or the same old stereotypical roles of servile Black butlers attending to White characters.

Various organizations in the Civil Rights Movement fought strongly to eliminate the negative depiction of Blacks in advertisements. Political, legal, and economic avenues were used to push the cause of racial equality: politicians were lobbied; legal action was taken; and products and businesses associated with ads portraying negative racial stereotypes were boycotted or ignored as part of "selective patronage" campaigns. While the effect of these efforts on the use of the racial Other in advertising during the post-World War II period will be explored in the following sections, it is worth mentioning here the advertising industry's response to the call to eliminate negative racial stereotypes. In a typical power play, the demand for eliminating the negative stereotyping of Blacks was answered not by attempting to depict them in a positive light, but by eliminating them from advertisements altogether. Jason Chambers insightfully outlines the roll-on effect of this move:

> By the early 1960s, the advertising industry had ceased using most of the pejorative and derogatory images that had been popular in the early portion of the century. But rather than featuring more realistic images of blacks, the industry simply eliminated blacks from most of the

advertisements in mainstream media, rendering them invisible. In turn, that invisibility helped perpetuate the belief that blacks were not equal to whites....Certainly blacks could open an *Ebony* magazine and see blacks enjoying the material comforts of the consumer lifestyle; finding similar results in *Life* or the *Saturday Evening Post* was nearly impossible. (Chambers, 2009: 122)

"WHAT'S COOKING?"
A LINGERING TRADITION COMPLICATED

The complex postwar political and economic conditions, combined with the racial struggles of the Civil Rights and Decolonization Movements, complicated the manner in which the racial Other was deployed in post-World War II advertisements in U.S. mainstream media during this historical moment.

The first issue was the persistent use of the colonial racial script despite mounting pressure from Black activists to project racial equality in ads. Compared to the imagery of the "aspiring" Blacks featured in the ads of *Ebony* in the following sections, the depiction of Black people in ads in mainstream publications was far from flattering. A Van Heusen ad from 1952 (Figure 3.2) provides one example. The ad was titled "4 out of 5 men want Oxfords...in these new Van Heusen styles." Five men were featured in the ad, and guess who is the odd one out? Apart from being the only Black in the scene, his Otherness does not stop there. While the four White men are all dressed in a shirt and tie, the Black man is not only naked, but he is wearing an animal bone and animal teeth as accessories, his body is tattooed, and his nose is pierced. Meanwhile, all the White men's expressions and body language are cheerful, but the Black man looks subdued and contemptuous. And while the White men are positively depicted showcasing the new Van Heusen styles of shirts in different colors, the Black man joins them only as an alienated object standing for everything the civilized Whites are not. His deployment in this ad was driven by the negative symbolic value of the racial Other assigned to him, that is, savage, uncivilized, and inferior. With these undesirable attributes linked to the only man not wearing an Oxford shirt—a Black man—the majority-

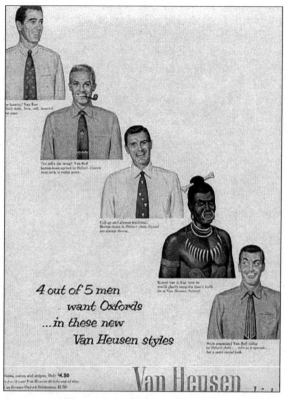

Figure 3.2, *Van Heusen, 1952*

White audience was persuaded to be anything but like the Black man—by way of consumption, by buying the Van Heusen Oxford shirt.

Colonial stereotypical roles also continued to be assigned to the racial Other when Black models or imageries were used in mainstream ads. In most cases, Black characters were deployed as servants waiting on White characters, as the following two examples demonstrate. In a 1947 ad for the New York Central Railway (Figure 3.3), the only Black person in the ad is a smiling train attendant who bends to light a cigar for a White man sitting on a couch. A 1960 ad for Austin Nichols (Figure 3.4) also has an explicit colonial flavor. It depicts a courteous Black servant holding a tray of alcohol for the pleasure of two uniformed White colonists. In the former ad, the trope of a Black man was used to sell the elation that modernity would bring to the Whites; in the latter, to satisfy a wishful affection for the colonial past. While the way in which Black characters were depicted was very similar in these two ads, they were deployed

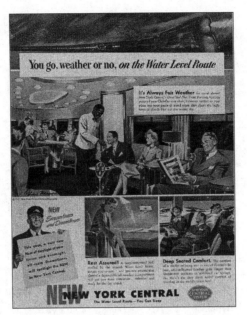

Figure 3.3, *New York Central, 1947*

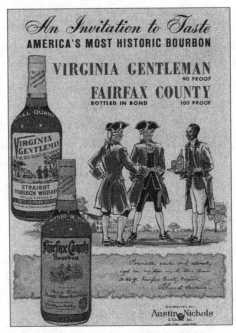

Figure 3.4, *Austin Nichols, 1960*

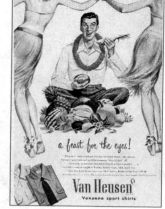

Figure 3.5,
Visit South Africa, 1957

Figure 3.6,
Hawaiian tourism, 1954

Figure 3.7,
Van Heusen, 1951

to signify two different things: one, the promise of modernity; the other, nostalgia in a postcolonial time. Yet in these different settings, both Black men were positioned in a lower socioeconomic role, as a minority to remain at the service of the White characters. The racial relationship constructed through the visual coding in both ads told the story of who was in power and who was the subordinate, who was the "us" and who was the "them" in mainstream culture, and, ultimately, who was superior and who was inferior in the post-World War II United States.

At the other end of the spectrum, an early sign of racial fetishism in the field of advertising can also be observed in post-World War II ads. A small number of ads from this period showed an interest in the exotic aspects of the racial Other and used these to add value to advertisers' products and services. In a 1957 ad promoting South Africa as a tourist destination (Figure 3.5), a single Black child is depicted stirring something mysterious in a giant metal pot. Accompanied by the heading "What's cooking?", the colorful headpiece, the accessories on the child's naked body, the unusual cooking gear with its mysterious ingredients, and the lure of a cute-looking Black child, this ad generated audience curiosity about an exotic culture and the desire to take a tour to discover the unknown. The naked Black child, wearing colorful and unusual accessories, was offered as a symbol for the whole continent.

Apart from rendering the racial Other as a child, feminine characters representing the Orient were often used in tourism ads (such as the one promoting Hawaiian tourism in 1954, shown here in Figure 3.6). However, the

exotic female body of the racial Other was not only used to symbolize the Orient and the Oriental; it was also used in other product ads as a fetish. In a 1951 ad promoting Van Heusen's Vanuana sport shirts (Figure 3.7), for example, a White man is depicted surrounded by all things exotic: his Van Heusen shirt is decorated with a lei, his right hand is holding an opened coconut, and his left hand holds a piece of pineapple. Lying on the ground in front of him is an assortment of tropical fruits and flowers. Yet these exotic products are not the high point of his treat. As expressed in the heading and his body language, he is having a ball enjoying "a feast for the eyes." And the source of this feast is the female islanders' bodies, their exotic costumes, and their seductive dance movements. The exotic and sexual qualities of the female body of the racial Other, as well as their folk culture, were realized and exploited and, in turn, consumed by the dominant Whites and their consumer culture.

The last point worthy of emphasis here is the somehow contradictory reaction to the demand for racial equality and the fight against the negative depiction of the racial Other in postwar advertising. For example, while some brands bowed to the pressure of Black consumer boycotts and began to modify the existing racially stereotypical branding imageries, other brands chose to continue to promote the existing racial stereotype. On the one hand, in 1968 Quaker Oats took the first step in reducing the racial stereotype of the Aunt Jemima trademark by replacing her kerchief with a headband and reducing her girth (Figure 3.8). On the other hand, overtly racist branding images were still being developed and deployed during this period. One such example was Fun to Wash washing powder, which was marketed during the post-World War II period with a typical southern mammy image similar to that of the original Aunt Jemima (Figure 3.9). Another was a White-owned restaurant chain,

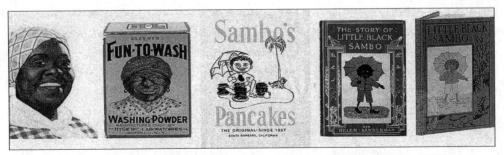

Figure 3.8, *Aunt Jemima, 1968;* 3.9, *Fun to Wash, 1950s;* 3.10, *Sambo's, 1960s;*
3.11 & 3.12, *The Story of Little Black Sambo, 1920s (from left to right)*

established in 1957, named Sambo's. After opening its first shop in Santa Barbara amid protests from Black activists, Sambo's managed to grow to 1,200 shops "from coast to coast" at its peak in the late 1970s. It became one of the biggest restaurant chains in the United States at the time, according to Sambo's corporate website. Despite the fact that its trade name was one of the most well-known racial slurs against Blacks, the restaurant owners maintained that it was nothing more than a play on their names—Sam Battistone and Newell Bohnett. The company also maintained that its use of the 1921 children's book *The Story of Little Black Sambo* as the branding of its promotion material was only an afterthought. However, there was a very strong resemblance between the restaurant's original logo (Figure 3.10) and the cover illustration of this popular book (Figures 3.11 and 3.12).

"MOVE UP"
INVITATIONS TO CONSUMERISM

One characteristic of the post-World War II period was the push toward consumption. By the early 1950s, as production exceeded demand in the West, the push for production was relatively secondary for manufacturers compared to the pressing need to stimulate consumption. For example, the desperate situation and the nervous sentiment within the U.S. corporate world were captured in a claim by the president of National Sales Executives: "Capitalism is dead—consumerism is king!" (quoted in Packard, 1957: 21). The unprecedented pressure on U.S. consumers has been best described by church groups as a push to "consume, consume and consume, whether we need or even desire the products almost forced upon us" (*Christianity and Crisis*, 1955). Arguably, the United States in the 1950s was where and when a culture of irrational consumption was cultivated through huge spending on advertising. According to Vance Packard, in 1955 roughly $53 in advertising was spent on every man, woman, and child to promote consumption. This sharp increase in advertising spending reflected the attitude in the business world toward the problem of overproduction. When confronted by the threat to the economy caused by overproduction, Wisconsin Senator Alexander Wiley, also known as the Cheese Senator, argued on behalf of producers: "Our problem is not too

much cheese produced, but rather too little cheese consumed" (quoted in Packard, 1957: 20–21).

True to the logic of capitalism, the strategy for solving the problem of overproduction was not to adjust production but to increase the consumer base and encourage consumption—be it rational or irrational. As the advertising industry, encouraged by record revenues, geared up not only to sell products but also to buy consumers, middle-class African Americans were recognized as an "undeveloped" consumer segment and were lured into the spending spree. The following section outlines the ways in which Blacks were targeted and depicted while the advertising industry enticed them through various promises to improve their social status.

Just as in the political sphere, the racial struggle for the right to be present and to be represented as equal citizens also surfaced in the post-World War II era. The Black magazines' struggle for political and financial survival and the surge in Black consumer power signaled the beginning of a changing dynamic in the landscape of postwar consumer culture. For the first time in history, Black Americans had established themselves not only as new (albeit minor) players in the mediascape of popular magazines, but also as new players in the econoscape of consumption.

The push to get Black magazines into the U.S. mediascape involved persistent efforts by publishers, including earlier pioneers such as W.E.B. Du Bois. However, the difficulties they faced were massive, as Tom Pendergast recounts:

> One after another, magazines that tried to reflect and comment on black culture failed because they could attract neither adequate advertising support nor ample circulation. Neither rage at racial injustice nor forbearance with slow but noticeable progress provided the motive force to build a commercially successful general magazine. (Pendergast, 2000: 243).

It was not until November 1945, with the publication of *Ebony*, that a Black-owned magazine reached a mass-circulation audience. *Ebony*'s success in tapping into a more broadly dispersed consumer culture did not take place by chance. Externally, it had benefited from a realization among advertisers of the need to cultivate underdeveloped markets in the country. Those advertisers began to widen the existing consumer base by including the previously ignored Black population in an attempt to boost the consumption of their products. Internally, to attract advertising revenue, the magazine also shifted its editorial

focus from the earlier Black magazines' collective concentration on "rights" issues for disadvantaged Blacks to promoting Black success and Black beauty, in terms of content, and adopting the style of leading mainstream magazines, most notably *Life*, in terms of design.

While providing a bridge for advertisers to reach Black consumers and a platform to lure and convert them to consumerism, *Ebony*, with its newfound position in the mass media and its clear focus on Black success and beauty, was effectively a part of the struggle for national recognition of Black models and the use of Black celebrities in advertisements, within the framework of the Civil Rights Movement.

The growing Black consumer market in the postwar U.S. economy is also significant. Throughout the 1950s, the Black population of the United States rose by 25%, in contrast to 16% for Whites. Among the 25 largest cities in the country, Black consumers accounted for more than 60% of all retail sales and 90% of all wholesale sales (Chambers, 2009: 119). The market could no longer ignore the importance of Black consumer power, and Blacks began to be described by industry commentators as "the least understood, most controversial, and yet most promising consumer group in the nation" (quoted in Chambers, 2009: 120). As a consequence of this newly emerging Black consumer power, advertisers, regardless of their racial attitudes, began to concede the importance of tapping into the Black consumer market—if not as a mere moral gesture, then defiantly, as a fight for market share (an economic imperative for business) amid the postwar crisis of overproduction.

The real joy of good living was promised by Schlitz in a 1959 ad (Figure 3.13). Beneath the imagery of a Black man in a business suit raising a glass of Schlitz to a woman in a Chinese silk dress, the copy suggested: "Make your move to Schlitz, the beer with just a kiss of hope. It's one of life's most refreshing pleasures." The ad suggested that by making a move to the brand, the Black man might be able to "Move up to quality." Through its visual framing, this multi-dimensional ad offered the Black man (and his fellow middle-class Black consumers) the chance to move to a more tranquil environment, a more intimate relationship, and a higher social class that embodied the "good life"—as well as a good-quality, refreshing beer! In so doing, it effectively linked happiness and virtue, social life and relationships, and success and failure, with the mere consumption of Schlitz.

For its part, a 1964 ad for Johnnie Walker persuaded Black consumers to drink its Red Label whisky by promising them: "You'll be glad you said

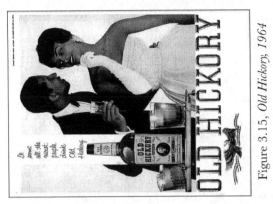

Figure 3.15, *Old Hickory, 1964*

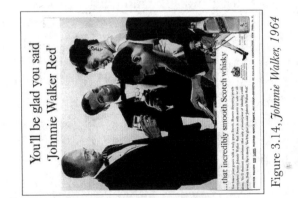

Figure 3.14, *Johnnie Walker, 1964*

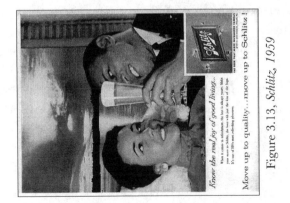

Figure 3.13, *Schlitz, 1959*

'Johnnie Walker Red'" (Figure 3.14). The ad features four Black people in formal attire at a social function. Directed at potential hosts, or guests, of social gatherings, the copy begins with the line: "You honor your guests with a truly great Scotch. Because discerning people everywhere honor Johnnie Walker Red." At one and the same time, the product's reputation was established and guidance to any Blacks wishing to match the socioeconomic status of their White counterparts was provided. While the advertiser counted on the desire and purchasing potential of the Black population, doubt remained as to whether they would be able to appreciate the said prestige product. This skepticism was evident in the remaining copy, as it delicately offered unusually detailed instructions on how to enjoy the "incredibly smooth Scotch Whisky." In other words, this ad not only tapped into the desire for social acceptance among the Black middle class and offered the Red Label as a symbol of success and good taste, it also assumed the problem of the inability of its "culturally inferior" audience to appreciate an upmarket product originally targeted to the educated and cultured. Thus, it thoughtfully provided a recipe for their improvement.

As well as promising a better life and improved status, advertisers tried to target other aspects of the desire of Blacks to be seen as equal citizens. Among these desires was the urge to be rid of the long-held negative images associated with them. An ad in the May 1964 issue of *Ebony* (Figure 3.15) provides one such example. It features a Black couple in evening dress behind a bottle of Old Hickory, the man holding a glass of whiskey in his right hand and his lady's waist in the other, while whispering to her: "It seems all the nicest people drink Old Hickory." By putting this line into the mouth of a Black man in an intimate private conversation, urban, middle-class Blacks were at once tagged with a hidden self-dissatisfaction and an obvious thirst to be accepted into the prestige group of the "nicest" elite. Here, the advertiser exploited their vulnerability brought about by past suffering from all forms of discrimination—the Black couple could get invited to a social event and could afford to dress like well-off Whites, yet they were not naturally considered (by society and therefore by themselves) as two of the "nicest people" unless, as the ad suggests, they joined the club of Old Hickory consumers.

"SOLVE DARK COLOR PROBLEM"
PROMISES OF IMPROVEMENT

If there were a product category of advertising that can be said to have been specially geared to Blacks and other non-White people in post-World War II consumer society, it would be ads for skin bleach. As reviewed in Chapters 1 and 2, dark skin tones, along with "nappy" hair textures, were consistently highlighted in colonial racial discourses as visual markers of Black inferiority. In slavery advertising, "black skin" by default equaled "slave," and vice versa. In the era of High Imperialism, dark skin tones were utilized to mark many overtly racist stereotypes, including the southern mammy, the Sambo, the piccaninny, the Golden Dust Twins, "the half-devil half-child," and "the dirty boy" who wanted to be White. Given that these were the very racist stereotypes that civil rights organizations challenged the advertising industry to eliminate, and given that the rationale for skin bleach products was rooted in a centuries-old colonial racial ideology and aesthetics, how did advertisers walk the fine line of selling skin bleach products, with their inherently racial overtones, through strategically deployed imageries of the racial Other within the post-World War II context?

The practice of skin bleaching (a.k.a. skin lightening) not only reminds us of the dominant aesthetic distinctions of the light, beautiful race and the dark, ugly race championed by Meiner; it is also closely linked to colonial relationships. Recounting the reports of the phenomenon from sixteenth-century journals, prominent scholar Harry Hoetink noted that "the Indian women of Santo Domingo subjected themselves to painful treatment with vegetable mixtures in order to bleach their skins, so as to be more attractive in the eyes of the conquistadores" (Hoetink, 1971: 182). In his 1973 book *Slavery and Race Relations in the Americas*, Hoetink suggested that the "skin color hierarchy" was one in which skin color became an index of socioeconomic status where, in general, the darker one's skin tone, the lower one's position in the social and economic hierarchy. While the color hierarchy helped to maintain the existing colonial status quo between Whites and non-Whites, it was complicated by the worldwide struggle for equality at the time and the rise of a middle class within the population of the racial Other. In this regard, the existence of a color hierarchy "conspires to encourage the colored elite to emulate white groups, both culturally and in physical appearance," as Hoetink

later asserted (1985: 70). The practice of bleaching one's skin to achieve a lighter tone that was closer to that of White people was one manifestation of what Ronald Hall termed a "bleaching syndrome" (Hall, 1995) in a racist society. In this situation, "the less powerful group must assimilate into the more powerful cultures to increase their quality of life" (Hall, 2008: 40) at the expense of their physical and psychological well being.

U.S. President Barack Obama himself recalls becoming aware of and shocked by the practice of skin bleaching at the age of nine while reading a magazine article about how such a "treatment" went tragically wrong:

> There were thousands of people like him, black men and women back in America who'd undergone the same treatment in response to advertisements that promised happiness as a white person.
>
> I felt my face and neck get hot. My stomach knotted; the type began to blur on the page. (Obama, 1995: 30)

The ads we will discuss here are representative of cases of the particular genre of skin bleach ads referred to in Obama's account. They reflect advertising's involvement in luring Blacks in particular, but also other non-White populations, into consumerism generally. They did so by creating a sense of self-denigration and reaffirming the inferior/superior, undesirable/desirable binaries between Blacks and Whites in a new and seemingly benevolent manner. To attract and win over non-White consumers, they made dark skin a "problem" and turned light skin into the "solution."

Following the advertising tradition of making big promises, the skin bleach ads guaranteed that their product would "improve" dark skin. In all cases, the underlying rationale for these ads was that dark skin tones were undesirable in society and therefore undesirable for Blacks themselves, and that the use of the advertised product could help Blacks to overcome the problems they faced in all aspects of life, be they social, personal, or psychological.

Issues of *Ebony* published from the 1950s to the 1970s show that skin bleach ads were prevalent throughout the 1950s and 1960s, but less frequent in number and less prominent in size in the 1970s. Let us look at the five most representative of these ads to identify the traces of colonial racial ideology and the ways in which the racial concepts of the colonial time evolved to fit postcolonial conditions in the strategic deployment of racial tropes.

One of these ads was for Bleach and Glow cream, featuring top Black model Helen Williams endorsing the brand with the tag line "You'd never

know...My Skin Was Once Dreadfully Drab" (Figure 3.16). The ad did not give any visual clues as to how "dreadful" her skin was, except through the use of the word "drab." What the ad chose to show were the desirable results of her projected transformation. Although photographed mainly in ads targeting the Black population at the time, Williams was called "one of the most beautiful models of all time, Black or White" by Linda Morand, an internationally renowned supermodel and now fashion historian and executive producer of the

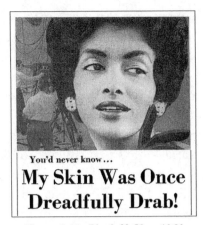

You'd never know...
My Skin Was Once Dreadfully Drab!

Figure 3.16, *Bleach & Glow, 1960*

Supermodels Hall of Fame TV Awards. This ad presented the audience with a lighter-skin-toned Williams—beautiful, confident, and on location. Individually, these signs spoke of personal fulfillment and career achievement. Together, they created a formula that reads:

$$\text{light skin tone} = \text{beautiful} = \text{confidence} = \text{success}$$

This equation reflected the aesthetic standard of the White-dominated modeling industry. According to Morand, Black models' White-like features were highlighted and their success implicitly attributed to them. Speaking from a White supermodel and industry insider's position, she wrote, for example:

> Barbara January, who posed for cigarette ads and other national ads. She was very beautiful; light skinned and had Caucasian features. With skin the luminous shade of milky caramel, Dorothea Towles is generally credited with being the first successful Black mannequin, appearing in various fashion shows. (Morand, 2010)

Significantly, the equation established in this Bleach and Glow ad reinforced Meiners's notion of a skin tone-based racial divide and aesthetic divide—which could also be read as "light = beautiful" and "dark = ugly." Perhaps even more significant is that this centuries-old colonial racial script was being (re)conveyed in the heat of the Civil Rights Movement, to a Black audience, with the endorsement of a Black celebrity—and in a Black-owned magazine that championed Black success and Black beauty. On the surface, Williams was being used to serve as living proof of the wonder of the product, but on

connotative and ideological levels, she was also being used to endorse colonial racial aesthetics, giving a first-person voice, as a successful Black woman, to the assertion that dark skin was problematic and undesirable.

Apart from promising career success, advertisers also promised romantic success. In a 1959 ad for Black and White Bleaching Cream, the "Black" is represented by an image of a Black man in the background playing with a snowman, and the "White" by a White-skinned woman (who could be White or a "lightened" Black) and the snowman (Figure 3.17). The woman is positioned in the foreground above the headline "YOUR LIGHTER, BRIGHTER SKIN will 'melt' him like a snowman." The sales pitch begins with the lines: "For nothing attracts a man more than a lovely, glowing

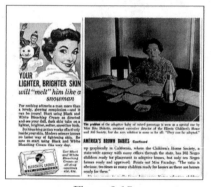

Figure 3.17,
Black & White Bleaching Cream, 1959

complexion—and it can be yours! Start using Black and White Bleaching Cream as directed and see your dull, dark skin take on a lighter, brighter, softer, smoother look." Here, the Black man was muted, while the White-skinned woman's role was not only to lecture Black women about what it took to "melt" a man, but also to assume the authority to speak for Black men about what they were (and should be) attracted to in a woman. The message conveyed in this ad was that if you did not fix your dull dark skin, you would have a

problem attracting men—a notion that was both racist and sexist at the same time. More ironically, this ad was placed on a page next to a story concerning the problems facing children of cross-racial marriage entitled "America's Brown Babies."

A 1964 ad promoting a German invention called Palidia claimed that it "Solves Dark Color Problems as No Other Cosmetics Could Before" (Figure 3.18). With the slogan "Lighten Dark Skin," and making the bold claim that by using the advertised product, "Dark skin—however dark it naturally may be, is bound to brighten," the ad shows two images of the same woman, judging by the storyline and the resemblance between the visual features of the two. The image in the background shows a Black woman with her supposedly natural skin tone—a "before" image in a sense—while the image in the foreground shows a character with a White-like skin tone—an "after" image

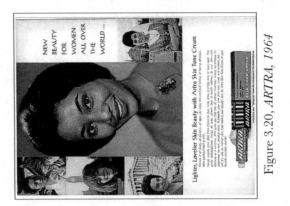

Figure 3.20, *ARTRA, 1964*

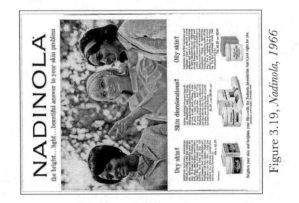

Figure 3.19, *Nadinola, 1966*

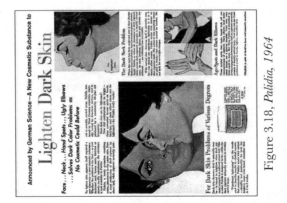

Figure 3.18, *Palidia, 1964*

that served as proof of the claim: "Now dark skin can be lightened!" The ad used a popular visual trick of contrasting the "problematic" dark-skinned look with the "improved" lightened-skin look of the same woman. Interestingly, the "improvement" shown in this ad was so dramatic that the woman in the foreground became somehow racially ambiguous after being "improved." On her own, the woman in the foreground could easily be identified as a White woman. Perhaps such ambiguity was a hidden part of the message the advertiser was communicating: By using the product, you will become a different woman—a White woman—and enjoy a good life. While perhaps trying to be helpful to the Black audience by completely transforming them to look White (unlike the Black boy in the Pears ad, whose skin was whitened only from neck down), the ad also reminded Black people to improve their "neglected zones" so as to leave no trace at all of their Blackness.

As mentioned in the first section of this chapter, Black models were seldom seen in mainstream magazine ads during this historical moment, as the advertising industry was preserving the old tradition of separating Black and White models. However, this common practice of segregation did not prevent White models from appearing in ads targeting Black audiences. In fact, a large majority of the ads in *Ebony* used Black models only; some used White only, but only a very few depicted cross-racial imageries. Figure 3.19 is a 1966 ad for Nadinola that depicted both Black and White models. The ad shows a photo of three women: two Blacks, one on each side of the frame, with a White in the middle. The ad's banner reads: "the bright...light...beautiful answer to your skin problem." What was the bright, light, beautiful "answer," and who were the ones with the skin "problem"? The visual language used here provides the key to these questions: the "answer" is embodied in and provided by the White woman, who points the two Black women troubled by their "skin problem" in the direction of the advertised product—Nadinola. The presence and role of the White woman in this ad provides a trace of the Enlightenment aesthetic, particularly that of Meiners, White, and Camper, discussed in Chapter 2: The advertiser had to use a White woman in this role, as only a White, blond woman could embody the ideal of bright, light, and beautiful under colonial racial ideology.

The concept of White as beautiful was specifically aimed at the Black population, though not exclusively. In an ad promoting the ARTRA brand of skin bleach cream, the advertiser widened its net to capture all women of color (Figure 3.20). With a claim of "NEW BEAUTY FOR WOMEN ALL OVER

THE WORLD," the ad made the familiar promise of "Lighter, Lovelier Skin Beauty"—though this time with a twist. This ad went one step further to imply that all non-White women had the problem of not being White: while they might not technically be Black enough to have the same degree of problem as Blacks, they nevertheless were not White enough to be considered light, lovely, and beautiful—which was a "problem" of its own that needed to be resolved. Again, a universal standard of beauty was assumed through the worldview of the West.

Unlike the above-mentioned examples, the next ad (Figure 3.21) was not published in *Ebony*. Designed for the African market, this 1964 AMBI ad featured three Blacks under the headline "Successful people use AMBI." What made this ad special was its strategy to (re)construct the mythical relationship between skin tone and success to promote skin bleach. Set in a medical clinic, the two lighter-colored Blacks are depicted as health professionals, with the darker-colored Black man depicted as a patient with a problem of some kind. The man with a stethoscope, on the left, and the woman holding a file, on the right, are both dressed in white gowns, and both look knowledgeable and confident. The man in the middle, on the other hand, is not only standing awkwardly, without any trace of clothing on the visible parts of his body, but also looks confused and disturbed. This was neither a "before and after" comparison nor a "Black vs. White" comparison like the examples discussed earlier, but a powerful comparison nonetheless. It was a comparison between

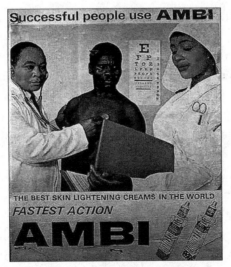

Figure 3.21, *AMBI, 1964*

middle-class Blacks and underprivileged Blacks based on their darker and lighter skin tones. The logic of this claim can be considered in line with the rigid dichotomy between "noble savage" and "barbarian savage," but this time the crux was what they decided to do with their skin tone. In this comparison, the Blacks who made the attempt to be accepted by the powerful White culture by whitening their faces (note that the visible part of their hands and the woman's neck are still as "Black" as the underprivileged Black man) were linked with success, whereas he who did nothing to solve his "problematic" skin tone and Black identity was doomed to be left behind. The rhetoric was obviously designed to persuade Black consumers of the value of the product being promoted. Yet, as outlined earlier in this chapter, the colonialist racial myth of a link between skin color and intelligence had already been debunked. The way in which the trope of racial Other was deployed and constructed in this ad illustrates a cruel reality of racial relationships at this point in history—social pressure was placed on the racial Other to assimilate within the dominant White culture by all means, if they wanted to gain legitimacy or be treated anywhere near equally.

This chapter has outlined the interplay between racial politics and racial representations in advertising during the post-World War II period. The decolonization movement across continents, the Holocaust of World War II, the demise of the scientific grounding of colonial racial ideology, and the Civil Rights Movement in the United States all contributed in one way or another to the worldwide recognition and eventual condemnation of racism. Unlike the previous era, this moment in history was one in which racist acts and attitudes were commonly recognized and officially condemned, and one in which the previously rigid colonial racial ideology was beginning to be questioned and challenged.

As World War II drew to a close, there was an air of excitement and hope for a new world free of fascism and racism. Given that historical events were all pointing toward a new dynamic and a paradigm shift, surely a significant change toward the racial Other was certain to follow. Insightful critics such as

Hannah Arendt and Michael Banton, however, voiced their concerns about such an illusion and warned of a long fight for racial equality ahead, given the durability of racism even at a time of jubilation. Unfortunately, these concerns proved to be legitimate, as this chapter has shown. Although Hitler's eugenics-based Holocaust during World War II gave racism a bad name, the defeat of Nazism did not equal the defeat of racism, nor did the physical withdrawal of European colonial ruling powers from their ex-colonies, the bursting of the scientific myth, or the hard-fought civil rights campaigns, for that matter. So what did this chapter reveal about the survival of the colonial racial script during this turbulent era of racial struggle, specifically in the hands of the advertising industry?

From the chosen vantage point of postwar advertising in the United States, and taking into account the mounting social and economic pressure for racial equality confronting the advertising industry, this chapter has indicated an unsatisfactory outcome, paralleling that of the Civil Rights Movement more generally as assessed by Martin Luther King in 1967. While progress was being made, the goals of increased Black representation in the advertising profession and a greater Black presence in advertisements were far from achieved. The demand for a positive portrayal of Black people in advertisements was met with resistance and was defused through tactical strategies.

The attitude in dealing with the imagery of the racial Other in post-World War II advertising, amid the struggle for racial equality, has been worth highlighting. We begin to see multiple attitudes instead of the uniformity of a homogeneously hostile attitude expressed in earlier ads. On the one hand, the existing paradigm was challenged and, to a degree, renegotiated, given that what was previously accepted and unchallenged in advertising discourse was no longer tolerated by the racial Other and the more liberal-minded people of post-World War II society. Advertisers and advertising agencies began to realize that overtly racist ads could no longer take a legitimate place in the postwar political and economic climate. It was during this era that advertisers learned the importance of avoiding bad publicity as they witnessed some very public lawsuits, marches, and sit-ins across the country and found that businesses could no longer afford to ignore, let alone offend, an increasingly important consumer group. They had to bow to Black spending power and avoid the risk of being on the receiving end of mass ethnic product/patronage boycotts. The retreat of many blunt racist ads in the 1960s provides some evidence of this. On the other hand, reflecting the competing racial ideologies, measures to eliminate

racial stereotyping varied. Some advertisers made an effort to either withdraw or modify existing racially discriminatory advertising imageries, while some found ways to continue to use or even create such imageries. While overtly racist stereotypes began to fade out, they were replaced by covertly racist stereotypes that maintained the colonial racial hierarchy despite some attempts at constraint.

The strategies reflecting the use and usefulness of the racial Other as observed through postwar U.S. advertising were also significant. After World War II, ads deploying Black people and containing derogatory rhetoric persisted. It was not until the 1960s that the industry by and large ceased using imageries of Black people with an overtly racist tone. Up until this historical moment, tropes of the racial Other had been unreservedly at the disposal of advertisers, given that Black imagery was used and abused freely in ads and aligned with negative stereotypes. In other words, what has been suggested here is that from the inception of the industry up to this point, advertisers had been enjoying a free ride in exploiting imageries of the racial Other for capital gain. However, mounting political and economic pressure from the Civil Rights Movement in some measure altered the rules of the game. When the free ride was interrupted or over, and there were demands to end the use of negative depictions of the racial Other, advertisers reacted by withdrawing the imagery of Blacks from mainstream advertisements altogether—the phenomenon of rendering Blacks invisible, as described by Chambers. This can be interpreted as a reactive strategy to deal with the intense pressure on the advertising industry mounted by the country's Civil Rights Movement. Furthermore, the loss of appetite for using Black imageries in postwar advertising and the elimination of Black imagery from advertisements in mainstream media says as much (if not more) about the perceived value and usefulness of the racial Other in advertising as the many ads that exploited them within different contexts.

The loss of appetite for deploying imageries of the racial Other in ads in mainstream media, however, should not be mistaken for a loss of appetite for the ethnic market. On the contrary, the growing consumer power of the Black population was so attractive to advertisers during the postwar era that it was enough to warrant a growing number of advertisers placing ads in popular ethnic media such as *Ebony*. Indeed, some researchers have considered the placement of "non-ethnic specific" product advertisements in ethnic media during the mid-1960s as the unofficial beginning of ethnic marketing (e.g.,

Kovach, 1985; McCarroll, 1993). The consequent need to treat Black people as consumers meant that, for the first time, the racial Other was on the receiving end of marketing and advertising campaigns—a marked shift from the roles they had been assigned for centuries, as outlined in previous chapters. This shift is important to this research because it signaled a turning point in which advertisers had to adapt to a newfound target market and to alter their rhetoric (even if mainly limited to the ads placed in ethnic media) to gain a benefit for their advertising dollars. By capturing this unique moment and focusing on the specific context through the advertising pages of *Ebony*, this chapter has provided a window into some noteworthy emerging themes and rhetoric of the time.

Typically, Black characters featured in ads targeting Black audiences were depicted as the aspiring middle class craving to be treated as equals in society. While this would seem to be a positive move, there was a catch. It was precisely by depicting Blacks in middle-class settings, by manipulating their aspiration for equality into a desire to be White, and by using the logic of neocolonialism and modernization theory, that advertisers found useful themes to communicate to their Black audience through Black-owned media: improvement and legitimacy. These themes were widely used to persuade Black people to consume the advertised product. Skin bleaches and hair straighteners were promoted as solutions to Black problems by physically transforming them into the Western ideal of beauty and civilization, enabling them to be more successful in all aspects of life, from employment to relationships. A range of non-ethnic-specific products, such as alcohol, promised Blacks a way to move into a higher class and be accepted as respectable—simply by consuming the said product. In short, while imageries of Blacks were deployed in a seemingly positive light in advertisements to attract the Black community to consumerism, the underlying rationale of these ads continued to be based on the premise of Black inferiority, despite the adaptation of the rhetoric and discourse to the context, the occasion, and the audience.

Located within the socioeconomic climate of the postwar era in the Western world, and with reference to the use of the trope of Black people in U.S. advertising, the events outlined in this chapter signaled the start of a palpable struggle for racial equality and identity in the field for years to come. The undercurrent of anger and discontent over the discriminatory racial tropes that for centuries had been constructed and circulated through the cultural industry had finally surfaced and manifested after World War II, and the

advertising industry felt the pressure. Through this organized power play, we can begin to appreciate the multiple ideologies, positions, actions, and shifts related to the deployment of the tropes of the racial Other. In Foucauldian fashion, we begin to see strategic and tactical resistance to the colonial racial tropes and the ways in which "each offensive from one side serves as a leverage for a counter-offensive from the other" (Foucault, 1980: 163). It seems fitting to use this quote to conclude Chapter 3 as it also helps introduce Part Two of this book, which investigates a more complex context and wider scope of advertising racial discourse during the moment of contemporary globalization.

PART TWO

DEPLOYMENTS OF THE RACIAL OTHER
WITHIN THE CONTEXT OF
CONTEMPORARY GLOBAL ADVERTISING

Racism is not what it used to be, and ideas of "race," and racisms and anti-racisms, are in constant motion.

– Shire, 2008: 7

The struggle to come into representation was predicated on a critique of the degree of fetishization, objectification and negative figuration which are so much a feature of the representation of the black subject. There was a concern not simply with the absence or marginality of the black experience but with its simplification and its stereotypical character.

– Hall, 1996b: 443

The three chapters in Part One of this book constructed a genealogy of tropes of the "racial Other" and their use in early advertising. In each of the key historical moments examined, the focus was on considering the tropes of the racial Other developed and communicated through proto- and early advertising discourse by the dominant Western commodity image industry for both political and economic gain and to enshrine particular cultural perspectives that hierarchize according to racial taxonomies. In Part Two of this book, we turn to the contemporary moment and examine the ways in which tropes of the racial Other—some new and some related to older exemplars—are deployed in contemporary advertising within the different cultural, social, and economic contexts of "globalization."

It has been widely acknowledged that "globalization" has become a ubiquitous term in contemporary political, academic, and popular discourses. As a complex and pervasive concept, globalization has been an important explanatory signifier in debates ranging from politics to economics, technology, and culture. As mentioned in the introduction to this book, the term globalization is approached here at once as a phenomenon and a process

through which a paradigm or domain of knowledge about race and racial ideology is being developed with elusive rather than predictable motions that make the already problematic concepts more unsettled, unequal, evolving, and multidimensional. Given the multidimensional nature of globalization, this book focuses specifically on its cultural dimension—as the realm of global culture is the meta-context in which the subject matter is located.

Walter Anderson characterized the new global age with the quip that "[r]eality isn't what it used to be," and Homi Bhabha and George Shire both reminded us that the concept of race was also in motion (Anderson, 1990; Bhabha, 1994; Shire, 2008). Imageries of the racial Other, therefore, have become more volatile and unstable within this context. Two critical questions arise here. The first concerns the reality of the condition of a global culture— what are some of its crucial parameters and features? The second concerns the ways in which imageries of the racial Other are deployed in contemporary advertising and branding campaigns within the context of globalization. The first question is addressed in Chapter 4 in the form of an account of the global context within which advertising and branding operate. The second is explored in detail in Chapters 5 and 6 through a close examination of the advertising discourse itself—a range of advertisements and branding materials tells the story of the different strategies employed and the cultural politics operationalized in deploying imageries of the racial Other.

In outlining the context, let us take advantage of the five dimensions, or "scapes," of the global cultural flows identified by Arjun Appadurai (Appadurai, 1996: 33-36) and use these as a basic framework through which to explore the disjunctures of a global culture relating to the subject matter of our quest here. In the first instance, advertising is a visible component of what Appadurai identifies as the "mediascape." But what advertising actually "does" closely links it to the ideoscape. Further, the tropes of the racial Other and their deployments are by and large "located" in the ethnoscape. In addition, the global relationship between ethnoscapes and the finanscapes and technoscapes, as Appadurai puts it, is "subject to its own constraints and incentives…at the same time as each acts as a constraint and a parameter for the movements in the other" (Appadurai, 1996: 35). All these dimensions are interconnected, as demonstrated throughout Part Two.

The contextual background of advertising in the age of globalization also cannot be satisfactorily understood in isolation from institutional shifts within the profession itself. As such, the interrelationship between advertising and the

spread of a global commodity culture, and the industry's strategic adjustment to the shifting geopolitical, cultural, and market environments such as national identity, multiculturalism, anti-discrimination, as well as growing non-White consumer power within and outside of Western countries, are outlined in general and considered in particular cases. An effort has been made to identify the dominant wisdom, attitude, and practice of an industry in a time of renewed challenges posed by the current process of globalization—of which the advertising industry itself is a powerful and visible force.

In examining the ways in which imageries of the racial Other are deployed in contemporary advertising and branding campaigns under the reality of globalization, we continue to employ a Foucauldian genealogical approach, using it to organize data examinations, focus on the recurrence of the racial scripts and tropes in advertising and branding campaigns, and investigate the different roles being selectively deployed under different challenges posted to advertisers by contemporary globalization. Instead of identifying patterns of racial representation in advertising according to industry or product, this book focuses on the strategies of racial representation as they arise and recur in different arenas and to address different challenges. This perspective leads to the need to "free" the advertisements and branding materials from the confines of their industry or product origins. Therefore, our analyses of advertising and branding materials are performed according to thematically divided discourses in which imageries of the racial Other are used to play different roles in different campaigns. The analyses are framed within unique scenes where racial politics and articulations are in play, in order to capture the conditions and practices, and to register the typical needs, motivations, dilemmas, and strategies of deploying imageries of the racial Other in contemporary advertising.

ADVERTISING, RACE, AND GLOBAL DISJUNCTURES

> Global advertising is the key technology for the worldwide dissemination
> of a plethora of creative and culturally well-chosen ideas of consumer
> agency. These images of agency are increasingly distortions of a world
> of merchandising so subtle that the consumer is consistently helped to
> believe that he or she is an actor, where he or she is at best a chooser.
>
> – Appadurai, 1990: 307

THE CONDITION OF GLOBAL CULTURE AND ADVERTISING

Although "globalization" became a buzzword only in the last decades of the twentieth century, its emergence and effect on culture was envisioned far earlier, in the age of High Imperialism. In the mid-nineteenth century, Marx and Engels foresaw the emergence of a global culture and linked it to the global spread of capitalism in their *Communist Manifesto*. Taking into account the constant revolutionizing of bourgeois production and the subsequent need to expand markets, and according to the logic of capitalism and imperialism, they predicted that "national one-side[d]ness and narrow-mindedness become more and more impossible, and from the numerous national and local literatures there arises a world literature" (Marx & Engels, 1976: 488). For them, the process of economic and cultural globalization leading to a genuine internationalism or universalism was

anticipated to be a force challenging nations and nationalism of nineteenth-century Europe.

Contemporary discourses link the emergence of globalization with a late-century shift in capitalism from Fordism to post-Fordism, regimes of flexible production and accumulation, and finance capitalism (see, e.g., Jameson, 1998; Appadurai, 1990, 1996; Harvey, 1990; Waters, 2001). Concerned about the spread of capitalism to every corner of the globe, some scholars claimed the existence of a global system of mass production and mass consumption (e.g., Cvetkovich & Kellner, 1997). Such a global system is described as one that "disseminates throughout the planet fantasies of happiness through consumption and the products that allow entry into the phantasmagoria of consumer capitalism" (Cvetkovich & Kellner, 1997: 6). By and large, a global culture has been interpreted by scholars as a late-world capitalist culture, or a global commodity culture.

The spread of this global commodity culture was—and continues to be—motivated by both economic and political concerns. In line with the historical pattern of inequality in world affairs, globalization can be considered as the simultaneous continuation and transformation of Western imperialist relations in the period after decolonization and postcolonial nationalism. Accordingly, past and present critics of globalization often ask questions also posed by postcolonial scholars, such as the nature and survival of social and cultural identities. In this regard, the insights into the cultural dimensions of imperialism and colonialism provided by postcolonial studies, particularly the insistence that culture must be seen as essential to the creation, production, and maintenance of colonial relations, remain valid in the context of the spread of a global culture. Or, as other neo-Marxist globalization scholars have put it, the global present is marked by "the becoming cultural of the economic, and the becoming economic of the cultural" (Jameson & Miyoshi, 1998: 60).

Much of the academic interest in cultural globalization has focused on the impact of the global spread of an American-style capitalist culture and on the overt threat posed to the very existence of many other local cultures and traditions. Many of the studies of global culture compare the global diffusion of American cultural products and values to cultural imperialism. A range of contemporary metaphors of globalization has been developed in critiques of the market domination and cultural perpetuation of Americentric products and tastes, as well as the emerging phenomenon of a "monoculture." Daryl Copeland, for example, finds that "globalization" and "Americanization" have

become largely indistinguishable (Copeland, 1997). Other than Americanization, value-laden terms such as "Coca-Colonization," "McDonaldization," and "MacDisneyization" have also gained currency in debates arguing that the domination of U.S. material and media products will eventually lead to a homogeneous world culture, erasing existing differences between local cultures and resulting in a standardized or Americanized culture of commodity consumption (see Wagnleitner, 1994, and Howes, 1996, on Coca-Colonisation; Ritzer, 1996, on McDonaldization; and Ritzer & Liska, 1997, on MacDisneyization). At the heart of the problem of cultural imperialism is the sweeping and strategic use of political and economic powers to exalt and spread the values and habits of a Western culture at the expense of a native local culture, as John Tomlinson points out (Tomlinson, 1999).

The critique of cultural imperialism and Americanization has not itself gone unchallenged. It has been argued that U.S. culture and ideology have not managed to turn a docile Europe into an Americanized global village (Kroes, 1999) and that the Americanization of Europe is a myth (Pells, 1997). In, for example, *Cultural Transmissions and Receptions: American Mass Culture in Europe* (Kroes et al., 1993), the authors argue for the term "cultural imperialism" to be replaced with "cultural transmissions," with an emphasis on interaction rather than domination. Crucially, however, the power and desire to dominate or exploit local cultures and markets can be exercised just as much through interaction as through naked subjugation. Therefore, the context-specific cultural politics and motivations underlying these interactions are the crux of the issue.

At the same time, it should be mentioned here that globalization is not a level playing field, and this is particularly so in those interactions where the political and economic powers of the parties involved are clearly unequal. This kind of imbalance between dominant multinationals and "Third World" markets is visually manifested in a 2007 ad from Nike designed by Gray Group Vietnam (Figure 4.1). Entitled "Nike Now in Vietnam," this ad, in replacing the Yellow Star with a Nike Swoosh and embroidering the Nike tag line within the country's red national flag, not only claimed Vietnam as its commercial territory; it also symbolically and effectively removed local historic and social identity and imposed its own—in a classic "Just do it" manner.

While advertisements deliver persuasive sales pitches for advertisers to promote their products and policies, they also, among other things, assert and express the underlying worldviews of those who are behind them. It is

Figure 4.1, *Nike, 2007*

important to understand that visual rhetoric of advertisements—this one as well as others—is conditioned by the advertiser's judgment about, attitude toward, and strategy regarding various global and local challenges that these ads were designed to manage. Therefore, a contextual awareness of the most influential theories, practices, and strategies of contemporary global advertising is needed at this point to help analyze the advertising and branding materials in later chapters. Bearing in mind the play of cultural politics manifest in the Nike ad, let us now turn to two of the most prevalent wisdoms that underpin the advertising industry's strategic response to the challenging cultural and racial politics brought about by the current acceleration of globalization.

STANDARDIZED ADVERTISING VS. GLOCALIZATION

There is no shortage of examples of multinationals manipulating local taste and values in the field of advertising. However, we begin here with the notion of "standardized" international campaigns—a pervasive advertising industry strategy predicated on ignoring the taste and values of local populations.

An influential champion of this approach to a globalized market is Theodore Levitt. For Levitt, following the direction of the world economies, consumption communities are to be viewed as global in nature, with local communities having little relevance in the larger framework of a global

economy. Declaring that "The world's needs and desires have been irrevocably homogenized" (Levitt, 1983: 93), he argues that "Different cultural preferences, national tastes and standards, and business institutions are vestiges of the past" (Levitt, 1983: 96). Based on this assumption and the logic of capitalism comes the suggestion that advertising agencies need to align with their clients' moves to become globalized, and to sell products to the global consumer market through a kind of "one sight—one sound" message, for the sake of "economies of scale."

Leading U.S. corporations and other multinational brands have shared and practiced Levitt's vision as an answer to the new challenges posed by their ever-expanding markets across the globe and across cultures. For example, in a program preparing the executives of a Fortune 200-sized firm for the challenges posed by global competition, James Bolt offered the corporate leaders ten "criteria for success." Notably, the ability to "operate as though the world is a large market, not a series of individual countries" was the fifth of his criteria, quoting Levitt and drawing on the success of McDonald's and Coca-Cola (Bolt, 1995: 333–343).

The influence of Levitt's strategy on the big end of town is significant to the operation of the advertising industry, which has also been trying to find a way to deal with its multinational blue-chip clients' need to advertise beyond their existing cultural comfort zones. The idea of treating the world as a single large market is one contributing factor to a series of Western-centric practices. The overwhelming dominance of the "global advertising industry" by agencies with headquarters in the United States and Europe is one aspect of this practice. According to the industry source AdBrands, by 2010, "[s]itting at the very top of the [advertising] industry pyramid are a small number of holding companies. There are now just four major international groups, Omnicom, WPP, Interpublic and Publicis Groupe, each of whom controls a huge number of different agency brands spread all over the globe." Among these four giants, two have headquarters in New York, one in London, and one in Paris. A study of the globalization of the advertising industry conducted in 2008 has also confirmed "the pre-eminence of New York as clearly the global advertising center" (Faulconbridge, Taylor, Beaverstock, & Nativel, 2008: 17). Even when taking into account factors such as market fragmentation and the need to set up local branches or joint ventures and hire some local staff in major market centers in other parts of the world, the U.S. headquarters (especially New York)

are firmly in control of strategy, direction, and decision making, and operate as the "lead office" for their global networks (Faulconbridge et al., 2008: 5).

Beyond the dollar value of revenue and billings to the "global advertising industry" that reaffirms the market dominance of the West, the recognition of creative achievements has similarly been dominated by the West over "the Rest." Every year, the most creative works of the circulated advertisements in all media around the world are judged by way of major annual international and regional awards. Scores are tallied, countries and agency networks are pooled and ranked according to their creative success, and industry reports are released (such as those of the above-the-line-advertising-focused *Gunn* and the below-the-line-advertising-focused *Big Won*). Even a cursory glance at the rankings across the years in these reports produces a sense of déjà vu—the top three agency networks are often either BBDO Worldwide, DDB Worldwide, or Ogilvy Worldwide. The United States, the United Kingdom, and Germany are consistently the most awarded countries, albeit with an occasional change of order between years and reports. While these rankings have symbolic and practical meanings for the profiles of agencies and clients alike, they also offer a window onto some aspects of the culture in the creative economy of our time. Although computed through a medal tally and being quantitative data in their own right, these rankings can also be considered as signs of the global culture. For example, they stand, at least in part, for what is accepted as "creativity," for what origins of ideas, concepts, and aesthetic are appreciated, for who are the named "winners" of the game of global advertising, and for who is judging and according to whose understanding of "value."

In contrast to a standardized approach, the advertising industry's other key strategic response to changed global conditions has been through the rhetoric of "glocalization." Originally developed as "global localization" and circulated in Japanese business circles in the 1980s when they were trying to penetrate markets in the United States and return to the market in Asia, glocalization refers to the process by which global corporations tailor products and marketing strategies to particular local circumstances to meet variations in consumer demand. Robertson suggested that just as the global modifies the local, the local practices also have a determinate impact on the global (Robertson, 1995). Correlate theoretical accounts can also be found in the works of postcolonial studies, which argue that the relationship between the colonizer and the colonized is a dialectical one in which the colonizer shapes the culture and identity of the colonized, on one hand, while being shaped by the encounter

with the colonized on the other (see, e.g., Said, 1978, 1993; Bhabha, 2002; Viswanathan, 1995). In a similar approach, the term glocalization has been used by Robertson to describe the reality of contemporary cultural globalization.

The original application of the glocalization strategy helped Japanese global brands to wash away the "odor" (Iwabuchi, 2002) associated with Japan's past colonialism, nationalism, and wartime brutality. A quite literal exemplar was the 2003 retreat of the existing Panasonic brand identity "National" from all markets *outside Japan*. Since the 1980s, different rebranding activities have been conducted by a number of multinationals whose established brand identities carried degrees of racist overtones. (Some of these cases will be examined in Chapter 6.)

The glocalization strategy and theoretical perspective has been criticized as neglecting the homogenizing aspects of Westernization/Americanization in the politics of globalization. George Ritzer, for example, offered a theory of "grobalization" to spell out the globalization phenomena that could not be fully explained by glocalization theory. Glocalization, according to Ritzer, was "the interpenetration of the global and local resulting in unique outcomes in different geographic areas" (Ritzer, 2004: 73). The theory of grobalization, at the other end of the globalization continuum, referred to the "imperialistic ambitions of nations, corporations, organizations, and the like and their desire, indeed need, to impose themselves on various geographic areas" (Ritzer, 2004). Ritzer argued that capitalism, McDonaldization, and Americanization were the three major forces behind globalization in general and imperialistic impositions in particular, in which these entities were forced to "explore and exploit possibilities for profit in more remote and less developed regions" (Ritzer, 2004: 80). As such, a companion to the notion of glocalization was needed:

> [T]hese imperialistic impositions occur whether or not there is opposition to them at the individual or local level. That is, those entities involved in such impositions take the necessary actions anywhere and everywhere they go. Again, at least theoretically, those actions do not depend on how they are received in various places throughout the world. (Ritzer & Ryan, 2007: 52)

The dialectical relationship, when in play, ultimately depends on the balance between cultural and economic forces. In the game of advertising, every informed player knows that the world is not flat. But for those who think they *can* make it flat, and treat it as such with standardizing ads, their industry

dominance is enough to reward them with the reduced financial burden of creating and producing multiple versions of localized advertisements, and with the reduced cultural burden of adapting to the ways of life of the local audience. However, multinationals with such an attitude do, from time to time, run into situations in which some of the standardized elements in their campaigns clash with the local culture. When dealing with cross-cultural communication challenges, brands' attitudes differ, and so do their strategies. To illustrate the multifaceted reactions and the different (and at times completely opposite) strategies, this book offers a rare example involving two different multinational brand entities facing the exact same problem in Spanish-speaking markets.

In the 1980s, both British General Motors in the United Kingdom and the Chevrolet division of General Motors in the United States used the word "nova" to name their car models, Vauxhall Nova and Chevrolet Nova respectively. Although the word in itself denotes "star" in English, and can somehow be connoted as "new" in Latin, Nova's pronunciation in Spanish was problematic. In local language, "no va" means "it doesn't go." Given that the model was manufactured in Spain and marketed to several Spanish-speaking countries, the Vauxhall Nova was sensitively launched as the Corsa in these markets and labeled Vauxhall Nova only in the U.K. market. The Chevrolet Nova, on the other hand, remained the Nova until its production ceased in 1988. It was not simply a case of innocent ignorance, because "Although GM's Mexican managers were worried about the name, Nova was indeed used," according to a report (*Business Mexico*, June 1993). In defense of the controversial decision, a local marketing analyst reportedly argued that such cross-cultural communication problems for a brand name in an international marketplace could be counterbalanced by a strong ad campaign. To back up his argument, the case of Coca-Cola was again used: "One thing that never ceases to surprise me is how Coca-Cola has never had a problem (in Latin America). 'Coca' has drug connotations and 'Cola' means 'tail'—yet no-one thinks the worse of it" (*Business Mexico*, June 1993).

This is a familiar line of defense for a common practice among multinational brands of standardizing rather than tailoring advertising campaigns and of ignoring local cultures instead of adapting to them when venturing into foreign markets. This practice is based on a long-held, almost religious-like belief in so-called "brand power" built with the help of the "magic" of advertising. Much has been said about advertising as a magical

system in the influential work of Raymond Williams mentioned earlier in this book, and advertising agencies have boasted of its unique selling point—a point preserved for "the propaganda to their clients" and rarely divulged to the public, as Williams has sharply pointed out (Williams, 1980).

The same can be said in the contemporary age of globalization, judging by the commonly drawn example of Coca-Cola and the example of Chevrolet Nova used here. Using the device of advertising and its power to name and to assign meaning and value, multinationals seem able to turn a blind eye to detrimental cross-cultural communication blunders if they so choose. With big advertising budgets and clever campaigns, locals in Spanish markets could be persuaded to think of Coca-Cola as an "it" drink (backed by the "Coke is it!" and the "America's real drink" campaigns of the 1980s) instead of a "drug tail." They could also be persuaded to value the Chevrolet Nova as a dream car that embodied the Americanness desired by people all over the world (as Chevrolet's "Feel the heartbeat of America" campaign of the 1980s suggested) instead of a self-proclaimed automobile that "doesn't go."

As this line of logic goes, whether or not a brand needs to respect local reactions and adapt to local cultures comes down to the question of whether or not the brand is powerful (or deep-pocketed) enough to sway locals through an expensive and "strong" advertising campaign in that market. Here we can see where the balance of power rests, lending weight to the warnings of scholars regarding the onset of a global capitalist monoculture.

THE CHANGES AND THE (UN)CHANGED

As a number of analysts have pointed out, im/migration is one of the most important elements of contemporary globalization, and "[m]assive global population movements are transforming many nations" (Anderson, 1990: 241). While William McNeill attributed the perpetuation of an ethnically homogeneous nation as a "barbarian ideal" that was "incompatible with the normal population dynamics of civilization" in the modern era (McNeill, 1984: 17), the ideologies of ethnic-nationalism and racism remain tenacious in reality, as we will see in various parts of this chapter.

Immigration, as one of the important elements of contemporary globalization and as the mechanism for global population movement, has contributed greatly to the changing racial politics of many Western nations. The sharp increase in non-White people migrating from Africa, the Middle East, and Asia to predominantly White Western nations during the new waves of immigration from the end of World War II to the late twentieth century and beyond, has not only challenged the ideology of ethnic-nationalism, but also begun to question the "minority" label that has been consistently assigned to the racial Other within these nations. For instance, in the U.K., one of the most racially diverse nations in Europe, a 2000 study by *Interfocus* predicted that by 2011 Blacks and South Asians would outnumber the White population in half of all London boroughs, as well as the cities of Birmingham and Leicester. Another typical example is the United States. By 2007, the U.S. Census found that minorities constituted a majority in four states: Hawaii (75%), New Mexico (57%), California (57%), and Texas (52%) (*New York Times*, 17 May 2007). The following year's figures prompted one of the country's leading demographers to predict that immigrants would "gradually change the fabric of minority-majority interactions nationwide" (*New York Times*, 8 December 2008).

This broader change has been celebrated by some as a triumph of multiculturalism, and feared by others as a threat to the existing status quo of nationhood and a dilution/degeneration of the dominant White racial identity. In any case, governments have had to re-evaluate existing policies, while marketers and advertisers have needed to re-map consumer demography and target audiences. For the purposes of this book, this widespread demographic change signals an emerging dynamic that has destabilized the previously stable power relationship, which in turn represents an important consideration affecting the strategy and rhetoric in the deployment of the racial Other in advertising and branding campaigns.

Wally Snyder, a leading figure in the advertising industry, has remarked on this shift and the necessity of the industry itself becoming more racially diverse. He states:

> Advertising that effectively addresses the realities of America's multicultural population must be created by qualified professionals who understand the nuances of the disparate cultures. Otherwise, agencies and marketers risk losing or worse, alienating millions of consumers eager to buy their products or services. Building a business that "looks

like" the nation's increasingly multicultural population is no longer simply a moral choice; it is a business imperative. (Snyder, 1993: 28)

Such a notion remains a point of advocacy rather than an experienced change. According to Blan Holman, "The boardrooms and executive suites of general-market advertising agencies nationwide resemble percale sheets washed by the latest detergent—whiter than white" (Holman, 1993: 10). In Kern-Foxworth's words: "The only thing that I have seen lately that is whiter than the advertising industry is snow" (Kern-Foxworth, 1994: 118).

Entering the twenty-first century, the Whiteness of the U.S. advertising workforce remained largely unchanged, prompting the launch in 2009 of the Madison Avenue Project. The project claimed that Madison Avenue not only has a diversity problem but is also guilty of "pervasive racial discrimination." A *Bendick Egan Advertising Industry Report* issued in 2009 found that for advertising agencies with 100 or more employees, African American representation was 13.3% among "sub-professional" employees, falling to 5.9% for professional positions, and to only 4.3% for managerial positions. At the other end of the scale, over the same three levels, the representation of Whites increased from 68.2% to 79.3% and then to 88% (Bendick & Egan, 2009: 27). For leading agencies with at least 50 professional and managerial positions, 15.9% had "zero Black professionals and managers" (Bendick & Egan, 2009: 29). The report concludes: "That failure [to hire, assign, advance, and retain the readily available Black talents], in turn, reflects an industry culture in which deeply-embedded racial bias, both conscious and unconscious, creates systemic barriers to inclusion for African American employees" (Bendick & Egan, 2009: 2).

The phenomenon of a lack of change in a changing time is worth considering as it indicates not only the measurable reaction of the advertising industry to the changing ethnoscape and the challenges of communicating to a multicultural audience in the age of globalization, but also who is behind planning, conceptualizing, directing, and executing the advertisements that circulate in the contemporary mediascape.

ENTERING A POST-RACIAL WORLD?

Putting aside structural inequalities within the advertising industry itself for the moment, questions have been asked as to whether the West has entered a post-race era wherein racial identity is no longer relevant. Among the many

factors complicating the question of racial identity is the pervasive ideology of color-blindness. Emerging in the 1980s, proponents of color-blindness effectively claim that we live in a post-race world in which racism and racial discrimination are no longer a problem, and that any current disadvantages or gaps between Black and White Americans are no longer the result of racial discrimination but of other factors such as the cultural and behavioral deficits of the disadvantaged (Brown, Carnoy, Currie, Duster, Oppenheimer, Shultz, Wellman, 2003: 225). Such claims have stimulated debates in the United States and Europe alike. The ideology has been criticized as "new racism" (Barker, 1981) "cultural racism" (Taguieff, 1990), "neo-racism" (Balibar & Wallerstein, 1991), "Color-Blind Racism" (Carr, 1997), and "racism without racists" (Bonilla-Silva, 2001). Suggesting that "color-blind ideology performs for whites in defending white advantage in the present context" (Ansell, 2006: 333), Amy Ansell explained that such ideology has "allowed whites to claim the moral high ground of "being beyond race" while refusing to sacrifice white privilege in the face of challenge" (Ansell, 2006: 352). As Toni Morrison rightly put it: "The world does not become raceless or will not become unracialized by assertion" (Morrison, 1992: 46).

It is relevant here to look at data showing the ways in which non-White citizens are perceived by the dominant group within two of the Western nations where the color-blind ideology has commanded a place in cultural discourses. In the United States, despite the data presented by proponents of the color-blind ideology showing minimal racist stereotypes, Michael Brown and colleagues' research data indicate otherwise:

> When the University of Chicago's National Opinion Research Center asked people to compare blacks and other ethnic groups on a number of personal traits in 1990, they discovered that 62 percent of nonblack respondents believed that blacks were lazier than other groups, 56 percent stated that they were more prone to violence, and 53 percent thought they were less intelligent. (Brown et al., 2003: 40)

In France, according to Michele Lamont, surveys at the turn of the twentieth century have consistently shown relatively high levels of racism and xenophobia:

> [A] 1999 Harris poll conducted for the Commission nationale consultative des droits de l'homme revealed that 68 percent of the respondents in a national sample declared themselves somewhat racist;

61 percent believed that there are too many foreigners in France; 63 percent believed that there are too many Arabs (up 12 percent compared with 1998); and 38 percent believed that there are too many blacks (up 8 percent compared with 1998). (Lamont, 2001: 1)

These findings suggest that color-blindness is a myth.

It has also been suggested that the identity of the racial Other has become less clear-cut in Western countries within the context of contemporary globalization. Charles Hirschman, for example, suggested that "the presence of immigrants is a hedge against the parochial view of us versus them." Some of his examples point to the effects of interracial marriages on attitudinal behavior against the racial Other in the West: "The children of intermarried couples are likely to be an important bridge to a more tolerant society"; and "It is more difficult to hold onto ethnic stereotypes when the "other" is a nephew, niece, cousin, or grandchild" (Hirschman, 2005). In addition, a range of anti-discrimination laws have also set boundaries for racial discourses. Compared with the 1920s, when speeches "by Ku Klux Klan members (against [non-White] immigrants) were virtually indistinguishable in substance and language, if not in style, from the writings of many university professors," according to Thomas Muller (1993: 41), the overtly racist language, the offensive KKK-style racial stereotypes can no longer have a legitimate place in today's intellectual or media discourse—though that is not to say they do not exist. While racial stereotyping has been deemed socially unacceptable, there is no lack of examples across the Western world of social elites getting caught uttering racial slurs in public by the media and later apologizing for their "slip of the tongue." The growing population of non-White immigrants, the children of intermarried couples, the rise of the non-White elite, the anti-discrimination legislation, and the assertions of a color-blind society would seem to carry some hope for solving the problem of negative racial identity in the West. But do they?

The personal experience of the author as a practitioner of the industry provides anecdotal evidence of racially shaped views within the profession itself. While a non-White female migrant from the ex-British colony of Hong Kong has been accepted in a range of leadership roles and even given the honor of serving as a juror in a number of international poster biennials and logo competitions may seem like supportive evidence to back the color-blind claim, it is not that simple. Comments such as "your design/style doesn't look Asian" (considered "praise" by peers) and rhetorical questions such as "how can an Asian girl/lady come up with such a bold [also "brave" or "cool"] idea?"

(expressed with "pleasant surprise" by superiors and clients) underscore an "enlightened" version of racial (and gender) stereotyping that regrettably remains in the sub-consciousness of even the most liberal-minded professionals who have the best of intentions. This paradox points to the complexity of the concept of race and discriminatory racial ideology in contemporary times. As Shire puts it: "Liberalism is technically anti-discriminatory, but it is plugged into the whiteness of the privilege of power" (Shire, 2008: 12).

The question of color-blindness, in a U.S. context, became part of public debate through the election of the current President, Barack Obama. Not only did the media dub the then-Senator Obama an "exceptional African American" and his family an "ideal family," his vice-presidential running mate, Senator Joe Biden, publicly branded him "the first mainstream African-American who is articulate and bright and clean and a nice-looking guy" on his first day of official campaigning (quoted in Swarns, 2007). In 2010, Senate Majority Leader Harry Reid had to apologize for his "poor choice of words" following reports that during the presidential campaign he had privately described Obama as a Black candidate the country was ready to embrace—with a "light-skinned" appearance and "with no Negro dialect, unless he wanted to have one" (quoted in Heilemann & Halperin, 2010: 37). From the Obama phenomenon, Tim Wise has identified a new form of racism—he terms it "racism 2.0" or "enlightened exceptionalism"—one that "allows for and even celebrates the achievements of individual persons of color, but only because those individuals generally are seen as different from a less appealing, even pathological Black or brown rule" (Wise, 2009: 9). He warns that "not only does the success of Barack Obama not signify the death of white racism as a personal or institutional phenomenon, if anything, it may well signal the emergence of an altogether new kind of racism" (Wise, 2009: 8–9). Furthermore, "the new, 'color-blind' racial system," Winant warns, "may prove more effective in containing the challenges posed over the past few decades by movements for racial justice than any intransigent, overtly racist "back-lash" could possibly have been" (Winant, 2004: xiv).

"NEW" MARKETS, NEW DEMANDS?

After contextualizing relevant developments in the ethnoscape and ideoscape, and before embarking on the bulk of the case studies of contemporary advertisements, it is appropriate to close the last section of this chapter with

the mediascape—a site in which advertising operates—to appreciate the complex condition that drives the desire and need of advertisers for the tropes of the racial Other. Here, the significance of the interrelationship between the recognition of the rising purchasing power possessed by the racial Other within predominantly White Western nations and worldwide and the forces and politics involved in the deployment of the racial Other in advertising and branding campaigns are outlined.

The greater currency gained by the trope of the racial Other in the last two decades of the twentieth century is not a phenomenon that is innocent or coincidental, nor a "natural" outcome of the changing minority-majority balance. It has much to do with the capitalist economy and the politics of multiculturalism in the context of globalization.

A 2000 study conducted by the Minority Business Development Agency (MBDA) of the U.S. Department of Commerce found that ethnic minorities in the country had expanded their purchasing power by 47% over the previous 15 years. In the 8 years between 1990 and 1998, the dollar value of ethnic purchasing jumped from $0.7 trillion to $1 trillion, and by the year 2000 ethnic purchasing power had reached $1.3 trillion (MBDA, 2000b). In releasing the report, Secretary of Commerce Norman Mineta reminded all levels of business of the significance of this set of figures: "America's population will increase fifty percent over the next fifty years, with almost ninety percent of that increase in the minority community. Both Fortune 1000 and minority businesses need to pay attention to the consumer purchasing power that will result from that growth" (MBDA, 2000b). The advice in the press release went one step further, concluding: "Companies that plan to stay competitive in the future will have to design and market their products to these new multi-cultural buyers. This will probably have to include multi-language packaging, target marketing and products geared to specific cultural needs" (MBDA, 2000a).

As discussed in previous chapters, Western capitalism had an eye on the local ethnic and international markets and tried to recruit their racial Other into their consumer base far in advance of the contemporary acceleration of the globalization process. But the emergence in the 1980s of ethnic spending power inspired the business world to move more swiftly—long before the release of this MBDA data and before the advice of government officials. In his highly influential work on business in today's global economy, Peter Drucker identifies the shift in population and the shift in the share of disposable income as the most reliable foundations of any business strategies. Among the two, the

share of "the disposable income of their customers" is "the truly important figure" for management, according to Drucker, who argues that consumer expenditure will determine the survivability of a business (Drucker, 1999: 43–44). As an economic imperative, the fast-growing ethnic population represents a newfound market segment for those who can penetrate it; and the rising ethnic purchasing power promises enormous potential for larger sales volume and greater profit margins for those who can manage to attract customers with high disposable incomes. Succeeding or failing in penetrating the non-White market domestically and globally can make or break a business in a highly competitive, cutthroat marketplace.

Pursuant to the disposable income factor, it is no coincidence that the unofficial beginning of ethnic marketing in the 1960s has expanded exponentially since the 1980s to involve more corporate players on a bigger playing field. No longer confined to Black media, as in the postwar United States as outlined in Chapter 3, advertisers have extended their boundaries from mainstream media networks to include more targeted racial groups through a wider scope of ethnic media. Leading advertising agency networks have actively sought to expand their client base to include ethnic-owned brands and made attempts to acquire established ethnic-owned agencies. By 2007, a study of the U.S. advertising industry found that agencies traditionally under Black ownership no longer exclusively commanded the market for advertising targeting Black consumers: "Under historic separations along racial lines, the market for these agencies was confined to an "economic detour" from the general market for advertising services" (Bendick & Egan, 2009: 12). Nor did these agencies necessarily remain under Black ownership, as acquisitions or joint ventures saw several of the largest traditionally Black-owned agencies (such as UniWorld and Burrell) become subsidiaries of leading agency networks (Bendick & Egan, 2009: 12).

The growing desire to grab a piece of the domestic ethnic market pie saw corporations such as Coca-Cola, AT&T, and Sears take drastic steps to run marketing campaigns targeting not only Blacks but also Latinos and Asians, using up to ten different language media. The financial return from the strategic cultivation of the non-White consumer segment is measurable. For example, in 1991 Estée Lauder marketed its "All Skins" line under Prescriptives offering 100 shades to match the skin tones not only of its traditional White consumer base, but also of the non-White population—its motto: "Designed for all skins, all women." By targeting "all women" and thus tapping into the

ethnic market historically ignored by nearly all other cosmetics companies, this strategic move resulted in an immediate and measurable financial reward. In its first year, All Skins attracted 50,000 African-American buyers in the U.S. market alone (Weems, 2000: 175).

The domestic market aside, the lucrative overseas market—the "underdeveloped world"—again became a battleground for the major powers, this time not between colonist nations but between multinationals for their global share and dominance. Coca-Cola was selling its products in more than 200 countries across the globe but was still trying to narrow the gap between it and Pepsi-Cola in the Middle East. In the battle for dominance, Coca-Cola spared no expense to acquire the local bestsellers. In 1999, it spent U.S. $300 million on a long and hard-fought battle to acquire Peru's Inca Kola. More recently, in 2008, it offered more than U.S. $2.4 billion in a failed attempt to acquire China's best-selling soft drink, Huiyuan Fruit Juice. Indeed, foreign expansion was already high on Coca-Cola's agenda as early as the 1970s. A 1971 advertising campaign, "I'd Like to Buy the World a Coke," illustrated its ambition. To make the point, young people from around the world were chosen to lip-sync the jingle on a hilltop near Rome, Italy. The song married the pop song "I'd Like to Teach the World to Sing" with Coke's sales pitch, ending with the "it's the real thing" slogan. While a White girl was the lead "syncer," the ad deployed the tropes of the racial Other throughout the clip by using different skin tones, facial features, and costumes to harmonize with the White girl and convey a sense of Coca-Cola's world presence (if not dominance) and goodwill.

It is interesting to observe what happened to Coca-Cola's profile in the years following this commercial. At the time this ad was aired, Coca-Cola remained unable to open the doors of its Cold-War rival Russia, or to enter one of the biggest markets, China. It had also been kept out of nations such as Egypt for more than 10 years. Entering the 1980s, apart from dominating the world's soft drink market (including these hard-to-enter markets), the Coca-Cola brand dominated. "The power and prestige of Coca-Cola" were exemplified in 1988: the company proudly quoted three independent worldwide surveys, conducted by Landor & Associates, confirming the brand's status as the world's best-known, most-admired trademark in its corporate website.

In light of these developments, it is worth highlighting the shifting emphasis in the featured character—"the face" of the brand—over time. Anyone watching the 1971 "I'd Like to Buy the World a Coke" ad would have little

Figure 4.2, *Coca-Cola*, 2010

doubt as to who was the ad's "featured character"—the White girl's image dominated for nearly 15 seconds. However, the image of an Asian girl who only appeared for 3 seconds in the middle of the same ad—in a group scene—is now being used as the sole image and icon of the chapter on the Coca-Cola official corporate website titled "The Chronicle of Coca-Cola" (Figure 4.2). The very fact that a "background" image of the 1970s has been brought to the fore and elevated to become a featured image nearly four decades later is indicative of a complicated re-negotiation and displacement of the meanings and sign value of the racial Other for multinational corporations. Imageries of the racial Other are, as is evident in this case and the data in the following chapters, becoming more useful for brands in the age of globalization. The question lies in the manner in which tropes are used and what makes them useful in contemporary advertising and branding campaigns.

In addition to the economic imperative, political climates and regulations are also factors in the increasing deployment of imageries of the racial Other in contemporary advertising and branding campaigns. To begin with, a range of governmental and institutional initiatives depend on the imageries of the racial Other in branding and making advertising statements. Clearly, governments tend to use imageries of the racial Other to send messages promoting multiculturalism and equality, and rejecting racism. Although it is not so apparent to the public, governments also instruct the use of non-White models in advertising campaigns outside these areas through general guidelines, as well as selected campaign briefings. Recently in Australia, for example, the casting of the federal government's 2013 "Better Schools for all Australians" advertising campaign was reported to have been specifically instructed to seek out ethnic models (including an indigenous athlete and female students who are of Indian/Asian/European or Middle Eastern background) to appear in the ad with other non-race-specific characters as endorsers of the initiative (Lewis, 2013). Ironically, however, while both major political parties in Australia encouraged the use of ethnic imageries in advertising campaigns for over two decades during their respective terms, they hardly put it into practice for their

very own election campaigns. It was noted by Sally Young that "In over 1000 newspaper ads published between 1949 to 2001, *not one* showed a Southern European, Middle-Eastern or Asian Australian and *not one* showed an Aboriginal person or a Torres Strait Islander" (Young, 2003: 213; emphasis in original), and this pattern still persists. Obviously, there has been (and still is) a game of inclusion and exclusion at play when it comes to depicting imageries of the racial Other in political campaign ads by politicians themselves. The fate of being ruling-in or ruling-out from the ad for non-White models is closely tied to the political judgment as to whether racial Otherness is considered to strengthen or weaken the campaign objective.

Transnational or supranational institutions also utilize the trope of the racial Other to project their global outlook and vision. For example, the United Nations General Assembly proclaimed the period 1988–1997 as the World Decade for Cultural Development. The logo for this initiative was formed using five abstract faces, each of a different color (Figure 4.3). Hans Erni, the Swiss artist who designed the logo, explained that the five faces represented the five continents of the Earth, and were used to symbolize the manifold creativity of social and cultural life. This imagined togetherness was also expressed in the 1991 *People to People — Paper Unites* calendar designed by German designer Helmut Langer, with involvement from the United Nations Educational Scientific and Cultural Organization (UNESCO), the International Council of Graphic Design Associations (ICOGRADA), and Germany's Zanders Fine Paper Company. The symbol on the cover of this calendar (which also became an official U.N. stamp) was illustrated by Marina Langer-Rosa (Figure 4.4) and constructed as a motif of 12 faces in diverse costumes, each representing a distinct ethnic population. Significantly, these two examples demonstrate a strategy and the need to use

Figure 4.3, *UN, 1988*

Figure 4.4, *UN, 1991*

different skin colors and different facial features to help convey messages of togetherness among global citizens. In both cases, designers created visual symbols using representations of different faces to signify racial/geographic differences on

the one hand, and arranged them in such a manner that each of the signifiers was equally (re)presented on the other hand. To manage this difficult balancing act, motif and circular composition were used and applied to the artistic expression in the faces to prevent the dominance of any of the racial or geographic group.

It is important to emphasize here that political and social institutions are not only among the major users of the tropes of the racial Other (such "public interest" deployment is the focus of Chapter 5 of this book); they also act as a force to push the use of the racial Other in commercial advertising campaigns. In multicultural countries such as the United States, the U.K., and Australia, policy and regulatory forces have set explicit or implicit guidelines about how the racial Other is to be included and depicted in advertising. One of the most explicit examples is the United States, in particular The Fair Housing Amendments Act of 1988 and Title VII of the Civil Rights Act, which together make up the government's Fair Housing Act, and the criteria issued and monitored by the Ad Watch Committee of the Black Media Association (BMA). As oversimplified as setting rules for the "Dos" and "Don'ts" or prescribing "good" versus "bad" (as these measures sometimes do) may seem, they nevertheless represent a factor that affects the cultural work of advertisements in a particular historical and cultural moment. In a sense these criteria remind us of the demands made by Black activists during the Civil Rights Era some decades ago as part of the struggle to change the rules of the game for racial representation in advertisements. They need to be appreciated as part of the context in which advertisements—both public interest and commercial campaigns that deploy imageries of the racial Other—are commissioned, regulated, and scrutinized.

Section 804 of the *Fair Housing Act*, for example, clearly puts racially discriminatory behavior in advertising in the spotlight. It unambiguously details possible violations in its Guidelines:

> You should be sensitive to advertising campaigns such as those which depict:
>
> - All or predominately models of a single race, gender or ethnic group
> - No families or children
> - Particular racial groups in service roles (maid, doorman, servant, etc.)
> - Particular racial groups in the background or obscured locations
> - Any symbol or photo with strong racial, religious, or ethnic associations
> - Minorities who are not residents of the complex

The guidelines take a further step in warning that advertising campaigns depicting predominately one racial group are particularly vulnerable to legal challenge if one or more factors are present. These include racial exclusion and segregation such as: "The complex is located in a neighborhood which is predominately white or known historically as being racially exclusive and the models are white"; "The complex is located in a neighborhood known to be a black or minority area and the advertising depicts minority-race models"; and "The ad campaign involves group shots or photos or drawings depicting many people, all or almost all of whom are from one racial group." Financial penalties are attached to the act, and the price for non-compliance is high. For example, a ruling delivered in 1992 levied $850,000 in damages against a branch of the Mobil Land Development Corporation for using only White models in the company's property advertising from 1981 to 1986.

Demands to stop racist stereotyping when deploying imageries of the racial Other have also been put to the advertising industry by civil rights organizations, and one of the clearest messages issued to the industry is again found in the United States. In 1982, the BMA used a carrot-and-stick approach with the advertising industry. Its Ad Watch Committee created letters praising ads depicting Blacks in a positive light, and shaming the agencies for any negative portrayals. To qualify for a letter of praise, the ad needed to meet the following criteria:

1. A black person is the sole spokesperson for a product or service. He or she is discussing the product's attributes intelligently without singing, dancing, or clowning.
2. The black(s) is portrayed as a serious person, a decision maker, and a responsible citizen.
3. Black youth are portrayed as honest, intelligent, and studious.
4. Ads that show a slice of black life (weddings, births). Ads that show being black in America is not always synonymous with poverty and frustration. Ads that show that blacks, like other Americans, have joys and triumphs.
5. Ads that show a dual-parent black family.
6. Ads that show black adults in caring relationships with their children, Ads that show parents concerned about their children's health, education, and safety. (Gist, 1992, quoted in Kern-Foxworth, 1994: 119)

On the other hand, a letter of shame was to be issued to the advertising agency for ads depicting the following:

1. Blacks using slang or talking jive.
2. The fat black mother, single parent.
3. Ads that portray blacks as living in only low-income communities.
4. Ads that portray all blacks as criminals, unemployed, and/or welfare freeloaders.
5. Everyone in ad has lines to say except black persons.
6. Blacks absent from situations in which they are present in reality. Example: an ad featuring an all-white professional basketball team.
7. Ads that resort to the following stereotypes: irresponsible black man, overbearing black woman, hustler, savage African, happy slave, petty thief, vicious criminal, sexual superman, natural-born athlete, chicken and watermelon eaters, intellectually inferior to whites. (Gist, 1992, quoted in Kern-Foxworth, 1994: 120)

Every line of both criteria is evidence of a long and bitter struggle against racist portrayals of the racial Other in advertising. The very fact that in the United States in the 1980s the BMA still had to take such measures to seek for the treatment their White countrymen took for granted tells part of the story. The legal step taken to make the presentation of ethnic imagery compulsory is also ironic. Despite the racial Other, particularly the Black population, having "earned" their "right" to be equal consumers many decades previously and despite being recognized as a valuable market segment, the Civil Rights Era struggle of being represented in advertising discourses still had to be fought in such a way decades later. These situations and the drastic measures the government and civil rights groups have had to take represent a phenomenon Stuart Hall calls a "struggle of the margins to come into representation" (Hall, 1997a: 34).

Between the commercial interests and the political interests, there was also an emerging trend that associated consumption with social activism and popular ideas by creating a link between the brand and the idea of consumer citizenship. Branding in the twenty-first century, as Elizabeth Moore observes, has become "the deliberate association of a product not just with a mere name but with an almost spiritual image, an idea" (Moore, 2007: 5). However, it needs to be acknowledged that as a strategy it can be traced back to as early as the nineteenth-century proto-advertising (as identified in Chapter 2), and by the last two decades of the twentieth century, some brands had begun to systematically build such a spiritual image. Benetton, for example, has built its advertising campaigns around social and political issues through an array of highly memorable ads from the 1980s to the 1990s. Among the many issues the brand has tackled, racial integration has gained the most market exposure.

The connection established between the brand and racial politics serves to give purchase a new meaning. In Benetton's case, imageries of the racial Other not only help to enhance the brand's corporate image, serving as a metaphor for the "United Colors of Benetton"; they also help to delineate difference and identity among its audiences, and appeal to the niche group of young unborn "progressives." Although, as Henry Giroux has argued, "[s]ocial conscience and activism in this [Benetton's] worldview are about purchasing merchandise, not changing oppressive relations of power" (Giroux, 1994: 5), Benetton effectively "fashioned" itself as a brand that not only united *color* in a product sense but also united *people* in a social sense—through some of the high-profile and racially charged advertising imageries (see, e.g., Figures 4.5 and 4.6). Strategically, mixing social activism with consumerism helped transcend ethnic faces into eye-catching objects of "color" with staged and often controversial relationships that made the brand—the "United Colors of Benetton"—a mediator for real-world racial problems. Through this fashionable strategy, racial struggles and ideologies are consumed alongside imageries of the racial Other by trivializing and neutralizing them, and by reducing them to refined commodity fetishes.

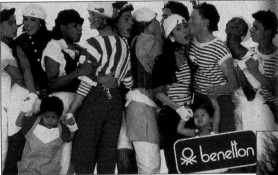

Figure 4.5, *Benetton, 1984*

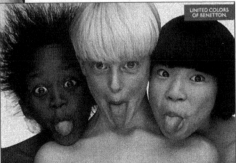

Figure 4.6, *Benetton, 1991*

Before examining the strategies of deploying imageries of the racial Other in contemporary advertising and branding campaigns, and before seeing the saturation of "colors" in all discourses being studied in contemporary works, we need to put the apparent demand for racial tropes in advertising into context and to leave no illusion as to the context in which they are depicted. Being the subject matter, all the ads studied in the following two chapters not only include non-White imageries, but also feature them as main characters conceptually and visually. However, even in the age of contemporary globalization, there are many other ads out there that still either exclude them altogether or deploy them tokenistically. A global advertising campaign to promote Levi's "Curve ID" line of women's jeans, launched in 2010 (the campaign has been so popular that it remains a point-of-sale display in some of the leading department stores in Australia as recently as 2013), is one such example. It uses the tag line "ALL ASSES WERE NOT CREATED EQUAL" and a claim at the end of the copy that "IT'S THE NEW DEMOCRACY OF JEANS! FINALLY, JEANS FOR US." The term "us" is represented by three White models (Figure 4.7) in the most widely circulated print ad and poster. Of the nine models used in the print campaign's three designs (each featuring three women in like manner and based on the same layout), only one non-White model was used (a Black model posing for the "Bold Curve" shape—most likely to be placed in ethnic media outlets).

Arguably, demands for racial tropes are growing, but only in relative terms, and the representation of non-White imageries in advertising and branding campaigns is by no means the norm. The struggle of the racial Other to come into representation is by no means settled. We need to be fully aware of the reality that the trope of the racial Other, therefore, is in demand in contemporary advertising for various reasons and to serve various interests.

In a commodity culture that is conditioned by racial politics within the context of contemporary globalization, radicalized Otherness becomes a necessary source of sign value that is addicted to new styles and appearances. Ethnicity, as bell hooks puts it, becomes spice—seasoning that can liven up the dull dish that is mainstream White culture (hooks, 1992: 21). With ongoing efforts to fine-tune existing radicalized commodity signs and to discover more of their previously unfound currencies, the commodity value of radicalized imageries has been upgraded to a more advanced version in contemporary advertising. The racist overtone in its old version has been recoded with some kind of non-threatening and desirable qualities suitable

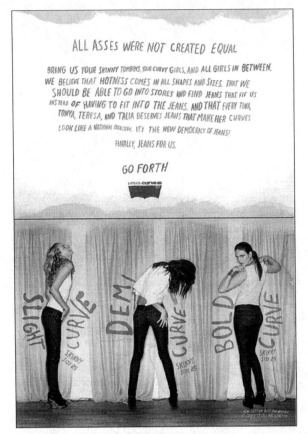

Figure 4.7, *Levi's, 2010*

for consumption. Not only a spice for those mainstream, culturally dull dishes, tropes of the racial Other have been developed into an elixir to perform the magic of mythifying, exotifying, romanticizing, stimulating, and neutralizing in order to seduce, to justify, and to persuade. It is within these general contexts and remarks that readers are introduced to each of the unique cases studied in Chapters 5 and 6.

CHAPTER FIVE

RACE IN PUBLIC INTEREST CAMPAIGNS

STEREOTYPING AND COUNTER-STEREOTYPING

The Commission for Racial Equality (CRE) was set up by the British government in 1977 under the country's 1976 Race Relations Act. Under the act, the commission is responsible for "the elimination of racial discrimination" and "the promotion of equal opportunity, and good relations between persons of different racial groups generally." Coinciding with a shift in the dominant national racial paradigm from an earlier emphasis on "integration" to "diversity," the birth of the CRE was indicative of a change in the official politics of race in the United Kingdom. During the 1990s, the commission launched several advertising campaigns with anti-racism messages partly to promote awareness of the commission and partly to draw attention to the existence of racism in Britain. Two of the most controversial campaigns were launched in 1998 and are examined here as complex exemplars of the tactic of using racial stereotypes to address racist attitudes at a national level.

Bhabha regards stereotypes—a major strategy within colonial discourse— as "a form of knowledge and identification that vacillates between what is always "'in place,' already known, and something that must be anxiously repeated" (Bhabha, 1994: 66). Indeed, as Hall (1997b: 249) notes, the traces of eighteenth- and nineteenth-century racial stereotypes had not died out but instead persisted into the late twentieth century. What makes these two CRE campaigns extraordinary is that while they had the express purpose of fighting the prevalence of racial stereotyping, the agency used the power of stereotyping itself as a strategy in executing the assignment.

A PROVOCATIVE APPROACH

On 18 September 1998, a "tease and reveal"-style advertising campaign was launched with a series of three "teaser" posters placed at 192 sites in major cities across Britain. All three posters in the series used negative stereotypes of Black people and then deconstructed them.

The most offensive stereotype employed in the posters (in Figure 5.1) explicitly linked the image of a Black man with the concept of a rapist. Spoofing a "rape alarm" advertisement, this poster depicted a man of African appearance sitting on a bus. Within the frame, the only passenger seen sharing the bus with the Black man is a young White woman who sits a row behind across the aisle, watching him with an anxious and cynical gaze. The tag line—on her side—is literally "alarming": "Because it's a jungle out there." Absent the advertiser's identity, the ad's only link to the CRE was a telephone number. In the same manner, another poster in the series bore the tag line "Born to be agile." Appearing to be a sport shoes advertisement, it depicts a Black sportsman and an orangutan jumping in the same manner—while the Black man aims to reach a basketball hoop, the orangutan reaches for a branch. The third poster in the series appears to be an executive recruiting advertisement that shows a competitive situation in which two men in business suits are climbing a ladder. Not only is the White man depicted on top of the ladder; he is also stepping on the hand of his Black competitor. The image is accompanied by the pun: "Dominate the Race."

The U.K.'s Advertising Standard Authority (ASA) expressed its concern and asked the CRE to withdraw the campaign following some complaints about the posters. Instead of complying, the CRE went on to release the follow-up "reveal" poster series in a weeklong campaign that began on 21 September. Each poster referred to the earlier "teaser," with the new posters containing a smaller-sized reproduction of the original racist advertisement, with a new and visually dominant headline in boldface that read: "WHAT WAS WORSE? THIS ADVERT OR YOUR FAILURE TO COMPLAIN?" (Figure 5.1). Revealing the overall objective of the campaign, the commission issued a statement claiming: "The unique advertising campaign is designed to generate complaints and condemnation and also acts as a snapshot of public reaction to racism," as reported by the BBC (cf. BBC News Online, 22 September 1998). Additionally, the statement described the number of complaints from the general public as "disappointing."

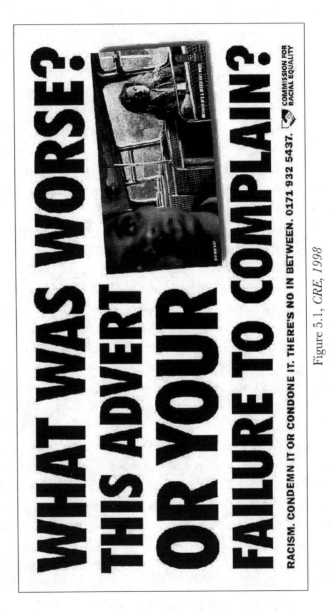

Figure 5.1, *CRE, 1998*

The number of complaints about the large-scale nationwide "teaser" campaign that depicted Blacks by means of extremely racist visual and written language was low indeed—the CRE reportedly received only six, the ASA twenty-seven. Yet even this small number of complaints was enough to put the government-funded race relations watchdog in the hot seat and see it attacked from a number of quarters for sanctioning and promoting racial stereotypes. The ASA, for instance, believed the CRE poster campaign had breached the advertising code of conduct in relation to taste, decency, and social responsibility and "concluded that the posters were likely to cause serious or widespread offence." It then announced that all future CRE advertisements would be vetted for 2 years for taste, decency, and social responsibility. In a traditionally self-regulated advertising industry, this ruling effectively made the CRE the first organization in U.K. media history to have its advertisements pre-examined by the industry watchdog.

Ethnic groups also expressed their disapproval of the poster campaign's approach. Milena Buyum of the National Assembly Against Racism said the campaign was dangerous: "The problem is people may see the teaser and take it at face value because there is nothing to say it is produced by the CRE." Worse yet: "Then, if they do not see the follow-up, it simply has the effect of reinforcing racial stereotypes, which I'm sure is what the CRE is trying to contradict."

The poster campaign controversy also provided ammunition for British Labor's political opponents. The most vocal criticism came from Tory MP Sir Teddy Taylor, who argued: "They [the CRE] have no right to put forward posters which are insulting to racial minorities, whatever their warped reasoning is for doing this." According to the BBC, the MP for Southend East and Rochford went so far as to call on Home Secretary Jack Straw to close down the commission and to withdraw all of its public funding.

The CRE defended its campaign by addressing most of these criticisms. First and foremost, the CRE and its advertising agency argued that the racist depiction of Blacks in the teaser posters was deliberately created and necessary for educational reasons. Sir Herman Ouseley, Chairman of the CRE, argued: "These posters are just the first part of a wider campaign to challenge passivity in the face of racism." As such, "The campaign is designed to force people into considering their own personal attitude to racism and is specifically intended to provoke a reaction—preferably complaint or condemnation." He went on to point out: "There were still thousands of people who must have seen these posters and thought about complaining but couldn't be bothered."

In an interview on BBC Radio's *The World at One* program, Brett Gosper, a spokesman for the advertising agency, branded those who failed to make a complaint a "passive majority." Pointing to the failure of past campaigns to target the passive majority, he said: "Advertising in the past had focused on 'extreme' acts of racism, the impact of which was to make people say, 'I'm not like that, I wouldn't do that, I wouldn't throw bricks through windows and so on.'" However, when encountering a racist joke, the passive majority would not protest—"they will perhaps laugh and move on," according to Gosper. This was used to justify the need to use a provocative tactic to make a statement. The message the CRE wanted the public to take away from this campaign was: "condone or condemn, there is no in-between."

Addressing the National Assembly Against Racism's criticism, a CRE spokesman made no apology for portraying Blacks with negative racial stereotyping, arguing that the early posters were just the "opening shot" of a public information campaign. "It is extremely unlikely that people who have seen these initial posters do not then see the follow-up," said the spokesman.

In November 1998, the CRE fired its closing shot in this controversial campaign. An "advertisement of apology" was launched with a new poster featuring the slogan "Sorry We Exist." According to Ouseley: "The purpose of this latest advert is both to highlight the amount of work still to be done to end discrimination and to stress that if everyone took action to deal with prejudice and discrimination we would justifiably be out of business" (BBC News Online, 4 November 1998). Unapologetic about the racist representation of Blacks in the teaser posters, as well as the manner and tactics of the campaign, the poster once again addressed the necessity of an ongoing campaign to combat the widespread tendency toward passive racism in the U.K. at the end of the twentieth century. In this regard, the apologizing poster could be read as a counterattack against its political opponents over their call to close down the commission and withdraw its public funding—a fight for the commission's own political survival while buttressing a political point.

A "HUMOROUS" TAKE

Soon after the release of the "Sorry We Exist" poster, the CRE fired another salvo in its fight against racism with a new campaign in late November 1998, again tackling racial stereotyping. The need for such a campaign was evident in a CRE-commissioned survey indicating that an overwhelming 84% of ethnic

minority respondents believed that Blacks and Asians were often perceived as victims and in a negative way. The survey, entitled *Stereotyping and Racism—Findings from Two Attitude Surveys*, also showed a collective desire among the respondents for more positive minority images in the media (CRE, 1998).

With the visual identity of the CRE clearly branded with its logomark and logotype, this campaign consisted of a series of three posters, each featuring a racial Other in the U.K. context—a Black man, an Indian woman, and a Muslim boy (Figures 5.2, 5.3, and 5.4). All three posters shared the same design style in terms of layout, color scheme, and typographic treatments, only with different characters and copy. The poster depicting the Black man went with the bold red headline: "SCARED?" Below it was a smaller-sized white punch line, "YOU SHOULD BE, HE IS A DENTIST." The headline in the poster depicting the Indian woman read: "IMPROVE YOUR ENGLISH," followed by the punch line "PERHAPS THIS HEADTEACHER COULD HELP." The poster featuring the Muslim boy bore the headline "NO-ONE RESPECTS ME," with the punch line "I AM AN ARSENAL FAN."

The image of each character was constructed through different visual treatments. The Black man was depicted in a close-up. With his hair and ears fading into the black background, the image featured nothing more than the center of the man's face—his eyes, nose, lips, and pronounced bone structure. The use of high-contrast lighting, projected from a low angle, added a touch of menace to the face. Such framing and lighting arrangements ensured that the typical facial features of Blackness commanded the center of attention on the one hand, and established a sense of horror on the other. The Indian woman, in contrast, was depicted from her upper body to her head. The framing and the softer lighting ensured that symbols of her Indianness were visible to the audience: her hairdo, her costume, and the Tilak/Bindi, a distinctive spot on her forehead that further identified her as a Hindu. The Muslim boy was also loosely framed. A small part of what looks like a school badge was visible on his jacket, suggesting the boy was wearing his school uniform. However, with the lighting pointed at the upper part of his head, one could not miss the white crocheted taqiyah (generally called a "prayer cap" in the West) that signified the boy's Islamic identity.

Along with the carefully arranged visual treatments that contributed to the representations of non-White people through the advertiser's gaze, it is also interesting to note the treatments of the gaze of the depicted racial Other in this series of posters. Matching their assigned professional status, the characters

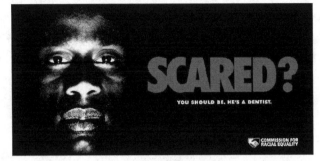

Figure 5.2, *CRE, 1998*

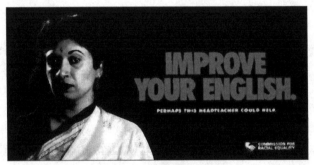

Figure 5.3, *CRE, 1998*

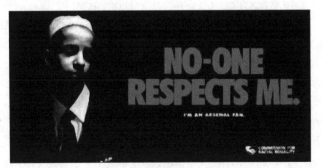

Figure 5.4, *CRE, 1998*

posing as dentist and headteacher were both depicted with an active gaze engaging with the audience (although the nature of each gaze is open to interpretation). Following the textual signifiers that were used as "hook lines," as the industry calls them, the Black man's gaze was more likely to be perceived as a sign of aggression, and the Indian woman's gaze a sign of ignorance. But if these gazes were to be interpreted in light of the respective punch lines, then the Black man's gaze could be perceived as a sign of concern, and the Indian woman's gaze a sign of thoughtfulness. In the case of the Muslim boy, the absence of eye contact with the audience was compensated for by the hook line that gave the character an active voice. Differing from the other posters, the boy became an active rather than passive subject who had some degree of power.

Unlike the earlier Condone or Condemn campaign, this campaign took a humorous approach to the problem of racial stereotyping. According to the CRE, the objective of the campaign was to "make a mockery of negative stereotypes of black and Asian people" (*The Independent*, 24 November 1998). To achieve this goal, prominent headings in each poster acted as hook lines that linked the individuals to a widespread negative stereotype typically associated with the ethnic group represented. The smaller punch lines then dispelled these prejudices by introducing "positive" statements. Ultimately, however, this humorous approach still relied on the trick of "tease and reveal." In the case of the "SCARED?" poster, while the hook line played on the deeply rooted perception of Black criminality and savageness to mock the public preconception of Black danger, the punch line revealed the Black man to be a dentist. Therefore the message in this poster was: "If this Black man is to scare you—it should not be because he is Black but because he is a dentist." Similarly, the IMPROVE YOUR ENGLISH hook line targeted the myth that Indians were less educated, and thus needed to improve their English. The punch line, on the other hand, introduced the character as a headteacher, and thus the message in this poster was: "If you think this Indian woman has some relevance to improving English, she does—not because she is Indian, but because she is a headteacher." In the same manner, while the NO-ONE RESPECTS ME hook line addressed the presumption that Muslims were outsiders in British society and therefore did not command respect, the punch line introduced the boy as a football fan with the message being: "If this Muslim boy does not deserve respect, he does not—not because of his religion but because of the football team he supports." The ads tackled racial stereotyping by demonstrating

that despite being Black, the man was a doctor helping to improve people's health; despite being Indian, the woman was a teacher contributing to the nation's educational system; and despite being Muslim, the boy was a devoted football fan "integrating" into mainstream British culture. The common message communicated by the three posters seemed to be: "Judge the racial Other on the basis of individual merit, not on the basis of stereotypical myths."

Despite its intention of tackling racial prejudice directed at the racial Other by attributing Britain's racial Other with some desirable qualities, the campaign still attracted criticism. This was particularly the case with the "SCARED?" poster, as the dangerous/Black man synonym behind the visual codes in the ad bore some traces of the colonial racial script of the "dangerous Other," and this particular coding was familiar to the public. Unsurprisingly, perhaps, the General Dental Council objected to the poster, though not on the grounds of potential damage to its profession. Instead the council argued that it was "offensive in assuming that people should be either scared of black people or surprised to find them in a qualified position," according to the ASA. The British Dental Association did voice a complaint about the poster's stereotyping of dentists, claiming it reinforced a connection between dentistry and fear (*The Herald*, 24 November 1998). While the ASA did not uphold the complaints, it nonetheless found the prominence given to the face in the poster to be "sinister." Further, it agreed that the visual representation and the headline could "be seen as advocating the negative stereotype that black men should be feared," while acknowledging that "They [the CRE] thought that by using the humorous and ironic stereotype about dentists they would dispel readers' harmful and insulting stereotypes of ethnic minorities, black men in particular" (ASA official website).

THE STRATEGICAL PLAYS

Both CRE campaigns discussed above deployed stereotypical imagery of the racial Other for a social cause. Imagery of racial Others was used in these poster campaigns to tackle negative racial stereotyping. More specifically, these images of racial Other were constructed in a stereotypical way, although the campaigns differed tactically and in tone. While the first campaign used shock tactics, the second campaign used humor. The first campaign confronted the audience and forced it to consider its own personal attitude towards racism while trying to provoke a preferred reaction such as complaint

or condemnation. The second campaign lured the audience into recognizing some of the prevalent racial stereotypes that "agreed" with the headlines and the imagery of the characters, but then attempted to undermine and ridicule those same stereotypes by revealing "unexpected" positive connotations. The first campaign used only Black citizens and "intentionally" portrayed them in an insultingly negative way through juxtapositions of image and copy—portraying them as rapist, animal, and loser—and only made public the punch line a few days later. The second campaign depicted not only Blacks, but also Indian and Muslim minorities, and while it showed restraint in its use of offensive visual texts due to the ASA censorship imposed on the CRE, suggestive negative racial stereotyping was in play in the linguistic text. Even at the lower level of offensiveness—as in the second campaign—racial stereotyping can still perpetuate hurtful notions, and racial Others are still very vulnerable. Even more problematic is the fact that, in both cases, the intended counter-stereotyping messages could only be effective if the audience followed the advertiser's "preferred readings."

If the "teaser" posters of the first campaign were designed (as the CRE maintained) to shock the public by deliberately representing Blacks in racially offensive ways with an intent to provoke emotions of anger and disgust that would lead to the action of complaining, the purpose failed, given the "disappointing" number of complaints. However, failure in this regard seemed to be a calculated one: backed by the evidence of the CRE market research that underpinned the campaign, the much-publicized disappointment about the muted voice of complaint from the general public was expected and anticipated. If this was not the case, the "planted" follow-up posters would have been unnecessary, and the CRE would not have been able to leverage the lack of public reaction as evidence of a collective passive attitude toward racism.

As for the second campaign, with its declared intent of mocking negative stereotypes of the racial Other, the posters first needed to hook the audience with an existing prejudice toward an ethnic minority, and then ridicule it with a punch line that contradicted the stereotype. To make the joke work, the advertisements deployed various tools of the trade to highlight the Otherness of the chosen characters in terms of their facial features, costumes, religion, and body language. Although the images in isolation (with the exception of the questionable "SCARED?" poster) may have seemed harmless, when viewed with their respective hook line, each contained at least one racist

statement. Surely the racist comments were meant to be undone through the poster's much less dominant punch line, but whether the racial stereotyping could be undone is highly questionable. The uncertainty is due not only to the punch line's subtlety, but also to the entrenched reality of societal inequality and deep-rooted racial ideologies that made it much harder for the audience to be convinced by the punch line. The crux is that while it is the audience, after all, that holds the power of interpretation, that power is affected (and somehow limited) by non-textural factors—such as various forms of social and cultural training—that predispose it toward certain normative forms of interpretation.

INCLUSION OR ILLUSION

AN UNEXPECTED PROXY

In October 1997, the British Ministry of Defence (MoD) launched one of its largest-scale national recruiting campaigns using print, radio, and television media. The face of this campaign was a Black army officer depicted using Lord Kitchener's signature gesture of pointing his finger at the viewer with the familiar message: "YOUR COUNTRY NEEDS YOU" (Figure 5.5). The concept and layout of this poster were not new—they were based on a famous World War I British Army recruiting poster in the collection of the Imperial War Museum (Figure 5.6). However, unlike many others before it that had attempted to inject new meaning into this old masterpiece, the 1997 MoD poster delivered a remarkable new take on this piece of legendary wartime propaganda. Further, given that this recruitment campaign targeted a national audience (as opposed to an ethnic-specific audience, as did some of the MoD's later campaigns or those of the U.S. Army and Navy near the end of the Vietnam War), not only was the use of a minority officer as the sole face of the campaign unorthodox; it was also strategic in that it raised his status by using him to personalize the state and giving him a first-person voice of the army at a time when it was under intense criticism and scrutiny for institutional racism. Indeed, the rhetoric and wisdom in the deployment of the imagery of the racial

Other in this example bears the hallmark of institutional racial politics in the age of contemporary globalization.

Before discussing the rhetoric and wisdom of basing a contemporary nationwide army recruitment campaign on an 80-year-old poster, and superseding the image of a prominent British World War I figure with that of an unnamed Black officer, we first need to appreciate the merit of the original. The 1914 poster on which the MoD recruiting poster was based is iconic in several ways. To begin with, it was one of the very first British Army recruiting posters in World War I, originally designed by Alfred Leete, and, arguably, it is the most powerful. First appearing on the cover of the 5 September 1914 issue of the *London Opinion*, it was printed as a poster and circulated around the country as the centerpiece of a nationwide campaign soon after Britain declared war on Germany. In a desperate effort to overcome the country's shortage of combat troops, the official poster made Lord Kitchener the face of this crucial recruitment campaign. As a national Boer War hero, Secretary of State for War and head of the British Army, Kitchener was himself an icon of the British war effort. Through his authority and status, with his stern face and finger-pointing gesture, a powerful direct appeal to the British people was delivered with the words "BRITONS [image of Lord Kitchener] WANTS YOU." To complete the recruitment pitch, a call to action: "JOIN YOUR COUNTRY'S ARMY!" and the phrase "GOD SAVE THE KING"—the title of the British national anthem at the time—were set at the bottom of the poster.

In addition to creating an icon that personalized the state and combining it with the use of a direct mode of address to the audience with the word "you" and the gesture, as well as achieving its purpose of helping to boost troop numbers for the British arms effort, this poster was also inspirational in the field of poster design. If imitation is indeed the sincerest form of flattery, then its most famous flatterer was arguably James Montgomery Flagg, the creator of the U.S. Army's 1917 "I WANT YOU" recruitment poster that featured Uncle Sam. Flagg has reportedly claimed that his design was "the most famous poster in the world." His words aside, the U.S. Library of Congress listed the poster in its collection under an unqualified heading: "The Most Famous Poster." Assuming the claim from the United States is true, the U.K.'s Lord Kitchener poster should be titled "The Father of the Most Famous Poster."

To generate enthusiasm and encourage enlistment, recruiting posters for the armed forces were typically designed using authority, patriotism, and emotional prompts or rewards. The 1914 poster delivered all three effectively

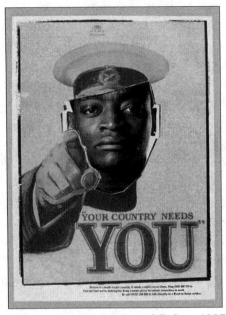

Figure 5.5, *British Ministry of Defence, 1997*

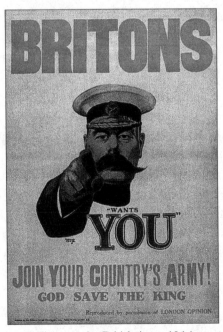

Figure 5.6, *British Army, 1914*

within a single non-cluttered layout: Lord Kitchener symbolized authority; the national anthem title called forth patriotism; the body language of Kitchener's piercing eyes and pointing finger and the prominent typographic treatment of the key words "BRITONS" and "YOU" left audiences with no doubt about their obligation and duty—the message that they were personally contacted, needed, and wanted by their country to fight the war could be effortlessly decoded by its audience. In 2002, the magazine *Campaign* recognized this 1914 poster as the "best recruitment advert of all time."

Given its success and iconic status, it is no surprise to see that the old masterpiece is still being "borrowed" by advertisers in both the public and private sectors. Over the years, the image of Lord Kitchener has been used in its original form to convey a range of messages, from "YOUR COUNTRY IS STILL CALLING. FIGHTING MEN! FALL IN!!" by the British government to help generate new recruits during the war, to "SHOP, DAMN IT SHOP, IT IS YOUR PATRIOTIC DUTY" by a London art gallery to boost consumption during the 2008 world financial crisis.

So what else made the 1997 MoD recruiting poster a remarkable new take on the old masterpiece? It was not because Lord Kitchener's image had been superseded. That iconic image has been superseded many times in the genre of wartime posters alone, by Uncle Sam in the United States and by John Bull in the U.K. (Figures 5.7 and 5.8), to cite two famous examples. It was not because of its use of the imagery of the racial Other in a recruiting ad, either. While it was extremely unusual to use imagery of the racial Other in recruiting posters in the West, it was not new—as shown in the "19 Weeks" and the "You can be Black, and Navy too" posters, both of which were part of the U.S. Navy's ethnic recruiting campaign between 1971 and 1972. This was a final attempt to boost troop numbers right before President Nixon ordered U.S. troop strength in Vietnam to be reduced by 70,000 (Figures 5.9 and 5.10). To appreciate the new take and the cultural work of this poster, we now turn to the extra-textual factors surrounding it.

Despite Britain having a 200-year history of employing overseas men such as Indians and Gurkhas to fight in its wars, and driven by the Victorian concept of "martial races," by which certain races were considered more "warlike" and therefore "born fighters" for the empire, ethnic recruits were not always welcomed. The change in attitude toward ethnic recruits can be observed through several policy changes that took place in the postwar era. The recommendation that "Men not of pure European descent should not be

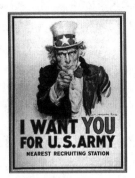

Figure 5.7,
US Army, 1917

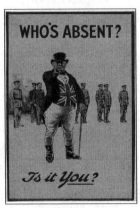

Figure 5.8,
British Army, 1916

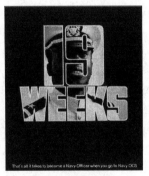

Figure 5.9,
US Navy, 1971

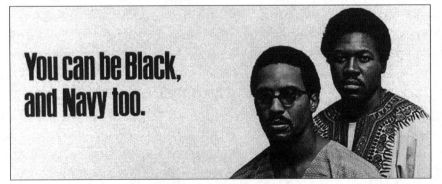

Figure 5.10, *US Navy, 1972*

allowed to enlist in U.K. regiments or corps of the Regular Army," in a 1946 Cabinet Paper entitled *Post-War Regulations Respecting the Nationality and Descent for Entry to the Army*, is one such example. This policy effectively drew a color line based on Whiteness (pure European descent) in order to exclude potential non-White applicants from joining the army. In a 1961 official document entitled *Recruitment of Coloured Personnel*, the Army Council made its negative attitude toward ethnic recruiting even clearer: "The strength of the British Army has always depended on the reliability of the individual soldier. The reliability of coloured soldiers is not certain and therefore too great a dilution of British units would be dangerous" (BBC News Online, 12 September 2006). Openly, a color-bar of no more than 3% non-White personnel was established to prevent such "danger." In 2005 a secret system of discriminatory and deceptive measures to racialize and control non-White recruits within the force was revealed. Reviewed by the BBC (BBC News Online, 4 January 2005), a 1972 confidential briefing paper, made available under the U.K.'s National Archive's 30-year rule, showed that army medical officers had been instructed since 1957 to record the racial features of all new recruits—not only to identify "Asiatic or Negroid features," but also to include more detailed descriptions such as "Chinamen, Maltese or even swarthy Frenchmen." The briefing outlined the deception: "Officially, we state that we do not keep statistics of coloured soldiers," but, "In fact, we do have a record, resulting from the description put on the attestation paper by the medical officer, of the features of the recruit." As a result, non-White personnel were designated as "D factor" personnel. Without explanation, the meaning of "D" was open to interpretation: Dangerous? Different? D-Class? D-Grade? The mysterious D factor may still have many unknowns, but one thing is certain—it was an official (albeit covert) way of "Othering" the colored personnel in the force, purely because of their non-White physical features. Evidently, the ideology of race was deeply rooted within the culture of the force, and racial politics were always in play around the issue of recruitment—before, during, and after the recruitment campaigns.

It was a radical move to use a Black officer—deemed a "D factor personnel" only 2 decades earlier—to front the recruitment campaign for a predominantly White military. Just over 1% of non-White personnel were serving in the combined army, navy, and air force in the year the campaign was launched. What was the wisdom of this rather unusual casting, and what does the poster tell us about the sign value of the racial Other in the age of

contemporary globalization? Let us first look at the context in which the campaign was created.

Several events related to the birth of this advertising push occurred early in 1997. In March, about 7 months before the launch of the recruiting campaign, the CRE ruled that the Defence Administration had failed to address its problem of racism in the force. It exercised its statutory power to place the MoD on probation for the second consecutive year, with the further threat of a Non-Discrimination Notice subject to review the following year. Among other problems, the Household Cavalry (commonly known as "the Guard') was accused of "institutional discrimination" in its recruitment and transfer policies. In addition, a stream of allegations of racist conduct against non-White members of the force came to light, including all forms of racial harassment and abuse. In one case, Mark Campbell, the first Black man in the Guard's 400-year history, not only had his bed soaked with urine and was constantly referred to as "nigger," but also received hate mail, such as a note stating: "There is no black in the Union Jack." Campbell left the army 17 months after being invited to join the Guard in 1994, as the BBC later revealed (BBC News Online, 25 March 1998). The army's public image was further damaged in 1997 when the Office of Public Management released a damning report that found evidence of widespread racism in the armed forces.

The year 1997 also saw the Labour government begin a Strategic Defence Review (SDR) to reassess Britain's military needs in a non-"bipolar world." The review identified the shortage of serving personnel as one problem for the country's defense. As the Cold War ended, the British armed forces shrank from about 315,000 to about 215,000. Yet with the country's increasing international commitments in Bosnia, Sierra Leone, and East Timor during the 1990s, the military realized it was again facing the problem of "manpower" shortages. Among other outcomes of the review, the SDR authorized the British Army to increase its size. With the problem of an understaffed military, Black recruiting became a hot topic at the top. In March, Prince Charles summoned Britain's top general to question why the army was failing to take on Black recruits. "The Prince wants to see changes in both recruitment and the culture of the Services," according to Ouseley, chairman of the CRE (Lewis, 1997). Adding to this political pressure, then-Prime Minister Tony Blair also expressed strong criticism of the army during his Labour Conference Speech in September, pointing to its lack of senior Black officers. Clearly, the MoD found itself in a position where, on the one hand, it desperately needed

a response to the accusations of being a racist institution that discriminated against Black members of the force, and, on the other, it needed to persuade the Black population to join the force to solve its manpower problem.

Having established the background that give birth to this 1997 army recruiting poster, let us now move to the rhetoric of using the Black officer in this particular campaign. The Black officer was portrayed as confident and dignified. Shown using the exact same posture and gesture as Lord Kitchener, he looked at and pointed straight to the audience and conveyed the message with authority: "YOUR COUNTRY NEEDS YOU" (a phrase used in some variations of the same design). With his visual prominence, his direct gaze, and his first-person voice, he was in effect speaking for the nation's armed forces. But the similarity stopped there in terms of visual juxtapositions.

The authority assigned to the Black officer was not the same as that assigned to Lord Kitchener. To begin with, as an individual appointed by then-Prime Minster Herbert Asquith as Britain's highest-ranking wartime official, Lord Kitchener not only initiated the recruiting campaign because of his position; he also made himself the face of the poster. As an established and recognized hero of the Boer War, he personally urged Britons to join the army and fight the war. The Black officer depicted in the poster, on the other hand, was unknown to the public. Reading the visual text, he was immediately identifiable to the general public only as a Black man, a racial Other in a White-dominant society. Only with an understanding of various cultural codes—cues such as his uniform, and a knowledge of the general requirements for serving in the army—can he then be decoded as an unnamed and unranked army officer, a British Army officer, and therefore a British citizen. As a matter of fact, the British media constantly used the terms "Black officer," "Black soldier," and even, in some cases, "Black face" when referring to the character in their campaign coverage. The Black officer, in fact, did have a name, a proper (albeit not superior) ranking, and a place in the army: he was Captain Fidelix Datson of the Royal Artillery. Ironically, it seems that the Black officer's authority established in this ad was granted not because of his government position, military ranking, or social status, but because those in the position of authority decided to make him one of "us" and put him in the spotlight as the face of Britain's army recruiting campaign.

On the surface, the symbolic power of an unknown Black officer may seem less than that of an iconic figure. For example, just by prominently featuring an illustration of Kitchener, the World War I recruiting poster could be read

by its audience as: "LORD KITCHENER WANTS YOU" or "BRITAIN'S SECRETARY OF STATE FOR WAR WANTS YOU." Conversely, if it used the same typographic treatment, the 1997 poster would be read by the general public as "AN ARMY OFFICER WANTS YOU" or "A BLACK ARMY OFFICER WANTS YOU"—neither of which sounds as powerful. This explains the need to compensate for this shortcoming by adopting one of the alternative tag lines—"YOUR COUNTRY NEEDS YOU"—from other varieties of the original Lord Kitchener poster.

If we consider the sign value of the Black officer within the context that gave birth to this poster, it becomes clear that the symbolic power of his Blackness and his Otherness as a minority army captain represented a value unmatched by *any* better-known, higher-ranking, majority White officer for the MoD's need to defuse the criticism of institutional racism and to solve its recruitment difficulties. On the one hand, the MoD desperately needed to convince the CRE that there was no further need for outside intervention (i.e., for the CRE to execute the Non-Discrimination Notice, allowing the commission to dictate race policy in the armed forces). To achieve this, it needed to address its poor record, which had led to the perception of it being a racist institution. On the other hand, the recommended personnel targets required the MoD to significantly increase recruitment. To achieve this, it looked to the underrepresented ethnic minorities for the answer. To attract ethnic minority recruits, the MoD needed to rebuild its image as a modern defense force and an equal opportunity employer.

Taking these circumstances into account, while the imagery of a Black officer unknown to the public could not match the "recognition" and "status" factors of a celebrity who had acquired government, social, and iconic credentials, for the advertiser, being Black and being one of the highest achievers in the defense force gave Captain Datson a unique edge. These sign values were precisely what were needed to address the problems facing the MoD at the time: a living proof that the accusations of a racist defense force were unfounded, and a mascot to beat the drum for the army recruiting campaign, so that desperately needed troops could be drawn from the non-White population. Taking advantage of the Blackness and Otherness embodied in the Black officer, this campaign represented a powerful strategy for politicians and officials in the politics of recruitment and race relations. In addition, while it was a national campaign, using a character that appeared to belong to their in-group was more appealing and persuasive to the ethnic minorities of the U.K. As such, the

persuasive power embodied in the Otherness and Blackness of Captain Datson was, for the purposes of this campaign, not less than, not equal to, but greater than the sheer celebrity power of Lord Kitchener and the like.

The strategic deployment of the Black officer in this campaign is significant. From being the unwanted and undesired to being the wanted and needed, from being the "Other" to being part of "Us," from being questioned for their "reliability" and associated with "danger" to being elevated to represent the public face of the British military, the sign value and group identity of Blacks (and, for that matter, other members of ethnic minority communities) shifted dramatically from D grade to A grade through the visual representation of this MoD poster. Commenting on the army's new approach to ethnic minorities, Col. Rory Clayton, head of officer and recruit marketing, admitted that "We need to own up to the fact that we have got it wrong in the past. Big institutions like this wake up and find the world has changed and they have been overtaken" (quoted in *Electronic Telegraph*, 12 October 1997). While the poster, as the major promotional vehicle of the campaign, does not in itself express Clayton's message, the elevation of a Black officer to the status of a British wartime icon showed the institution's changing attitude toward the racial Other and sent a persuasive message to its target audience (chiefly the CRE, but also other pressure groups) in a more effective and convincing way. As a result, the image of a Black officer—a member of the very group traditionally considered undesirable by the force—was used and assigned a new meaning: as a symbol of a changed, non-racist, and non-discriminatory British military. Through the deployment of this Black officer in its poster, the MoD was trying to convince both its critics and potential recruits that the army was now an equal opportunity armed force, that it needed ethnic members, and that they could have a bright future in the force.

It needs to be pointed out that this poster was the product of a particular time as a solution to a particular set of problems for the advertiser, and that the deployment of the image of the racial Other was far from the norm among military recruitment campaigns in the West. For example, the same advertiser did not use any ethnic imagery in the double-page newspaper spread that formed part of the MoD's first-ever ad campaign specifically aimed at recruiting ethnic minority officers in 1998. Despite both the deployment of imagery of the racial Other in military recruitment ads and the fact that senior-ranking military officers from ethnic groups were still the exception rather than the norm, the extraordinary lengths the campaign went to in order to elevate

and promote a Black officer to play the modern-day Lord Kitchener is phenomenal enough to indicate how useful the imagery of the racial Other can be for advertisers who want to prove a point, project an image, and make their message convincing.

COLORING UP AND SPICING UP

The British Council's 1998 campaign to promote education, travel, and U.K. culture to the world targeted international audiences and distributed posters to the council's overseas branches in 54 countries.

Britain, it seemed, had an image problem; the traditional aspects of the country were what usually sprung to people's minds. This problem posed a dilemma for the council, which had a mandate to promote a desirable image of the country to the world. On the one hand, it did not want to trash Britain's proud heritage; on the other, it wanted to promote the allure of modern-day Britain. Clearly aware of this dilemma, Chris Hickey of the British Council told the press that "We wanted to show Britain with great traditional successes, but also as a contemporary, forward looking society" (BBC News Online, 24 September 1998). With this brief in mind, designer Michael Johnson revealed his strategy: "…you couldn't throw out the heritage. In fact you can't do one without the other" (BBC News Online, 24 September 1998).

The solution was a series of posters, each comparing an old image of Britain on the left-hand side with a new one on the right. Perhaps to enhance the contrast of the old and the new, all posters shared the typographically treated heading "Britain," with the first half of the word situated within the left-hand panel using a serif font to convey a sense of tradition, and the second half of the word situated inside the right-hand panel using a sans-serif font considered modern in style.

The contrast between old and new was applied to emphasize a wide range of British cultural achievements—from sport to art to literature to music to people to food. It was in the departments of people and food that imageries of the racial Other were represented. Figure 5.11 is the poster that emphasized people, or the social makeup of British society. In contrast to the monoracial social makeup of the old picture next to it, the "new" panel was taken up with a multiracial snapshot. Both depicted a group of innocent children. The picture on the left was presented in gray scale and looked dull and cold; the picture on the right was in color, lending an impression of liveliness and warmth. Figure

5.12 is the poster that emphasized food, or the way of life in Britain. A single plate of steak, potato chips, and salad was featured on the "old" panel, while the "new" panel showed a variety of exotic dishes from other cultures, most notably Italian and Asian cuisines.

The connotative messages from these two posters could be read as follows: Britain is no longer a monoracial society; her people are now multiracial and living together in harmony; and Britain's cuisine is no longer boring. It is now exciting, diverse, and embraces an international flavor. Both posters were aimed at tackling elements of Britain's unfavorable reputation by associating her with the new image of a multicultural Britain. To achieve this objective, elements of the Other—people of ethnic minority backgrounds and tastes of the exotic—were deployed.

Notwithstanding the presence of the racial Other in these two posters, it is revealing to note its absence in the other ten. Essentially, in the areas where Britain was seen as having a rich heritage, the racial Other was absent. For example, in the poster featuring entertainment Benny Hill's image was chosen from the talent pool of old masters to symbolize the past glory of British entertainment, while Rowan Atkinson was the face of the current crop of high-achieving entertainers. The message conveyed by this poster (and, for that matter, the rest of the posters in this category) could be consistently interpreted as "Britain not only produced ___ in the past, but also possesses the greats such as ___ now." This was significantly different from the rhetoric of the posters where Otherness was used, namely: "Britain is no longer ___, as in the past, but now ___."

With this difference in mind, it is reasonable to conclude that the presence or absence of the racial Other in this campaign depended on need. It seems that the Other only became useful where there was a lack, where the racial Other could serve to bridge the gap or make amends: the ethnic faces of the children were needed to paint a picture of a racially inclusive society to shake the image of a racist society, just as the ethnic cuisines were needed to demonstrate a sense of richness and diversity, to compensate for the traditional lack of a food culture. From this perspective, images of the racial Other were valued only when they could help to add color to the snapshot of a society eager to be seen as what it was not. Similarly, the cuisine of the Other was useful only when it could help spice up the national flavor of a culture appreciated for the lack of it.

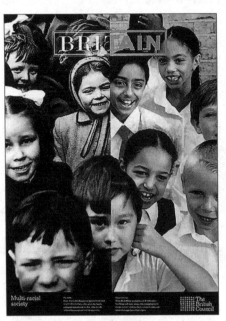

Figure 5.11, *British Council, 1998*

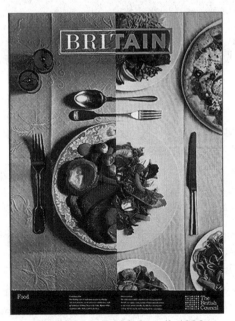

Figure 5.12, *British Council, 1998*

THE MANY FACES OF "BENEFICIARIES"

A PLAY OF "SOFT POWER"

To celebrate the 50-year anniversary of the establishment of the British Council, on 25 September 1984 the Royal Mail issued a set of four commemorative stamps designed by Newell and Sorrell (Figures 5.13a, 5.13b, 5.13c, and 5.13d). Each of the stamps in the series was designed to promote achievement in a specific area of the council's core initiatives, specifically: language and literature; technical training; promoting the arts; and education for development. Although it is an item intended for sale, the humble postage stamp has been used by governments as an effective means of promoting messages to the domestic and international population throughout history—indeed, messages communicated through pictures and slogans in the design of postage stamps and the event of official issue serve as a de facto public-interest advertising campaign.

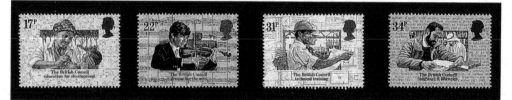

Figures 5.13a, 5.13b, 5.13c, and 5.13d, *Royal Mail, 1984*

Answering to the Foreign and Commonwealth Office, the British Council is a non-departmental public body and a registered charity for cultural relations in the U.K. Originally set up in 1934 as the British Committee for Relations with Other Countries, its name was later changed to the British Council for Relations with Other Countries, and in 1936 shortened to the British Council as we know it today. The British Council has been officially acknowledged as the brainchild of Sir Reginald Leeper, who identified the importance to the national interest of promoting Britain abroad, deeming it a form of "cultural propaganda" (British Council website). Leeper's 1930s vision of a British Council that could help maintain the U.K.'s position on the world stage through dissemination of British culture can perhaps be explained by Joseph Nye's more contemporary concept of utilizing a nation's "soft power" to influence others through its attractive resources—such as culture, ideologies, and institutions—

without having to resort to "hard power," including military threats and economic sanctions. Nye wrote:

> Soft co-optive power is just as important as hard command power. If a state can make its power seem legitimate in the eyes of others, it will encounter less resistance to its wishes. If its culture and ideology are attractive, others will more willingly follow. If it can establish international norms consistent with its society, it is less likely to have to change. If it can support institutions that make other states wish to channel or limit their activities in ways the dominant state prefers, it may be spared the costly exercise of coercive or hard power. (Nye, 2004: 77)

While the British Council is proud of its reputation for "doing good" through teaching English, providing libraries, laboratories, training, and promoting British culture in developing countries, the council is also sensitive to its critics, particularly those who make the accusation that its activities are a form of cultural imperialism. Heated debates over the idea of a "New World Information and Communication Order" (NWICO) within UNESCO, for example, reached a boiling point in 1984. Developing nations and a number of developed nations, such as Canada, France, and Finland, promoted the idea of a more equitable exchange of information and cultural materials between rich and poor nations. At the same time they condemned cultural imperialism in the media industry, particularly the one-way traffic of world news and the influx of print and audiovisual products from powerful Western nations that threatened the survival of the local culture of the vulnerable developing nations. Finding itself on the receiving end of the criticism, the United States withdrew in protest from UNESCO in 1984, with the U.K. following suit in 1985.

These tensions and criticism inevitably had an impact on the design of this series of stamps. Released in this context—in the year the United States withdrew and a year before the U.K. withdrew from UNESCO—the use of the imageries of the racial Other and the construction of their relationship with "the Empire" was evidently carefully managed.

Three of the four stamps in the series featured unambiguous images of Britain's racial Other. With the caption "language and literature," the 34p stamp featured two men of Middle Eastern appearance. The featured character in the foreground was not depicted in traditional dress, while the man in the background was. Both men appeared to be reading in a library. To accompany the caption "technical training," the 31p stamp depicted two men of South Asian appearance, both wearing safety helmets and Western-style

shirts. Within the backdrop of a construction site, they appeared to be studying a building plan. Reflecting the caption "education for development," the 17p stamp showed a Black woman wearing a local-style flora kerchief and a white coat. She appeared to be performing a medical examination of a Black baby— though the pattern of trees in the background was not suggestive of a typical clinic setting.

With the help of captions, this set of commemorative stamps was designed to deliver messages such as "The British Council helps developing countries to improve their knowledge of English language and literature"; "The British Council helps developing countries to improve their technical knowledge through technical training"; and "The British Council helps developing countries to improve their life through developments in education." Of the various visual constructs, the framing in this case is particularly interesting.

It was not unusual to see advertisements promoting the contribution of the "developed" West to the "developing" rest, and the ex-colonies were often on the receiving end. However, in the spirit of neocolonialism and under the influence of Rostow's modernization theory as discussed in Chapter 3, the racial Other was typically depicted in advertisements with the rhetoric of infancy and dependency, explicitly claiming that the modernization of the poor nations was only possible with the help of the West.

Instead of featuring imageries of the initiative provider (typically the British), the stamps featured imageries of the recipients (typically the racial Other). Although visual clues of Britishness were present, they were rendered subtly. The official silhouette of Queen Elizabeth was set in the top right-hand corner of the template. The line that named "The British Council" was placed quietly on top of each individual caption—using the same typography and without any sign of the special treatment a "birthday boy" deserves. Looking more closely at the stamps' visuals, one finds that the passages of text on the book in the 34p stamp, the construction plan in the 31p stamp, and the scientific codes in the 17p stamp were all presented in English, without a trace of any local touches. Judging by the arrangement of the visual signs, the subjects of the messages were relegated to the background through the subtle visual treatment and the somewhat understated representation, while the object of the message was brought to the fore by assigning visual prominence—from position to proportion to focal point to detail.

Apart from being visually prominent, the imageries of the racial Other were also presented in a positive way. In isolation, their body language connoted

confidence, optimism, and capability—almost a collective affirmation that "People in the developing countries are doing well." However, when read in conjunction with the symbols of Britishness—as subtle as they were—a considerable sense of dependency was attributed to the racial Other. With all the main characters positioned slightly below and facing toward the queen, the design erected a bond between Britain's racial Other and the British Council. As a result, the collective message in this set of commemorative stamps became: "People in the developing countries are making progress, thanks to the help of Her Majesty and the British Council." With the strategic arrangement of the visual signs, the imageries of the racial Other were literally represented as being "under" the queen, and being "looked after" by the queen.

The way in which the racial Other had been looked after by the empire (via the queen) in this case differed greatly from Frank Rippingille's Oil Stove ad mentioned in Chapter 2. Compared to the tag line "ENGLAND'S GIFT A BLESSING TO ALL NATIONS" and the visual depiction and framing, the rhetoric conveying such notions differed significantly both in attitude and manner between the earlier stage of globalization and the contemporary stage under discussion here. While in the earlier example the empire was explicitly painted as the benefactor modernizing the world's population, it was charged with the dominant ideology in the era of High Imperialism. Designed within the context of contemporary globalization, and amid intense debate about cultural imperialism, the implicit visual language used to construct the power relationship between the empire and other nations in the example we are discussing here reflected a carefully managed shift in ideology and the cultural paradigm.

Discourses are affected by the governing ideological frame of the time. In the 1930s, Leeper openly described the function of the British Council as "cultural propaganda." In the 2000s, without overriding its enduring heritage and mission, the organization has had to redefine and defend this much-publicized term. For example, in his short essay "Cultural Imperialism?"—a key article in the History section of the organization's official website—Philip Taylor, the first historian to be allowed into the archives of the British Council, replaced "cultural propaganda" with the new term "cultural diplomacy" as a conduct not only engaged in by the U.K. but also "by most developed countries." Conceding that cultural diplomacy may be "a form of international propaganda on behalf of the value systems of the countries conducting it," he argued that "if the objective is to inform, educate and

entertain on the assumption that greater mutual understanding will result, then it can only be argued that this is propaganda on behalf of peace" (Taylor, 2004). It is interesting to note that the power factor—or, more precisely, the "soft power" factor—had been carefully neutralized in this discourse by the stated objectives of informing, educating, and entertaining, as well as in the interest of peace.

On the eve of the British Council's 70-year anniversary, in an article on the council's official website, Richard Weight reflected on its achievements and offered this assessment: "[T]hroughout almost seventy years of activity, the Council has proved that cultural propaganda, sensitively managed, can help to create international understanding, and with it, a more peaceful world" (Weight, 2004). "Sensitively managed" seems to be the phrase that relates so well to the design approach of the council's 50-year commemorative stamps. Even without official confirmation of this consideration, the observable representation strategy nonetheless signifies the advertiser's awareness of the need to avoid being seen as yet another example of cultural imperialism at a sensitive time, while still managing to deliver the message with carefully calculated subtlety.

MORE THAN A DOSE OF SHOCK

Here we examine the deployment of the imagery of the racial Other in charity advertisements, using the cases of five different campaigns and their rhetoric. Let us begin with the visual language that constructed the racial Other as the dying, the dangerous, and the victim in the first three examples, and the visual play on the "us and them" relationship between the "charitable" West and the "needy" Rest in the remaining two examples.

As non-profit organizations, charities must utilize advertising as a vehicle to help advance their causes. On the one hand, charity ads are used to raise public awareness of the organization and its particular social cause; on the other, they are used to raise money through public and corporate donations to fund the organization and its initiatives. It goes without saying that attracting donations is the key goal of even those ads that look "purely awareness" in nature. Charities operate in a highly competitive environment. For example,

in 2010 there were 507,608 IRS-registered charities in the United States, according to the National Center for Charitable Statistics, and 160,274 registered charities in England and Wales (Charity Commission website). In a battle to tug at the heartstrings of prospective donors and make them open their purses for a given cause, charities spare no effort to stand out from the crowd through striking advertising campaigns. Part of this effort is to create different strategies to represent the needy beyond the predictable, to maximize public awareness and attract donations.

The shock tactic is the most trusted strategy used in international charity campaigns. It has been a tradition to depict an emaciated Black child or adult and to use these shocking imageries as the focal point of the ads to elicit the desired emotion. Research into charity advertising posters that showed mentally handicapped people (Eayrs & Ellis, 1990), for example, confirmed that the images that achieved the greatest success in prompting donations were those that engendered feelings of guilt, sympathy, and pity. Images of Black children with "skin stretched over ribs, enormous heads, pot bellies, wasted buttocks and sticks for arms and legs" typified the representation of Biafra as a place of humanitarian crisis in Oxfam posters (Warren, 1995: 17). One particular poster, produced by UNICEF and featuring a 2-year-old barefooted Zimbabwean boy named Kwasi with the tag line "CHANCES ARE HE WILL STARVE TO DEATH" (Figure 5.14), typified the shocking images

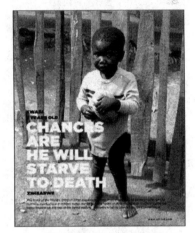

Figure 5.14, *UNICEF*

used to evoke the desired emotions. However, as the imagery of a poor (and often dirty and weak) African child, with his or her hopeless gaze fixed on the viewer, was overused to the point where it became a cliché, and as the focus on the "Third World problem" shifted into overdrive, new approaches began to emerge in the twenty-first century.

Figure 5.15 is another UNICEF poster advocating for the welfare of African children, designed by Jung von Matt of Sweden. To complement the tag line "Bad Water Kills More Children Than War," a Black African girl with a deadpan expression was depicted holding a water pistol and pointing it to her temple. Another poster, from the International Society for Human

Rights (ISHR), showed a close-up image of a veiled woman wearing fashionable smoky-eye makeup, with a touch of metallic highlight on her upper eyelids (Figure 5.16). Her black veil was visually manipulated to include five metal bars.

In these three ads, children and women of color were depicted as "victims" through the use of different shock tactics. While their respective tag lines stated each campaign's different cause, their design attempted to raise awareness and engage the public's emotion in different ways. In Figure 5.14, little Kwasi was pictured from above. As the viewer looked down at him, his body was noticeably disproportionate—a sign of poor nutrition that was further enhanced by the selected camera angle. Although Kwasi was the featured story in the ad, he was made a symbol for the poverty-stricken African continent at large, and African children in particular. The wooden fence behind him also contributed significantly to the story. The irregularity of the shape of the pieces and their arrangement not only connoted the Third World from the perspective of the West; it also provided the optical illusion that Kwasi was not standing stably on his own feet. More important, the visibly curved fence effectively separated Kwasi from the space on the other side, as would a cage. Because neither side of the fence looked any better than the other, it did not matter whether he was being fenced in or fenced out. What mattered for the advertiser was whether the image of a poor and feeble Black boy, and the frightening prospect of him "starving to death," were powerful enough to prompt the public to rescue the poverty-stricken African children from that symbolic cage.

To a large degree, the advertisers behind ads of this nature strategically constructed images of the racial Other in shockingly disadvantaged states to stir the "guilt complex" of well-meaning White audiences. They offered them the satisfaction of taking the moral high ground of "helping" the African nations (symbolized by this helpless, starving Black boy) by donating to the said charity. This genre of advertisement has been criticized as "an incorrect and damaging representation of people who live in poor countries" that "helps to perpetuate incorrect ideas of why these countries are in economic difficulty, obscuring the role wealthy nations play in the cause of their problems" (Warren, 1995: 18). The poster that depicted Kwasi said nothing more than "a poor Africa is in need of charitable help from the rich West." It did nothing to address the cause of the African problem, which Kwasi's tiny, emaciated body was used to symbolize. In so doing, it made the "Third World problem"

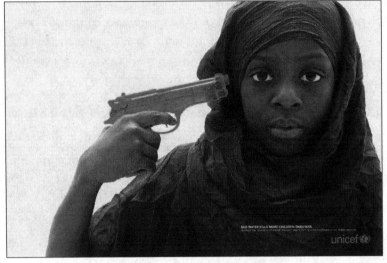

Figure 5.15, *UNICEF, 2007*

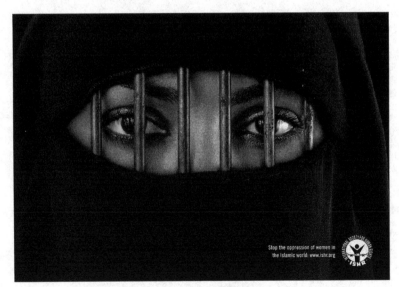

Figure 5.16, *ISHR, 2008*

seem as if it just happened to be out there in the ex-colonies, and the historic and current roles the ex-colonist nations played remained masked.

A discussion of the cause of this approach is beyond the purview of this book. However, it has been pointed out that there is a "chain of power relations which exercises control over the public definition of the cause of poverty" in play in the West, preventing such discourse. According to Geoff Warren, in the U.K.:

> If those actively seeking to help people in poorer countries have come to the view that the most important need is for changes in the policy of Western governments, in trading relations and regulations, in the activities of multinational companies and the exploitive activities of industries like the arms trade, it remains that charities concerned to help people in poorer nations are forbidden by law to campaign for these ends. (Warren, 1995: 22)

The use of imageries of the racial Other in the next two ads shows a shifting emphasis in the persuasive function—from one that focused on evoking feelings of pity and sympathy to one that focused on eliciting anxiety and disgust. Arguably, the situations used to elicit these emotions were carried via the constructed imageries of the racial Other and were attributed to their own national problems, rather than the ongoing unequal socioeconomic power balance between ex-colonial and ex-colonized nations.

In Figure 5.15, we see a well-arranged studio shot in which, against the white background, the Black girl was neatly dressed in a hijab made from a good-textured garment. The public did not know her name, but according to the cultural code of her skin color and her hijab, she was identified as an African Muslim girl. Judging by the smooth skin of her face and hand, the girl did not represent ill health or physical defect, and she was playing with a pretty decent-looking toy. So where did the shock come from? Visually, its source was the toy gun the Black Muslim girl was playing with. To begin with, it may disturb some audiences to see any girl playing with guns (the norm is, girls play with Barbies). However, because she was not just any girl—she was presented to the viewer as a Black Muslim girl—another level of anxiety was triggered at a time when the West was at war in Iraq and Afghanistan, and at a time when the war in Somalia attracted some coverage in the West. Given the vivid memory of images of child soldiers and suicide fighters frequently seen on their TV screens and in newspapers, audiences could be forgiven for associating this girl with those images as they tried to comprehend the

unusual setting being presented to them in the poster. When this anxiety was triggered, the imagery of the girl carried different meanings. She was no longer a Black girl playing with a water pistol but a sign of danger, of war, of hate, and of self-harm. Although the visual language dominated the space of the poster, the biggest shock was delivered by the subtly presented statement: "Bad Water Kills More Children Than War." Why compare bad water with war? Yes, unsafe drinking water is a problem for humanity, and there are data to prove the seriousness of this global problem. U.N. Secretary General Ban Ki-moon has reportedly commented: "More people die from unsafe water than all forms of violence, including war" (quoted in IPS, 2010). Although it is not clear whether "war" was mentioned as a highlight or an afterthought here, it is certain that war is only one example among many other forms of violence. Serena O'Sullivan, of London-based End Water Poverty, used other comparisons, stating that unclean water kills more children than malaria, HIV/AIDS, and TB combined (IPS, 2010). The choice of another natural or manmade phenomenon—for example, earthquake, epidemic, famine, or genocide—would arguably have been more convincing and less controversial at a time of criticism of a war still being fought. The problem is that "playing it safe" is often the last strategy that charities choose for their advertising campaigns. Most of them deliberately walk a fine line and opt for being provocative and controversial to gain public attention and free media exposure. In this case, and in many like it, insult is added to the injury of the very victim the campaign is meant to protect.

Figure 5.16 is a 2008 poster designed by Germany's Grabarz & Partner for the European public. A close-up of a black veil dominated the layout of the ISHR poster. In an in-your-face manner, two visual signifiers were presented to the viewer: the veiled woman and the metal bars as signs of oppression. Yet the veil or a veiled woman bears different meanings in different cultures and in different times. According to Egyptian anthropologist Fadwa El Guindi, in Arabic societies the veil "is about privacy, identity, kinship status, rank and class," and "[i]n general, veiling by women or men communicates, not subordinate gender status or the shame of sexuality, but the group status of the individual, the identity of the group and the sacredness of privacy" (El Guindi, 1999: 126). In his study of a 1910 postcard entitled "Arab Woman" depicting a veiled Egyptian woman, Robert Young argued that "for an Egyptian looking at the image in 1910, the veil would have symbolized the woman's social rank" because "Women of the lowest class, particularly the peasantry in the

countryside and the bedouin women of the desert, would not have worn a veil at all" (Young, 2003: 88–89). Unlike the veiled woman in Young's study, the veiled woman in this 2008 ISHR poster did not stand for the exotic objects of the Orient but for the oppressed victims of Islam. As if the overused image of a veiled woman in Western advertising was not by itself considered shocking enough to grab attention or to communicate "oppression," a set of five metal bars were superimposed on the photo. The rusty bars blocked part of the woman's otherwise uninterrupted vision, and the tag line stated: "Stop the oppression of women in Islamic world." Because of this alteration, the woman was not only "behind the veil" but also "behind bars." Symbolically, the rusty metal bars not only helped to convey the sense of imprisonment, but also unambiguously linked the otherwise equivocal nature of the veil to concepts such as backwardness, patriarchy, and control, among other oppressive measures. With the call to "Stop the oppression of women in the Islamic world" and with the metal bars implanted on her veil, the Muslim woman behind the veil no longer needed a name, an ethnic identity, a culture, or a history—she had been transformed into a symbol of an oppressed object, namely, "women in the Islamic world." This was a contentious ad filled with a range of controversial concepts. If the intended reading was to follow, the civilized (and therefore unveiled) public in the West was expected to take appropriate action to help the organization behind the ad free the "women in the Islamic world" from the veil that apparently imprisoned them.

Besides generating new ways of delivering the shock effect, concepts of "us" and "them" have been tweaked in a number of charity ads in recent times. Here we examine two advertising campaigns: one from Cordaid (Figures 5.17a, 5.17b, 5.17c, and 5.17d), designed by Saatchi & Saatchi Netherlands in 2007, and the other from Humana (Figures 5.18 and 5.19), designed by LoweDraftFcb Netherlands in 2009.

Through its "People in Need" poster series, Cordaid appealed for cash donations via SMS to help it assist people in need. African women and men were used as models—not only as models in the general sense, but actually in "modeling" or mimicking professional models in the West. Their postures were directed in such a way as to make them look like models for fashionable consumer items as seen in Western media. And yes, each of them had one such item in their hands—a handbag, a pair of sunglasses, a bottle of aftershave, and a pint of beer, each bearing a price tag in Euros. However, the similarities ended there. The models were not well groomed, they sported no makeup or

expensive hairdos, and they wore only so-called tribal accessories. They were bony. Some appeared barefoot, some wore shabby footwear, and their clothing was worn and torn. These accumulated visual signs spelled "poor"—if not "poverty"—for the Other of the West. These were the imageries of "them," the poor and needy Africans—the "people in need."

Where, then, was "us"? The imagery of us as people was nowhere to be seen among the posters in the campaign. Yet the invisible West was at once behind the campaign, at the heart of the campaign, and in front of the campaign. To begin with, the Africans' poses were directed by a European agency for the eyes of a European audience. Visibly uncomfortable, they were made to imitate the alluring postures of Western models for us so that such unusual settings would attract our attention. The consumer items in their hands did not have much to do with their lives, yet these items were considered daily basics for us and thus connoted a kind of lifestyle and consumer culture we

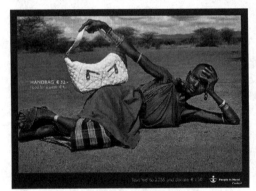
Figure 5.17a, *Cordaid, 2007*

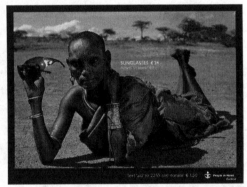
Figure 5.17b, *Cordaid, 2007*

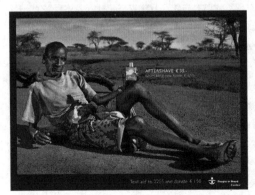
Figure 5.17c, *Cordaid, 2007*

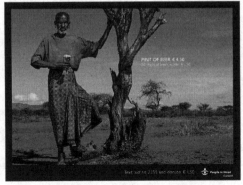
Figure 5.17d, *Cordaid, 2007*

were accustomed to in the West. The West was there when the price of a simple handbag was eight times that of the African woman's weekly food costs; when a pair of ordinary sunglasses cost three times that of the African woman's access to water; when a bottle of aftershave cost five times more than the basics for a new home that an African man needed to buy; when the cost of a pint of beer could buy the African man 150 liters of fresh water. It is through the differences highlighted by the gap between "us" and Africa that the West finds its superiority—and its wholeness and trueness. This is a case of the labor of the negative, using Hegel's term (Hegel, 1979), in which the self recognizes its trueness by mediating itself in terms of its sameness with the Other on the one hand, and constituting itself by its very difference to the Other—a negative of itself—on the other. In this poster series, both the sameness and Otherness were mediated mentally, visually, and literally to fill the gap in our fractured egos. By texting "aid" to 2255 and donating €1.5 to Cordaid, as the poster instructed, the self reacted to its Other and, for a moment, reclaimed its Ego-Ideal and its moral high ground.

Humana's "Let your 2nd hand clothes help the 3rd world" ads also depicted only imageries of Africans against the backdrop of local conditions that had all the requirements for connoting the "Third World." In Figure 5.18, four Black people were pictured standing in line facing a well. Their faces were unrecognizable because they had been poorly (if not deliberately) positioned against the harsh sunlight. Vaguely, these figures denoted two adults and two children, with their genders evenly distributed among age groups. They were standing still, with their hands placed behind their backs. In short, the only people depicted in this ad—all Africans—were arguably faceless and evidently motionless. While their faces could not be recognized, and with their relationship to each other also unclear, they were nonetheless effective signs in this ad. First, they could be denoted as Africans, or Blacks. Second, they could be connoted with concepts such as needy, indigent, poverty-stricken, backward, lacking, and, above all, "Third World'—a keyword in the campaign tag line. Third, and on an ideological level, since they were used to symbolize the Third World, their apparent inaction, communicated via the ad's depiction of idleness in their collective body language, was almost a visual version of Rostow's theory, which suggested that the development of the Third World could be made possible only with the help of the West/North.

In contrast to the stillness of the passive Third World people, the well and the white polo shirt became the center of activity in the ad. Water was visibly

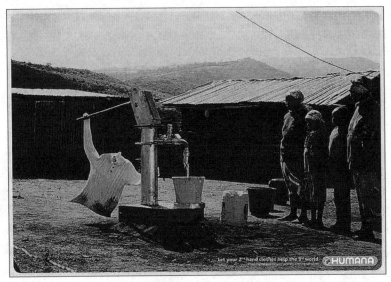

Figure 5.18, *Humana, 2009*

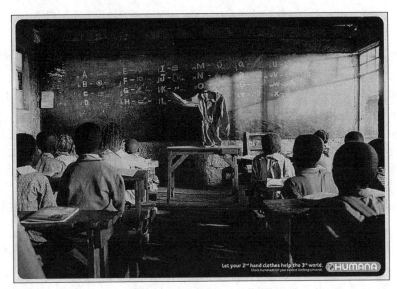

Figure 5.19, *Humana, 2009*

flowing from the well into one of the plastic containers in the queue. What made this happen, the ad showed us, was the floating white polo shirt: its left sleeve was holding the pipe while its right sleeve was plumbing the water from the pipe to the bucket. On one level the dirty white polo shirt denoted secondhand clothes. On another level, it symbolized the helping hands from "us" in the West. It stood not only for our secondhand clothes but also for our help to the poor nations—a give-and-take relationship clearly defined by the tag line's appeal to the Western audience: "Let your 2nd hand clothes help the 3rd world." As such, even in the absence of any Western faces or figures, the white polo shirt stood for the help provided, generosity offered, and actions taken by the charitable West to the Third World.

Using a focus on education, the other ad in the series (Figure 5.19) took the same approach. A dozen African children were depicted sitting in a poorly equipped classroom. Again, although the Africans were the only people in the ad, their faces were not shown to the audience. Again, the local condition they were in spelt "Third World" and the problems associated with it. And yet again, all of the Black characters were in a stock-still position. Therefore, these boys and girls were used to symbolize the passive, backward Third World youth. In the same manner, the West was represented by a floating, secondhand piece of clothing—this time a pink shirt—as a symbol of the helping hand from the West. Again, the only action was from the pink shirt. This time, the right sleeve was rising up, pointing at the blackboard to teach the English alphabet, for example "a A = apple."

Imageries from both ads in the campaign were taken from a 60-second TV commercial of the same title. A comparison of the motionless depiction of the racial Other in the printed version against the moving TV version left no doubt about the contrast between the inaction of the local and the action of the West—indeed it became even more obvious. While strictly speaking not motionless, the Africans remained spectators while the secondhand clothes (signifiers of the help from the West) were the doers, performing all the work for the locals. Following the Humana truck, the first sighting of the locals was of two boys sitting on top of a broken wall. The second shot was of an expressionless Black male sitting on the ground in front of a petrol station. None did anything other than watch the truck drive by. As the truck stopped, the secondhand clothes, led by a pair of blue jeans, readied themselves for a rush to action to help the locals: the pink shirt found its way to the school to get into its role as teacher by inviting the children to learn

(the scene depicted in Figure 5.20); a blue shirt found its way to a football field, encouraging the children to play and found itself a role in the game as a gatekeeper; the blue jeans walked into a hospital holding a Black baby; the Polo shirt struggled to drag a large water pipe with no help at all, while a long shot showed a Black boy laughing at its effort from a distance. The next thing we saw was the scene depicted in Figure 5.18—the Polo shirt was pumping water for the locals using the very equipment it singlehandedly delivered (and presumably installed) as the locals stood by watching. The commercial ended with a shot of the very same broken wall, but this time it was painted with the Humana logotype.

In short, when it came to solving the "Third World problems," be they water or education, the ads showed the audience that only the West was in control and taking action. The narrative and visual depiction of the ads in this campaign told a story about the differences between "us" and the Third World and told us about our place in the world. Although its stated purpose was laudable—to attract donations—it carried a familiar notion of the modernization theory. Through the portrayal of the "Third World" locals as passive people who took no action to help themselves, the campaign suggested that even the secondhand clothes from the West could be the savior of the Third World. Rather disturbingly, in the guise of the benevolent appeal to "Let your 2nd hand clothes help the 3rd world," a recast Great Chain of Being for the contemporary age has emerged, one that suggests the following hierarchical order:

1st world people, 2nd hand clothes, 3rd world people.

OLD CLICHÉS FOR NEW AGENDAS

RECYCLING "ANIMALITY'

The Agricultural Rehabilitation Programme for Africa (ARPA) of the U.N.'s World Food Organization launched a campaign in 2009 in an attempt to raise public awareness of the extinction of wild animals. Designed by DKP Brazil, the campaign contained three posters with the tag line "Their extinction is ours as well" appearing subtly above the ARPA logo (Figures 5.20a, 5.20b, and 5.20c). All three posters were shot in a rain forest with the tone, shade, and

mood reflective of nature and "green" (visually and politically). With the jungle as the background, each poster in the series featured a model aping an endangered animal: a crocodile, a panther, and a gorilla. A male model of African appearance was used to pose as the crocodile, a female model of African appearance was used to pose as the panther, and a male model of Latino appearance was used to pose as the gorilla.

All three models posed nude, with their bodies exposed to the audience. Regardless of their different positions, their facial expressions were the same. Their mouths were tightly closed, their eyes were all sharply engaged with the audience as if they were pleading—perhaps on behalf of the animals they were imitating—to be protected and spared from unwanted human intervention in their natural habitat. If this was the message, the models played the role of creatures that could not "speak" for themselves, with their eyes effectively getting the message across. The question is this: Could White models have performed the same role equally well? Given that non-White models were still highly underrepresented in the ad world, why weren't the more highly valued White models useful to the advertiser on this occasion?

The logic underpinning inclusion and exclusion aside, the role the Black and Latino models were playing in communicating the message becomes obscure when one reads the small tag line: "Their extinction is ours as well." Considering that their images were constructed as representations of animals, the question is: Are they the first-person "us," the human, or the third-person "them," the animal? Despite the tiny tag line suggesting the former, the non-White models were indisputably posed as animals, appearing nude like animals, pleading like animals, looking scared and ready to escape and, more significantly, mute. The organization of the visual signs makes it clear that the Black and Latino models did not own the tag line. The tag line was for the audience, while the objectified non-White models were merely the living props replacing real animals for additional attention and appeal. This effectively made them the awkward in-betweens—reminders of the all-too-familiar colonial racial script that linked people of color (Blacks in particular) with animals, either by likeness or by ridiculing their relationship with animals. Take the crocodile as an example. While the first poster in ARPA's campaign (Figure. 5.20a) was a contemporary play on the old Black animality script, one that deliberately constructed the Black model's body to create the "likeness" of a crocodile in danger of extinction, the 1902 ad for the Stainilgo brand of soap (Figure. 5.21) was one of the many early ads that exploited

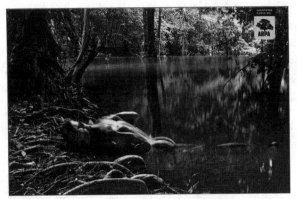

Figure 5.20a, *ARPA, 2009*

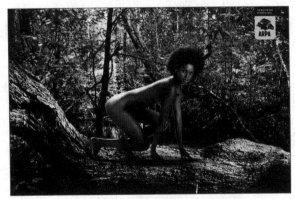

Figure 5.20b, *ARPA, 2009*

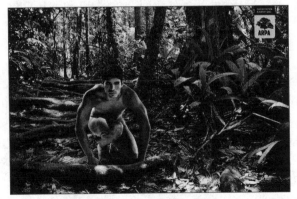

Figure 5.20c, *ARPA, 2009*

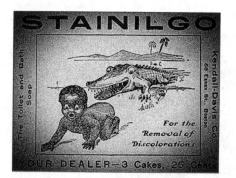

Figure 5.21, *Stainilgo, 1902*

imageries of Black children escaping the fate of being the crocodile's "prey."

The imageries of the racial Other in the ARPA campaign were used in a way that was at once strategically familiar and different. Instead of using imageries of the endangered animals to construct the ad and make the appeal, the campaign opted for the human metaphor—and not just any human, but only the "colored" human. The blanket use of imageries of the racial Other, and the absolute non-use of White imageries associated with concepts of animality was a familiar phenomenon with a colonial logic. Through both its casting and construction, the campaign quite clearly recycled the colonial racial imagination, particularly the concept that likened the racial Other to that of subhuman and animal, as outlined in Part One of this book. This campaign essentially remodeled an old and officially redundant cliché of Black animality to communicate a new and popular political agenda.

THE LURE OF "DEFORMITY"

In 2008, Tourism Thailand launched its Amazing Thailand campaign (designed by JWT) to promote the country to the world. A set of five posters—Karen, Boxing, Monkey, Songkran, and Floating Market—formed part of the campaign. Here we examine the first of these posters for its theft of identity and for its new take on the "deformed" body.

The poster entitled Karen (Figure 5.22) depicted two young girls from the Karen-Padaung tribe in native costumes. While the headgear of both girls and the face painting on the girl on the right already expressed a sense of the exotic Orient, the neck rings they were wearing stood out as the ultimate symbol of exoticism. The neck ring had fascinated the West ever since Marco Polo reported the practice of neck stretching in his journey through China to Asia in the thirteenth century. For centuries the Karen-Padaung women had been wearing brass coils on their necks. However, they only became accessible to international tourists in "real life" in 1989 when they fled from their homes in Burma into Thailand to escape the armed ethnic conflict between the Burmese

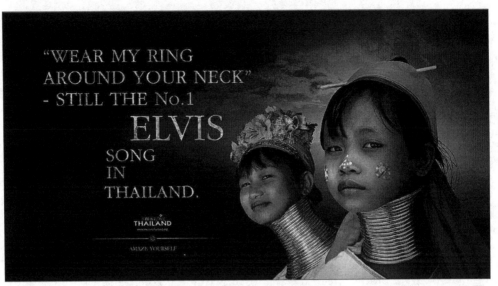

Figure 5.22, *Tourism Thailand, 2008*

government and the Karenni resistance groups. Before then, under Burma's military regime, foreigners were not allowed to travel to the Karenni State where the Padaung people lived, and so they remained beyond the gaze of the outside world.

To use the Karen-Padaung girls as symbols of Thailand was far-fetched to say the least. The Karen-Padaung people were essentially the minority racial Other in the country. The Karen population was estimated to be 3,500,000 in Burma and 400,000 in Thailand. Of the Karen people living in Thailand, only around 500 were from the Padaung sub-tribe whose women wear neck rings, according to the BBC's Andrew Harding. Compared to the other Karen sub-tribes that settled in Thailand more than 5 decades ago, the Padaung was among the smallest and newest. Upon their arrival, the Padaung people typically settled in villages near the refugee camps in the country's mountainous north. Tapping into the curiosity about the Padaung's ancient practice and the mythical female body, some of these villages were developed as fee-paying tourist attractions. To complicate the matter further, the Thai government and the U.N. refugee agency UNHCR were locked in a dispute about the residency status of the Karen-Padaung people, and in January 2008 a UNHCR spokeswoman advocated a tourism boycott, claiming the village was "absolutely

a human zoo" and that the Karen-Padaung people were being trapped there (BBC News Online, 30 January 2008).

Although the use of the Padaung girls to symbolize Thailand is worthy of challenge on many fronts, there were very good reasons to deploy the imagery of the neck-ring-wearing Padaung girls to promote Thailand to the Western world. The "long-necked hill-tribe villages," as promoted by tourist agencies, had become a tourism drawing card, feeding the West's fascination with the Padaung women ("long-necked women" or even "giraffe women") by offering a close encounter with them. Reporting for the BBC from Mae Hong Son in Thailand, Harding captured the West's obsession with the "long-necked women" and the ways in which the Otherness of a deformed "abnormality" (even animality) attracted the tourist gaze:

> It is hard not to stare. At the end of a dirt track, deep in the Thai jungle, a group of women sit in the shade, fingering the coils of brass which snake tightly around their unnaturally long, giraffe-like necks.
>
> "It's incredible," says a Canadian tourist, snapping away with his camera, as the women pose—heads bobbing stiffly far above their shoulders—and try to sell him a few souvenirs from the doorsteps of their bamboo huts.
>
> For years the prospect of visiting one of three "long-necked" Kayan villages in this remote corner of north-western Thailand, close to the Burmese border, has been a major lure for foreign tourists. (BBC News Online, 30 January 2008)

Both in reality and in the ad, then, the "long-necked" Karen-Padaung girls were used as the lure of exotic Thailand. Bearing the sign value of an ancient time and isolated land, the charm of the unfamiliar, and the seductive modified female body, the girls were used to attract, to seduce, to entice, to persuade, to brand, and to sell the country to the outside world.

Although their identity was not as authentically "Thai" as the kick-boxers, or the Songkran festival, or the pig-tailed macaques, or the Floating Market, the Karen-Padaung girls were deployed in the campaign to symbolize a country in which they took refuge beside these icons of local culture. This was, in effect, a form of economic inclusion in which "abnormality" was sold as exotic appeal, the "deformed" body became an extra currency. If there was any doubt about the nature of exoticism in this poster and its attempt to tap into the appetite of the Western tourist, consider the very pronounced yet highly peculiar tag line, which read: "WEAR MY RING AROUND YOUR NECK"—STILL THE

No. 1 ELVIS SONG IN THAILAND. This identity game unambiguously attempted to appeal to the West's fetishism toward the racial Other. While the deployment of the "long-necked" Karen-Padaung girls, through a twist in the complicated process of Othering, added value to Thailand's attractiveness as a tourist destination, the key selling point—the neck rings—still needed the West's seal of approval. In this case, U.S. cultural icon Elvis Presley provided the endorsement.

CHAPTER SIX

RACE IN COMMERCIAL CAMPAIGNS

REDEMPTIVE MAKEOVERS

Three major makeovers of brand identities between the 1980s and the 2000s are examined in this section—all with a theme that is typically redemptive in nature. While enjoying a high status in their respective industries (oral hygiene, sport, and confectionery), all three brands suffered from a common trait. That is, their existing trademarks and logos were historically marked by a racist overtone that had damaged and could have further damaged the brand's reputation and business prospects if changes were not forthcoming. These makeovers represent different strategies for managing such pressing needs by making good their otherwise problematic branding images in the age of contemporary globalization, and by telling the story that they have moved on and changed for the new era.

The earliest and most publicized makeover of this nature was performed by Quaker on the Aunt Jemima logo in 1968, as mentioned in Chapter 3. At this time the brand was under threat of a product boycott from civil rights groups because of its negative and stereotypical portrayal of Black women as mammy cooks. In 1989, the image of Aunt Jemima in the logo was further reshaped—she became much thinner, younger, and was fashioned with a perm, pearl earrings, and a white shirt. The result of these changes has been well documented by Karen Jewell: "Unquestionably, there have been changes in the traditional images of mammy, Aunt Jemima," yet "[t]he major changes that were made in the mammy image affected her physical characteristics more than her emotional makeup" (Jewell, 1993: 183). What prompted the following

branding image makeovers was different, and the process and strategy in addressing the challenges were unique. What aspects of the existing racist branding images were changed in these makeovers, in what manner, and to what effect?

THE WHITENING OF DARKIE

The circumstances that triggered the need for a redemptive makeover of the Darkie Toothpaste branding were extraordinary. Originally owned by the Hong Kong-based company Hawley & Hazel, the English brand name "Darkie" and its logo had been part of the "bilingual trademark" of Asia's most popular toothpaste since the 1920s (Figure 6.1). As the product was known by its Chinese brand name 黑人牙膏 (Black Person Toothpaste), the image in the logo was seen as a smiling Black man by the locals in its major markets of Hong Kong, Taiwan, Singapore, and Malaysia. The locals lacked the language and

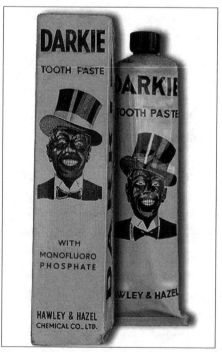

Figure 6.1, *Darkie, 1920s*

cultural understanding needed to detect the racist connotations of the word "darkie" (which could not be found in the commonly used English/Chinese Dictionary of the 1980s, while its synonym "darky" was translated as: "[俗] 黑人," meaning "[Colloquialism] black people)," and for decades the brand attracted no criticism in Asian markets for its racist representation. It was not until 1985, when U.S. giant Colgate-Palmolive brokered a deal to buy 50% of the brand from Hawley & Hazel, that the racial slur inscribed in the company's branding became public knowledge and attracted criticism in the United States. Two years of growing U.S. public pressure eventually led to Colgate's 1987 decision to rebrand Darkie. However, the search for a new brand name took longer than 2 years to settle, and the modified logo did not reach the market until 1991.

This is a case of a brand whose identity was built for an Asian market on and around the concept of Blackness in the early twentieth century, and a case of a rather reluctant and awkwardly long journey of redemptive rebranding by its new multinational owner amid domestic political pressure in the United States in the late twentieth century. The far-from-voluntary decision to change the existing branding and the resulting strategy of "whitening" the racial references in the original trademark speak to the complexity of this case. Our examination of the case, therefore, involves both textual and contextual analysis that interrogates the design and redesign of the trademark considering the historical, cultural, and commercial dynamics. Why and how was the word "darkie" and the image of a Black man considered useful and used to brand the toothpaste in the first place? What triggered the makeover? In what manner was the makeover carried out and with what considerations? What was changed and achieved as a result? Through the window of the design and redesign of the Darkie brand, the different strategies used to deal with tropes of Blackness can be seen at different times and in different cultural contexts in the process of globalization.

Hawley & Hazel have never offered an official explanation as to the origin of the design and rationale for the Darkie brand identity. However, according to Colgate-Palmolive, the Darkie name and logo were conceived in the 1920s after Hawley & Hazel's chief executive visited the United States and saw an Al Jolson show. The executive saw Jolson's wide smile and bright teeth as an excellent image for a toothpaste logo (*New York Times*, 27 January 1989: D1). Another version of the story, however, disputed the visit to the United States or the Al Jolson show. It claimed that, having resided in Hong Kong, none of the founders had actually met a Black person at the time, and that the logomark was based on photos they had found in magazines. The rationale for deploying the black-faced imagery, however, more convincingly corresponds with the Colgate version. According to legend, the brand image was the work of an Irish-Englishman who helped to render the Darkie logotype and transform the image of a black-faced Jolson into a logomark that became a registered trademark for the brand.

The Darkie brand consisted of both word (the brand name) and image (the logo). If we read into the historical roots of these original branding elements, there is no shortage of racist references. Brand-name wise, the word "Darkie" may have denoted a person with black or dark skin in dictionary terms for centuries. However, when taking into account the word's association with the

historic institutional, cultural, and economic abuse of Blacks in the United States, "Darkie" was indeed a derogatory cultural term with extremely offensive connotations for African Americans. The term has been belatedly recognized as such and tagged with labels such as "offensive" and "racial slur" in most dictionaries. Logo-wise, the inspiration of Al Jolson imagery (be it firsthand or mediated) in establishing the Darkie name and imagery linked it to the iconic and degrading images typically seen in minstrel shows. In these shows, non-Black entertainers darkened their faces and painted their lips red, pink, or white for their performances—mocking, ridiculing, and degrading Blacks.

In terms of its visual components, the original logo (Figure 6.2) immediately denoted a Black man. The visual signifiers—the inky-black skin, googly eyes, pronounced thick lips, and toothy smile—all came from and further reinforced the stereotyping of Blacks as portrayed and popularized by minstrel shows. Several record covers with Jolson's iconic images in the 1910s and 1920s back this claim, with *The Best of Al Jolson* perhaps the most significant one (Figure 6.3). The face in the logo and the image of the famous Jolson on the record cover were almost identical.

While the resemblance between the logo and Jolson's black-faced image was clear, the use of the black-faced Jolson was not total, as visual manipulation was also evident and should not be ignored. The addition of the top hat and the bow tie in the costume department is worth noting, as is the altered appearance of the mouth in the facial department. Both the top hat and bow tie were typical accessories in minstrel shows. In fact, Jolson himself was depicted on the cover of his *Stage Highlights 1911–1925* album wearing a similar costume (Figure 6.4).

In terms of facial manipulation, a number of notable changes of expression between the logo and its identified source were made around the mouth area. In Figure 6.3, Jolson's mouth was open in a way that suggested he was singing an "R" note. In the logo, the Black character's mouth was shaped in a way that suggested he was singing an "E" note. This alteration enabled the maximum number of teeth (both upper and lower) to be shown in the logo, improving the existing image in which only the upper teeth and tongue were visible. The other change worth noting is the transformation of the color of the lips. Although subtle, the designer chose to darken the Black character's lips—in marked contrast to Jolson's tendency to paint his lips lighter than his face. By doing so, the Black man's teeth were highlighted, and the highest possible degree of contrast, namely black and white, was achieved. As we can see, while

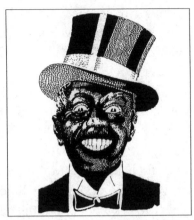

Figure 6.2, *Darkie, 1920s-1991*

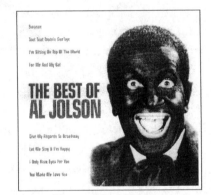

Figure 6.3, *2006 issue*

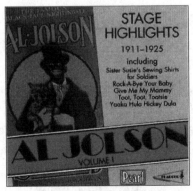

Figure 6.4, *1991 issue*

the design inherited a great deal of the visual elements from the Jolson reference, it was not simply a carbon copy. The designer picked and chose useful elements to construct an image that delivered the brand's selling point: "Use Darkie and your teeth will be as white as a Black man's." In fact, the image of the Black man created for the Darkie brand reminds us as much of Bernier's typology of Blacks during the colonial era (referenced in Chapter 2) as of the Jolson iconography. It begins with: "1. Their thick lips and squab noses" and ends with "finally, their teeth whiter than the finest ivory, their tongue and all the interior of their mouth and their lips as red as coral."

Examining the way in which the image of a Black man was used in the original Darkie branding is crucial to appreciating the usefulness of such an image. It would be naïve to think that the Englishmen who established the branding identity used the image of a Black man because they worshipped Jolson to such an extent that they honored him by linking his image with their product (like the gesture that the U.S. Postal Service made in 1994 when it issued a 29-cent postage stamp in his honor). In this case, the usefulness of the racial Other relied squarely on the colonial racial myth that Black people had the whitest possible teeth. Hawley & Hazel's decision to choose the word "Darkie" as their product's brand name may well have been inspired by one owner's experience of a minstrel show or by the worship of Jolson through the magazine coverage of such shows, but ultimately the choice was motivated by what the image and concept of Blackness could offer the company's flagship product—toothpaste. In other words, the stereotypical and mythical beliefs associated with the word "Darkie" bore the desired sign value—namely, its stereotypical and mythical association with whiter teeth—and Hawley & Hazel were astute enough to pick up on this and to associate it with the promotion of their product.

What attracted Colgate-Palmolive's interest in acquiring the Darkie brand was a great deal of market exposure and the dominance the brand had enjoyed in Asia for decades. For example, Darkie toothpaste had dominated the market from the time Hawley & Hazel started manufacturing it in Taiwan in 1949, and was commonly described as 微笑的黑色巨人 (smiling black giant) in the local media. A government document titled *Industry Forecast: Hygienic Product Industry*, for example, stated that Darkie toothpaste had been a firm industry leader in Taiwan. The report's author used the term "unshakeable" to describe the brand's unchallengeable market share (黑人牙膏在市場的地位屹立不搖). The golden age for Darkie was the 1980s, before a number of multinational

brands entered the local market. In Taiwan at that time, the brand's market share was said to be about 80% across the board and close to 90% in rural areas.

Obviously, Colgate-Palmolive acquired Darkie because of its market position and the potential for cultivating even greater market share and profit. However, it would prove impossible for the U.S.-based multinational giant to overlook the racist connotation of the brand's very identity, given the sensitivity of Black citizens at home to past racial injustices. If it had taken comfort in the fact that there had been no previous complaints or criticism of the brand's racist overtones, then it had failed to understand the cultural reasons for this in Asia and, perhaps more significantly, failed to realize the degree of anger and reaction the brand would attract in its own backyard.

In its first year in the Asian market, the company's U.S. $50 million investment reaped annual sales in the double-digit millions. However, from 1986 on, its links with Darkie toothpaste began to attract attention and criticism in the United States. The Interfaith Centre on Corporate Responsibility, a non-profit New York-based organization of more than 240 church groups, led the protest, decrying the brand name as racist and its logo as demeaning to Blacks. It demanded that Colgate-Palmolive change both identity elements, or the brand would be seen to be "associated with promoting racial stereotyping in the Third World" (*Multinational Monitor*, 1986). Investors also campaigned, pressing Colgate-Palmolive to discontinue marketing toothpaste in Asia under the "Darkie" brand name. In 1987, the company was confronted with a shareholder resolution calling for a change in the product's "name and imagery" (Fortune 1988: 21). The General Assembly of Pennsylvania, for example, delivered House Resolution No. 318 publicly urging the Colgate-Palmolive Company to change the name and logo of Darkie toothpaste, and transmitted this Resolution directly to the company's corporate headquarters in New York. In it, the assembly stated: "This repugnant name and logo is blatantly racist and deeply offensive to African-Americans" (The General Assembly of Pennsylvania, House Resolution No. 318, 1990). The developing controversy was brought to the attention of the American public through the media, including articles in the widely circulated *New York Times* and *Wall Street Journal*, among others.

In January 1989, after years of pressure from Black activists, religious groups, politicians, and stakeholders, the Colgate-Palmolive Company finally announced its decision to rebrand Darkie toothpaste by making changes to both its brand name and logo. Obviously, Colgate-Palmolive's decision to

change the visual identity was a long time coming and was far from voluntary. Facing the initial criticism in 1985, the company refused to change the marketing of Darkie toothpaste in any way, arguing that the Darkie name and the black-faced logo were not perceived in Asian culture as derogatory toward Blacks. Making it clear that Darkie toothpaste was not going to be marketed in the United States, Colgate argued that should that change, the company's position "would be different" (*Wall Street Journal*, 1988). However, as public pressure mounted, the company found itself caught in a dilemma between maintaining a positive corporate image in the United States and protecting its commercial interest in the newly acquired golden goose in Asia.

In February 1987, reacting to its religious shareholders' threat to introduce a tough resolution in relation to the company's Darkie brand, Colgate softened its stance by signaling its intent to change the Darkie identity. According to the *Wall Street Journal*, Gavin Anderson, company director of executive services, announced: "We are attempting to find a way of naming and designing the package that might remove any inference of racial stereotyping." The same source noted that in response to this gesture, three Roman Catholic religious orders agreed to withdraw the planned shareholder resolution challenging the company practice. In the following years, Colgate and Hawley & Hazel were said to be conducting research for new Darkie branding. However, given the longer-than-expected time it took to realize the promised rebranding, Colgate was criticized for dragging its feet over the issue.

What happened in the period before this point provides the context that led to the identity makeover; what happened after 1987 was a rather uncomfortable economic and political joust between its relationship with the public and its corporate bottom line. Colgate-Palmolive's vice president for marketing, Michael Hoye, quite unusually publicized the objective of the rebranding. The challenge for the exercise, Hoye indicated, was to find a name and logo that eliminated the racial offensiveness yet was close enough to be quickly recognized by loyal customers (McGill, 1989). It went without saying that the desired outcome of the redesign, from the company's perspective, was one that maintained maximum likeness to the original trademark for economic reasons on one hand, while escaping public criticism for racial stereotyping on the other.

Such a challenge proved to be a tough one. In terms of the brand name, the redesign started with the development of a list of all possible one-letter changes from the word "Darkie." Several professional marketing firms were

engaged to help suggest alternative names. According to one source, after rejecting names such as "Darbie" and "Hawley," Colgate and Hawley & Hazel began market testing one from a shortlist of new names—"Dakkie"—before finally settling on "Darlie." No statement was made to explain why "Dakkie" was picked in the first place, or why "Darlie" ended up being the final choice. What we do know is that Colgate's market testing of "Dakkie" as the potential new name again got the company into trouble in the court of public opinion, engendering criticism as not seeing the light after such prolonged protest and struggle. With the benefit of Hoye's much-publicized rebranding objective, it is not difficult to understand the wisdom. "Dakkie" was the first choice because of its maximum likeness to "Darkie" in both visual and phonemic terms. The one-letter change looked close enough to the original name to foreigners' eyes, and sounded like it to foreigners' ears. The company may have tried to push its luck in the hope that "Dakkie" would be socially acceptable because—unlike "Darkie," or the cloned "Darky," for that matter—the spelling of "Dakkie" was not on the list of existing racial slurs back home.

However, this was not the case. After pushing the limit and attracting yet another round of negative publicity, Colgate finally settled on "Darlie." If the company had not been so desperate to maintain a likeness in both pronunciation and spelling, and if it had understood the cultural factors that dictated how the brand was recognized and uttered in the local market, it should have chosen "Darlie" in the first place—not only because "Darlie," like "Dakkie," involved changing only one letter from the original brand name, but also because "Darlie" did not sound like "Darkie" and thus represented a more decisive move away from the problem. The reality is that, either way, the change was not even noticed by the great majority of local consumers, as they did not recognize or utter the brand name in English. The change of name attracted little if any meaningful attention in the market—particularly given that the Chinese brand name 黑人牙膏 remained intact following the rebranding.

If it was challenging for the company to come up with a new name, it appeared to be even more difficult to come up with a new image to replace the black-face in its controversial logomark. When market testing the Dakkie solution, Colgate tried to get away with using the same black-faced logo but such action copped another round of criticism. On 17 April 1989, a full-page newspaper advertisement from Colgate-Palmolive was published in Singapore's English-language newspaper *The Straits Times*, formally announcing that one of the most popular brands of toothpaste in Southeast Asia was changing its

name from "Darkie" to "Darlie." The disappointment was, as the *New York Times* noted, "Colgate-Palmolive had said it would phase in the new name and a racially ambiguous face under the top hat. However, the advertisement today in *The Straits Times* carried the same blackface logo" (*New York Times*, 18 April 1989: D25).

The absence of a new logomark in the advertisement was not a blunder by the company or its agency. It was explained as being the result of the difficulty the company encountered in changing the logo. The *Wall Street Journal* (14 April 1989: 1) quoted Anderson: "We've done an enormous amount of work on the logo, but it continues to be a problem." He elaborated on the cultural factors involved: "We thought the solution would be a lot easier, Darkie is so ingrained in the culture, particularly in Taiwan. There's never been a bleep about it [there]."

In 1988, with Colgate supposedly in the process of developing a non-racist logomark to calm the Darkie controversy, the company launched another toothpaste in Japan under the brand name "Mouth Jazz." Featuring an extremely similar logomark—a black-faced man in a top hat—the company attracted more criticism in the United States, with "Mouth Jazz" considered a Japanese version of "Darkie." Answering its critics, Colgate insisted that "Darkie" and "Mouth Jazz" were unrelated. Anderson argued: "There is no reason to associate the two products. The name is totally different and the product bears no resemblance to Darkie" (*Wall Street Journal*, 14 April 1989: 1). In terms of the logomark: "I don't think it is indicative of a minstrel at all. It is a black-faced person wearing a top hat" (quoted in Fortune 1989: 21).

So the search for that elusive fine line between a "minstrel" figure and a "black-faced person in a top hat" continued. While Colgate hinted that a racially inoffensive new logo would be released in early 1989, the new logomark was not revealed to the public until 1991. Figure 6.5 shows the much-anticipated new logomark. With the posture, expression, top hat, and rest of the costume in the original logomark intact, the makeover logo looked almost the same as the original, except for its facial features and complexion. To silence the critics, the newly created caricature could no longer be described as having an inky-black skin, googly eyes, and exaggerated thick lips and looking like a grinning simpleton—like the stereotypical portrayal of blacks popularized by minstrel shows in the United States. The face was slightly longer, the lips thinner, the eyes narrower, the bridge of the nose significantly higher, and the

nostrils smaller—converting the existing facial features typical of Black populations to those of Whites. Although these alterations sound like a job for a cosmetic surgeon, the procedures were performed by the illustrator and the designer according to Colgate's brief.

The face job was not complete without the whitening of the existing inky-dark face. Visual tricks involving switching drawing styles and rearranging light distribution were used to help achieve the whitening effect. The original even-toned caricature was replaced by a black-and-white silhouette. The change in drawing style, coupled with the change in

Figure 6.5, *Darlie, 1991*

lighting distribution, resulted in a face that reflected more of the white/light area than the black/shadow area. Like the 2-year-long game the brand played with the word, this 4-year-long game with the image was driven by public opinion and played with reluctance, hesitation, and deliberate calculation.

Just as in the choice of name in the word game, the choice of visual style was less an aesthetic decision than a strategic maneuver: it carefully whitened the otherwise distinctive features typical of Black people to such an extent that was just enough to avoid the criticism of racial stereotyping, yet not quite enough to lose the brand's iconographic heritage in its Asian market. It walked the line between difference and similarity.

Looking back, it took more than a year of intense social and economic pressure for Colgate to accept that the Darkie branding identity must change, 2 years of playing the "word game" to change one letter in the existing brand name, and 4 years of playing the "image game" to complete the cosmetic surgery needed to whiten the logo's black-faced image. The Darkie controversy and Colgate's strategy to manage it raises many more questions. But for the purposes of this section, it is clear that this makeover was involuntary in manner, inconvenient in practice, calculated in strategy, and cosmetic in nature.

CASTRATING THE "SAVAGE"

For more than 100 years, an illustrated image of an Indian warrior had been used as a visual symbol for the renowned U.S. brand Savage Arms, founded in 1894 by Arthur Savage in Utica, New York. Throughout the century there had been several redesigns of the company's logo (Figures 6.6, 6.7, 6.8). The strategically altered imageries of the Indian warrior, often referred to by the company as the "Savage Indian" or the "Indian head," provide a typical case of a measured makeover that transformed the original vicious-looking savage into a virtuous-looking savage. The move to tone down the racist overtones was typically low-key and occurred in stages, making the continued use of a racially charged sign sound and look legitimate. As a result, it has managed to avoid major criticism.

Looking into the origin of the Savage brand and its logo, there are discrepancies about when Savage Arms first deployed "Savage Indian" in its branding material and as its logo. In *Symbols of America*, for example, Hal Morgan states that the warrior symbol was introduced in 1906, the first logo in 1913, the first redesign in 1953, and the latest in 1984 (Morgan, 1986: 62). However, evidence indicates that the company's mass promotional use of the Indian warrior image predated 1906. For example, it appears from the cover of the company's full-color 1905 catalogue No.16 (Figure 6.9) that the warrior image was already being used and introduced to the market in that year, if not earlier. Furthermore, while we agree with Morgan that the first logo was debuted in 1913, Savage Arms' corporate literature states that the logo was

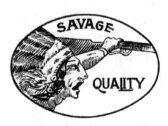

Figure 6.6, *1913* Figure 6.7, *1953* Figure 6.8, *1984*

Figure 6.11, *1915*

Figure 6.10, *1898*

Figure 6.9, *1905*

first adopted in 1919—7 years later—as a result of a deal between the company and Chief Lame Bear (Figure 6.10). According to the company:

> In 1919, Chief Lame Bear approached Arthur to purchase lever-action rifles for the Indian reservation and the two men struck a deal. The tribe would get discounted rifles and Savage would get their support and endorsement. It was at this time in the company's history that Arthur Savage added the Indian head logo—a direct gift from the Chief—to the company name. (from Savage Arms corporate website)

This official story neutralized the original idea of using the image of an Indian Chief to symbolize the company. As the story goes, the founder of the company named it after his family name—Savage—and that the Savage Chief image was "a direct gift from the Chief" to the company. While it can be argued that the brand name "Savage" reflected the family name, Savage Arms had already used an Indian Chief image in its 1905 catalogue, and again in its 1915 catalogue (Figure 6.11). Given that Morgan's research dates the first Savage Arms logo to 1913, the deal between Arthur Savage and Chief Lame Bear as a causal factor is questionable. According to the evidence, the company had established its Savage/Indian synonym more than 14 years earlier, and had made use of the Indian Chief image for years before the claimed 1919 "deal" with Chief Lame Bear. In other words, "the deal" was at best a belated endorsement, and not the reason behind the Savage Chief logo.

In addition to creating an innocent and almost noble rationale for using the Indian Chief image, the deal in this official narrative also served to justify the consumption of indigenous imagery. The very essence of a "deal" denotes an agreement entered into by the parties for their perceived mutual benefit. Claiming that the use of the imagery of an Indian Chief was the result of a "deal" between both parties or—better still—the result of an event initiated by Chief Lame Bear himself, effectively suggested that "the logo was obtained by legitimate means and the tribe depicted was fairly compensated financially." This framed an understanding that "the logo honored, respected, and had the blessing of the native people." However, history shows that the company felt free to exploit the image of the native people in a stereotypical manner before any apparent "deal" was made.

In the absence of evidence as to the extent of the "discount" that Chief Lame Bear received on the rifles in exchange for the right to use his image and for the endorsement and support of his people, the fairness of the deal is open to question. The question of fairness may sound academic—after all, how can

one put a price on the identity of a dignified individual, and how can the goodwill of an entire ethnic tribe be measured in dollar terms? This said, aside from whether or not it was financially a good deal for the chief and his people, the existence of the deal in itself is significant. On the one hand, the claimed "deal" suggested that the company, to an extent, morally recognized the sign value of the native people to its Savage Arms brand, while on the other it demonstrates that race politics was already a commercial reality—at least symbolically—at the turn of the twentieth century.

An Indian per se does not denote "savage"—an Indian is an Indian is an Indian. Conversely, the word "savage" does not denote "Indian" by itself. It denotes concepts of fierce, violent, uncontrolled, cruel and vicious, aggressively hostile, primitive, and uncivilized. It is only at the connotative, ideological, and mythical levels that the image of an Indian was constructed as a symbol of "Savage," possessing the "savage qualities." As mentioned in Part One, starting with Columbus, Indians have been historically depicted in both words and pictures as heartless, bloodthirsty, and brutal savages in colonial cultural discourses. One of the most famous contributions to the idea of "what the Indians are" came from Theodore Roosevelt in a speech 5 years before he became president of the United States: "Reckless, revengeful, fiendishly cruel, they rob and murder…" (quoted in Dyer, 1980: 86). In the same speech, Roosevelt claimed: "I don't go so far as to think that the only good Indians are dead Indians, but I believe nine out of every ten are, and I shouldn't like to inquire too closely into the case of the tenth." This reaffirmed the colonialist association between Indians and cannibalism, barbarism, and all things uncivilized. At times, however, they were considered as useful, born warriors, as outlined in Chapter 2. Speeches like this from political leaders and negative portrayals in the media helped to create a social and cultural convention in which the concept of "Indian" stood for "Savage"—society recognized the "Savage Indian" stereotype. Taking these conditions into account, the company and its designer were able to take advantage of the established Indian/Savage synonym and to make use of the image of a native people as its mascot. The Savage Indian was created not only as a symbol that stood for the name of the company, but also as a signifier of its desired quality—the "Savage Quality"— the very quality the company built its reputation on. It astutely realized the usefulness of the Indian imagery to enhance this quality.

In the original logo, the Savage Indian was framed in an oval shape together with the logotype "SAVAGE QUALITY" (Figure 6.6). The design was by and

large based on the template of the painting on the front cover of the company's 1905 catalogue, as seen above. The logo was a black-and-white line-art version of the painting featuring the image of a seemingly untamed Indian warrior in action—screaming while firmly holding a rifle in his hand. Looking further, we can see his eyes burning with aggression, his mouth wide open as if shouting. Apart from his facial expression, the character's posture is also worth noting: the warrior's head leans forward, and his hair and the feathers and beads on his headgear are being blown backward, suggesting dynamic movement toward an enemy. The black-and-white logo preserved the vividness of the original painting in a way that one could almost see the battleground, hear the sound of fighting, smell the gunpowder and blood, feel the wind blowing, and touch the warrior, the gun he was holding, and the headgear he was wearing.

Over the years, the logo has undergone two major changes. The first redesign took place in 1953 (Figure 6.7) and the second in 1984 (Figure 6.8). At a glance, one can see that while each of the redesigned logos still bore the image of an Indian Chief, the look was less "savage" compared with its predecessor. The 1953 makeover was a major visual alteration from the original logo, and the changes were significant. The most notable change was the deletion of the arm and the gun and the removal of the words "SAVAGE" and "QUALITY." Furthermore, the Savage Indian was no longer depicted in motion, and the character was semi-framed in a circle instead of an oval. In all, the Savage Indian was portrayed with a much softer touch: his expression looked tough yet not brutal, his posture appeared rather restful, and greater attention was paid to the detail of his headgear, such as the feathers, the braid, and the beads.

The 1984 reworking of the Savage Arms logo incorporated only subtle changes. The stillness of posture and composition remained. However, the fine-line drawing style was replaced with bolder strokes on one hand, while the Savage Indian's facial expression was softened by reshaping his mouth—one can even find the hint of a smile on his face—on the other hand. Framing the entire Savage Indian image inside a complete circle helped to eliminate the last remaining sense of movement.

Although no further changes to the Savage Indian logo have been publicly announced, the company's Corporate [Identity] Standard Guidelines issued in 2009 show some related changes. One interesting development is the change of terminology by which the previous term "Savage Indian Head Logo" has now become "Savage Medallion Logo." Other than replacing "Indian head"

with the word "Medallion," the guidelines also rule out the use of the logo in isolation. Despite these measured changes, however, the guidelines reaffirm the Savage-Indian Chief association in the first sentence under the heading SAVAGE MEDALLION LOGO in the guideline:

> The Savage Medallion is a graphic depiction of an Indian Chief facing to the right. The Savage Medallion face may never turn any other direction than to the right. The Medallion logo may never be used as a stand alone logo. It may be used for design purposes, but must always be accompanied by the Savage Signature or Savage Logotype somewhere on the piece. Any placement of the Medallion with the Savage Logotype that departs from the corporate Signature is prohibited.

Compared to the Darkie makeover, the Savage Arms logo makeover was not directly prompted by negative public opinion. Unlike some logos in the United States that still use Indian imageries and references, Savage Arms has managed public opinion well. In contrast, for example, the logo of the popular Cleveland Indians baseball team has attracted public protest and media criticism, forcing a number of makeovers (Figure 6.12). With its narrative of the Savage-Lame Bear deal as a shield, and with a series of proactive and sensitive actions to improve its brand identity, the company has been anxious to wash out the stink of racial stereotyping while protecting its valued legacy. The efforts to transform the Savage visual symbol and the imposing of restrictions on its application are in effect gestures aimed at neutralizing the "savage quality"—historically a desired selling point but a potential public relations disaster in a changing time. With the help of the mythical brand history and visual manipulation, the Savage Arms branding makeovers have been low-key, without pressure, and without the need to admit the very problem the brand quietly invested in solving.

In light of these changes, then, has the logo shed its use of dubious racist stereotyping? Fundamentally—no. On the surface, the consequentially updated

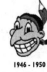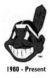

1928　　1929 - 1932　　1933 - 1945　　1946 - 1950　　1980 - Present

Figure 6.12, *Cleveland Indians, since 1928*

versions of Savage Arms reduced the stereotypical "savage" features represented in the original logo. It appears that the visual elements associated with the stereotypical Indian Chief have all been altered: the "Savage Quality" wording has been deleted, the gun-toting arm has been removed, the sense of battle has been erased, the previously screaming and furious facial expression has been redrawn and refined to construct a less brutal, more tranquil character, and the originally untamed Indian Chief has been fully contained within a circle. However, as much as these changes represent a positive response to neo-liberal aspirations and sensitivity to anti-racist sentiments, the creative effort to make the Savage Indian less fearsome seems to stop short of going beyond a cosmetic and fashion makeover to address its inherent branding problem of racial stereotyping. As such, one fundamental remains: the Indian/Savage synonym remains firmly intact despite the play on word and image. After all of the altering and fine tuning of the logo and its application, none of the redesigns has attempted to break the stereotypical link between the concept of "Savage" and the trope of an "Indian" other than rendering the Indian non-threatening by way of a kind of castration that is both "a reactivation of the material of original fantasy…as well as a normalization of that difference and disturbance in terms of the fetish object" as a substitute (Bhabha, 1994: 74). Essentially, the transformation of a vicious-looking savage into a virtuous-looking savage in the Savage Arms branding makeover has produced a "castrated" noble savage who is no longer "wild," "ferocious," and "dangerous," but a "domesticated," "assimilated," and "tamed" object of fetish.

SUGAR-COATING CONGUITOS

Conguitos is a popular Spanish brand of chocolate-coated peanuts owned by the LACASA Group. The logo, which also serves as a brand mascot named Conguito, features an armed, dark-brown character (Figure 6.13). It was created in 1961 by Spanish designer Juan Tudela Ferez. The logo has undergone two makeovers, one in 1997 (Figure 6.14) and the other in 2009 (Figure 6.15). The company's version of its heritage and the nature of the remodeling of the Conguito image have been communicated to the audience thusly:

> Conguitos, roasted peanuts covered in chocolate, have been on the market for over 40 years. Their mascot, the Conguito, is a familiar and endearing character. Due to evolution and the changing times, our

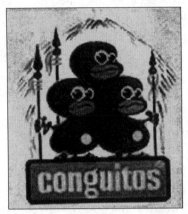

Figure 6.13, *Conguitos, 1961*

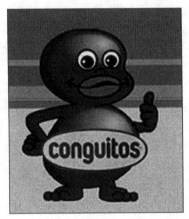

Figure 6.14, *Conguitos, 1997*

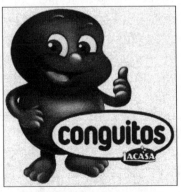

Figure 6.15, *Conguitos, 2009*

mascot has also evolved and slightly changed in order to adapt to the present day. (Conguitos corporate website)

What has been changed is not mentioned, other than that the changes were "evolved" in nature and "slight" in scale. From the company's perspective: "When the 'Conguito' was born in the sixties the mascot was perceived as a tiny character covered in chocolate and it has slowly evolved and been updated" (Conguitos corporate website). But was Conguito merely a tiny innocent character? And were the makeovers of the Conguitos logo an uninterrupted gradual evolution that just happened?

Looking back, the original construction of the Conguitos brand indicates that the tropes of Africa and Africans have been used to brand the product ever since it was first introduced to the domestic market. To begin with, the brand name can be loosely translated as "little Congo boys" in the local language. But why the reference to the Congo? Apparently, the concept was driven by fashion, since at the time the Congo had just become independent, and, according to its creator, the company chose it for its exotic look (*El Periódico de Aragón*, 5 March 2003). In the original logo, all three Conguitos were presented as chubby cartoon characters with uniformly inky skin, thick, red lips, and googly eyes—in a style that closely resembled the various portrayals of Little Black Sambo. The unique visual features of the Conguitos, such as the exposed belly buttons of the two front characters, the spears in their hands, and the thatched hut image in the background, all connoted the widespread primitive, wildish, and backward qualities associated with Black people.

The Congo had declared its independence from its colonizer, Belgium, in 1960—a year before the birth of Conguitos in Spain. However, it is worth noting that although developments in the Congo were still in the news by the time Conguitos was launched on the market, the Congo stories were no longer about independence, but rather about the civil war that had erupted in the poor yet resource-rich African nation. Obviously, the image of the Congo was not chosen to celebrate the decolonization of a colony in Africa by a brand that operated within the cultural context of one of the most powerful European colonialist empires at the time. So what, then, was the relevance of the imagery of the Congo to a brand that sold chocolate-coated peanuts? On the surface, and considering Ferez's claim, the Conguitos did give the brand its desired "exotic look"—they were Black, they were naked, they were from the jungle, and—if these signs were not exotic enough—as revealed in one of Conguitos' signature TV commercials, they were represented as pygmies!

The usefulness of the Congo trope, however, goes beyond the face value of exoticism. To appreciate the range of sign values the trope of the Congolese brought to the brand, the depiction of the Conguitos in the same animated commercial provides further cues. With the backdrop of a jungle, three Conguitos were singing and dancing next to a cooking pot—bodies swinging and eyeballs rolling with rhythm. One of the Conguitos was also stirring the chocolate-coated peanuts as he danced with the group. Vividly, the bubbly Conguitos brought a sense of fun and pleasure to the brand, giving the chocolate peanuts an attractive personality. The Congo had a reputation as a cocoa- and peanut-producing nation, and its people were renowned for their knowledge of these products. Given this, the use of Conguito cooks in action, preparing chocolate-coated peanuts, effectively produced a Congolese endorsement of the product and provided a perfect mascot for the brand. Strangely, these signifiers seemed to present the Conguito as a Spanish version of little Black Sambo with a combined nature of cheerfulness and slavishness. The marked difference was that, unlike the U.S. versions of the Sambo imagery, which attracted fierce protest and were largely withdrawn from the market by the 1960s, there was no effective challenge to the branding of Conguitos in Spain. By the 1960s, U.S. consumers were no longer able to buy and eat "Black Babies" chocolate and the like. Conversely, Conguitos were conceived, born, and grew in popularity in the same era, amid the post-World War II decolonization movement and the new anti-racism paradigm in world politics. The Conguitos branding image uninterruptedly carried its racial overtones into the late 1990s.

The remodeling of the Conguitos logo tells the story of an identity makeover that was inevitable on the one hand, but the need for which was denied on the other. The racially charged brand name and the stereotypical visual languages deployed to construct the Conguitos visual identity (as the logo and mascot) seemed to be taken for granted in Spain, and for more than 30 years virtually no thought had been given to the racialized signifier and its connotations. Changes only became necessary as a result of the brand's ambition to go global. What the company website referred to as "the changing times" began with the company's stream of business acquisitions domestically and market expansion into other European countries such as France, Portugal, and Argentina. Inevitably—and sensibly—the visual identity of Conguitos had undergone a major remodeling in 1997 to avoid possible criticism abroad. It hardly needs to be said that the brand was conscious that what was acceptable

in Spain was not necessarily acceptable elsewhere in Europe. A redemptive makeover was needed before the overseas launch to safeguard the first vital step of its global venture. Two major aspects of the Conguito character were changed. First, the Conguito was disarmed, with the spear removed. Second, the Conguito no longer appeared fully naked, as his belly button was reshaped into an oval stamp of the brand name (Figure 6.14). While he was still recognizable as a "little Black sambo" after the remodeling, the extent of his wildness had been toned down.

In Spain, the most publicized challenge to the logo was launched in 2003, when an academic from the University of A Coruña criticized it as being racist and insulting to African migrants living in Spain. Campaigning to have it changed, he argued that the logo "serves only to promote and perpetuate the negative stereotypes associated with African people" (*El Periódico de Aragón*, 13 April 2003). The company rejected the criticism outright. In response, it emphasized the fact that the logo had served the brand for 42 years and insisted that the mascot "respects everyone and is accepted and appreciated by an overwhelming majority." The complaint also attracted a high level of governmental attention. On the day after the complaint went public, Arturo Aliaga, Spain's Minister of Industry, Trade and Development, reportedly expressed concern about the allegation of racism against one of the country's most popular brands, which sold 30 million bags a year to 40 countries worldwide. Aliaga stated: "[B]efore launching this type of critical message, one should mediate and talk to the company because they can seriously harm your image or impair any part of the production or marketing." He further expressed his fear that the negative publicity "could jeopardize both its international and financial results," according to the Spanish newspaper *El Periódico de Aragón* (5 March 2003). With this reaction and the muted public support for the campaign, the logo predictably remained unchanged in its domestic and international markets for another 6 years. Yet in 2009, without any apparent public pressure, the company moved, on its own, to make some significant changes to the logo.

In this round of remodeling, the Conguito character underwent some extreme surgery-style makeovers: his thick red lips were dramatically reduced to almost invisible; his bug-eyedness was corrected, or normalized; and the oval brand name was positioned away from his body, thus removing any remaining trace of an imagined belly button (Figure 6.15). Clearly, this sugar-coating completed the unfinished business from the first round of remodeling. The

changes significantly minimized the remaining racial references and the Sambo stereotypes embodied in the Conguitos logo. For a brand that was on track to grow its global market share, this latest round of remodeling was a major step toward avoiding the foreseeable negative publicity directed at the branding imagery as it pushed to widen its international distribution.

Why the company or the country—the very same one that ignited the famous Valladolid race debate in the sixteenth century—chose not to recognize the racial overtones embodied in the Conguitos brand is beyond the scope of this book. Yet the unacceptable truths that the Conguitos logo has been rich in racial overtones and was racially offensive certainly have not been publicly acknowledged in this case. Instead of admitting that the changes were made to right the wrongs, the company officially neutralized the changes by stating that the logo had merely "evolved and slightly changed in order to adapt to the present day." This was a carefully constructed rhetorical discourse that conveniently left out the crucial factor behind the remodeling—namely, to eliminate the logo's existing racist connotations which were unacceptable in other potential markets (such as the United States).

It is quite clear that the Conguitos logo remodeling did not "evolve" naturally but resulted rather from a series of strategies involving knowing without admitting, calculated inaction, and action driven by economic necessity. The Conguitos logo was not just an innocent "tiny character covered in chocolate," but a racially charged identity that made "eating the Other" a normal part of daily life. Throughout the process, the Conguitos brand image was managed as if it had two identities—one local, the other global. The brand image had a near trouble-free run within its home market, and when trouble did arise, the brand had the power to defuse the challenge. But to become global, the company was conscious that Conguito would be measured through the eyes of the rest of the world and needed to be "sugar-coated," so to speak. Furthermore, the small dark body of the Conguito also manifested as two identities: one that "respects everyone and is accepted and appreciated by an overwhelming majority" as declared by the company, and the other that was admitted into the cultural lexicon and used as a racial slur against Black people.

One of the most publicized racist applications of the term "Conguito" can be seen in a campaign against British Formula One driver Lewis Hamilton before his historic race in the 2008 Brazilian Grand Prix for the prestigious World Number One spot. Among more than 16,000 racist messages addressed to him on a Spanish website, Hamilton was dubbed a "Conguito" in hate mail

(one threatening him with the message "Conguito, you are going to die"), alongside other more old-fashioned yet equally offensive slurs such as "nigger," "half-breed," and "monkey" (*Daily Mail Australia*, 31 October 2008). It is from the social application of the term, the understated remodeling of Conguito lacking acknowledgment of any problem, the continuing consumption of Conguitos as a candy, and the mutation of it into a twenty-first-century racist cultural term that we gain a taste (and aftertaste) of the ways in which branding imagery interacts with the ideology of the local and the global.

FETISHISM AT WORK

In this section we examine ads that are marked by a fetishistic imperative in their deployment of the imagery of the racial Other. First we interrogate the fetish for the feet of Black sport stars and models in a series of Pirelli ads. We then examine ads from four international brands, all of which depict the racial Other with sexual (even some erotic) overtones to promote the advertised product. Finally, we investigate the fetishism toward exotic cultural practices through two cases that commodify ancient cultural practices and religious rituals, effectively making them speak for the value of the brands.

Used within anthropological discourse, the term fetishism refers to the belief that godly powers can inhere in inanimate objects such as in totems for groups or tribes. Marx first highlighted fetishism in capitalist societies in 1867 when he named "the fantastic form of a relation between things" as "the Fetishism…of commodities" (Marx, 2007: 83). He approached the concept from the relationship between production and consumption that led to a false consciousness-type of desire. Freud's fetishism (Freud, 1961), on the other hand, was described as a castration complex of the male psyche—obsessively focused on one object that could be controlled in an attempt to reassert a sense of control and power out of fear of lacking them—a false and proxy object of desire.

The concept of racial fetishism has been directly and indirectly an integral part of postcolonial studies, such as Fanon's notion of the "epidermal schema" of Blacks, which is produced by a racist culture in which the White man weaves "a thousand details, anecdotes and stories" of the "Negro" to define him

(Fanon, 1991: 111). It is also reflected in Said's *Orientalism*, where he refers to it as a Western style of dominating, restructuring, and having authority over the "Oriental." According to Said (1978), a distinctive aspect of being the Other was that one was the object of someone else's fantasies, but not a subject with agency and voice. Extending from the Freudian concept of sexual fetish, Bhabha defined racial fetishism as a fixation on other races being not different but lesser, or "mutilated" versions of the "me" and "mine" of the White male. Racial fetishism, like sexual fetishism, was a form of castration of difference: "in Freud's terms: 'All men have penises'; in ours 'All men have the same skin/race/culture'... for Freud 'some do not have penises'; for us 'some do not have the same skin/race/culture'" (Bhabha, 1994: 74). These critiques of fetishism and Bhabha's ideas in particular are very helpful in exploring the changes in advertising discourses that were designed to manage the anxiety toward racial differences and to protect the narcissism of the dominant culture.

SUPERHUMAN AND THE MIRACLE BLACK FEET

American athlete Carl Lewis was used as the face and figure for Italian tire giant Pirelli in the brand's 1994–1995 advertising campaign designed by Young & Rubicam London. The campaign comprised a 1994 print/outdoor advertisement (Figure 6.16)—the main subject of this case—and a 1995 TV commercial in which Lewis appeared running, bounding, and flying across the

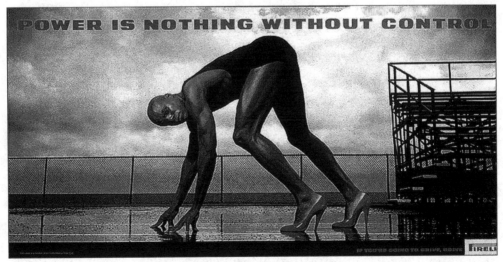

Figure 6.16, *Pirelli Tyre, 1994*

New York cityscape barefooted. The 60-second commercial was almost a "Lewis the miracle" show except for a shot near the end when the imprint of a Pirelli tire was seen molded onto the bottom of his feet. This revealed a trace of the product to the audience, before Pirelli's "Tire Man" jumped from the top of the iconic Empire State Building.

In the print advertisement, Lewis was depicted in a tight black bodysuit, crouched in the track athlete's starting position. Unlike in real life, Lewis's face was turned toward the camera and the reader instead of facing forward. The ad also contained two other major abnormalities—both associated with Lewis's feet: a pair of red pointy high heels substituted for his running shoes; and the surface under his feet was wet and sandy, unlike the texture of a typical racing track. Apart from the footwear and the ground, the metal fence and spectator stand indicated a site for another kind of racing. Thanks to the caption at the bottom of the advertisement—"Carl Lewis is a member of the Santa Monica track club"—we know that the photo was taken at the motor-racing track in Santa Monica, California. The headline, "Power is nothing without control," together with the visual representation, appropriately established a relationship between high-performance cars and high-performance tires. The logic of this advertisement seems clear: without control, power is nothing; without a reliable set of tires, a fast car is meaningless. As the advertisement demonstrated through Lewis, without a proper pair of running shoes on his feet, even the fastest man in the world could not run properly. True to this message, one level down in the information hierarchy, and with the brand's logotype positioned in the lower right-hand corner of the advertisement, the tag line urged its audience: "If you're going to drive, drive Pirelli."

In his *The Spectacle of "the Other,"* Hall used this ad as an example to invite readers to consider "What is this image saying? What is its message? How does it 'say' it?" (Hall, 1997b: 233). Let us venture here into a different yet equally important enquiry to ask, "What drives the use and usefulness of the image of Lewis in this ad and, by extension, images of other Black stars in following campaigns?" To do so, we need to read the ad not only by decoding it in isolation but also by analyzing its recurrences and appreciating it as a significant part of an old branding tradition and the moment of birth of an iconic contemporary advertising campaign strategy.

It helps to develop a deeper understanding of the ad and the strategy of selecting a Black athlete (and other Black celebrities in subsequent campaigns) to promote the brand and its product, if we start with the unique Pirelli

branding style. Established in 1872 and named after its founder, Italian tire maker Giovanni Battista Pirelli, the Pirelli brand grew with the process of globalization. By the turn of the twentieth century, Pirelli had started manufacturing above- and below-sea-level telegraph wiring, and its portfolio now extends to include telecommunications, real estate, and fashion. However, tire manufacturing and communications cabling remain Pirelli's core business.

American giant Groupe Michelin, considered the biggest tire manufacturer in the world, is Pirelli's major international competitor, and these two rivals took markedly different approaches to build their brand images. While Michelin chose to go straight to the point, depicting the quality and form of "rubber" and "tires" in the company logomark and advertisements, Pirelli opted for a more sophisticated approach to its promotional material and advertisements. There is no better example of a public relations tool than Pirelli's famously sexy calendar. A tradition dating back as far as 1964, the company commissioned some of the world's leading photographers to produce a calendar featuring well-known female models. "The Calendar" or "The Cal"—as it was dubbed by the brand—was a free, limited-edition gift for a select group of 40,000 people, including members of the British Royal Family, the King of Spain, Paul Newman, and Bill Gates. It quickly gained a reputation as "the world's greatest official status symbol." It served its purpose well. According to Gioacchino Del Balzo, Pirelli's global calendar coordinator, for every $1 million Pirelli spent producing the calendar, it attracted $60 million worth of media coverage (*Forbes*, 15 November 2004). With the anticipation of its elite recipients and the massive global media exposure year after year, Pirelli acknowledged that the company's strategy of making the calendar "exclusive" was what "made the Calendar fantastically successful" (Pirelli Tyre brochure, 2005). Interestingly, the obvious strategy of using sexual appeal—consistently executed in the making of the calendar for more than half a century—was not even mentioned, let alone given the credit it deserved.

If Pirelli was proud of its calendar project as a public relations exercise, the brand was also proud of the "Power is nothing without control" campaign featuring Carl Lewis, valuing it as a milestone in the brand's advertising—so much so that the campaign was specifically mentioned in Pirelli Tire's 2005 corporate literature as exemplifying one of the brand's two continual concepts—"sport." The calendar exemplified its counterpart—"exclusiveness."

It is worth noting that the slogan, specifically designed for the Carl Lewis campaign, was so well received that it remains the theme for campaigns to promote Pirelli tires. In 1997, the campaign was also granted the prestigious Gold Award in the U.K. for the best long-term campaign.

Why Lewis was selected for the ad may seem obvious. Dubbed the "son of the wind" and the winner of nine Olympic gold medals, Carl Lewis was arguably the world's fastest man. Given his renowned athletic achievements as a champion sprinter and long jumper, it was no surprise to see Lewis as a symbol of speed and power. For Pirelli, a brand claiming to be the best-performing tire in the world, and with a long history of associating its tires with high-performance sports, the deployment of Lewis as its celebrity endorser (or "testimonial," to use Pirelli's terminology) seemed to be a "natural" choice. However, the question remains: Is the outstanding athletic quality and stardom acquired by Carl Lewis the sole value desired by Pirelli in its campaign? In other words, are there other hidden values that make Lewis useful for the Pirelli brand beyond the obvious?

To begin with, true to the brand's well-established tradition of generating sexual and sensual appeal in its branding material, there seemed to be an element of sexuality in the use of Lewis in this ad. In fact, as the presence of the red stiletto heels unambiguously conveyed a sense of femininity, questions regarding Lewis's sexual orientation were again raised in the media. Existing rumors about Lewis being gay were renewed—some pointed to his crouched posture, while others even saw the shape of the clouds pointing to his buttocks as "evidence." Pirelli made no comment. For his part, Lewis made his position known through the *Atlanta Journal-Constitution* in two ways: (a) "Pirelli came with the idea to do an ad"; and (b) "[W]hen it all comes down to it, I did it for two reasons. No. 1, it's a commercial and they paid me to do that. Secondly, I like working with Annie [Liebowitz]" (quoted in *Jet*, 16 May 1994: 47). For the record, Lewis also said he was paid a six-figure sum for the advertisement that was shot in less than half a day. Lewis's response was not a powerful way to set the record straight, but maybe the record was never meant to be—or needed to be—set straight. After all, ambiguity of sexual orientation has made Grace Jones a Black cultural icon in the performing arts. More to the point, in advertising any publicity is good publicity—and Lewis's sexuality was undoubtedly newsworthy and guaranteed to generate free publicity. While not necessarily quashing the rumor regarding his sexual preference that again surfaced following the campaign's release, Lewis's discourse does provide some

valid points of interest to this study. The first part of his statement can be perceived as confirming the fact that Lewis was deployed in the ad because of certain qualities he possessed. The brand desired these qualities and wanted to associate itself with them because they could add value to the product. Lewis's second statement recognized the essence of his relationship with the brand on one hand, and with the creative agent on the other. By paying the right price, Pirelli turned Lewis into a commodity and used his desirable qualities—be they athletic, sexual, or racial—for the brand's own benefit. Conversely, Lewis may not have valued Liebowitz merely for her creative talent, either. The idea of joining the celebrity photographer's impressive list of iconic subjects, such as John Lennon, Mick Jagger, Arnold Schwarzenegger, and the like may also have influenced Lewis's decision to take up the offer and his willingness to be "modeled" by her.

While the Otherness of Lewis's sexual preference may have attracted media attention, there was a consistent yet often overlooked element of Black fetishism in this and two subsequent Pirelli campaigns that made up the three-part series. The campaigns appropriated the Otherness of the Black body and Black feet in particular.

After the success of the Lewis campaign, Pirelli released two more advertisements with the same slogan and design style. Both campaigns used sports celebrities who were, like Lewis, non-White and non-Italian. The 1996–1997 campaign featured Olympic gold medalist Marie-Jo Pérec of France (Figure 6.17). Pérec, the 200-meter and 400-meter dual gold medalist of the 1996 Atlanta Olympics, had also won the 400-meter gold at the 1992 Barcelona Olympics. She was the first athlete, male or female, to retain an Olympic 400-meter title. In the advertising campaign, she was depicted in explosive motion, escaping the clutches of monsters of ice, fire, and water while barefooted. Brazilian megastar footballer Ronaldo Luiz Nazario Lima was the face of the 1998–1999 campaign (Figure 6.18). Hailing from a country where football is almost a religion, and dubbed "son of God" by football fans around the world, this Brazilian megastar football striker and World Cup hero was featured wearing his famous number 10 jersey, arms spread, and with a tire tread on the sole of his striking foot. With Ronaldo's posture, the ad's composition, and the use of the location of the "Christ the Redeemer" statue, the Ronaldo campaign was perceived as mimicking the figure of Christ that overlooks Rio de Janeiro. This angered the Catholic Church and was criticized by Rev. Don Eugenio Salles of Rio as "an abuse that deserves disapproval by

the church" (*Advertising Age International*, 13 April 1998: 11). Of the three campaigns, the Pérec campaign received the least media attention, the Ronaldo campaign was the most controversial, and the Lewis campaign not only reached iconic status, but also attracted worldwide attention.

Pirelli's focus on Black feet continued after this three-part campaign. More than a decade after the Lewis campaign, and far from coincidently, Pirelli's PZero fashion line used supermodels Naomi Campbell and Tyson Beckford as its ambassadors—both are of African descent and are non-Italian (Campbell is British of African origin, while Beckford is the son of a Jamaican father and a Chinese American mother). Again, the brand's 2005 campaign focused on their feet. With little or no trace of any other clothing (Figures 6.19, 6.20, 6.21), both Campbell and Beckford's feet were highlighted in PZero shoes. This high level of consistency in Pirelli's advertising campaigns provides proof that the deployment of Lewis and other Black celebrities was hardly coincidental and that a distinct flavor of racial fetishism was present.

In general, the selection of the Black celebrity was one aspect of the strategic use of imageries of the racial Other, as it showed an observable condensation of the obsession about Blackness in corporate advertising. The Otherness of the Black body was constructed as "superhuman" for the benefit of promoting the brand and its products. Despite the differences in their strengths and specialties, Lewis and his fellow Pirelli "testimonials" were constructed with mythical abilities in the "Power is nothing without control" campaign. If the still images in the posters did not say enough about Black power, the respective TV commercials provided a richer source of visual cues. The Lewis commercial showed him running across water, sprinting up the Statue of Liberty, and jumping between skyscrapers. The Peréc commercial showed her escaping the clutches of monsters of ice, fire, and water. The Ronaldo commercial featured the international football sensation scoring goal after goal in major matches before assuming his Godlike posture. In short, through the visual language of advertising, all three Black sports celebrities were portrayed in such a way that they were no longer real-life superstars. They were divine, mystical, powerful, effectively superhuman—a seemingly new trope for the racial Other in the visual language of advertising.

As flattering as it may sound, the portrayal of the racial Other as "superhuman" is very much a contemporary version of the colonial concept of "subhuman," in which Blacks were perceived as freaks of nature, and the

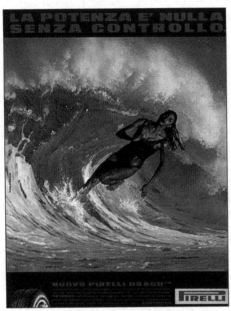

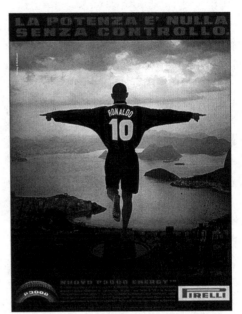

Figure 6.17, *Pirelli Tyre, 1996*

Figure 6.18, *Pirelli Tyre, 1998*

Figure 6.19

Figure 6.20

Figure 6.21

Pirelli PZero 2005

219

belief that they possessed some kind of mythical power was widespread. As outlined in various sections of Part One, much of the Black fetishism was grounded in the premise that Black people were closer to animals in their biological makeup than to humans. Attributed with animalistic powers, Africans were stereotyped and mythicized as objects with inherently superior sexual and athletic power. While these perceived powers were highly desired, the "Black power" (so to speak) was also feared and held as a threat to the systems of White supremacy in general, and White patriarchal hegemony in particular. The newness of the superhuman stereotype, however, lay in appropriating Black identities and presenting them in ads as glorified and romanticized objects of desire.

Furthermore, in the Pirelli tire and PZero shoe campaigns, the particular obsession with Black feet became even more pronounced. Collectively, the three commercials featuring Lewis, Peréc, and Ronaldo all ended with a tire tread revealed on the soles of their feet, although because of the framing of the posters, this treatment was only visible in the Ronaldo campaign. A decade later, the feet of two Black supermodels—Campbell and Beckford—were again used, this time to promote PZero shoes. Such focused attention on Black feet is particularly interesting here, as it not only reminds us of the Victorian sexualized foot fetish but also its displacement. In Chapter 2, among the measurements, anecdotes, and stories about the Black body in general and Black feet in particular, the Black physique was mostly associated with animality and the subhuman state. Blacks were seen at best as born fighters (as in the series of Sanitary Commission studies). As for Black feet, some considered the foot as the only physical deformity of Blacks as soldiers. At least one examiner considered the "large, flat, inelastic foot…almost splay-footed" as an advantage in marching over rough terrain (quoted in Haller, 1971: 31). The use of Black feet by Pirelli in its ad campaigns shows the work advertisers do to create a magical object for their own use—by emptying the historically known meanings and filling them with desirable sign values to suit the taste of the dominant culture.

In imprinting Pirelli tires on the feet of Lewis, Peréc, and Ronaldo, and in attaching PZero shoes to Campbell and Beckford, the company established a close bond between the "Black Testimonials" and the Pirelli products. The Black feet of the sports and model superstars became miracle "Pirelli feet." Put simply, depicting the Black Testimonials as superhuman with miraculous feet in these Pirelli ads was a vivid, memorable, and persuasive way to use

the Black body as a fetish to help claim the "super tire"/"super shoes" status for Pirelli. As such, the miracle Black feet in the ads discussed here were transformed from a Victorian sexual fetish to a modern-day commodity fetish through these advertising discourses.

THE EROTICIZED EXOTIC BODY

Here we draw on multiple cases from contemporary advertising to explore another side of racial fetishism—one that paints erotic pictures on, uses, or is suggestive of the exotic bodies of the racial Other.

The Refreshingly Brazilian advertising campaign was designed by Jung von Matt Alster of Germany and circulated during 2007 and 2008 to promote the newly introduced beer Bit COPA. COPA was a new addition to the existing Bit family, which already owned two popular beers: Bit SUN, a light beer; and Bit PASSION, a blend of beer and pomegranate. Ingredient-wise, Bit COPA was created with an exotic taste in mind, being a hybrid of German beer and Brazilian cachaça. As a product, it was marketed with an emphasis on foreignness, from the product's attributes to the serving experience. In an official press release entitled "Bit goes Brazil," the company introduced its new kid on the block as being "sparkling, fruity lime inspired looks more to the famous Caipirinha cocktail and is always served with a fresh slice of lime"—an exciting alcoholic drink that was exclusively "refreshing and with a real Brazilian cachaça" (*Bit-World*, 15 March 2007). The Otherness of Brazil and Brazilian women became more vivid and sensual as soon as one looked at the ads (Figures 6.22, 6.23, and 6.24). Each poster featured an almost naked, tanned female body. No faces were visible, as the ads were all framed below the neck and above the upper thighs. The colorful and naughty body paintings, the dark background color, and the sparkles, bubbles, and decorative flora in the foreground not only enhanced the sex appeal of the colored bodies, but also suggested an exotic carnival atmosphere. The known Brazilian cultural event was also put to work to invite spectators to a new reading of the spectacle— one that involved the hybrid German beer.

Despite the heavy use of exotic female bodies and atmosphere, the campaign was not set up to sell the exotic Other. The agency was not commissioned to promote Brazil (or Brazilian women, for that matter), but to sell Bit COPA. The trope of Brazil was deployed here because (a) part of the Brazilian drinking culture was appropriated in the making of the product; (b)

other signs of Brazilianness were identified as being useful to the brand and able to be appropriated as selling points for the product. One of these sign values was "refreshing," which was expressed via written language in the campaign headline, and via visual language in all three ads (such as the lime-colored headline and tag line; the sparkle, bubble, and flora references; the dewdrops on the Bit COPA bottles; and the different experience of consuming a drink held in the hands of a sexy woman with nails on one hand painted pink and unpainted on the other). In addition to "refreshing," the tag line spelled out another selling point—"exciting"—with the claim of "a Bit more exciting." In a profession that often practices the rhetoric of exaggeration, this tag line may sound like an unusual understatement, but it was a cleverly calculated approach. There is little doubt that the exotic female bodies depicted in the campaign could deliver the desirable effect of excitement (if not astonishment) and link it with the product. With confidence in the visual's ability to excite its audience, the brand could afford to be more humble with the tag line. While appearing to be modest, however, the brand name "Bit" was tactfully but cleverly embedded into the phrase as a pun.

Equally impressive was the visual treatment that maximized the usefulness of the exotic female bodies in this campaign. The three different shapes and forms of the exotic nude bodies not only attracted attention; each also carried a story about the consumer and Bit COPA. Three different consumer market segments were painted on the nude bodies—on each pair of breasts we first saw the faces of a flirting, middle-aged couple, then a groovy young couple, and in the third ad a pair of future customers (too young to drink alcohol legally, but watching the boozy clown, who was served a bottle of COPA, with envy and eager anticipation). At all points of interaction within these relationships, the Brazilian female body was in service: the tanned skin provided a ready-made canvas on which the relationships were painted; the breasts provided a 3D platform for rendering the characters; the hands were holding COPA bottles in a servile posture (both to the characters painted on the body as well as to the audience facing the ad); and even the woman's belly button in the third poster was used as the clown's mouth, sucking COPA from the bottle through a straw. The strategy of adding a strong Brazilian flavor via the carnivalesque of Brazilian carnival and putting the exotic bodies of Brazilian women in these theatrical representations and attaching them to the branding of a German beer exemplified the creative effort invested to combine the exotic racial, sexual, and cultural appeals of the product by maximizing the use of

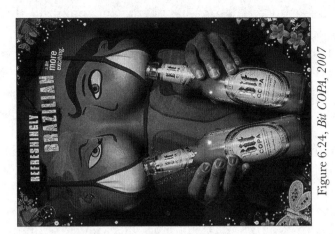

Figure 6.24, *Bit COPA, 2007*

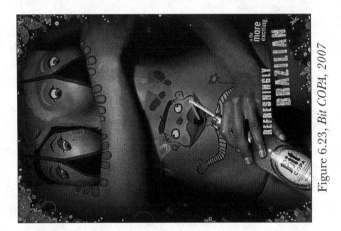

Figure 6.23, *Bit COPA, 2007*

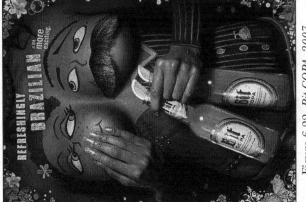

Figure 6.22, *Bit COPA, 2007*

Brazilian female bodies, fetishizing them, and painting them with erotic imageries to further "sex up" the advertising campaign.

It would be a major mistake to assume from the Bit COPA campaign that racialized sexual fetishism is performed only on the female body. Exotic male bodies are also frequently deployed in advertisements to sell products in contemporary advertising, albeit in a more carefully managed and often muddied way. One example is the use of a totally naked Black male body in a 2005 ad for the Italian fashion brand Diesel (Figure 6.25). Designed to sell female leather boots, this globally circulated ad was banned by the ASA in the U.K. on 8 March 2006, after its last run in the market. According to the ASA: "The ad showed a naked man from the rear with three pairs of women's legs straddling his body" (ASA, 2006). The following is a summary of the 28 complaints received:

> The complainants objected that the position of the women's legs around the man's body overtly suggested sexual behaviour and was therefore offensive. They were also concerned that the image was unsuitable in a magazine that might be seen by children. One complainant, who believed the man in the ad was black, objected that the ad was racist. (ASA, 2006)

The ASA upheld complaints about the "overtly suggested sexual behaviour" and its possible exposure to children and, as a result, the ad was belatedly banned. However, the advertising watchdog dismissed the complaint of racism, as it considered that "the use of a male model with dark skin was intended to create contrast with the light skin of the women's legs and was unlikely to be seen as racist" (ASA, 2006). But was that the only useful sign value for deploying a naked Black male body in this ad?

The use of the Black body indeed delivered the effect of contrast—but it did so in more than one way. On the surface, the use of a naked Black man certainly did help to create a contrast with the legs of the White women in this ad. But it was the racial Otherness of his Black skin (not any other objects with a dark color tone) that was fetishized to deliver the desired contrast with the White women's legs. On a connotative level, the deployment of a naked Black man also established a contrast between Black masculinity and White femininity. The deployment of the Black male model also helped to deliver two contrasting mythical stereotypes—the Black man as a sexually potent "scorpion" (the title of this ad) and the White women as the predatory sexual figure of a "black widow." Last but not least was the contrast between the

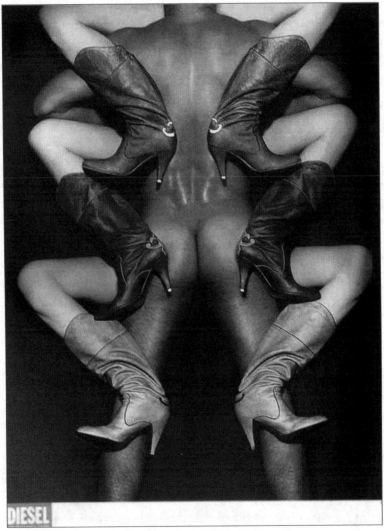

Figure 6.25, *Diesel, 2005*

interpretations of the Black man himself in the ad. On the one hand, his racial Otherness was exaggerated not only by his skin tone but also by his physique and the colonial interpretation of these signifiers as dangerous hypersexuality. On the other hand, the ad attempted to reproduce these signifiers as a non-threatening and fully controllable object ready for consumption.

Like the Diesel scorpion ad, racialized and sexualized body imageries in commercial ads often muddy rather than clarify the message. Nevertheless, the confusion that is generated draws attention to and sells the brand and its product in a profound way—by being visually suggestive or explicit. For example, in a 2004 Magnum advertising campaign, the agency McCann Erickson Paris arranged the chocolate-coated ice cream bars in such a way that the resulting imagery resembled part of a Black body. One of the two ads in the campaign showed a close-up image of the product (Figure 6.26), depicting the ice cream bar with bites taken out in a way that was suggestive of the waist of a Black body. The second ad used a mid-range shot, with three of the ice cream bars arranged to form the buttocks and upper legs of a Black body (Figure 6.27). The campaign deliberately created an association between the Magnum and the Black body, inviting the audience to "bite into" a racialized sexual fantasy through the sexual attractiveness of the Black body shapes and the seductive poses. However, the gender of the sexy Black bodies was left to the audience's imagination. If the gender of those bodies was vague, the rule of "opposites attract" applied, and the brand could tap into more market segments. For an extremely explicit use of the exotic Other in ads, consider Figure 6.28. Designed in 2003 for the Snowboard School in Switzerland, this poster left nothing to the imagination. It picked up the imagery of the Kama Sutra and turned the erotic private sexual positions of an Indian man and woman into an attention-grabbing visual statement that was put on public display. While the Kama Sutra position had nothing to do with the sport of snowboarding or the courses offered by the school, the Orientalist obsession with the Kama Sutra prevailed. Imagery of the Orient was picked up by the West and used to speak for the West—in this case, the mythical bedroom techniques of India were used to back up the claim that "GOOD TECHNIQUE IS EVERYTHING," for the benefit of promoting a European snowboarding school.

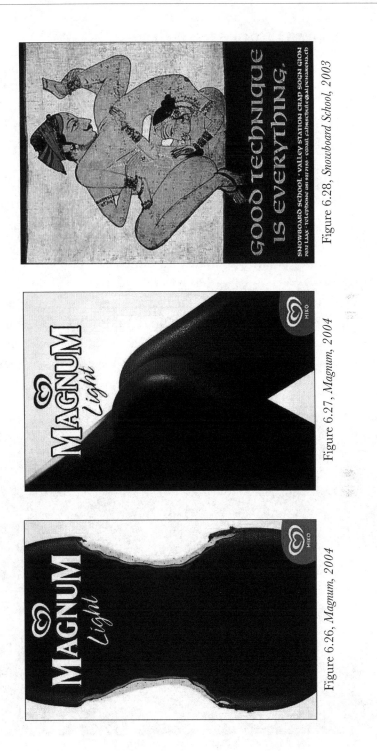

Figure 6.28, *Snowboard School, 2003*

Figure 6.27, *Magnum, 2004*

Figure 6.26, *Magnum, 2004*

ORIENTAL AND RELIGIOUS SYMBOLS

In an award-winning 1992 Levi's ad designed by McCann Erickson Italiana, a man's buttocks and upper legs dominated the layout (Figure 6.29). The man was naked except for a pair of blue jeans used like a G-String to cover his private parts, but fastened in the back with a tight knot. Although no facial features were shown, the figure's size and posture gave away his Japaneseness. Although the average audience member may not have been able to name the way in which the jeans were arranged as mimicking the "mawashi," the transmission of foreign imageries in the age of contemporary globalization meant it should be easy to identify the featured body as a Japanese Sumo wrestler.

The ad used the Japanese cultural tradition of Sumo wrestling, visualized through the highly recognizable Sumo body build, dress code, and posture, in an in-your-face display to the audience. At first glance, there appeared not to be much in common between the Sumo and Levi's, a well-recognized American symbol. Blue jeans had their humble beginnings among Californian miners and went on to become a fashion must-have in wardrobes across the world—regardless of gender, race, occupation or social status. More specifically,

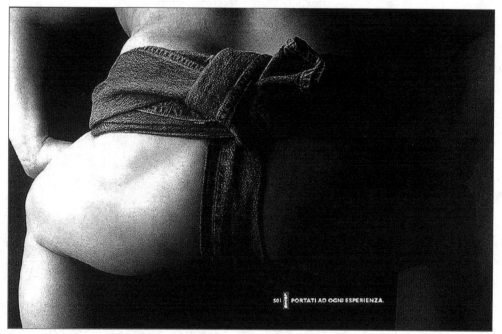

Figure 6.29, *Levi's 1992*

Levi's 501s®, the product advertised in this ad, is the pride of Levi Strauss—the original, the authentic, the real thing of the "blue jean" as we know it today. So what was the wisdom behind the U.S. multinational fashion icon picking up this rather isolated ancient Japanese sport that began in the Edo period and is still only practiced professionally within Japan?

From the time the brand was conceived during the California gold rush, Levi's jeans have been consistently promoted for their craftsmanship and quality. Their consistent selling points are durability and toughness. In the visual language of advertising, there are different ways to spell durability and toughness. Historically, the tough-guy characters of iconic Hollywood cowboys such as Gary Cooper, Tom Mix, and John Wayne wore Levi's on the silver screen in the 1930s, and imageries of American cowboys were heavily used in Levi's ads to convey these qualities circa 1900. Ads for Levi's 501® have stuck with these selling points into the twenty-first century. In a 2005 Levi's ad, the product itself was used to convey durability and toughness. The image was a close-up of a back pocket with the red Levi's tag on the right-hand side of a pair of blue jeans. While this small section of the product was sufficient for the audience to identify the brand, the ad counted on a tag line that read: "1 3/4 yards of Denim, 213 yards of thread, 5 buttons, 6 rivets" to deliver the message and persuade the audience about the product's superior craftsmanship.

The use of the imagery of a Japanese Sumo wrestler as a persuader is different from these common approaches. Unlike the Americanness expressed by the cowboy imagery, the Sumo wrestler signified Japaneseness. Unlike the product-oriented Levi's ads that signified a modern and mass-produced product, the mawashi signified a pre-modern cultural practice. Being an ancient heavyweight and full-contact sport, Sumo wrestling in itself already connoted the desirable sign values such as "heritage," "tradition," and "toughness." But the mawashi (replicated by the 501® jeans) offered an even more fitting sign value of "durability" for Levi's, as it needed to withstand the fierce attack of the opponent and stay securely in place. According to the rules of the game, if a wrestler's mawashi comes off during a bout, he is automatically disqualified. That said, if we compare this 1992 ad to the above-mentioned 2005 ad, it is not hard to judge which approach is more persuasive and effective in selling durability for Levi's. Without the need to spell out the little-known facts that the mawashi is typically made of silk or cotton, is about 9.1 meters long and 0.6 meters wide, and weighs between 3.6 and 5 kilograms, the audience already had some idea about the toughness of Sumo wrestling

and the quality required of this garment (without knowing the name "mawashi" or the rules of Sumo). Visually substituting a pair of 501® Levi's for the durable mawashi on the Sumo wrestler's body conveyed a playful and powerful message that the jeans were so tough that they could literally substitute for the mawashi and could endure fierce attacks from an opponent. While Eastern cultural practices such as Sumo were made the fetish in this ad—by way of association and the play of symbolic power—it contributed to a commodity fetishism that imagined the original 501® as capable of taking part "in every experience," as the tag line claimed, and the imaginative benefit that may come about through the consumption of the product.

This is a situation in which fetishism was at work to create an association between the iconic modern tradition of a mass-produced fashion that originated in the United States and spread across the globe, and an iconic pre-modern tradition of an ancient sport that originated in and is still only practiced in Japan. Despite the contradiction, the ad both managed the difference and generated the sameness of a desirable quality. By wrapping a pair of 501® jeans around the exotic body of a Sumo wrestler in action, this ad established a different kind of fetish that was rarely seen in early advertising. It was based on the Otherness of a cultural practice both known and foreign to the West, rather than on the Otherness of skin color or exotic body that had attracted most of the attention and criticism in current literature.

The use of exotic cultural practices in commercial ads is neither unique to this Levi's ad nor limited to Sumo wrestling. The phenomenon of commodifying exotic cultural practices and rituals began to emerge in contemporary advertising and branding in the late twentieth century. Marketing campaigns have used exotic cultural references to the extent that even sacred religious and spiritual practices of the East have been appropriated to name a product and shape its branding image. For example, renowned French beauty house Guerlain used the Hindu concept of "Samsara" to name a perfume, while the Buddhist concept of "Zen" has been used to name products ranging from Creative's internationally marketed MP3 players to a chic apartment building in downtown Melbourne. Even "novelty" golf balls, listed as "Buddha Balls," were on sale through *Time* magazine's 2006 pre-Christmas Internet shopping guide (*Time* Online, 13 November 2006). In addition to the name, "Zen-like" language was used—"The self says: I am" "The ball says: You are nothing" was printed on one side of the ball and, in a rather unthinkable way to treat any religious icon, an illustrated image of the

Laughing Buddha (a.k.a. Fat Buddha in the West) was featured on the other side of the ball—ready to be hit by "enlightened" golfers in the United States and beyond.

An inventory of the increasing presence of religious and spiritual references of the East in integrated advertising would be incomplete without noting the participation of print advertising. The ad for Wasa Light Rye (Figure 6.30), designed by Euro RSCG Chicago in 2007, provides an example of an approach in which a visual reference to a Buddhist deity was appropriated to promote the company's crispbread. Wasa was a leading Swedish brand with an 80-year history before it became part of the Italian Barilla Group in 1999. In many aspects, Wasa was a unique brand. It carried the Northern European tradition of preserving crops over the region's long and cold winters. Its brand name, "Wasa," was "associated with the name of the Swedish King Gustav Vasa and was picked to create an easy recognizable brand for all Swedes," according to official sources. Today, Wasa prides itself as "the world's largest baker of crispbread. In one year people enjoy 60,000 tons of crispbread in 40 different countries" (Wasa corporate website). Despite its rich Northern

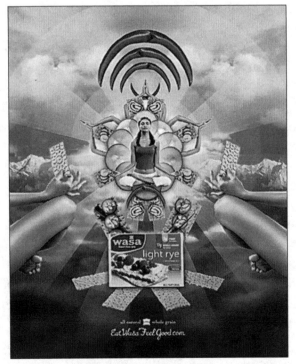

Figure 6.30, *Wasa, 2007*

European cultural tradition and authentic and unique taste and style—readily available to be developed into fitting and unique selling propositions—the advertiser chose to poach from the religious cultural stock of the East and play with the fetish of the remote and sacred to promote its product.

With some modification, the ad's overall layout mimicked the style of a Buddhist deity scroll painting. The model in the center of the ad was seated in a "lotus posture" with a Gyan mudra, a halo formed behind her, and rays of light shining from her mythical surrounding into the blue sky. The ad clearly put the racially ambiguous girl in the role of a Buddhist deity. The connection between the deity figure and Wasa Light Rye was the packaging and a few pieces of the product featured in the lower part of the frame. On both sides of the box, the mirrored image of two feminine hands resting on their upper legs appeared, each holding a piece of the crispbread in a Gyan mudra manner. Although seated in the same position as the deity figure, these two legs appeared naked. While it may be that the presence of part of these two female bodies serves to suggest some kind of divine duality, it is equally likely that these imageries were constructed simply to further "sex up" the ad. Interestingly, the Gyan mudra is known to bring about benefits such as mental peace, concentration, sharp memory, and spiritual feelings. If the ad meant to use the fetish of an exotic hand gesture to suggest the product's healthiness and energy, a Pran gesture—the mudra that energizes the body and improves its vitality—should have been depicted instead.

Given that there was neither a connection between the brand and Buddhism nor between the crispbread and the deity, it seems the use of the imagery was grounded in a desire to be exotic. The mythical deity scroll painting was not only "Other" to the origin of the brand, but also appealed to a "desire for the absolute other" (Levinas, 1979: 34). The ad's intent may have been to use the deity reference because of its extreme Otherness, hoping the fetish would help grab attention, stand out from the crowd, or give the product a mythical quality. However, while artistically pleasing, the deity scroll paintings are sacred artifacts used in Buddhist practices. The devotional images are the centerpiece of rituals and ceremonies, as well as mediums of prayer and meditation. Despite the artistic effort to paint the product as divine and magical, as capable of awakening consumers through the reference to an Eastern religious artifact, such an association was far-fetched, unconvincing, misleading, and—needless to say—lacking in cultural sensitivity and respect.

In short, this Wasa ad signified an emerging phenomenon in which the use of the racial Other in advertising went a step further by making use of their religious practices and symbols to appeal to New Age-minded consumers and boost consumption of the product being advertised. This ad worked to commodify fetishism by generating a false consciousness-type of desire for the product in Marxist terms (the Wasa Light Rye) and creating a fetish for a spurious, surrogate object of desire in a Freudian sense (the Buddhist iconography). The exploitation of religious symbols in contemporary advertising was inspired and made possible by a global commodity culture. As Anderson put it: "Never before has a society allowed its people to become consumers of belief, and allowed belief—all beliefs—to become merchandise" (Anderson, 1990: 188). It is taking advantage of a growing number of Westerners' desire for "an attractive way to distance themselves from the stresses and uncertainties of the contemporary world" (Anderson, 1990: 188).

BANKING ON A HERITAGE

The cases studied in this section all play with earlier stories, icons, hierarchy, and myth, turning elements of an existing highly discriminatory racial relationship into selling points in product advertising. Imageries of the racial Other have been deployed with references to their historical roots. In this section, we first analyze the ways in which leaders of racial struggles, such as the iconic Chief Joseph (leader of the bloody Nez Perce Indian War of 1877 between the indigenous people and White military in the United States) and Nelson Mandela (one of the African National Congress [ANC] leaders who led the movement against South Africa's apartheid government), are used as proxy endorsers for Timberland shoes and M&M chocolates. We then examine the different uses of the classic colonial racial script about the subordinate place of Black and Asian people in society and the myth of native cannibalism in contemporary culture to generate the "X" factor for the French high-fashion brand Louis Vuitton luggage and for Australia's Southwark White Beer.

Advertisements only have meaning within a system of meaning that, according to Williamson, "must already exist…and this system is exterior to the ad—which simply refers to it, using one of its components as a carrier of

value" (Williamson, 1978: 19). The imageries of the racial Other deployed in the ads in question, be they leaders of past racial struggles or oppressed laborers or mythical cannibals, all carry certain historical currencies. These currencies are useful for the sign values they carry and their potential adaptability to the product being advertised. As Williamson put it: "Currency is something which represents a value and in its inter-changeability with other things, gives them their 'value' too" (Williamson, 1978: 19).

The main focus of our investigation in this section is the different ways in which the stories of past racial injustices are retold, iconic fighters in racial struggles commercialized, racial hierarchies re-articulated, and myths recreated in the present to serve the global commodity culture and build image and add value to the brands.

RETELLING A NATIVE STORY

Designed by Leagas Delaney of London, this 1989 newspaper advertisement for the leading U.S. footwear brand Timberland used the image of an American Indian—referred to as "Red Indian" in the copy—to promote the brand and its leather boots and shoes (Figure 6.31).

Contrary to the conventional image-driven approach in newspaper advertising, this Timberland advertisement was predominantly copy driven. To begin with, unlike the "short and sweet" approaches such as Nike's "Just Do It," BMW's "Sheer Driving Pleasure," and Absolut vodka's "Absolut Perfection," the tag line in this Timberland advertisement contained 16 words—two complete sentences. Set in a bold, sans-serif typeface occupying close to half of the layout, these words read: "WE STOLE THEIR LAND, THEIR BUFFALO AND THEIR WOMEN. THEN WE WENT BACK FOR THEIR SHOES." A well-researched body copy the length of a mini-essay flowed across three columns underneath the tag line. As tempting as it is to explore the copy for the wit and words used to turn an uncomfortable piece of U.S. history into a selling point for the brand, we will concentrate on the tag line and the imagery to focus on visual language.

The first sentence of the tag line was constructed in a confessional tone in which the "Us" and "Them" relationship was emphasized through the "We/Their" binary. Unmistakably, "us" identified the dominant White establishment as the guilty party and the offender, while "them" signified the American Indians as the victim and the offended. The offense was stealing a

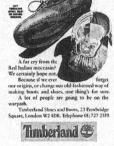

Figure 6.31, *Timberland, 1989*

list of "items" from the American Indians—their right (land), their property (buffalo), and their people (women). Although it used the same rhetoric, the second sentence—"Then we went back for their shoes"—is more open to interpretation. Following the previous sentence, it could be interpreted as doubletalk, suggesting that the White establishment also stole their shoes—with "shoes" more of a metaphor for "smaller items" compared to the others mentioned. But taking into account both its context as an ad for Timberland shoes and the copy, it becomes clear that the "we" in the second part of the confession was more about Timberland than about the White establishment, and that the act of "going back for their shoes" was more about virtuous cultural borrowing than the crime of stealing possessions. Through this switch, the ad could also be read as "We, the Timberland Company, returned to the traditional Native way and wisdom of making shoes, namely the moccasin, and offer the world Timberland footwear that is worth every cent of its 'heap big price tag.'" This clever spin turned an admission of sin on the part of the establishment into a promotion of the brand's attitude toward racial respect, cultural adaptation, and unique product selling points.

Only three small-scale images shared the column space with the ad's body text—an American Indian man, a waterproof casual shoe and moccasin, and the Timberland logo. The size of the respective images decreased, confirming a visual hierarchy designed to place the American Indian in the foreground. The American Indian man was represented portrait-style, in gray scale, in what appeared to be an historical photograph. Although the visual treatment was low-key, the racial identity of the man was unambiguous: he was presented to the reader wearing traditional American Indian headgear and accessories. He faced the camera directly with an expression of sadness, and the portrait was positioned in the middle of the layout at the top of the middle column—a commanding location. Every visual element of the ad was treated with a basic approach—from image, to typeface, to layout. This no-frills approach was strategic. It, and the accompanying audacious statement, effectively captured the audience's attention by directing the eye to the visual hierarchy from the tag line to the American Indian, to the story of Timberland shoes with its references to the "Red Indians." It ended with a Timberland logotype being de-bossed on a piece of leather, working like a full stop.

In several ways, this Timberland ad was both successful and controversial. As a creative effort, the ad won a Silver Pencil in the prestigious D&AD award in the year of its release. As a marketing effort, it took the pulse of its targeted

demography and cashed in on the sign value of the American Indian in a tailored sales pitch. The brand's target audience was identified as people who "seek authenticity and heritage, a taste that borders on the nostalgic, wanting to feel the brands they choose stand for something" (*American Demographics*, January 1999). By denouncing racial oppression and depicting people and products that symbolized native people and culture, the brand sensitively tapped into this "class habitus," a term coined by Bourdieu in 1984. On the product level, the American Indian man served as a proxy endorser for Timberland outdoor footwear, taking advantage of the sign value of his authenticity, heritage, and wisdom—ingredients of "the real thing" specifically desired by the target audience. On the branding level, Timberland continued the visual bonding between it and the oppressed racial Other following this ad. For example, its 1992 "Give Racism the Boot" press ad showed a single Timberland boot under that tag line to declare the brand's support for diversity and against racial oppression, enhancing the brand's reputation for corporate responsibility. Projecting such a corporate image had its economic rewards. By 1993, Timberland's classic waterproof boot had reportedly overtaken Nike's Air Jordans as a fashion statement for both urban youth and professionals, and the Timberland share price increased 400% in 10 months. One of the reasons for this success was said to be the brand's stand against racism, as described by *Time* magazine: "'Give Racism the Boot.' That politically correct advertising slogan, combined with environmentally conscious products, has turned Timberland Co. of Hampton, New Hampshire, into a hot marketer and a torrid stock" (Greenwald & Fallon, 1993).

Ironically, the controversy over the ad—the objection to the use of the American Indian—was fueled by the response from both ends, although each was driven by a different concern. At one end, as Delaney recalled, his agency "even had Americans calling the office to say how offended they were" about the ad for retelling the story of oppression (Delaney, 2007). But at the other end, complaints from the advertising industry claimed the ad "contain[ed] racist nuances," with the character in the portrait referred to as "a somber American Indian," according to a feature article in *The New York Times* (Rothenberg, 1989). Besides the choice of imagery, some parts of the main copy—such as the opening sentence, "The Red Indians were an ungrateful lot," and the use of offensive terms such as "squaw"—must have also raised some eyebrows, despite the ad's attempt at satire.

If we place the controversy into perspective by considering the other five less noticeable ads in this six-ad series, the ad in question was not designed to condemn the past sins of the United States for its treatment of native peoples, despite the tag line that may have left such an impression. Although identical in style and tone, this was the only ad that engaged with racial issues in the United States. Tag lines such as "OUR SHOES OUTLAST THE MEN WHO MAKE THEM," "YOUR EYES ARE FROZEN. YOUR SKIN HAS TURNED BLACK. YOU'RE TECHNICALLY DEAD. LET'S TALK BOOTS," and "TIMBERLAND GIVES YOU BACK THE COAT FOUR MILLION YEARS OF EVOLUTION TOOK AWAY" provide a feel for the campaign's provocative tenor and unique storytelling sales approach. Indeed, each of these ads was "a story about the mythology of boots and their role in the development of America," as Delaney himself later explained (Delaney, 2007). Conversely, the ad was not designed to snub the American Indian and paint the native people in a negative way—given that the ad, through its copy, forcefully tried to link Timberland's shoe-making method with the native culture's famous moccasin. As for the imagery of the "American Indian" (as he is known to most, even the author of the above-mentioned *New York Times* article), we can hardly claim that by itself it had a racist nuance. The man in the portrait was not just any somber "Red Indian." He was Chief Joseph—the leader of the Nez Perce people who were forced to fight their way to freedom against the larger and better-equipped White military during the bloody Nez Perce Indian War of 1877. Different from the young, dignified Chief Joseph depicted in a nineteenth-century W.S. Kimball & Co. cigarette trading card collection (noted in Chapter 2), his somber-looking face, captured in this particular portrait, tells a story of indigenous struggles for land, for life, and for freedom.

While we are not quite convinced that the ad was, on the one hand, an ideological statement condemning the United States' racist past or, on the other, that it should be condemned for having a racist nuance in its imagery, it is nevertheless a classic example of the use of the trope of the racial Other for commercial gain. It cashed in the currency of the American Indian on at least two fronts: the currency of a tribal leader of a hard-fought racial struggle, for the sign values of freedom, justice, and equality; and the currency of a piece of North American indigenous culture—the famous moccasin—for the sign values of authentic design, natural living, and rugged durability. The issue, then, is not that Chief Joseph was somber looking in the portrait used in the

ad. If one knows how he and his people were betrayed by the establishment, and if one reads of his heartfelt surrender speech, the man had every reason to look somber. The issue is that we need to realize that his expression as captured in the portrait reflected his loss of land and people, telling of early racial struggles between the indigenous people and the White establishment. It was *not* meant for the purpose of endorsing Timberland shoes in a commercial ad. Through the power of visual and written language, imagery, and clever "myth building," the advertiser has hijacked, commercialized, and consumed the story of the racial Other.

CASHING IN ON THE ICONS

Although the Timberland ad discussed above is in itself a modern classic, it is neither the first nor the last to hijack and commodify the imagery of leading figures of racial struggles in branding and advertising campaigns. The 2007 ad of U.S. confectionery brand M&M's, designed by BBDO Cape Town (Figure 6.32), is one of the more recent examples of such an approach. In an apparent birthday greeting, the M&M's ad featured the image of a smiling Nelson Mandela constructed from yellow, orange, red, blue, green, and brown button-shaped chocolate candies, with the line "Happy Birthday, Madiba." At face value, it was a nice—and literally "sweet"—way to celebrate the internationally recognized icon of political struggles in honor of his upcoming birthday. However, as in the Timberland case, this ad was not merely a very expensive birthday card, but was commissioned to sell the brand and its product through mythical construction that cashed in on the historic sign value of a Black leader—Mandela.

Under the "sweetened" portrait of Mandela, the ad showed two different M&M's packs in the lower right corner, complete with the standard sales pitch, "The milk chocolate that melts in your mouth, not in your hands." Beyond this predictable visual reminder of the product and its Unique Selling Proposition (USP), known to the market since 1954, the tag line took a significant step further to force a link between M&M's and Mandela: "Thanks for encouraging us to embrace all our colours." One may wonder how—and indeed if— Mandela had anything to do with encouraging the brand "to embrace all our [M&M's] colours." Looking into the history of M&M's according to the company's official website, one finds that the brand was built on color from the very beginning. M&M's were originally made as a high-energy field snack for

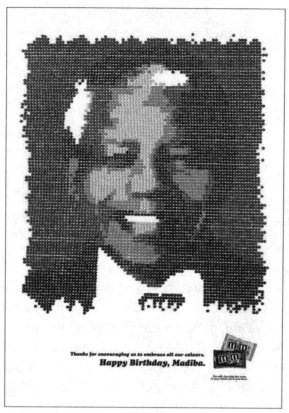

Figure 6.32, *M&M's, 2007*

U.S. soldiers in 1941. Even during World War II, when they were sold exclusively to the military, the patented button-shaped candies were produced in five colors per tube—red, yellow, brown, green, and violet. In the late 1940s, violet was dropped and replaced by tan, and in 1976, red was dropped and replaced by orange. The official explanation for eliminating the color red from the M&M mix was health concerns related to the dye amaranth (Red Dye No. 2 had earlier been banned by authorities). Given that the banned dye was not used in red M&M's, and given that, after having been excluded for 9 years during the Cold War, red M&M's returned to the family in 1985 to coincide with the Soviet Glasnost and Perestroika, this claim is open to question. Perhaps red M&M's were sent into exile as a reaction to the political climate and the Cold War's "red phobia."

The subsequent changes to M&M's colors have been continuously driven by the brand's marketing campaigns. In a 1995 campaign searching for a

replacement color for the soon-to-be-discontinued tan M&M's, blue—the only color missing from the unique hue in the M&M mix at the time—was finally included. In the 2005 Mpire campaign, designed to "tie in with the Star War's Episode III *Revenge of the Sith* movie release, M&M'S® were offered in a dark variety for the first time" (to use the company's words) complemented by the theme "Mpire Strikes Dark." In 2008, 20 colors were made available for the MyM&M's line, in which consumers could personalize the chocolate buttons with their own image or message. Effectively, you no longer had to be a Mandela to have M&M's linked to your face. The rule of the game became that, as long as you are willing to pay, you can have the satisfaction of having your face printed on your favorite M&M color. It doesn't matter who you are, or what color your skin is. This is a very well-played game of consumer citizenship: you are led to think you are empowered with choices and the right to choose, without realizing that you are given only one "choice"—M&M's.

Among its well-executed color plays, the cultivation of color in the creation of M&M's' very own "spokescandy" characters is also worth noting. It is interesting to observe that, throughout M&M's' history, while every other color in the mix has been assigned a "spokescandy" in the brand's advertising campaigns, brown has not, despite being a foundation color from Day One. In other words, while the advertiser created a red M&M mascot called "Red" for the original milk chocolate variety, a yellow M&M mascot called "Yellow" for the peanut variety, a blue M&M mascot called "Blue" for almond, a green M&M mascot called "Miss Green" for peanut butter, mint, and dark chocolate, and an orange M&M mascot called "Orange" (aka "Crispy') for other types of M&Ms, no suitable role has been found for a brown M&M mascot in nearly 70 years, despite many varieties being produced and marketed. What is the problem with being brown? What has prevented the birth of a mascot "Brown"?

Evidently, the Mars Company—the creator of M&M's—embraced color from the very beginning of the journey. Obviously, the wisdom of patenting the color-coated, button-shaped chocolate candies in 1941 and creating a series of color-oriented campaigns emerged without Mandela's encouragement. Furthermore, while M&M's were busy playing the color marketing game, Mandela was locked up for 27 years by South Africa's apartheid government. At the time this ad was circulating and until mid-2008, Mandela and his fellow South African leaders remained on the U.S. Terror Watch List, and by law he and other ANC members "could travel to the United Nations headquarters in

New York but not to Washington DC or other parts of the United States," according to the BBC (BBC News Online, 1 July 2008).

Yes, Mandela does connote "color" as a Black man and a Black icon in South Africa's struggle for racial equality. He fought a lifetime battle against apartheid, a system of segregation based on race devised by the all-White National Party to oppress the Black majority, and to build a multiracial democratic nation. But having Mandela's image constructed with M&Ms was like putting "Yellow"'s famous line "Eat Me!" into Mandela's mouth—forcing him and his history of racial struggle to endorse a commercial product without consent. Similarly, as illogical as it sounds, Renault has made Che Guevara endorse a flash convertible in this 2007 ad (Figure 6.33).

Yes, the M&M color mix has been growing and will continue to grow in number. But the growing number of available colors of M&M's on the market was unambiguously driven by a competitive market environment and a marketing and advertising campaign strategy to keep the brand in the media spotlight, to keep the M&M image fresh and alive in consumers' minds, and to stimulate demand, increase market share, and improve the profit margin in the cutthroat yet lucrative candy and snack food sector. Ultimately, we know it was

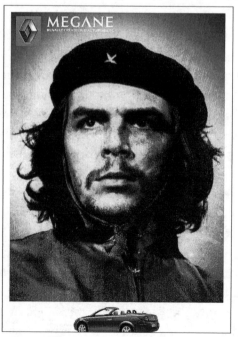

Figure 6.33, *Renault, 2007*

the brand's historical archrival, Hershey Kisses, that really forced and "encouraged" M&M to "embrace all our colours." Despite this inconvenient truth, Mandela's iconic stardom, his sign value of being "colored," and his historical relationship with the "color line" were conveniently picked up, consumed, and spun into a kind of visual M&M's pun to forge a marketable brand image on both the product and mythical levels.

CARRYING ON THE TRADITION

In contrast to the Louis Vuitton (LV) tradition of depicting the rich and the prestigious, two of the brand's 1984 advertisements differed markedly, depicting instead non-White laborer Penny Toys. One ad for LV luggage featured an African man transporting a pile of LV luggage on a nineteenth-century-style gig (Figure 6.34). Another in the same campaign featured two Asian men transporting a single LV carrybag on top of an oriental trunk (Figure 6.35).

For more than a century and a half, Louis Vuitton has been making luxury luggage and bags for a privileged clientele ranging from royalty to superstars. With each of its products a designer piece and globally recognized status symbol, the brand has a cult-like following. Louis Vuitton's efforts to cultivate the sign value of prestige is evident through its consistent use of celebrity power, employing superstars such as actresses Jennifer Lopez, Scarlett Johansson, Chloe Sevigny, Uma Thurman, and Christina Ricci, and supermodels Gisele Bundchen, Kate Moss, and Naomi Campbell in its advertising campaigns. Given this pattern, the strategy employed by these two ads of using visual elements of non-White laborers as substitutes for the celebrity endorsers is interesting.

The tag line "always the unexpected, since 1854" is a good starting point from which to view these ads and appreciate the strategic wisdom of a brand focused on the luxury market depicting the underprivileged racial Other in one of its major advertising campaigns. Through its use of the key concept "the unexpected," it is obvious why superstars and supermodels were not featured in this campaign: they were too predictable and were clearly the "expected." Conversely, the use of the non-White laborer Penny Toys was guaranteed to be effective, as they were the least predictable endorsers of a LV campaign and were therefore the "unexpected." In other words, the depicted characters in these two ads were chosen for their absolute Otherness. Such Otherness was not merely about their respective skin colors, but the historical

meaning attached to these skin colors—their cultural identity and their place in society. If the superstar and supermodel endorsers for LV were selected for their collective sign values of affluence, eminence, and fame, the African gig operator and the Asian porters were everything but. They were the "have-nots" and "underprivileged" who had no name other than "servant" and "coolie." Therefore, being the direct opposite of what LV symbolized, their lack of wealth and status gave the racial Other that highly desirable "X" factor.

Acquiring the "X" factor is one thing; converting it into a selling point is another. In this regard, the play of visual signs pushed the commodification of the racial Other even further to make them deliver more than a mere visual surprise. For example, given the history of slavery, the African servant could be serving his affluent masters anywhere in the world, but the ostrich driving the gig and the mark "KAMERUN" on the carriage signified that the place was the West African country of Cameroon (Cameroun in French), which was ruled by Germany from 1884 to 1916 and by the French and the British until the early 1960s. Similarly, while there was no specific reference to place in the other ad, the visual clues all seemed to point to China. The porters' pigtails are a Western visual symbol for "Chinaman," while the rest of their costumes, from head to toe, also spelled Chineseness and subordination with Orientalist references. The unexpected spatial shift came with an unexpected temporal shift that spanned the contemporary to the pre-modern, and the Occident to the African Sahara and the Orient. Instead of private jets and limousines, the advertisements employed a nineteenth-century-style gig driven by an African man to transport the famous Monogram Canvas case, and a personalized lacquered oriental trunk dating back to at least the sixteenth century and carried by two Asian men to transport the prestigious Epi leather bucket bag. As a result, imageries of the racial Other were used to shift the place of the brand's European origin to its exotic Other; of its time from the age of contemporary globalization to the era of colonialism and High Imperialism. In so doing, a colonial relationship between the colonizer and the colonized/semi-colonized was managed and consumed to generate nostalgic appeal.

In short, elements of the humble racial Other were used in this campaign instead of glamorous and/or successful celebrities, because the meanings attached to racial Otherness could help provide the appeal that celebrity lacked. In this case, imageries of the racial Other not only helped to enhance the unexpectedness that the campaign was explicitly set up to convey, but, at a deeper level, also served as a feel-good factor feeding the nostalgia of the

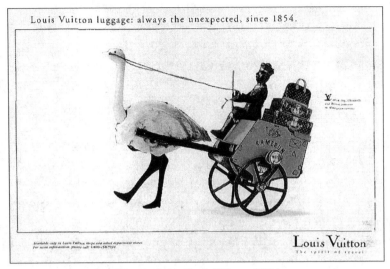

Figure 6.34, *Louis Vuitton, 1984*

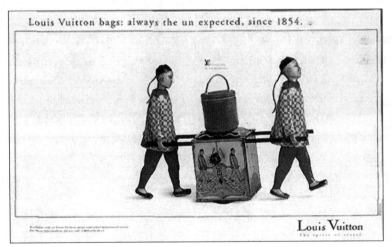

Figure 6.35, *Louis Vuitton, 1984*

brand's privileged clientele. The ghosts of yesterday's masters behind the private gig and the personalized oriental trunk reminded the audience of a superior-inferior/master-servant relationship, through both the presence of the ultra-luxurious LV products and the absence of their owners, who were obviously freed of the burden of handling the luggage. Instead, the house chauffeur and porters were left to carry on the tradition of catering to the superior few.

Apart from the nostalgia for the colonial relationship, the colonial myth is also being re-staged in contemporary advertisements. A 2007 advertising campaign promoting Southwark White Beer (Figures 6.36 and 6.37) is one such example. Designed by Ogilvy & Mather Australia, the campaign used the imagery of dark-skinned people—named as "the natives" in the ad—to promote the brand. Both ads in the series were presented to the audience as framed etchings, each capturing a horrific scene of torture carried out by the dark-skinned people against White people. The first ad depicted a native-chief character cutting open a White man's chest and pulling something out, assisted by five others to stop the prey's struggle. In addition to the suffering White man, three horrified White women were seen tied up. Under the etching, the ad's caption read: "Although sceptical at first, the natives soon grew fond of the unique taste of white." In similar fashion, the second ad had a group of native people violently subduing a White man and forcing a sheaf of wheat into his mouth. This time the caption read: "After much debate, the Engai agreed it was the subtle addition of wheat that gave the whites their distinct taste."

Clearly, the campaign made a pun on the word "white" and played with the concept of "White race" and "white beer." However, the pun itself was only a play on words and meanings—and was not yet a sales pitch. To promote the selling points of White Beer, *the Self needed its Other in order to have meaning*. Exploiting the Other concept of "white" provided the solution, and imageries of the racial Other were chosen to complete the pitch.

Imagery of the racial Other was extremely useful here. Without staging some "natives'" kidnapping, dissecting, and presumably tasting the flesh of the White man, the advertiser could not claim "the unique taste of white" for the product in such a memorable fashion. Furthermore, without scripting the "natives" in the act of torturing the White man by violently stuffing wheat into his mouth, the ad could not vividly convey the "distinct taste" of wheat so desperately desired in the White Beer.

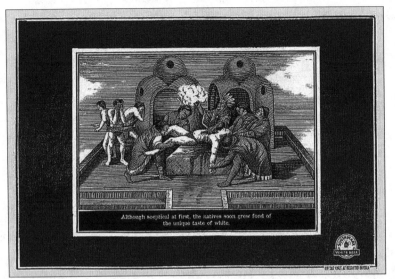

Figure 6.36, *White Beer, 2007*

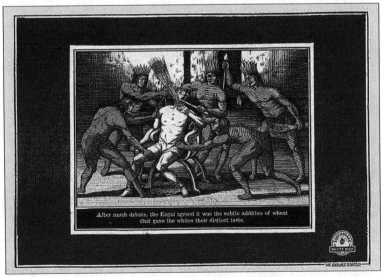

Figure 6.37, *White Beer, 2007*

There is more to the obvious sales messages than the use of imagery of native people to help "prove" the unique taste and attributes of the product. In a settler colony such as Australia, with a contemporary Hensonistic racial ideology[1] still lingering, a number of hidden statements from the familiar stocks of the colonial racial script are apparent. "Cannibals," "wild beast," "barbarian," "primitive," and "uncivilized" are just a few racial signifiers of "natives" frequently evoked in this campaign. Therefore, on a deeper level, the behavior of the "natives" depicted in this campaign sent an ideology-based sales message: "You know how good the White Beer tastes when even the uncivilized barbarians like it and can't get enough of it."

In short, the way in which the White Beer was promoted continued the tradition of a colonial racial imagery that carried with it the colonialist racial ideology. As with the African man and the Asian men in the Louis Vuitton campaign before it, a colonial script drove this portrayal of the native people's inferiority and transformed it into the "X" factor that was so useful in promoting Southwark White Beer. The fact that the campaign was designed around a new product for the mass market of beer drinkers in a settler colony indicates that you do not need to run a campaign that claims "always the unexpected," nor do you need to be a brand associated with the long journey of colonialism. Finally, you do not need to have a nostalgic prestige clientele—as does Louis Vuitton—to turn to stock colonial traditions for inspiration and advertising solutions. The Other is always useful in making sense of the Self.

A STRANGE GAME AT PLAY

This final section identifies some of the contemporary, left-field approaches to deploying the racial Other using the classic colonial racial script, experimenting with new versions of the script, or utilizing taboo racial stereotypes. While all of these tactics push the envelope, the ads were constructed in a highly unexpected manner. It appears that "those strange strategies and power relationships" that interested Foucault (Foucault, 1988: 15) were in play. Using visual imageries, advertising was able to assume and tap into a pre-existing body of knowledge. As Williamson put it, "to decipher and solve the problems we must know the rules of the game. Advertising clearly produces knowledge…

but this knowledge is always from something already known" (Williamson, 1978: 99). Within the context of contemporary globalization, were these left-field efforts breaking free of the existing colonial racial script, or were the apparent "newness" and "coolness" generated by these efforts still haunted by the ghost of colonial racial ideology?

MIMICKING THE TRIBAL

An advertisement for the U.K.'s Habitat retail chain, designed by Saatchi & Saatchi London in 1998, promoted the launch of a new product line named "Tribal" (Figure 6.38). The copy below the main image read: "We've travelled all over the world for ideas for Habitat's new tribal collection. Drop by if you don't have too much on your plate."

With a product line named "Tribal," we all know which series of images will jump out from the cultural reference system of our minds. But it was not to be in this ad. The ad denoted a young Caucasian woman and a plate. Although on the face of it this may not seem like an advertisement that deploys the imagery of the racial Other, what the ad really communicates is, indeed, the concept of Ethiopia and the Otherness of her native people, customs, and artifacts. As we further explore the details, we can see that significant alterations have been made to the White model's appearance to give her a "tribal look": her blond hair has been dreadlocked, and her natural eyebrows, eyelashes, and eyelids have been dramatically darkened at a time when "smoky eyes" were not yet in vogue. Styling and makeup have transformed her original fair facial features and her Whiteness to an extent, but obviously not quite enough. More extreme, surgical-style visual intervention has been used to manipulate the model's lower lip into the shape of a plate, mocking the "Lip-Plated women," typically from Ethiopian tribes such as the Mursi and Suri. Evidently, an extreme makeover has been planned and executed on the Caucasian model, mixing her Whiteness with the Otherness of a tribal woman. Here, strangely—but necessarily—in a study about the use and usefulness of imageries of the racial Other in advertising, we face questions as to why the imagery of a "real" tribal woman was not used, and why instead the advertisers went to the trouble of using a White woman to mock a tribal woman.

What drove the omission of the tribal woman and the resulting imagery is complex, involving the discursive sign value of the Lip-Plated women and the politics of consuming Otherness for the benefit of the advertiser. To begin with,

the Lip-Plated women are well known to the West and are, arguably, one of Ethiopia's main attractions. The fact that fascinated Western tourists spend considerable time, money, and effort to make a tough, 3-day journey from Addis Ababa to the Omo River Valley just to get a glimpse of the Lip-Plated women attests to the commodity value of these tribal women. A 2006 government report found that most tourists to Ethiopia come from the United States, followed by the U.K. (*National Coffer*, No. 17). Notably, "Among the most visited group is the Mursi, renowned for the huge clay lip plates worn by the women," according to a review of Ethiopian tourism (*Mail and Guardian*, 31 January 2002). In the age of globalization, images of these women are also available to the masses who cannot afford to travel such distances to see them firsthand—through TV documentaries broadcast internationally (e.g., *Global Village* on SBS TV in Australia and *The Tribe* on the U.K.'s BBC 2) and travel literature ranging from tourist brochures to *Lonely Planet* publications.

It also needs to be appreciated that the Lip-Plate has historic, economic, and cultural significance for the Mursi/Suri people. Historically, it connotes bitter resistance to colonialism, having been used as a measure to discourage slave traders from kidnapping their women. According to a 1938 article published in *National Geographic* magazine, "This form of disfigurement was begun centuries ago to discourage slave riders, the French Administrator told us" (Thaw & Thaw, 1938: 357). In *The Tribe*, Bruce Parry suggested that the Lip-Plate is also an economic signifier—according to his Suri host, the size of the Lip-Plate is somehow indicative of the bride's value. However, real-life examples seem to contradict the popular bride-wealth theory. Using the perspective of the locals, David Turton concluded: "When one asks a Mursi woman why she stretched her lip, she usually replies, simply and predictably, with a version of the phrase 'This is our custom'" (Turton, 2004: 4). In this regard, the Lip-Plate serves as a powerful visual marker of Mursi identity for the local men and women. Although the interrelationship between the Lip-Plate and bride wealth remains debatable, there is little doubt that the Lip-Plate has been turned into an economic asset in the age of globalization. For the Ethiopian government, it is the major drawing card for attracting Western tourists and their money. For the Western tourists and the people who consume the Lip-Plate phenomenon, Lip-Plates and the Lip-Plated women are objects of fetish—the plates as souvenirs and the women as subjects of tourist photos This is because, in a thoroughly commodified global world, they are hard to find and still seem authentically not-modern, driven by a desire for what

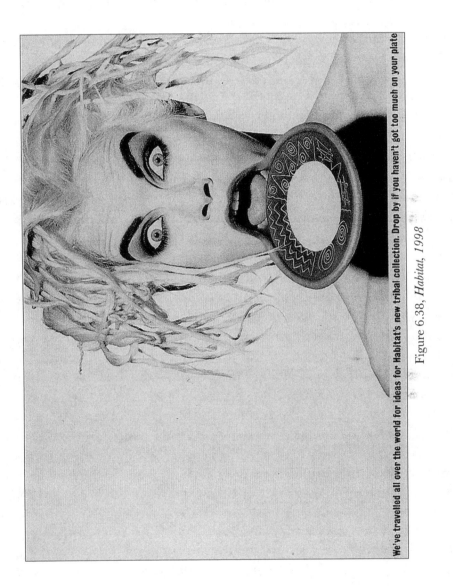

Figure 6.38, *Habitat, 1998*

Emmanuel Levinas called "the absolutely other" (Levinas, 1979: 34). Closer to home, for Habitat, the Lip-Plate is a famous, fascinating signifier for the absolute "tribal." It acts as an exotic and eye-catching way to display a product line and enables the advertiser to play word games in the copy—"Drop by if you don't have too much on your plate."

The desirable sign values of the Ethiopian Lip-Plate women make the advertising strategy even more puzzling. Why take the trouble to mock an Ethiopian Lip-Plated woman instead of deploying her like the rest of the ads analyzed in this book? The politics of consumption are at play here. First, while used as a visual symbol for Ethiopian attractions by tourism promoters, the Lip-Plated women also connote concepts of inferiority, backwardness, and wildness in the minds of those from the outside world. Even in Ethiopia, the use of the Lip-Plate—as a symbol of Mursiness and Mursi autonomy—has been under constant pressure from Ethiopian governments past and present. The Lip-Plate has been branded by politicians as an "uncivilised custom" and a "harmful traditional practice," and calls for it to be abandoned have come with government threats, including that "any girl who decided to stretch her lip would have her lower lip cut off entirely, to make an example of her" (Turton, 2004: 5). However, given the contribution that tourism makes to the country's economy, the fact that the Mursi Lip-Plate is arguably at the top of the international tourist's must-see list, and the fact that the Mursi remain autonomous, the threats seem to be no more than empty rhetoric. Furthermore, it is worth noting that the Mursi/Suri people are held by the Ethiopian government as its Other. For example, on the government's official tourism website, under the heading "Ethiopian Cultural Attraction," the Mursis—unlike the dominant groups, who are introduced by their ethnic/tribal identities—are labeled as "Fascinating People," and there is no mention of the Lip-Plate. Evidently, while the government is using the Mursi identity to attract international tourism revenue, it is ashamed of the existence of the Otherness embodied in their cultural traditions. Such a love-hate relationship is also reflected in Westerners' feelings toward the Lip-Plate. While expressing disdain, shock, and disgust, they nevertheless travel great distances to enthusiastically photograph them, showing off these pictures back home as trophies. It seems that the Lip-Plate is at once desired and loathed by Westerners, and this contradictory sentiment obviously had implications for the ad's strategy of non-representation and presentation.

Thus, although the Ethiopian Lip-Plate women are highly sought-after photographic subjects for Western travellers, and the Lip-Plate is identified and made a fetish by the advertisers, the imagery of a "real" Lip-Plated woman is too dangerous to be consumed as a whole. She needs to be consumed in part—the part that is magical and desirable but not real or controversial. What needs to be taken from her is her symbolic backwardness and a racial identity that represents the opposite of civilization, which is considered to be incompatible with the Western audience.

The merits of Othering the White model also involved strategic consideration. First, we need to recognize that the image of the Lip-Plate was not only used in this advertisement as a source of wit but also as a source of shock. The procedure used to create a Lip-Plate was known to the West as an "extremely painful ritual," among other tribal customs such as scarification and stick fighting. A Lip-Plate appearing on the face of a White woman compounded the cultural "shock" factor. Because the model was recognized as one of "us," she was able to bring the shock closer to home, where the audience was more likely to "feel" for her—even though the procedure performed on her by the agency was a painless one that involved only digital manipulation. The "real thing" involves body modification using procedures such as piercing the lower lip, excising two (or more) lower front teeth, and years of inserting plates and stretching skin. As such, the Othering of a White model delivered an image that was unexpected, was capable of eliciting a stronger emotional response, and in turn made for a more unique and memorable advertisement.

The advantage does not stop here. After the less intrusive makeovers, such as the sophisticated styling techniques used to make her hair look dreadlocked and her face exotic, her seemingly exciting facial expression and wide-eyed gaze delivered a "Look at me!" message with the unspoken "I feel exotic!" and "Look at the plate!" The underlining sales message is rather obvious: "You can get this feeling if you buy Habitat's tribal collection" or, better still, "Transform your identity profoundly by purchasing Habitat's tribal collection." Any of these messages was highly desirable from Habitat's point of view, and the advertiser evidently believed that this sounded more persuasive coming from an identity considered a member of the in-group rather than the out-group—thus the need to "tribalize" the Caucasian model.

In Woodhead's 1991 documentary *The Land Is Bad*, some rarely heard local voices recounted the unequal and uncomfortable relationship between Western

tourists and their Lip-Plated photographic subjects: "Do they want us to be their children, or what? What do they want the photographs for?… We said to each other, 'Are we here just for their amusement?'" As the Mursi people have already questioned the motive behind the consumption of their identity and value and expressed their displeasure regarding the unequal economic and power relationship imposed on them by Western tourists, it is hard not to wonder what they would feel about the use of the Lip-Plate as part of an extreme makeover, and its juxtaposition on the face of a White model. One can only imagine that this would be even harder for them to comprehend, and an even more bitter pill for them to swallow, since the opinions of the tribal Other are rarely heard, and by and large their voices have been muted. In this strange play on racial representation, it is the advertiser who holds the means and power to consume. The tribal Other, essentially, is only there to provide.

This Habitat ad differs from the rest of the cases examined in this book because the main signifier of racial Otherness—the Lip-Plate—was taken from the face of a "backward" tribal woman and implanted onto the face of a "cultured" Caucasian model. While this kind of calculated and highly manipulative approach to the visual mimicking of the racial Other helped to maximize the ad's impact, it is a new addition to the multifaceted visual rhetoric of appropriating and consuming the racial Other in contemporary advertising. It represents a drastic way of appealing to the "class habitus" by consuming the imagery of the racial Other in part through visual dispossession and with the help of digital technology.

THE ECCENTRIC EXPLOITATION

A 2000 ad designed by TBWA Johannesburg to promote U.S. multinational Sara Lee's She Bear label featured three fully veiled people who appeared to be Muslim women (Figure 6.39). At the time, Sara Lee also owned famous lingerie brands such as Playtex and Wonderbra. She Bear is an upmarket lingerie line that, like the more well-known sister label Wonderbra, is internationally recognized in the world of high fashion. While Wonderbra is famous for its "push-up" effect, with an emphasis on enhanced functionality, She Bear claims it "celebrates women" with a luxurious and sexy appeal promoting a sense of femininity.

The ad's tag line read: "WEAR IT FOR YOURSELF." It was typeset in a subtle manner on the top left-hand corner of the layout, followed by the She

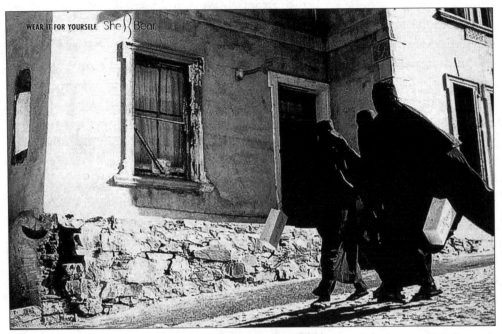

Figure 6.39, *She Bear, 2000*

Bear logotype. An otherwise stylish building that appeared to be in bad shape dominated the background. Not only was there a big hole in the sidewall and significant damage to the corner of the retaining wall, but the window and the door were also in a state of disrepair. In the foreground, three fully veiled Muslim women in black chador were depicted walking from the right of the picture down a sloping street. Two could be seen holding white shopping bags bearing the She Bear logo. Strategically, the presence of the shopping bag provides the reader with the only clue that these women are buying and using lingerie products.

This ad used a highly unconventional approach to promote a lingerie line in general, and a "sophisticated" brand in particular. There was no sign of the familiar imageries of beautiful faces, perfect bodies, sexy lingerie, and romantic surroundings—a typical formula used for almost every ad in this category. Instead, the advertisement showed models with their faces concealed and bodies fully covered. The only visible garment was the black chador, and the background was a clearly devastated street. Reading into the imageries, the chador served as a symbol to identify the three models as Muslim women, implying that the wearers were following certain cultural practices required by

Islamic teachings. The cultural practice most relevant to this ad is the preservation of modesty by concealing the body. This would appear to be a mismatch with the advertised product. The She Bear label stands for femininity. Its entire identity is designed to make a feminine statement—from the label's name to the logotype that manipulates the initials "S" and "B" to suggest womanly body curves. Yet the chador made it impossible to show the models' curvaceous figures or the sexy She Bear bra the ad was designed to promote.

Although the use of imageries of Muslim women, who are known for their conservative dress code, to promote a lingerie line built on sexiness and feminine appeal is a puzzle, it may have served an ironic purpose. The ad may have been set up to sell a feminine image by deliberately using visual language that normally signified the opposite. Because the design was the antithesis of the normal visual rhetoric, it performed the magic of attracting greater attention. It evoked surprise and became more memorable—and the black chador and the women who wore it became the fetish to deliver this effect. In addition, this type of irony can at times be even more thought provoking. Even with the tag line "wear it for yourself" to guide the ad's interpretation, it could still be read as a double-edged satire—either aimed at the perceived "backwardness" and Otherness of the particular Muslim way of life, or at the extrinsic value system within the consumer culture and the patriarchal society, or both. Furthermore, it could also be interpreted as giving the brand a feminist attitude, or even as presenting a moral claim to free the "oppressed" women (as in the case of the ISHR poster discussed in Chapter 5). There can be many other interpretations, all subject to the audience's background.

If casting fully veiled Muslim women to sell sexy lingerie in the She Bear ad was somewhat offbeat, other ads appear to be totally incomprehensible. A 2009 ad for Mangaloo juice, designed by Rust Prague from the Czech Republic, is an example of these extremes (Figure 6.40). The ad featured a Black boxer as the dominant image against a dark gray background. His face, together with his black leather Everlast headgear, occupied more than half of the space, with his naked upper body occupying the rest. Judging from his facial expression, the boxer was still in the mood to fight; however, an unpeeled orange appears to have been forcibly squeezed into his mouth. The tag line "Freshly squeezed juice" was typeset in a relatively small font and floated in the middle of his chest. To its right the orange juice was identified by the logo as being Mangaloo.

The tag line "freshly squeezed" was the key phrase in this ad. One may wonder in what way a boxer with an orange squeezed into his mouth helped to

convey the selling point that Mangaloo orange juice was freshly squeezed. Was it a visual pun on the word "squeeze"? But how was juice squeezed from a boxer's mouth—or anyone's mouth, for that matter—a selling point rather than a turn-off for the audience? The "freshness" of the juice, through an imagined "natural" process, only brought attention to the sweat and saliva visible on the Black boxer's body and mouth. Furthermore, if the boxer was chosen for his stereotypical strength to be the best "squeezer,'" why was he Black, given that boxers come in all shapes, weights, and races, and given that the racial makeup of the juice's country of origin was predominantly White? Was it because Blackness connoted greater physical strength and the aggressiveness needed to

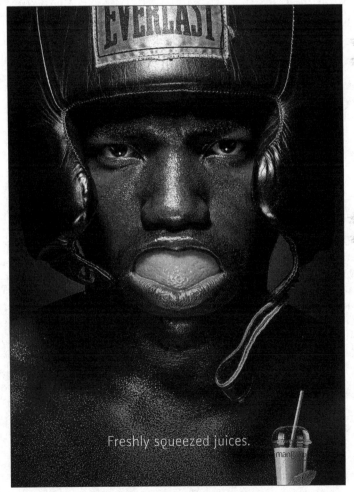

Figure 6.40, *Mangaloo, 2009*

257

perform this "primitive" way of squeezing? Or was it because Black skin provided the best background to accommodate the white-colored tag line and orange-colored packaging (which is akin to using a Black man's naked body to provide the contrast to the White women's legs, as interpreted by the ASA in its ruling on the Diesel Scorpion ad discussed earlier)?

These two cases suggest a new way of using imageries of the racial Other in contemporary advertising discourse, in which elements of racial Otherness are utilized and constructed as a paradox or riddle. The realization of this newfound usefulness is at least partly attributable to the contemporary cultural context in which the concept of the racial Other has become more fluid and its tropes more plastic. In other words, it is likely that the more unstable the concept, the more vulnerable the imageries of the racial Other are to being manipulated by advertisers to grab attention, provoke thought, and maximize advertising return. Taking comfort from these potential rewards, as the two ads examined above show, the balance between an ad's ambiguity and process outcome is crucial. If that balance is interrupted, the rhetoric can turn against itself.

NOTE

[1] Pauline Hanson's widely publicized Hansonistic ideology has spurred national debate about race and multiculturalism in Australia since her election to the House of Representatives in 1996. A founder of the right-wing One Nation Party, Hanson was named by *The Bulletin* as one of the "100 most influential Australians of all time" in 2006. In her Maiden Speech to the House of Representatives, Hanson proclaimed herself a "red-blooded Australian who says no [to multiculturalism] and who speaks for 90% of Australians." She has asserted that "A truly multicultural country can never be strong or united. The world is full of failed and tragic examples, ranging from Ireland to Bosnia to Africa and, closer to home, Papua New Guinea. America and Great Britain are currently paying the price." She has promoted a radical review of the country's immigration policy and the abolition of multiculturalism.

CONCLUSION

Through a journey interrogating some prime advertising pieces to examine the use and usefulness of imageries of the racial Other within the context of contemporary globalization, and with reference to the genealogy of racial tropes in early advertising discourse, this book has presented a snapshot of popular culture to puzzle out whether the world has moved on to a "color-blind" era in which "race" is no longer relevant or, conversely, whether race issues linger in twenty-first-century minds, and the once-pervasive racial politics continue to be in play. In the current landscape of global advertising, the use of imageries of the racial Other in a range of public interest and commercial campaigns suggests that the currency of race and the commodity-sign value possessed by the racial Other continues to hold and even grow.

This book has also shown that the debunking of the science underpinning the colonial concepts of race, the official condemnation of racism, the politics of multiculturalism, and the proclaiming of a color-blind era have not—some exceptions notwithstanding—prevented the colonial racial script from continuing to function and shape racial representations in advertising discourses. At best, the post-World War II struggles continue: postcolonial racial politics and acceleration of globalization have resulted in a situation where the ticket for overtly racist representations in advertising is no longer valid or permitted. Similarly, shifting racial demographics, consumer segmentation, and the resulting greater consumer power that the racial Other possesses have also driven adjustments in the manner and tone of racial representations to make them appear more "enlightened," so to speak, although patronizing language can still be detected in some instances. At worst, some of the overtly racist stereotypes considered taboo in written and spoken language in the age of contemporary globalization are still being articulated either implicitly or explicitly through the visual language of advertisements and branding materials. Some of these ads receive public complaints and are eventually banned by

regulators; others receive praise from advertising peers and win major international awards.

The matter of commodification adds to these contradictions. Due to the increasing fluidity of the concept of race within the context of contemporary globalization, imageries of the racial Other are more vulnerable to being more highly manipulated, appropriated, and consumed. They are used at will to prove a claim or statement, as brand or campaign mascots, as inspirers of emotions ranging from disgust to fear to guilt to humor to nostalgia to desire. In all cases, they are used to persuade and to influence by a cultural industry that White male professionals and perspectives still typically dominate. Amid all the chaos and hype, the racial Other is, by and large, still only there to provide. While the global commodity culture may have democratized consumption, the same has not transpired in representation.

At a cursory level, the representation of the racial Other in print advertising and branding campaigns from the 1980s onward has to some extent differed from earlier ads. As encouraging as some of these differences may seem, they are more variations on old scripts than departures from them. A deeper look into the apparent newness of each of the cases reveals that they are not so new after all. Operating silently behind each and every advertising and branding campaign is a visual strategy, or a combination of several. These strategies are the keys that enable those centuries-old colonial racial scripts to be recaptured and remodeled in contemporary advertising and branding campaigns. Working the magic of advertising, they turn redundant into useful, make taboo acceptable (if not fashionable), and inject new life into the lingering colonial racial concepts in contemporary advertising discourses. While the majority of these strategies have been outlined in this book, it needs to be stressed here that they set the theme and tone of the discourse by not only responding to but also contributing to the global commodity culture. In terms of the themes in which imageries of the racial Other are utilized, a "redemption theme" has appeared in both public interest and commercial campaigns. In terms of the social roles assigned to the racial Other and consumed, the emerging "proxy," "us," and "victim" roles can be seen in public interest campaigns. The racial stereotypes being coded in advertising language are also more fluid and vulnerable to manipulation, with wild oscillations in stereotyping evident across the board. The analysis demonstrates that the legacy of colonial racial stereotypes continues and has been recaptured and/or remodeled.

All of the new strategies, themes, roles, and the somehow altered stereotypes have arisen from the political and commercial challenges and needs of advertisers. Even those positive messages about race that ads communicate to audiences have still by and large been constructed with historically developed negative stereotypes at both the conceptual and visual levels—which have worked like a double-edged sword. The effort to reinvent new looks and new codes so as to make new the old ones was pithily summarized by Thomas Jefferson in his 1813 letter to John Waldo in a different nineteenth-century U.S. context: "The new circumstances under which we are placed call for new words, new phrases, and for the transfer of old words to new objects." Such an effort has been escalated significantly in the age of globalization, as cultural texts such as advertisements and other media discourses are often heavily coded. More than ever, we need to read into not only the image and message but also the interrelationships between colonial and postcolonial ideology, between old and new rhetoric, and between overt and covert stereotypes of the racial Other.

Overall, the contemporary advertising, branding, and public interest campaigns examined in this book reveal more similarities to existing racial representations than otherwise. Significant residual traces of the colonial racial script have been identified among contemporary advertising and branding materials. In terms of the themes in which imageries of the racial Other are utilized, traditional ones (with the exception of slavery ads), such as the appropriation and commodification of a quasi-logical racial hierarchy and the range of racialized metaphors and depictions that have a long history of exploiting imageries of the racial Other, not only continue to exist but have also, in a sense, been renewed and remodeled within both public interest and commercial campaigns. In terms of the social roles assigned to the racial Other and consumed, Part One of this book demonstrated that the social roles assigned to the racial Other in advertising during the post-slavery period are more diverse than has been commonly acknowledged in advertising literature—while blood-thirsty savages, sexual freaks, Southern mammies, happy servants, and Black Sambos are prevalent, we cannot ignore the presence of some non-White kings, merchants, consumers, well-off elites, and the like among historical ads. As such, this book does not consider that contemporary commercial advertising and branding campaigns have assigned to the racial Other higher social roles unseen in earlier advertisements. That said, it does find that the trend in which casting once considered "left-field" in early

advertising has now become more commonplace—although it is still far from the norm—within the context of globalization.

In terms of the stereotypes being coded into the visual languages of advertising, the co-existence of two varieties of racial stereotypes has been identified. On the one hand, the *legacy* colonial racial stereotypes, such as barbaric and disgusting behavior; deformed, animalistic, and supersexual body forms; non-White features and skin tones; criminal and evil tendencies; the White man's burden; and subservient, Sambo, clownish, and illiterate bizarreness have been, in one way or another, inherited by advertisers in contemporary advertising discourses. While most of them have been remodeled to some degree, some are easily identifiable, and some appear in disguise. On the other hand, the *romanticized* breeds include those stereotypes that can be traced from the ads of the era of High Imperialism (such as the noble savage, the mythical, and the authentic) as well as the newer ones that belong to the age of contemporary globalization (such as the exotic tradition and the superhuman). Although they appear less offensive in manner and present as seemingly harmless or even admirable imageries, romanticized colonial racial stereotypes share the same origin as the legacy colonial racial stereotypes—though the overt racist connotations may have been adjusted into undertones, and the cruel expressions may have been hidden behind the highly neutralized language of advertising.

In short, the concept of the "racial Other" deployed in advertising and branding campaigns has not substantially changed its colonial script within the context of contemporary globalization, despite some visible differences in appearance.

Change requires commitment—which is needed but remains elusive. Repetition leads to cliché—which echoes the past but can help to persuade. Variation breeds distinction—which is manageable yet still can appear avant-garde. These are the cruxes of the contemporary dilemma for the deployment of imageries of the racial Other in contemporary advertising and branding campaigns. They result in a range of racial representations that appear to be at once different from, yet similar to, those early advertisements constructed more overtly with colonial racial scripts.

With institutions and corporations commonly denying the evidence of the existence of deeply rooted racism within their ads (even when those overtly discriminatory racist eyesores are being fixed in redemptive advertising and rebranding campaigns), the commitment needed to make substantial change

is still lacking. Unless society and the advertising industry truly commit to change, the phenomenon of struggle, chaos, manipulation, hype, and contradiction captured in this book is more likely to be replicated through variation rather than substantially changed.

REFERENCES

Agoncillo, T.C. (1990). *History of the Filipino People* (8th ed.). Quezon City: Garotech Publishing.

AAA. (1998). *American Anthropological Association Statement on 'Race'*. Retrieved 17 December 2008 <http://www.aaanet.org/stmts/racepp.htm>.

Anderson, W.T. (1990). *Reality Isn't What It Used to Be*. San Francisco: Harper & Row.

Ansell, A.E. (2006). "Casting a Blind Eye: The Ironic Consequences of Color-Blindness in South Africa and the United States." *Critical Sociology*, 32(2–3), 333–356.

Appadurai, A. (1990). "Disjuncture and Difference in the Global Cultural Economy." *Theory, Culture & Society*, 7, 295–310.

———. (1996). *Modernity at Large: Cultural Dimensions of Globalization*. Minneapolis: University of Minnesota Press.

———. (2002). "Here and Now." In N. Mirzoeff (Ed.), *The Visual Culture Reader* (2nd ed., pp 173–179). London: Routledge.

ASA. (2006). *ASA Non-Broadcast Adjudication: Diesel (London) Ltd*. Retrieved 9 March 2006 <http://www.asa.org.uk/ASA-action/Adjudications/2006/3/Diesel-(London)-Ltd/CS_40992.aspx>.

Atlantic Charter. (1941). "Joint Statement by President Roosevelt and Prime Minister Churchill."August 14 1941. Published in Department of State Executive Agreement Series No. 236.

Balandier, G. (1974). "The Colonial Situation: A Theoretical Approach." In I. Wallerstein (Ed.), *The Modern World System: Capitalist Agriculture and the Origins of the European World Economy in the Sixteenth Century*. London: Academic Press.

Balibar, E., & Wallerstein, I. (1991). *Race, Nation, Class: Ambiguous Identities* (C. Turner, Trans.). New York: Verso.

Barker, M. (1981). *The New Racism*. London: Junction Books.

Barthes, R. (1967). *Writing Degree Zero* (A. Lavers & C. Smith, Trans.). London: Jonathan Cape.

———. (1972). *Mythologies* (A. Lavers, Trans.). London: Granada.

Baudrillard, J.B. (1981). *For a Critique of the Political Economy of the Sign* (C. Levin, Trans.). St. Louis, MO: Telos Press.

Baum, B.D. (2006). *The Rise and Fall of the Caucasian Race: A Political History of Racial Identity*. New York: New York University Press.

BBC. (1998). "Army Improves Racism Record." BBC News Online 25 March 1998. Retrieved 12 September 2006 <http://news.bbc.co.uk/2/hi/uk_news/ 69507.stm>.

———. (1998). "UK Equality Campaign is 'Racist'." BBC News Online 22 September 1998. Retrieved 16 June 2002 <http://news.bbc.co.uk/2/hi/uk_news/176300.stm>.

———. (1998). "Images Selling Britain to the World." BBC News Online 24 September 1998. Retrieved 23 November 2002 <http://news.bbc.co.uk/2/hi/uk_news/ 171818.stm>.

———. (1998). "Censor Order Over 'Offensive' Ads." BBC News Online 4 November 1998. Retrieved 16 September 2002 <http://news.bbc.co.uk/2/hi/uk_news/ 207603.stm>.

———. (2005). "Army Restricted Ethnic Recruits." BBC News Online 4 January 2005. Retrieved 7 January 2005 <http://news.bbc.co.uk/2/hi/uk_news/4143811.stm>.

———. (2006). "Colour barred?" BBC News Transcript 12 September 2006. Retrieved 17 September 2006, <http://news.bbc.co.uk/2/hi/uk_news/magazine/533 3874.stm>.

———. (2008). "Burmese Women in Thai 'Human Zoo'." BBC News 30 January 2008. Retrieved 31 January 2008 <http://newsvote.bbc.co.uk/mpapps/ pagetools/print/news.bbc.co.uk/2/hi/asia-pacific/7215182.stm>.

———. (2008). "Mandela Taken off US Terror List." BBC News Online 1 July 2008. Retrieved 2 July 2008 <http://news.bbc.co.uk/go/pr/fr/-/2/hi/americas/ 7484517.stm>.

Bendick, M.J., & Egan, M.L. (January 2009). "Research Perspectives on Race and Employment in the Advertising Industry." *Bendick Egan Advertising Industry Report.*

Berger, A.A. (1998). *Media Analysis Techniques* (2nd ed.). London: Sage Publications.

———. (2004). *Ads, Fads, & Consumer Culture: Advertising's Impact on American Character and Society* (2nd ed.). New York: Rowman & Littlefield.

Bhabha, H.K. (1994). *The Location of Culture.* London: Routledge.

———. (2002). "Of Mimicry and Man: The Ambivalence of Colonial Discourse." In P. Essed & D.T. Goldberg (Eds.), *Race Critical Theories: Text and Context* (pp. 113–122). Malden, MA: Blackwell.

Biagi, S., & Kern-Foxworth, M. (1997). *Facing Difference: Race, Gender, and Mass Media.* Thousand Oaks, CA: Pine Forge Press.

Bit-World. (2007). "Bit Goes Brazil—Bit COPA Start in the Restaurant Scene." 15 March 2007. Retrieved 23 March 2007 <www.bit-world.de/flash.html>.

Blum, L. (2002). *I'm Not a Racist, But…: The Moral Quandary of Race.* Ithaca, NY: Cornell University Press.

Bolt, J.F. (1995). "Global Competitors: Some Criteria for Success." In T.W. Meloan & J.L. Graham (Eds.), *International and Global Marketing: Concepts and Cases* (pp. 333–344). Chicago: IRWIN.

Bonilla-Silva, E. (2001). *White Supremacy and Racism in the Post-Civil Rights Era.* London: Lynne Rienner.

Boorstin, D.J. (1973). *The Americans: The Democratic Experience*. New York: Random House.

Bradley, P. (1987). "Slave Advertising in the Colonial Newspapers: Mirror to the Dilemma." Paper presented at the Annual Meeting of the Association for Education in Journalism and Mass Communication, San Antonio, Texas.

BrandRepublic UK. (2004). *Advertisers Treble the Use of Ethnic Minorities in Ads*. Retrieved 16 January 2004 <http://www.brandrepublic.com/news/199423>.

British Empire & Commonwealth Museum. (2007). *Breaking the Chains* Exhibition.

Brooks, D.E. (1991). "Consumer Markets and Consumer Magazines: Black America and the Culture of Consumption, 1920—1960." Unpublished PhD thesis, University of Iowa.

Brown, M.K., Carnoy, M., Currie, E., Duster, T., Oppenheimer, D.B., Shultz, M.M., & Wellman, D. (2003). *Whitewashing Race: The Myth of a Color-Blind Society*. Berkeley: University of California Press, 2003.

Burns, R. (Ed.). (1975). *Voices From Other Cultures*. Sydney: Australia and New Zealand Book Company.

Business Mexico Newsletter, June 1993

Carr, L.G. (1997). *Color-Blind Racism*. London: Sage.

Chambers, J. (2009). *Madison Avenue and the Color Line: African Americans in the Advertising Industry*. Philadelphia: University of Pennsylvania Press.

Charity Commission, UK. (2010). *Window Shopping in a Crowded Market*. Retrieved 29 July 2010 <http://www.charitycomms.org.uk/articles/in_focus>.

Cixous, H., & Clément, C. (1996). *The Newly Born Woman* (B. Wing, Trans.). London: I. B. Tauris Publishers.

Clarke, K.M., & Thomas, D.A. (Eds.). (2006). *Globalization and Race: Transformations in the Cultural Production of Blackness*. London: Duke University Press.

Cody, C.A. (1996). "Cycles of Work and of Childbearing." In D.B. Gaspar & D.C. Hine (Eds.), *More Than Chattel: Black Women and Slavery in the Americas* (pp. 61–78). Bloomington: Indiana University Press.

Cohen, W.B. (2003). *The French Encounter with Africans: White Response to Blacks, 1530–1880*. Bloomington: Indiana University Press.

Commission for Racial Equality. (1998). "Stereotyping and Racism: Findings From Two Attitude Surveys." London: CRE.

Copeland, D. (1997). "Globalization, Enterprise and Governance." *International Journal*, 97–98 (Winter), 17–37.

Cortese, A.J.P. (2008). *Provocateur: Images of Women and Minorities in Advertising*. Lanham, MD: Rowman & Littlefield.

Crais, C., & Scully, P. (2009). *Sara Baartman and the Hottentot Venus: A Ghost Story and a Biography*. Princeton, NJ: Princeton University Press.

Cronin, A.M. (2000). *Advertising and Consumer Citizenship: Gender, Images and Rights*. New York: Routledge.

———. (2004). *Advertising Myths: The Strange Half-Lives of Images and Commodities*. London: Routledge.

Cross, M. (Ed.). (1996). *Advertising and Culture: Theoretical Perspectives*. London: Praeger.

Cvetkovich, A., & Kellner, D. (1997). "Introduction: Thinking Global and Local." In A. Cvetkovich & D. Kellner (Eds.), *Articulating the Global and the Local: Globalization and Cultural Studies*. Boulder, CO: Westview Press.

Daily Mail Australia. (2008). "Spanish Racists Target Lewis Hamilton on Website." 31 October 2008. Retrieved 1 November 2008 <http://www.dailymail.co.uk/news/article-1081822/Spanish-racists-target-Lewis-Hamilton-website-willing-crash-world-title-deciding-race.html>

Darwin, C.R. (1874). *The Descent of Man, and Selection in Relation to Sex* (2nd ed.). London: Tenth Thousand.

Davidson, B. (1994). *The Search for Africa: History, Culture, Politics*. New York: Times Books.

Delaney, T. (2007). "Inside Story: Tim Delaney's Masterclass in Writing Great Ads." *The Independent*. Retrieved 28 December 2007 <http://www. independent.co. uk/news/media/inside-story-tim-delaneys-masterclass-in-writing-great-ads-398182.html>.

Dickason, O.P. (1997). *The Myth of the Savage, and the Beginnings of French Colonialism in the Americas*. Edmonton: University of Alberta Press.

Dirlik, A. (2000). "Globalization as the End and the Beginning of History: The Contradictory Implications of a New Paradigm." *Rethinking Marxism*, 12(4), 4–22.

Drucker, P.F. (1999). *Management Challenges for the 21st Century*. New York: Harper Business.

Du Bois, W.E.B. (2007). *The Souls of Black Folk*. New York: Cosimo, Inc.

During, S. (Ed.). (1993). *The Cultural Studies Reader*. London: Routledge.

Dyer, T.G. (1980). *Theodore Roosevelt and the Idea of Race*. Baton Rouge: Louisiana State University Press.

Eayrs, C.B., & Ellis, N. (1990). "Charity Advertising: For or Against People with a Mental Handicap." *British Journal of Social Psychology*, 29(4), 349–366.

El Guindi, F. (1999). *Veil: Modesty, Privacy and Resistance*. New York: Berg.

El Periódico de Aragón (2003). "Controversy over the Sweet Conguitos." Retrieved 8 March 2007 <http://www.educared.net/PrimerasNoticias/hemero/2003/marzo/soci/congui/congui.htm>.

Electronic Telegraph. (1997). "We Got it Wrong on Blacks, Army Chief Admits." Electronic Telegraph 12 October 1997. Issue 871

Elliott, S. (1996). "A Rainbow Coalition of Sorts Can Be Found in a Wider Range of Campaigns Than Ever Before." *New York Times*, 19 April 1996. The Media Business: Advertising.

Eltis, D. (2000). *The Rise of African Slavery in the Americas*. Cambridge, UK: Cambridge University Press.

Evers, M.B., & Peters, W. (1967). *For Us, the Living*. Garden City, NY: Doubleday.

Ewen, S. (1976). *Captains of Consciousness: Advertising and the Social Roots of the Consumer Culture*. New York: McGraw-Hill.

———. (1988). *All Consuming Images: The Politics of Style in Contemporary Culture*. New York: Basic Books.

Eze, E. (Ed.). (1997). *Race and the Enlightenment: A Reader*. Oxford: Blackwell.

Fanon, F. (1968). "Concerning Violence." In *Wretched of the Earth* (pp. 35-106). New York: Grove.

———. (1991). *Black Skin, White Masks* (C.L. Markmann, Trans.). New York: Grove Press.

Faulconbridge, J., Taylor, P.J., Beaverstock, J.V., & Nativel, C. (2008). "The Globalization of the Advertising Industry: A Case Study of US Knowledge Workers in Worldwide Economic Restructuring." A Research Report for the Sloan Foundation. Retrieved 29 January 2009 <http://www.academia.edu/3054367/THE_GLOBALIZATION_OF_THE_ADVERTISING_INDUSTRY>.

Feagin, J.R. (2006). *Systemic Racism: A Theory of Oppression*. New York: Routledge.

Fields, B.J. (1982). "Ideology and Race in American History." In J.M. Kousser & J.M. McPherson (Eds.), *Region, Race, and Reconstruction: Essays in Honor of C. Vann Woodward* (pp. 143–177). New York/Oxford: Oxford University Press.

Finkelman, P. (2003). In *Race—The Power of an Illusion* [3-part TV Documentary, PBS]. California Newsreel, in association with the Independent Television Service.

Fitzgerald, T.K. (1992). "Media, Ethnicity and Identity". In P. Scannell, P. Schlesinger, & C. Sparks (Eds.), *Culture and Power: A Media, Culture & Society Reader*. London: Sage.

Fortune, M. (1988). "Colgate's Racist Logo Leaves Bad Taste." *Black Enterprise*, 21.

Foucault, M. (1977). *Language, Counter-Memory, Practice: Selected Essays and Interviews* (D.F. Bouchard & S. Simon, Trans.). Ithaca, NY: Cornell University Press.

———. (1980). *Power/Knowledge: Selected Interviews and Other Writings 1972–1977* (C. Gordon, Trans.). New York: Harvester Wheatsheaf.

———. (1984). "What is Enlightenment?" In P. Rabinow (Ed.), *The Foucault Reader* (pp. 40-58). London: Penguin Books.

———. (1988). *Technologies of the Self: A Seminar with Michel Foucault*. L.H. Martin, H. Gutman, & P.H. Hutton (Eds.). London: Tavistock.

Frankenberg, R. (1993). *White Women, Race Matters: The Social Construction of Whiteness*. Minneapolis: University of Minnesota Press.

Fraser, M.H. [Mrs. Hugh Fraser]. (1899). *The Custom of the Country: Tales of New Japan*. New York: Macmillan.

Freud, S. (1961). "Fetishism." In J. Strachey (Ed.), *The Standard Edition of the Complete Psychological Works of Sigmund Freud. Vol. XXI.* (pp. 152–158). London: The Hogarth Press and the Institute of Psycho-Analysis.

Frith, K.T. (Ed.). (1997). *Undressing the Ad: Reading Culture in Advertising*. New York: Peter Lang.

Frith, K.T., & Mueller, B. (2003). *Advertising and Societies: Global Issues*. New York: Peter Lang.

Fu, L. (2000). "Visual Communication Across Culture: A Semiotic Study of the Interpretation of Western Brand Images in China." Unpublished MA thesis, University of Canberra, Australia.

Gans, B. (1968). "Letter to Carter." *OA COM 3/1/1: Confidential Papers on Nigeria/Biafra 1968–70*, 1.

Gaspar, D.B., & Hine, D.C. (Eds.). (1996). *More Than Chattel: Black Women and Slavery in the Americas*. Bloomington: Indiana University Press.

Gates, H.L., Jr. (1985). Editor's Introduction: "Writing 'Race' and the Difference It Makes." *Critical Inquiry*, 12(1), 1–20.

General Assembly of Pennsylvania. (1990). "House Resolution No. 318." Retrieved 9 January 2002 <http://www.legis.state.pa.us/CFDOCS/Legis/PN/Public/btCheck.cfm?txtType=HTM&sessYr=1989&sessInd=0&billBody=H&billTyp=R&billNbr=0318&pn=3428>

Giroux, H.A. (1994). *Disturbing Pleasures: Learning Popular Culture*. New York: Routledge.

Gobineau, J.A. (2003). "The Inequality of Human Races." In K. Reilly et al. (Eds.), *Racism: A Global Reader* (pp. 195–197). New York: M.E. Sharpe, Inc.

Goldman, R. (1992). *Reading Ads Socially*. New York: Routledge.

Goldman, R., & Papson, S. (1996). *Sign Wars: The Cluttered Landscape of Advertising*. New York: The Guilford Press.

Greenwald, J., & Fallon, K.J. (1993). "Timberland Hits Its Stride." *Time Magazine, US*. Retrieved 16 September 2007 <http://www.time.com/time/magazine/article/0,9171,979712,00.html>.

Guevara, C. (1967). "Cuba: Historical Exception or Vanguard in the Anticolonial Struggle?" In E. Guevara (Ed.), *Che Guevara Speaks: Selected Speeches and Writings*. New York: Pathfinder Press.

Hall, R.E. (1995). "The Bleaching Syndrome: African Americans." Response to Cultural Domination Vis-à-Vis Skin Color'. *Journal of Black Studies*, 26(2), 172–184.

Hall, R.E. (Ed.). (2008). *Racism in the 21st Century: An Empirical Analysis of Skin Color*. New York: Springer.

Hall, S. (1996a). "Cultural Studies and Its Theoretical Legacies." In D. Morley & K.-H. Chen (Eds.), *Critical Dialogues in Cultural Studies* (pp. 263–275). New York: Routledge.

———. (1996b). "New Ethnicities." In D. Morley & K.-H. Chen (Eds.), *Critical Dialogues in Cultural Studies* (pp. 442-451). New York: Routledge.

———. (1997a). "The Local and the Global: Globalization and Ethnicity." In A.D. King (Ed.), *Culture, Globalization and the World-System* (pp. 19–39). Minneapolis: University of Minnesota Press.

———. (1997b). "The Spectacle of the Other." In S. Hall (Ed.), *Representation: Cultural Representations and Signifying Practices*. London: Sage.

Haller, J.S., Jr. (1971). *Outcasts from Evolution: Scientific Attitudes of Racial Inferiority, 1859–1900*. Urbana: University of Illinois Press.

Harper's New Monthly. "Pictures of the Japanese." November 1863.

Harris, M.D. (2003). *Coloured Pictures: Race and Visual Representation*. Chapel Hill: University of North Carolina Press.

Harvey, D. (1990). *The Condition of Postmodernity: An Enquiry into the Origins of Cultural Change*. Oxford: Blackwell.

———. (2003). *The New Imperialism*. New York: Oxford University Press.

Hegel, G.W.F. (1975). *Lectures on the Philosophy of World History* (H. B. Nisbet, Trans.). London: Cambridge University Press.

———. (1979). *Phenomenology of Spirit*. A.V.M. Findlay (Trans.). Oxford, UK: Clarendon Press.

Heilemann, J., & Halperin, M. (2010). *Game Change: Obama and the Clintons, McCain and Palin, and the Race of a Lifetime*. New York: HarperCollins.

Helmreich, W. (1984). *The Things They Say Behind Your Back*. New Brunswick, NJ: Transaction Books.

Herald Scotland. (1998). "Dentists Want This Racism Poster Pulled." 24 November 1998. Retrieved 17 September 2002 <http://www.heraldscotland.com/sport/spl/aberdeen/dentists-want-this-racism-poster-pulled-1.317646>.

Hilton, M. (2001). "Advertising, the Modernist Aesthetic of the Marketplace? The Cultural Relationship Between the Tobacco Manufacturer and the 'Mass' of Consumers in Britain, 1870–1940." In M. Daunton & B. Rieger (Eds.), *Meanings of Modernity: Britain in the Age of Imperialism and World Wars* (pp. 45–70). Oxford, UK: Berg Publishers.

Hirschman, C. (2005). "Immigration and the American Century." *Demography*, 42(4), 595–620.

Hoetink, H. (1971). *Caribbean Race Relations: A Study of Two Variants*. New York: Oxford University Press.

———. (1973). *Slavery and Race Relations in the Americas: An Inquiry into their Nature and Nexus*. New York: Harper & Row.

———. (1985). "'Race' and Color in the Caribbean." In S.W. Mintz & S. Price (Eds.), *Caribbean Contours* (pp. 55–84). Baltimore, MD: Johns Hopkins University Press.

Holman, B. (1993). "Changing the Face(s) of Advertising: AAF and Its Members Seek Solutions to Advertising's Dearth of Diversity." *American Advertising*, Fall, 10–13.

hooks, b. (1992). *Black Looks: Race and Representation*. Boston, MA: South End Press.

Horsman, R. (1981). *Race and Manifest Destiny*. Cambridge, MA: Harvard University Press.

Horton, J.O., & Horton, L.E. (1998). *In Hope of Liberty: Culture, Community and Protest among Northern Free Blacks, 1700–1860*. New York: Oxford University Press.

Howes, D. (1996). *Cross-Cultural Consumption: Global Markets, Local Realities*. London: Routledge.

Hughes, L. (1983). *A Pictorial History of Black Americans*. New York: Crown.

Idler. 20 January 1759. No. 40.

The Independent (1998). "Equality Board Defends Racist Posters." 24 November 1998. Retrieved 16 September 2002 <http://www.independent.co.uk/news/equality-board-defends-racist-posters-1199816.html>.

IPS. (2010). "Bad Water More Deadly Than War." 18 March 2010. Retrieved 30 July 2010 <http://www.ipsnews.net/2010/03/development-bad-water-more-deadly-than-war/>.

IRIN Humanitarian News and Analysis. (2002). "Ethiopian Tourism Picking Up After the War with Eritrea." Retrieved 26 February 2006 <http://www.irinnews.org Report/30001/ETHIOPIA-Tourism-picking-up-after-war-with-Eritrea>.

Iwabuchi, K. (2002). *Recentering Globalization: Popular Culture and Japanese Transnationalism.* Durham, NC, and London: Duke University Press.

Jackson, F. (1970). *The Black Man in America, 1791–1861.* New York: Franklin Watts.

Jacob, M.C. (1988). *The Cultural Meaning of the Scientific Revolution.* Philadelphia, PA: Temple University Press.

———. (2001). *The Enlightenment: A Brief History with Documents.* Boston, MA: Bedford/ St. Martin's.

Jahoda, G. (2007). "Towards Scientific Racism." In T. Das Gupta (Ed.), *Race and Racialization: Essential Readings* (pp. 24–30). Toronto: Canadian Scholars Press.

Jameson, F. (1998). "Notes on Globalization as a Philosophical Issue." In F. Jameson & M. Miyoshi (Eds.), *The Cultures of Globalization.* Durham, NC: Duke University Press.

Jameson, F., & Miyoshi, M. (Eds.). (1998). *The Cultures of Globalization.* Durham, NC: Duke University Press.

Jefferson, T. (1955). *Notes on the State of Virginia.* Chapel Hill: University of North Carolina Press. (Original work published 1787)

Jet. (1994). "Lewis Undaunted by Ad of Him in High Heels." 16 May 1994: 47

Jewell, K.S.W. (1993). *From Mammy to Miss America and Beyond: Cultural Images and the Shaping of U.S. Social Policy.* New York: Routledge.

Jhally, S. (1990). *Codes of Advertising: Fetishism and the Political Economy of Meaning in the Consumer Society.* New York: Routledge.

Johnson, F.L. (2008). *Imaging in Advertising: Verbal and Visual Codes of Commerce.* New York: Routledge.

Jordan, D., & Walsh, M. (2008). *White Cargo: The Forgotten History of Britain's White Slaves in America.* New York: New York University Press.

Jordan, V. (1975). "Advertising: The Image Is Incomplete." *Opportunities,* Fall, 24–25.

Joseph, G.I., & Lewis, J. (1986). *Common Differences: Conflicts in Black and White Feminist Perspectives.* Boston, MA: South End Press.

Kern-Foxworth, M. (1994). *Aunt Jemima, Uncle Ben and Rastus: Blacks in Advertising, Yesterday, Today and Tomorrow.* Westport, CT: Praeger.

King, M. L., Jr. (1972). "Where Do We Go from Here?" In P.B. Levy (Ed.), *Let Freedom Ring: A Documentary History of the Modern Civil Rights Movement* (pp. 228–231). Westport, CT: Praeger.

Kovach, J.L. (1985). "Minority Sell: Ads Target Blacks, Hispanics, But..." *Industry Week,* 11 November 1985, 29.

Kroes, R. (1999)."World Wars and Watershed: The Problem of Continuity in the Process of Americanization." *Diplomatic History*, 23(1), 71–77.

Kroes, R., Rydell, R.W., & Bosscher, D.F.J. (Eds.). (1993). *Cultural Transmissions and Receptions: American Mass Culture in Europe.* Amsterdam: VU University Press.

Kulikoff, A. (1986). *Tobacco and Slaves: The Development of Southern Culture in the Chesapeake, 1680–1800.* Chapel Hill: University of North Carolina Press.

Lamont, M. (2001). "Immigration and the Salience of Racial Boundaries Among French Workers." *French Politics, Culture and Society*, 19(1), 1-21.

Lash, S., & Urry, J. (1994). *Economies of Signs and Space.* London: Sage.

Leiss, W., Kline, S., Jhally, S., & Botterill, J. (2005). *Social Communication in Advertising: Consumption in the Mediated Marketplace* (3rd ed.). New York: Routledge.

Lester, P., & Smith, R. (1989). "African-American Picture Coverage in *Life, Newsweek* and *Time*, 1937–1988." Paper presented at the 72nd Annual Convention of the Association for Education in Journalism and Mass Communication, Washington, DC.

Levinas, E. (1979). *Totality and Infinity: An Essay on Exteriority* (A. Lingis, Trans.). Pittsburgh, PA: Duquesne University Press.

Levitt, T. (1983). "Globalization of Markets." *Harvard Business Review*, May/June, 92–102.

Levy, P.B. (Ed.). (1992). *Let Freedom Ring: A Documentary History of the Modern Civil Rights Movement.* Westport, CT: Praeger.

Lewis, J. (1997). "Prince Acts over Army Race Issue." *Sunday Mail*, 16 March.

Lewis, S. (2013). "Gillard Government to Spend $50 Million on Gonski Advertising Campaign." *News Limited* 1 May 2013. Retrieved 2 May 2013 <http://www.news.com.au/national-news/federal-election/gillard-government-to-spend-50million-on-gonski-advertising-campaign/story-fnho52ip-1226632600044.

Lewontin, R. (1972). "The Apportionment of Human Diversity." *Evolutionary Biology*, 6, 381–398.

Library of Congress. "Emilio Aguinaldo y Famy." Retrieved 23 September 2006 <http://www.loc.gov/rr/hispanic/1898/aguinaldo.html>.

Lombroso, C. (2006). *Criminal Man* (M. Gibson & N.H. Rafter, Trans.). Durham, NC: Duke University Press. (Original work published 1876).

Magnis, N.E. (1999). "Thomas Jefferson and Slavery: An Analysis of his Racist Thinking as Revealed by his Writings and Political Behavior." *Journal of Black Studies*, 29(4), 491–509.

Mail and Guardian. (2002). "Ethiopian Tourism Picking Up After the War With Eritrea." 31 January 2002. Retrieved 12 March 2002 <www.mg.co.za/mg/za/archive/2002jan/features/31janethiopia.html>.

Malefyt, T., & Moeran, B. (2003). *Advertising Cultures.* Oxford: Berg Publishers.

Marchand, R. (1985). *Advertising the American Dream: Making Way for Modernity, 1920–1940.* Berkeley: University of California Press.

Mars, Inc. "M&M's History." Retrieved 29 October, 2010 <http://www.mms.com/us/about/mmshistory/>

Marx, K. (2007). *Capital: A Critique of Political Economy*. Vol. I, Part I: *The Process of Capitalist Production*. New York: Cosimo, Inc.

Marx, K., & Engels, F. (1976). *Collected Works*. New York: International Publishers.

Maxwell, A. (2000). *Colonial Photography and Exhibitions: Representations of the 'Native' and the Making of European Identities*. London: Leicester University Press.

MBDA. (2000a). "Minority Purchasing Power in the 21st Century." Retrieved 9 March 2001 <http://minorityresources.us/article/263/Minority-Purchasing-Power-In-The-21st-Century-Minority-Purchasing-Power-In-The-21stCentury.html>.

———. (2000b). "The Emerging Minority Marketplace: Minority Purchasing Power 2000–2045." Retrieved 9 March 2001 <www.nmsdc.org/nmsdc/app/template/Content. vm/attachmentid/1658>.

McCarroll, T. (1993). "It's a Mass Market No More." *Time*, Special issue: The New Face of America, 142(121), 80–81.

McClintock, A. (1995). *Imperial Leather: Race, Gender, and Sexuality in the Colonial Conquest*. New York: Routledge.

McFall, E.R. (2004). *Advertising: A Cultural Economy*. London: Sage.

McGill, D. (1989). "Colgate to Rename a Toothpaste." *New York Times*, 27 January, p. 1.

McNeill, W.H. (1984). "Human Migration in Historical Perspective." *Population and Development Review*, 10(1), 1–18.

McPhail, T. (1989). "Inquiry in Intercultural Communication." In M. Asante & W. Gudykunsy (Eds.), *Handbook of International and Intercultural Communication* (pp. 47–67). Beverley Hills, CA: Sage.

Meijer, M.C. (1999). *Race and Aesthetics in the Anthropology of Petrus Camper (1722-1789)*. Amsterdam: Rodopi.

Meyer, J.W. (1980). "The World Polity and the Authority of the Nation-State." In A. Bergesen (Ed.), *Studies of the Modern World-System* (pp. 109–137). New York: Academic Press.

Mitchell, W.J.T. (2002). "Showing Seeing: A Critique of Visual Culture." In N. Mirzoeff (Ed.), *Visual Culture Reader* (2nd ed., pp. 86–101). London: Routledge.

Mittelman, J.H. (2000). *The Globalization Syndrome: Transformation and Resistance*. Princeton, NJ: Princeton University Press.

Moeran, B. (2003). "Imagining and Imaging the Other: Japanese Advertising International." In W. Malefyt & B. Moeran (Eds.), *Advertising Cultures* (pp. 91–112). Oxford, UK: Berg Publishers.

Molnar, S. (1992). *Human Variation: Race, Types, and Ethnic Groups* (3rd ed.). Englewood Cliffs, NJ: Prentice Hall.

Mooij, M.K.D. (2005). *Global Marketing and Advertising: Understanding Cultural Paradoxes* (2nd ed.). Thousand Oaks, CA: Sage.

Moore, E.A. (2007). *Unmarketable: Brandalism, Copyfighting, Mocketing, and the Erosion of Integrity*. New York: The New Press.

Morand, L. (2010). "Reshaping the African American Image." Retrieved 23 June 2010 <http://minimadmod60s.com/AfricanAmericanSupermodels.html>.

Morgan, H. (1986). *Symbols of America*. New York: Viking Penguin.

Morrison, T. (1992). *Playing in the Dark: Whiteness and the Literary Imagination*. Cambridge, MA: Harvard University Press.

Muller, T. (1993). *Immigrants and the American City*. New York: New York University Press.

Mullin, G.W. (1972). *Flight and Rebellion: Slave Resistance in Eighteenth-Century Virginia*. New York: Oxford University Press.

Multinational Monitor. Issue 7 [7] 1986.

Murphy, G. (2010). *Shadowing the White Man's Burden: U.S. Imperialism and the Problem of the Color Line*. New York: New York University Press.

National Center for Charitable Statistics. (2010). "Number of Public Charities in the United States, 2010." Retrieved 29 July 2010 <http://nccsdataweb.urban.org/PubApps/profileDrillDown.php?state=US&rpt=PC>.

National Coffer (2006). "Discover the Land of Wonders: Tourism Data 1997–2005." *National Coffer Newsletter*, No 17.

National Negro Congress. (1947). 'The Negroes Status in Advertising'. *NNC Papers*, Part II, Reel 34.

New York Times. (1989). "Colgate to Rename a Toothpaste." 27 January 1989, Business, p. D1.

———. (1989). "A New Name for Toothpaste." 18 April 1989, The Media Business, p. D25.

———.(2007). "New Demographic Racial Gap Emerges." Retrieved 18 May 2007 <http://www.nytimes.com/2007/05/17/us/17census.html>.

———. (2008). "In Biggest U.S. Cities, Minorities Are at 50%." 9 December 2008. Retrieved 29 January 2014 <http://www.nytimes.com/2008/12/09/us/09survey.html>.

Nixon, S. (2003). *Advertising Cultures: Gender, Commerce and Creativity*. London: Sage.

Nobel Prize. (ca. 1907). "The Nobel Prize in Literature 1907." Retrieved 19 April 2011 <http://nobelprize.org/nobel_prizes/literature/laureates/1907/>.

Norris, J.D. (1990). *Advertising and the Transformation of American Society, 1865–1920*. New York: Greenwood Press.

Nye, J.S. (2004). *Power in the Global Information Age: From Realism to Globalization*. New York: Routledge.

Obama, B. (1995). *Dreams from My Father: A Story of Race and Inheritance*. New York: Three Rivers Press.

O'Barr, W.M. (1994). *Culture and the Ad: Exploring Otherness in the World of Advertising*. Boulder, CO: Westview Press.

O'Shaughnessy, M. (1999). *Media & Society: An Introduction*. New York: Oxford University Press.

Packard, V. (1957). *The Hidden Persuaders*. London: Longman.

Pagden, A. (1982). *The Fall of Natural Man: The American Indian and the Origins of Comparative Ethnology*. Cambridge, UK: Cambridge University Press.

Pells, R. (1997). *Not Like Us: How Europeans Loved, Hated, and Transformed American Culture*. New York: Basic Books.

Pendergast, T. (2000). *Creating the Modern Man: American Magazines and Consumer Culture, 1900–1950*. Columbia: University of Missouri Press.

Petty, W., Sir. (1677). "The Scale of Creatures." In *The Petty Papers* (1927). New York: Kelley.

Phillips, U.B. (1966). *American Negro Slavery. A Survey of the Supply, Employment, and Control of Negro Labor as Determined by the Plantation Regime*. Baton Rouge: Louisiana State University Press.

Pieterse, J.N. (1992). *White on Black: Images of Africa and Blacks in Western Popular Culture*. New Haven, CT: Yale University Press.

Ploski, H.A., & Williams, J.D. (1989). *The Negro Almanac: A Reference Work on the African American*. Detroit: Gale Research.

Poliakov, L. (2003). *The History of Anti-semitism: From the Time of Christ to the Court Jews* (R. Howard, Trans. 3). Philadelphia: University of Pennsylvania Press.

Preston, M. (2010). "Reid Apologizes for 'Negro Dialect' Comment." *CNN online*. Retrieved 11 January 2001 <http://politicalticker.blogs.cnn.com/ 2010/01/ 09/reid-apology-for-negro-dialect-comment/>.

Prude, J. (1991). "To Look Upon the 'Lower Sort': Runaway Ads and the Appearance of Unfree Laborers in America, 1750–1800." *Journal of American History*, 78(1), 124–159.

Ramamurthy, A. (2003). *Imperial Persuaders: Images of Africa and Asia in British Advertising*. Manchester, UK: Manchester University Press.

Richards, T. (1990). *The Commodity Culture of Victorian England: Advertising and Spectacle, 1851–1914*. Stanford, CA: Stanford University Press.

Ritzer, G. (1996). *The McDonaldization of Society: An Investigation into the Changing Character of Contemporary Social Life*. Thousand Oaks, CA: Pine Forge Press.

———. (2004). *The Globalization of Nothing*. Thousand Oaks, CA: Pine Forge Press.

Ritzer, G., & Liska, A. (1997). "'McDisneyization' and 'Post-Tourism': Complementary Perspectives on Contemporary Tourism." In C. Rojek & J. Urry (Eds.), *Touring Cultures: Transformations of Travel and Theory*. New York: Routledge.

Ritzer, G., & Ryan, J.M. (2007). "Postmodern Social Theory and Sociology: On Symbolic Exchange with a 'Dead' Theory." In J.L. Powell & T. Owen (Eds.), *Reconstructing Postmodernism: Critical Debates* (pp. 41–57). New York: Nova Publishers.

Robertson, C. (1996). "Africa Into the Americas? Slavery and Women, the Family, and the Gender Division of Labor." In D. B. Gaspar & D. C. Hine (Eds.), *More Than Chattel: Black Women and Slavery in the Americas* (pp. 3-42). Bloomington: Indiana University Press.

Robertson, R. (1992). *Globalization: Social Theory and Global Culture*. London: Sage.

———. (1995). "Glocalization: Time-Space and Homogeneity-Heterogeneity." In M. Featherstone, S. Lash, & R. Roobertson (Eds.), *Global Modernities* (pp. 25–44). London: Sage.

Rostow, W.W. (1960). *The Stages of Economic Growth: A Non-Communist Manifesto.* Cambridge, UK: Cambridge University Press.

Rothenberg, R. (1989). "Is British Creativity Declining?" *New York Times.* 18 April 1989, Advertising.

Rout, L.B. (1977). *The African Experience in Spanish America.* New York: Cambridge University Press.

Said, E. (1978). *Orientalism.* London: Routledge & Kegan Paul.

———. (1993). *Culture and Imperialism* (1st ed.). New York: Knopf.

Saussure, F. de. (1969). *Course in General Linguistics* (W. Baskin, Trans.). New York: McGraw-Hill.

Savage Arms. "Savage Arms History." Retrieved 22 December 2007 <http://www.savagearms.com/history/>.

Schmidt, L.E. (1997). *Consumer Rites: The Buying and Selling of American Holidays.* Princeton, NJ: Princeton University Press.

Scott, L.M., & Batra, R. (Eds.). (2003). *Persuasive Imagery: A Consumer Response Perspective.* Mahwah, NJ: Lawrence Erlbaum.

Shapiro, F.R. (Ed.). (2006). *The Yale Book of Quotations.* New Haven, CT: Yale University Press.

Sharpe, J. (2000). "Postcolonial Studies in the House of US Multiculturalism." In H. Schwarz & S. Ray (Eds.), *A Companion to Postcolonial Studies* (pp. 112–125). Malden, MA: Blackwell.

Sherry, J.F., Jr. (1987). "Advertising as a Cultural System." In J. Umiker-Sebeok (Ed.), *Marketing and Semiotics: New Directions in the Study of Signs for Sale* (pp. 441–461). Berlin: Walter de Gruyter & Co.

Shire, G. (2008). "Race and Racialisation in Neo-Liberal Times." In S. Davison & J. Rutherford (Eds.), *Race, Identity and Belonging: A Soundings Collection* (pp. 7–18). London: Lawrence and Wishart.

Sinclair, J. (1987). *Images Incorporated: Advertising as Industry and Ideology.* London & New York: Croom Helm.

Smedley, A. (1997). "Origin of the Idea of Race." *Anthropology Newsletter*, November 1997.

Smith, B.G., & Wojtowicz, R. (1989). *Blacks Who Stole Themselves: Advertisements for Runaways in the Pennsylvania Gazette, 1728–1790.* Philadelphia, PA: University of Pennsylvania Press.

Snowden, F.M.J. (1983). *Before Color Prejudice: The Ancient View of Blacks.* Cambridge, MA: Harvard University Press.

Snyder, W. (1993). "Advertising's Ethical and Economic Imperative." *American Advertising*, (Fall): 28.

Sowell, T. (1995). *Race and Culture: A World View.* New York: Basic Books.

Spencer, F. (1997). *History of Physical Anthropology: An Encyclopedia.* New York: Taylor & Francis.

Spencer, S. (2006). *Race and Ethnicity: Identity, Culture and Society.* London: Routledge.

Stern, B.B. (1999). "Gender and Multicultural Issues in Advertising: Stages on the Research Highway." *Journal of Advertising*, 28(1), 1–9.

Sturm, C. (2002). *Blood Politics: Race, Culture, and Identity in the Cherokee Nation of Oklahoma.* Berkeley: University of California Press.

Swarns, R.L. (2007). "So Far, Obama Can't Take Black Vote for Granted". *New York Times*. Retrieved 3 Feb 2007 <http://www.nytimes.com/ 2007/02/02/us/ politics/02obama.html>.

Taguieff, P.-A. (1990) "The New Cultural Racism in France." *Telos*, 83 (Spring 1990), 109-122.

Taylor, P. (2004). "Cultural Imperialism?" In British Council website, Retrieved 26 July 2010 <http://www.britishcouncil.org/history-why-cultural-imperialism.htm>.

Thaw, C., & Thaw, M. (1938). "Trans-African Safari." *National Geographic*, 64(3), 357.

Thompson, L.A. (1989). *Romans and Blacks*. London: Routledge.

Tomlinson, J. (1999). *Globalization and Culture*. Chicago: University of Chicago Press.

Tucker, S.C. (Ed.). (2009). *The Encyclopedia of the Spanish-American and Philippine-American Wars*. Santa Barbara, CA: ABC-CLIO.

Turton, D. (2004). "Lip-Plates and 'The People who Take Photographs': Uneasy Encounters Between Mursi and Tourists in Southern Ethiopia." *Anthropology Today*, 20(3), 3–8.

Twitchell, J.B. (1996). *Adcult USA: The Triumph of Advertising in American Culture*. New York: Columbia University Press.

UNESCO. (1969). *Four Statements on the Race Question*. Paris: UNESCO.

United Nations. (1966). *International Convention on the Elimination of All Forms of Racial Discrimination*. United Nations Treaty Series. G.A. res. 2106 (XX), 47, U.N. Doc. A/6014.

Virginia General Assembly. "Virginia Slavery Acts (1662, 1705)." In W. W. Henning (Ed.), *The Statutes at Large; Being a Collection of all the Laws of Virginia from the first session of the Legislature in the year 1619*. Charlottesville: University Press of Virginia [1969].

Viswanathan, G. (1995). "Beyond Orientalism: Syncretism and the Politics of Knowledge." *Stanford Humanities Review*, 5(1), 18–32.

Wagnleitner, R. (1994). *Coca-Colonization and the Cold War: The Cultural Mission of the United States in Austria After the Second World War*. Chapel Hill: University of North Carolina Press.

Waldstreicher, D. (Ed.). (2002). *Notes on the State of Virginia: With Related Documents*. New York: Palgrave.

Walker, A. (1834). *Physiognomy Founded on Physiology*. London: Smith, Elder and co.

Wall Street Journal. (1988). "Colgate Still Seeking to Placate Critics of an Asian Product." April 14, 1988: 36.

Wallerstein, I. (1974). *The Modern World-System: Capitalist Agriculture and the Origins of European World-Economy in the Sixteenth Century*. New York: Academic Press.

Warren, G. (1995). "Our Image of the Third World." In T. Triggs (Ed.), *Communicating Design: Essays in Visual Communication* (pp. 17–22). London: BT Batsford Ltd.

Waters, M. (2001). *Globalization* (2nd ed.). London: Routledge.

Weems, R.E.J. (2000). "Consumerism and the Construction of Black Female Identity in Twentieth-Century America." In J. Scanlon (Ed.), *The Gender and Consumer Culture Reader*. New York: New York University Press.

Weight, R. (2004). "Selling the UK in the 21st Century." In British Council website. Retrieved 26 July 2010 <http://www.britishcouncil.org/history-why-selling-uk.htm>.

Weis, L., Proweller, A., & Centrie, C. (1997). "Re-Examining 'A Moment in History': Loss of Privilege Inside White Working-Class Masculinity in the 1990s." In M. Fine, L. Weis, L.C. Powell, & L.M. Wong. (Eds.), *Off White: Readings on Race, Power, Society* (pp. 210–228). New York: Routledge.

West, C. (2003). "A Genealogy of Modern Racism." In L.E. Cahoone (Ed.), *From Modernism to Postmodernism: An Anthology* (pp. 298–309). Oxford, UK: Blackwell.

Williams, R. (1961). *The Long Revolution* (2001 Universal Reprint ed.). Ontario: Broadview Press Ltd.

———. (1980). "Advertising: The Magic System." In *Problems in Materialism and Culture: Selected Essays* (pp. 170–195). London: Verso.

Williamson, J. (1978). *Decoding Advertisements: Ideology and Meaning in Advertising*. London: Marion Boyars.

Wilson, C.C. II, Gutiérrez, F., & Chao, L.M. (2003). *Racism, Sexism, and the Media: The Rise of Class Communication in Multicultural America*. London: Sage.

Winant, H. (2004). *The New Politics of Race: Globalism, Difference, Justice*. Minneapolis: University of Minnesota Press.

———. (2007). "The Dark Side of the Force: One Hundred Years of the Sociology of Race." In C. Calhoun (Ed.), *Sociology in America: The ASA Centennial History* (pp. 535–571). Chicago: University of Chicago Press.

Windley, L.A. (Ed.). (1983). *Runaway Slave Advertisements: A Documentary History from the 1730s to 1790*. Westport, CT: Greenwood Press.

Wise, T. (2009). *Between Barack and a Hard Place*. San Francisco, CA: City Lights Books.

Woodhead, L., & Turton, D. (Directors). (1991). *The Land is Bad* [documentary], UK.

World Bank. (2002). "Globalization, Growth and Poverty: Building an Inclusive World Economy." Washington DC. Retrieved 12 February 2002 <http://econ.worldbank.org/prr/structured_doc.php?sp=2477&st=&sd=2857>.

Wright, E.O. (1985). *Classes*. London: Verso.

Young, R.J.C. (1995). *Colonial Desire: Hybridity in Theory, Culture and Race*. London: Routledge.

———. (2003). *Postcolonialism: A Very Short Introduction*. London: Oxford University Press.

Young, S. (2004). *The Persuaders: Inside the Hidden Machine of Political Advertising*. Melbourne: Pluto Press Australia.

Zantop, S. (1997). "The Beautiful, the Ugly, and the German: Race, Gender, and Nationality in Eighteenth-Century Anthropological Discourse." In P. Herminghouse & M. Mueller (Eds.), *Gender and Germanness: Cultural Production of Nation* (pp. 21–31). New York: Berghahn Books.

INDEX

A

advertising
 and consumer culture, 37–39; 94–95; *see also* commodity capitalism
 and global commodity culture, 2; 15; 115; 118–119; 233–234; 260
 and its social influences, 1–2; 119–120
 and multiculturalism, 16; 115; 126–127; 259; *see also* the "minority" label
 and race concepts, 20–21; 37–39; 73–76
 and racial politics, 7–8; 120; 134–135
 and slavery, 14; 23–25; 26–27; 36; *see also* slave trading ads and runaway slave ads
 and the age of globalization, 15–16; 114–115; 117–125
 and the age of High Imperialism, 14–15; 38–39; 73–76
 and the post-World War II and post-colonial era, 15; 86–89; 106–110
advertising industry
 global advertising industry, 15; 121–122
 racial inequality, 86–87; 126–127
 racial segregation, 87–89
Advertising Standard Authority (ASA), 144; 146; 151; 224; 258
aesthetic judgments, 48–52; *see also* Hottentot Venus

African National Congress (ANC), 233; 241
Agoncillo, Teodoro, 47
Agricultural Rehabilitation Program for Africa (ARPA), 181
Aliaga, Arturo, 210
AMBI, 105
American Anthropological Association, 9
American Century, 7
Americanization, 118–119; 123
Anderson, Gavin, 196; 198
Anderson, Walter, 114; 233
animalism/animality 43; 181–184; 186
Ansell, Amy, 128
Appadurai, Arjun, 114; 117
Aristotle, 40
ARTRA, 103; 104
Asquith, Herbert, 160
Atkinson, Rowan, 164
Aunt Jemima, 66–68; 75–76; 93; 189
Austin Nichols, 90–91

B

Balzo, Gioacchino Del, 215
Ban Ki-moon, 175
barbarism/cannibalism, 25; 43
 contemporary representation, 246–248
 historical representation, 40; 56–59
Barthes, Roland, 4; 13
Beckford, Tyson, 218–220
Benetton, 138–139
Bernier, François, 41; 51–52; 194
Bhabha, Homi, 114; 123; 143; 213

Biden, Joe, 130
Bit COPA, 221–224
Black and White (bleaching cream), 102
Black celebrities, 101; 217–218
Black consumer power, 15; 95–96
Black Media Association (BMA), 136–138
Black-owned media, 15; 132
Black Peter, 68
Blair, Tony, 159
Bleach and Glow, 100–102
Blum, Lawrence, 25–26
Bolt, James, 121
Boorstin, Daniel, 7; 16
British Council, 163–165; 166–170
Brown, Michael, 128
Buddha, 230
Buddhist deity and ritual, 230–233
Buyum, Milena, 146

C

capitalism, 117–118; 121; 123; 131
capitalist economy, 131–134
Campbell, Mark, 159
Campbell, Naomi, 218–220
Camper, Petrus, 20; 49–50; 59; 104
celebrity power, 162; 220–221; 243
Chambers, Jason, 86; 88–89; 108
charity ads, 170–171; 176–181
Chief Joseph, 70; 233; 238
Chief Lame Bear, 201–202; 205
Churchill, Winston, 79
Civil Rights Movement, 8; 15; 78–79
 and persistent racial inequality, 82–83
Cixous, Hélène, 82
Clarke, Deborah, and Kamari, Thomas, 13; 19
Clayton, Rory, 162
Cleveland Indians logo, 205
cliché, 11; 171; 181; 184; 262

Coca-Cola, 119; 121; 124–125; 132; 133–134
Cold War, 133; 159; 240
Colgate-Palmolive, 8; 190–191; 194–199
colonial race concepts, 19–20; 43–44
 dangerous Other, 56–59
 uncivilized Other, 44–48
 ugly Other, 48–55
 see also Grate Chain of Being
colonial racial script, 3; 6; 14–16; 37–76; 248–249; 259–262
 animal/sub-human, 43
 barbarism and savagery, 40; 56–59
 born fighters, 59–60
 born entertainers, 60
 hypersexual; see Hottentot Venus; Diesel
 primitive/lawless, 43
 uncivilized, 44–46; see also Third World
colorblind, 1; 127–130; 259
Columbus, Christopher, 40; 203
Commission for Racial Equality (CRE), 143–153; 159; 161; 162
commodification, 35; 61; 82; 244; 260
commodity capitalism, 20, 76
commodity sign value, 14, 16; 30; 140–141; 259
Congress of Racial Equality (CORE), 86
Conguitos, 206–211
 used as a racial slur, 212
consumer power, 15; 95–96; 108; 115; 259
consumerism, 15; 62; 94; 96; 100; 109
 and social activism, 138–139
Copeland, Daryl, 118
Cordaid, 176–178
Cream of Wheat; see Rastus
creative economy, 122
Cross, Mary, 1
cross-cultural communication challenges, 124–125
cultural diplomacy, 169

cultural imperialism, 15; 118–119; 167; 169–170
> debates within UNESCO, 167
cultural propaganda, 166; 169–170

D

Darkie, 190–199; 205
> Dakkie, 197
> Darlie, 197–199
> Mouth Jazz, 198
Darwin, Charles, 19; 56
> Social Darwinism, 19
Datson, Fidelix, 160–162
Davidson, Basil, 25
deformity/abnormality, 184–187
Delaney, Tim, 234; 237; 238
Dewey, George, 46–47
DIESEL, 224–226; 258
Disraeli, Benjamin, 20
Dr. Johnson, 24
Drucker, Peter, 131–132
Du Bois, W.E.B., 1; 95

E

Ebony, 81; 89; 95–96; 98; 100; 104; 105; 108–109
economic inclusion, 186; *see also* game of inclusion and exclusion
El Guindi, Fadwa, 175
elixir, xi; 141
Elvis, 187
endorser, 76; 134
> celebrity endorser, 72; 216; 243; 244; *see also* proxy endorser
erotic imagery, 221–227
Estée Lauder, 132
ethnic-nationalism, 125–126
Evers, Myrlie, and Peters, William, 77

exotic imagery, 92–93; 184–187; 208–209
exoticism, 28; 184; 186; 209;
extreme makeovers, 189; 198–199; 200; 204; 206; 210; 249; 254

F

facial angle, theory of, 49–50
Fair Housing Amendments Act, 136–137
Fanon, Frantz, 82–83; 85; 212
Feagin, Joe, 30; 39
fetishism, 92; 139; 187; 212–213; 217–220; 221; 224; 230; 233
> Black feet, 60; 217–221
> commodification of, 233; *see also* racial fetishism
> deformity, 51; 54–55; 60; 220; *see also* Habitat; Karen
> exotic practices, 92–93; 228–233
> female body, 92–93; 221–224
> male body, 224–226
Fields, Barbara, 7
Flagg, James Montgomery, 154
Fordism/post-Fordism, 118
Foucauldian genealogy, 4–6; 8; 20–21; 110
Foucault, Michel, 5; 13; 20; 21; 37; 110; 248
Frank Rippingille, 72–73; 169
Freud, Sigmund, 212–213
Frith, Katherine, 1
Fun to Wash, 93

G

game of inclusion and exclusion, 86–89; 104; 133–134; 136–138; 163–165; 181–182; 186
Gates, Henry, 9
gaze, 54; 144; 148; 150; 160; 171; 185; 186; 253
General Assembly of Pennsylvania, 195

General Motors, 124–125
Giroux, Henry, 139
global advertising industry, 121–122
global commodity culture, 2; 15; 115; 118; 233; 234; 260
globalization
 and advertising, *see* advertising and the age of globalization
 critiques of, 117–120
 definition, 12; 113–114
 metaphors of, 118–119
glocalization, 122–123
Gobineau, Arthur, 43
Golden Dust Twins, 69; 99
Goldman, Robert, 1; 19
Golliwog, 68
Gone with the Wind, 75
Gosper, Brett, 147
Gould, Stephen, 80
Great Chain of Being, 20; 43–44; 50; 79; 181; *see also* colonial race concepts
grobalization, 123
Guevara, Che, 80; 242

Hirschfeld, Magnus, 78
Hirschman, Charles, 129
Hitler, Adolf, 20; 107
 Nazism/Nazi, 19; 78; 107
Hoetink, Harry, 99
Holman, Blan, 127
hooks, bell, 140
Hottentot Venus, 39; 52; 54–55
Hoye, Michael, 196; 197
human rights ads, 175–176
Humana, 178–181
hypersexuality, 54; 55; 226

I

imperialism, 37; 45; 61; 74; 80; 117; *see also* cultural imperialism; High Imperialism
Indian/Savage synonym, 203
institutional racial politics, 154; 156–163
Interfaith Centre on Corporate Responsibility, 195
International Society for Human Rights (ISHR), 171; 173; 175–176; 256

H

Habitat, 249–254
Hall, Ronald, 100
Hall, Stuart, 113; 138; 143; 214
Haller, John, 59; 60
Hamilton, Lewis, 211
Harding, Andrew, 185; 186
Harvey, David, 7; 118
Hawley & Hazel, *see* Darkie
Hegel, G.W.F., 41; 43; 178
Hershey Kisses, 243
Hickey, Chris, 163
High Imperialism, 14; 38; 70; 99; 169; 244; 262
Hill, Benny, 164
Hilton, Matthew, 1

J

Jacob, Margaret, 40; 41
Jefferson, Thomas, 20; 30; 32–33; 35; 41; 261
Jewell, Karen, 189
Jhally, Sut, 1; 39
Jim Crow laws, 20
John Bull, 156
Johnnie Walker, 96–98
Johnson, Michael, 163
Jolson, Al, 191–194
Joseph, Gloria, and Lewis, Jill, 7

K

Kama Sutra, 226
Karen, 184–187
Kern-Foxworth, Marilyn, 7; 23; 24; 26; 31; 88; 127
King, Martin Luther, Jr., 82; 107
Kipling, Rudyard, 44–45
Ku Klux Klan (KKK), 129

L

Lamont, Michele, 128
Landor & Associates, 133
Leeper, Reginald, 166; 169
Leete, Alfred, 154
Lester, Paul, and Smith, Ron, 88
Levinas, Emmanuel, 232; 252
Levi's, 140; 228–230
Levitt, Theodore, 120–121
Levy, Peter, 82
Lewis, Carl, 213–218; 220
Lewontin, Richard, 80
Liebowitz, Annie, 216
lip-plated women, 249–254
 politics and consumption of, 249–252
 mocking of, 249; 253–254
Lombroso, Cesare, 59
long-necked women/giraffe women, 186
Lord Kitchener, 154–156; 160–163
Louis Vuitton (LV), 233; 243–246

M

Madison Avenue Project, 127
Magnum, 226–227
Malefyt, Timothy, 1
Mandela, Nelson, 233; 239–243
Mangaloo, 256–258

market expansions
 domestic ethnic market, 131–133
 markets in "undeveloped world," 133
Marx, Karl, 117; 212
mascot, 161; 203; 241; *see also* Conguitos
Maxwell, Ann, 52
McClintock, Anne, 37; 38; 61
McDonald's, 121
McDonaldization, 119; 123
McFall, Liz, 4
McKinley, William, 46
McNeill, William, 125
Meiners, Christoph, 41; 42; 48; 49; 51; 52; 101; 104
Meyer, John, 12
Michelin, 215
military recruitment ads, 153–163
 British, 153–156
 U.S., 153; 156–157
Mineta, Norman, 131
Ministry of Defence (MoD), 153; 154; 156; 159; 161; 162
Minority Business Development Agency, U.S. Department of Commerce (MBDA), 131
minority in question, 126
minstrel shows, 68; 75; 192–194; 198
M&M's, 239–243
 color game, 239–241
 spokescandy, 241
modernization theory for world development, 83; 85; 109; 168; 181
Moeran, Brian, 1
Moore, Elizabeth, 138
Morand, Linda, 101
Morgan, Hal, 200; 202
Morrison, Toni, 128
Muller, Thomas, 129
Mullin, Gerald, 31
multicultural Britain, 163–165
multiculturalism, 16; 115; 126; 131; 134; 259
multinationals, 119; 120; 123–125; 133

cultural and economic forces, 119; 123–125; *see also* global advertising industry; politics of multiculturalism

N

Nadinola, 104
National Assembly Against Racism, 146; 147
National Association for the Advancement of Colored People (NAACP), 86
National Negro Congress (NNC), 86–87
National Urban League, 86–87
nationalism, 118; 123; 125; 126
neocolonialism, 83; 109; 168
New York Central Railway, 90–91
Nietzsche, Friedrich, 13
Nike, 119–120; 234; 237
Nixon, Richard, 156
Nixon, Sean, 1
non-government organizations (NGOs), 6
non-profit organizations (NPOs), 6
Norris, James, 87
nostalgia, 85; 92; 244–246; 260
Nova, 124–125
Nye, Joseph, 166–167

O

Obama, Barack, 100; 130
Old Hickory, 98
Orient/Oriental, 10; 64; 82; 83; 85; 92–93; 176; 184; 213; 226; 228; 243
Orient and Occident, 11; 83; 85; 244
O'Shaughnessy, Michael, 10
O'Sullivan, Serena, 175
Ouseley, Herman, 146; 147; 159

P

Packard, Vance, 39; 94
Palidia, 102
Parry, Bruce, 250
Pears' Soap, 44–48; 51; 61–66; 85
Paterson's, 68
Pendergast, Tom, 95
Pérec, Marie-Jo, 217–218; 220
Petty, William, 40
Piccaninny, 70; 99
Pirelli, 212; 213–221
 the Calendar, 215
 PZero, 218–220
politics of multiculturalism, 134–135; *see also* multiculturalism
Prince Charles, 159
proxy, 153; 212; 260
proxy endorser, 233; 237
Prude, Jonathan, 31–32

Q

Quaker; *see* Aunt Jemima
Queen Elizabeth, 168; 169
Quetelet, Adolphe, 59

R

race
 and slavery, concepts of, 25
 before colonization, concept of, 25–26
 definition, 9–10
racial classification
 aesthetic, 42; 48–52
 nature, 43–44
 see also Enlightenment tenor
racial fetishism, 212–213
 Black (male) body, 224–226

Black feet, 60; 213–214; 217–221
exotic traditions, 230–231
sexualized female body, 92–93; 221–224; 226–227
racial identity, 2
earlier encounters, 25–26
Enlightenment tenor, 41–42
the "minority" label, 126
racial Other, 10
racial politics and struggles
age of globalization, 123–125; 473–474
Civil Rights Movement, 82–83; 86–89
decolonization movements, 78–80
demands for inclusion in ads, 136–138
demise of scientific race theory, 80–81
in ads promoting Britain, 163–170
in anti-racism ads, 143–153
in charity ads, 170–171
in military recruitment ads, 153–163
significance of the U.S. experience, 7–8; see also King, Martin Luther, Jr.
through Black media, 95–96
racial profiling, 59
racial representation in advertising, 259–262
dynamics of, 3
increase of, 2
lack of, 87–89; 140
market factor, 133–134
political and regulation demands, 134–138
power play between cultural and economic forces, 123–125
public protest and pressure, 195–197
specific guidelines, 136–138
racial stereotypes, 143; 260; 262
aspired middle class, 94–98
dangerous criminals, 35; 58–59; 144–145
deformed/abnormal, 184–187
dirty (for being Black, indecent, or non-believer), 61–66

endangered animals, 181–184
hypersexual, see Hottentot Venus, Bit COPA; Diesel
Sambos and Piccaninnies, 68–70; 93–94; 208–209
savages (barbarian savage, noble savage), 40; 106
sub-human, 43–44
subordinates (mammies, cooks, servants, and coolies), 66–68; 90–92; 243–244
superhuman, 218–220; 262
Third World people (needy and passive), 176–181
uncivilized/White man's burden, 44–48
victims (dying, dangerous, and oppressed), 171–176
want to be White, 61–62; 99–106
racism
and color-blind ideology, 127–130; commodity racism, 14; 38–39
institutional racism; 153; 156–159; 161
official condemnation of, 78; 106; 159–160; 259
philosophical and scientific racism, 39–44
postwar awareness of, 77–78
racism 2.0/enlightened exceptionalism, 130
Rastus, 66–68
Red Indian, 234–238
Reid, Harry, 130
Renault, 242
Ritzer, George, 119; 123
Robertson, Roland, 12; 26; 122–123
Ronaldo, 217–218; 220
Roosevelt, Theodore, 45–46; 79; 203
Rostow, Walt, 83; 85; 168; 178
Rough on Rats, 57

S

Said, Edward, 2; 82–83; 123; 213
Sambo, 68; 76; 94; 99; 208–209; 211; 262
Sambo's restaurant, 93–94
Sanitary Commission, 59–60; 220
Sarotti-Mohr, 68
Savage Arms, 200–206
Savage, Arthur, 200; 202
Savage Indian/Savage Chief, 202; 203; 204–205; 206
Schlitz, 96–97
Schmidt, Leigh, 38
semiotic, xi; 4–5
She Bear, 254–256
Sherry, John, 1
Shire, George, 113; 114; 130
shock tactic, 151; 171–174
skin bleaching ads, 100–106
skin color, 9–10; 25; 32; 33–34; 72; 106; 135; 174; 230; 243–244
 as index for slaves, 28; 34; 99
 as marker of racial stereotypes, 99
skin color hierarchy, 99–100
slavery advertisements, 23–36
 significances of, 23–27
 slave runaway ads, 30–35
 slave trading ads, 27–30
Smedley, Audrey, 28; 80–81
Snowden, Frank, 25
Snyder, Wally, 126–127
soft power, 166–167; 170; *see also* cultural diplomacy
Southern Mammy, 66; 75; 76; 93; 99; *see also* Aunt Jemima
Southwark White, 233; 246–248
Sowell, Thomas, 77
Spencer, Stephen, 10; 23; 25; 36;
Spencer, Frank, 50
Stainilgo, 182; 184
standardization and glocalization, 120–125

stereotyping and counter-stereotyping, 143–153
Straw, Jack, 146
Sumo, 228–230
superhuman, 213–214; 218–221, 262

T

taboo, 248; 259; 260
Taylor, Philip, 169–170
Taylor, Teddy, 146
Third World, 10; 11; 79; 83; 85; 119; 171; 172; 178–181; 195
Timberland, 234–239
Tomlinson, John, 119
tourism ads, 90–91; 92–93
Twitchell, James, 1

U

Uncle Sam, 154; 156
UNESCO, 80; 135; 167
UNHCR, 185
UNICEF, 171; 315
Union Carbide, 83–85
United Nations (U.N.), 78; 79; 135; 241

V

Valladolid debate, 40
Van Heusen; 89–90; 92; 93
veil, in Islamic culture, 175–176
veiled woman
 in human right ad, 173; 175–176
 in lingerie ad, 254–256
Vinolia, 61–62
visual strategies
 significance of, 3; 260–261

to balance, 135–136

to castrate, *see* Savage Arms; Conguitos

to dehumanize, 47–48; 181–184

to echo the past, 89–92; 93–94; 144; 148–151; 181–184; 243–248

to elicit anxiety and disgust, 174–176

to eroticize, 63–64; 221–227

to evoke nostalgia, 85; 90–92; 244–246

to exclude, 51; 53; 140–141

to exoticize, 92–93; *see also* Bit COPA; Karen

to hijack, 119; 228–233; 234–243

to juxtapose, 89–90; 105–106; 163–165; 166–170

to make proxy, 70–73; 92; 133–134; 153–163; 233; 237; *see also* Karen

to manipulate (surgical style), *see* Conguitos; Darkie; Habitat; Savage Arms

to mock, 147–151; 253–254

to mythify, 83–86; 213–221; 230–233

to parade, 70–73; 135–136; 138–139; 166–170; 176–181

to promise, 96–98; 100–106

to provoke, 144–147

to puzzle, 254–258

to redeem, 189–212

to shock, 56–58; 170–176; and its variations, 176–181

to sweeten, 206–212; 239–243

to tribalize, 89–90; 246–248; 249–254

to trivialize, 139; 234–239; 239–243

to whiten, 61–66; 100–106; 190–199

Voltaire, 41; 43; 51

W

W. Duke Sons & Co, 70–71

W.S. Kimball & Co, 70–71; 238

Waldstreicher, David, 41

Wallerstein, Immanuel, 12

Warren, Geoff, 171; 172

Wasa, 231–233

Weight, Richard, 170

West, Cornel, 13; 74

White man's burden, 44–48; 62; 66; 85; 262

white mythology, 85

White, Charles, 50–51; 104

Williams, Helen, 100–102

Williams, Raymond, 1; 24; 125

Williamson, Judith, 1; 4; 233–234; 248–249

Winant, Howard, 1; 19; 37; 74; 130

Wise, Tim, 130

Woodhead, Leslie, 253

World Bank, 12

X

X factor, 233; 244; 248

xenophobia, 57; 128

Y

Young, Robert, 30; 82; 85; 175–176